Central European
Drawings
1680–1800

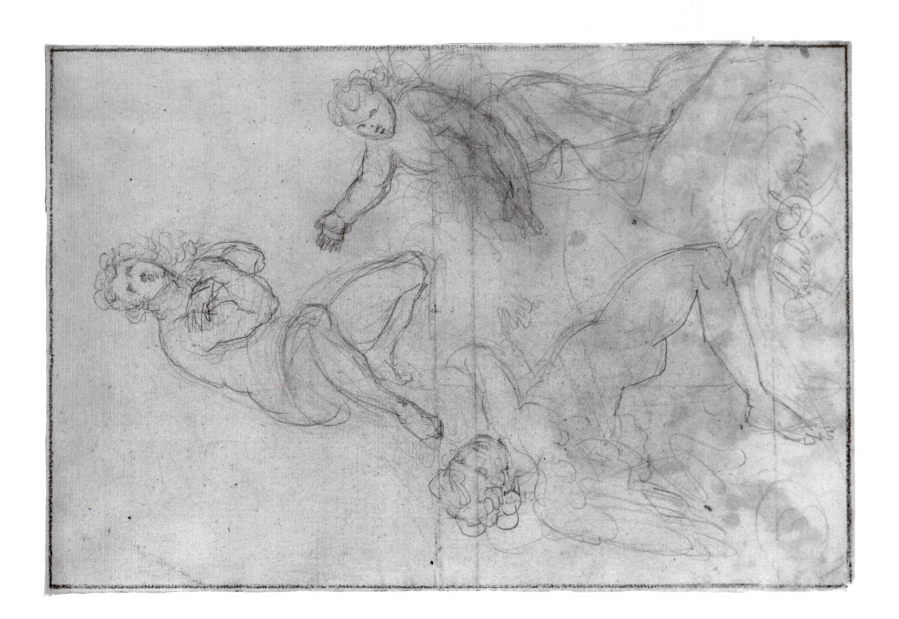

Central European Drawings 1680–1800

A SELECTION FROM AMERICAN COLLECTIONS

THOMAS DACOSTA KAUFMANN

The Art Museum, Princeton University
IN ASSOCIATION WITH PRINCETON UNIVERSITY PRESS

Published in conjunction with the exhibition
"Central European Drawings 1680–1800: A Selection
from American Collections"

The Art Museum, Princeton University
October 21–December 3, 1989

The University Art Museum, Santa Barbara
January 10–February 25, 1990

Library of Congress Catalog Card Number 89-062098
ISBN 0-943012-11-2 (paper); ISBN 0-691-04082-6 (cloth)

Published by The Art Museum, Princeton University, in associa-
tion with Princeton University Press, Princeton, New Jersey 08540.
In the United Kingdom, Princeton University Press, Oxford.

Cover illustration: Martin Johann Schmidt, *The Apotheosis of a Painter,*
Spencer Museum of Art, University of Kansas (cat. no. 45).

Frontispiece: Georg Raphael Donner, *Kneeling Nude Figure and
Two Studies of Angels,* the Metropolitan Museum of Art (cat. no. 50
recto).

The exhibition has been supported by a grant from the National
Endowment for the Arts, a Federal agency. The publication of this
book has been supported by the publication funds of the Depart-
ment of Art and Archaeology, Princeton University.

Editor: Jill Guthrie, assisted by Dorothy Limouze and
Betsy Rosasco
Designer: Bruce Campbell
Set in type by Columbia Publishing Company, Inc.
Printed by Meriden/Stinehour Press

Lenders to the Exhibition

Contents

Contents

List of Illustrations

WORKS EXHIBITED

Joseph Winterhalter, *Three Donors of Zábrdovice*, Collection of Robert and Bertina Suida Manning 25

Januarius Zick, *The Idolatry of Solomon*, Stanford University Museum of Art 42

Adrian Zingg, *A View of Dresden*, Harvard University Art Museums, Fogg Art Museum 102

FIGURES

Figure 1. Marcantonio Franceschini, *Mercury Snares Birds—Cupid Hearts* (preparatory study for a painting in the Liechtenstein Palace, Vienna), pen and brown ink, 98 × 275 mm. The Art Museum, Princeton University, gift of Frank Jewett Mather, Jr., x1976–61b.

Figure 2. Giambattista Tiepolo, *Head of a Bald Old Man with a Moustache, Seen from Above* (study for a fresco in the Residence, Würzburg), red chalk heightened with white on blue prepared paper, 229 × 175 mm. The Art Museum, Princeton University, bequest of Dan Fellows Platt, x1948–829.

Figure 3. Georg Friedrich Schmidt, *Portrait of Julien Offray de la Mettrie*, red chalk and crayon, 320 × 250 mm. (sheet). The Minneapolis Institute of Arts, gift of David M. Daniels, 74.95.2.

Figure 4. Samuel Bottschild, *The Victory of Scipio over Syphax*, pen and black ink, gray wash, 183 × 280 mm. The Harvard University Art Museums, Fogg Art Museum, gift of Belinda Lull Randall from the John Witt Randall Collection, 1898.174.

Figure 5. Sigmund Freudenberger, *Corner of a Rustic Barn*, black chalk, 232 × 283 mm. Collection of Andrew Robison.

Figure 6. Johann Georg Wille, *Farm Buildings*, pen and black ink, brown wash over graphite, 230 × 278 mm. University Art Museum, University of Minnesota, Minneapolis, General Budget Fund, 62.13.

Figure 7. Franz Xaver Wagenschön, *Holy Family with Saints*, pen and brown ink, gray wash over traces of graphite, 232 × 130 mm. The Art Institute of Chicago, Leonora Hall Gurley Memorial Collection, 1922.3515.

Figure 8. Matthäus Günther, *Scene from the Life of St. Benedict*, 1745, pen and brown ink, gray washes, white heightening and black chalk, 733 × 516 mm. Philadelphia Museum of Art; the John S. Phillips Collection, acquired with the Edgar V. Seeler Fund (by ex-

change) and with funds contributed by Muriel and Philip Berman, PAFA 112.

Figure 9. Caspar Franz Sambach, *Academic Study*. Szépművészeti Múzeum, Budapest, inv. no. 833.

Figure 10. J. M. Schmutzer, *Academic Study*, red-brown chalk, 520 × 411 mm. Collection of Mr. and Mrs. Martin S. Baker.

Figure 11. Ottmar Elliger the Younger, *From the Revelation of Saint John* (4: 1–8), pen and ink, gray wash and lead white, 140 × 207 mm. The Art Institute of Chicago, Leonora Hall Gurley Memorial Collection, 1922.2083.

Figure 12. Anton Kern, after Giovanni Battista Pittoni, *Epitaph of Charles Sackville*, brush and red-brown wash heightened with white gouache over traces of black chalk, 401 × 288 mm. The Art Institute of Chicago, Leonora Hall Gurley Memorial Collection, 1922.3799.

Figure 13. Daniel Gran, *Sketches of Angels and Putti*, pen and brown ink, gray wash, 267 × 201 mm. The Art Institute of Chicago, Leonora Hall Gurley Memorial Collection, 1922.992.

Figure 14. Jakob Andreas Friedrich, after Johann Christoph Liška, *The Blessed Humbelina*, engraving, from Augustinus Sartorius, *Cistercium Bis-Tercium*, Prague 1708.

Figure 15. Johann Evangelist Holzer, *Adoration of the Shepherds*, etching, 169 × 115 mm. Augsburg, Städtische Kunstsammlungen, G 4500.

Figure 16. Johann Christoph Steinberger, after Johann Evangelist Holzer, *Adoration of the Shepherds*, engraving. Munich, Staatliche Graphische Sammlung, 1991.

Figure 17. Franz Sigrist, *Design for Book Illustration*, pen and black ink, gray and brown washes, graphite, on paper covered with pink wash, 94 × 135 mm. The Metropolitan Museum of Art, gift of James C. McGuire, 26.216.71.

Figure 18. Franz Sigrist, *Design for Book Illustration*, pen and black ink, gray and brown washes, graphite, on paper covered with pink wash, 100 × 156 mm. The Metropolitan Museum of Art, gift of James C. McGuire, 26.216.70.

Figure 19. Ignaz Unterberger, *St. Agnes*, red chalk, 152 × 202 mm. Collection of Robert and Bertina Suida Manning.

Foreword

In 1982 The Art Museum, Princeton University, organized the exhibition "Drawings from the Holy Roman Empire 1540–1680," which traveled to the National Gallery of Art, Washington, D.C. and the Museum of Art, Carnegie Institute, Pittsburgh. The exhibition, which explored in depth historically important material little known in this country, clearly filled a need and was very well received. That response encouraged the organization of the present exhibition of drawings of the following period in Central Europe. The curator and author of the catalogue for both exhibitions is Thomas DaCosta Kaufmann of the Department of Art and Archaeology, Princeton University, and I wish to thank him for these exhibitions, which will make a significant and lasting contribution to the study of Central European art.

Fortunately, the Museum has been able to count on many of the same people who contributed to the quality and success of the earlier exhibition. Betsy Rosasco, associate curator, was the staff curator of the exhibition and assisted significantly in the editing of the catalogue. Maureen McCormick, registrar, was central to the organization of the exhibition at Princeton and its tour to the University Art Museum, Santa Barbara. Jill Guthrie, managing editor of publications, has overseen not only the copyediting and production of the catalogue but has greatly contributed to aesthetic decisions and the design of the invitation and poster. Susan

Lorand assisted with the preparation of the manuscript. Dorothy Limouze, graduate student in the Department of Art and Archaeology, assisted in the editing of the catalogue. Once again, Bruce Campbell has designed a very handsome catalogue. Columbia Publishing Company, Inc., did the fine job of typesetting; and Meriden/Stinehour Press the high quality of printing we have come to depend upon.

The Department of Art and Archaeology, Princeton University, provided support from the Spears Fund for travel by Professor Kaufmann, and from the publication funds for the catalogue. A grant from the National Endowment for the Arts, a Federal agency, made the exhibition possible. Funds from the Museum's Corporate Partners: American Reinsurance Company, Carvel Corporation, Johnson & Higgins, Johnson & Johnson, Merrill Lynch & Co., Inc., Mobil Research and Development Corporation, and the Pullman Company provided additional support for the exhibition. The Samuel H. Kress Foundation and the International Research and Exchanges Board supported the participation of foreign scholars in the symposium held in conjunction with the exhibition at Princeton.

I am greatly indebted to the lenders, both institutions and private collectors. Their generous response to our requests for works of art from their collections has made possible this rich representation of Central European drawings.

ALLEN ROSENBAUM
Director

xiv

Acknowledgments

The good will that I encountered in the preparation of *Drawings from the Holy Roman Empire 1540–1680* has sustained me in this project as well. In the seven years that have passed since that exhibition was organized, the cooperation and support of many individuals and institutions have carried *Central European Drawings 1680–1800* past what might have seemed major obstacles.

I am grateful first of all to those who are most directly responsible for the realization of this exhibition and catalogue. Museums and private collectors have been almost universally generous with loans. They have also been forthcoming with information about objects in their care, to which they have readily granted me access. The Art Museum, Princeton University, the organizing institution, has completed this project during a period of expansion, reconstruction, and reinstallation. For their continuing support at a time when they had to deal with many other difficult problems, I am thankful to the staff of The Art Museum. Allen Rosenbaum, director, placed his confidence in this enterprise, and was helpful in many ways. Jill Guthrie, managing editor of publications, edited and oversaw the publication of the catalogue. Betsy Rosasco, associate curator, assisted with the editing and oversaw the administration of the show. Susan Lorand, office assistant, helped with the preparation of the manuscript. Maureen McCormick, registrar, provided for the often complicated arrangements concerning insurance, photography, and transportation. In addition to the staff, Dorothy Limouze assisted with the editing of the catalogue; Bruce Campbell was the designer.

The Department of Art and Archaeology, Princeton University, also provided major personal and material support for this project. Emily Bakemeier, Malcolm Daniel, Grazyna Fremi-Hamilton, Martin Gasser, Meredith Gill, Eva J. Iscoe, Deborah Krohn, Michael Rabens, Sabine Schultz, and Vanessa B. Sellers were students in seminars that discussed issues related to, and prepared entries on, the drawings in this exhibition. Although none of these entries has been directly used here, the research that they carried out in this way and in their seminar reports has formed one of the foundations of my own work.

Through its funds for publication, the Department of Art and Archaeology provided generous subven-

tion for the catalogue. The Spears Fund of the Department also enabled me to travel abroad and to obtain assistance in research in the United States and in Europe from Emily Bakemeier, Grazyna Fremi-Hamilton, and Sabine Schultz, whose loyal aid I appreciate.

Other funding in support of this exhibition, including monies for travel and research assistance, was generously provided by the National Endowment for the Arts. A fellowship from the Alexander von Humboldt-Stiftung enabled me to reside and carry out research in the Federal Republic of Germany for nine months. During my stay in Germany, the Kunsthistorisches Institut of the Freie Universität, Berlin, and the Zentralinstitut für Kunstgeschichte, Munich, were welcoming hosts.

I am grateful to libraries and museums in West Germany, as well as in Austria, Belgium, Czechoslovakia, Denmark, France, the German Democratic Republic, Great Britain, the Netherlands, and Poland, where I was able to continue my research. Many collections enabled me to study their drawings. In particular, I would like to single out the following individuals for making special efforts to facilitate my work: Yvonne Boerlin [-Brodbeck], Basel; Peter Dreyer (now in New York) and Hans Mielke, West Berlin; Werner Schade, East Berlin; Jiří Kroupa, Brno; Werner Schmidt and Christian Dittrich, Dresden; Richard Harprath, Munich; Pavel Preiss, Prague; Heinrich Geissler, Stuttgart; Konrad Oberhuber and Fritz Koreny, Vienna; Renate Barth, Weimar.

I received advice, information, and suggestions from many individuals in Europe and in America. These include Rolf Biedermann, Richard Bösl, Barbara Butts, Nicola Courtright, Elaine Dee, Claudia Diemer [-Maué], Jan Dreisbach, Thomas Gaehtgens, Heinrich Geissler, Laura Giles, Stephen Goddard, Christian von Heusinger, Eckhard Knab, Jiří Kroupa, Ebba Krull, the late Edward Maser, Miklós Mojzer, Helen Mules, Suzanne Folds McCullagh, Konrad Oberhuber, Carlotta Owens, Ann Percy, Pavel Preiss, William Robinson, Steffi Röttgen, H. Jeffrey Ruda, Miriam Stewart, Peter Volk, and Eric Zafran. Andrew Robison helped me with the initial selection of drawings. Richard Harprath, Vojtech Hron, Jeffrey Chipps Smith, and Michael Zimmermann accompanied me on travels to

see related monuments. Closest to home, Virginia Roehrig Kaufmann was a constant source of counsel and support, as well as offering a critical reading of the introduction.

To all I am grateful.

THOMAS DACOSTA KAUFMANN
Princeton, December 1988

Central European
Drawings
1680–1800

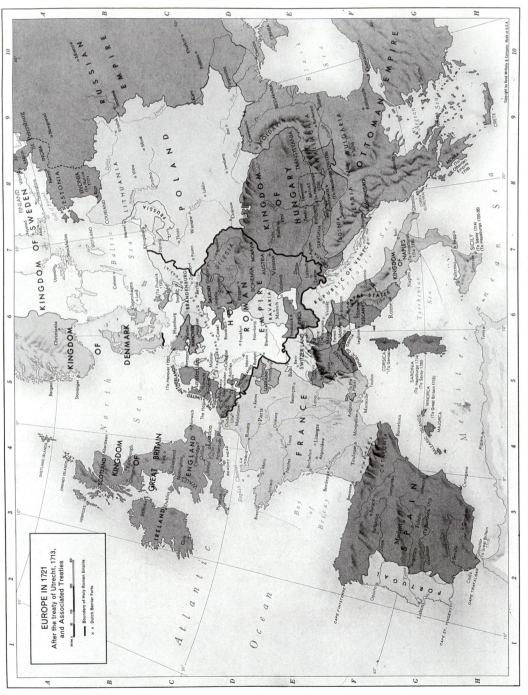

EUROPE IN 1721
After the treaty of Utrecht, 1713,
and Associated Treaties

Boundary of Holy Roman Empire
x x Dutch Barrier Forts

From *Historical Atlas of the World*. ©Copyright 1989 by Rand McNally & Company, R.L. 89-s-110.

Central Europe occupies a prominent place in many realms of eighteenth-century culture. From ca. 1680, while the region recovered from the wars of the previous era, and states such as Prussia and the Habsburg lands grew in power and importance, there occurred a flowering of arts and letters. Bach, Handel, Telemann, Mozart, Haydn, and the young Beethoven all created musical masterworks. Great authors such as Goethe and Schiller began writing in the latter part of the century. And Baumgarten, Winckelmann, Lessing, and Kant effected a revolution in philosophy and criticism.

Although admirable works of art were also produced during this period, the visual arts have never gained the high regard enjoyed by accomplishments in other fields. From ca. 1680 architecture, painting, sculpture, and the graphic arts all gradually attained a high standard. The rococo churches and palaces of Central Europe are among the most extraordinary ensembles of their time. German-speaking artists also played leading roles in the artistic movements of the late eighteenth century. Yet, except for a few names or monuments, most Central European art from this period remains largely unfamiliar.

Central European Drawings 1680–1800: A Selection from American Collections deals with the art of an era that may be somewhat better known than that covered by the exhibition and catalogue *Drawings from the Holy Roman Empire 1540–1680: A Selection from North American Collections*,[1] to which it may be considered a sequel. However, it also opens up relatively unknown territory. While recent European exhibitions and books have acquainted wider audiences with drawings of the period, no general survey has resulted to replace a work now half-a-century old.[2] And while a few previous exhibitions on this continent have incorporated material from the epoch, none has yet provided an adequate picture of the holdings of eighteenth-century drawings in this country. Thus, like its predecessors, this book and exhibition undoubtedly contain many surprises, at the same time that they necessitate further explication.

Since the division of Europe into two rival camps in 1945, even the idea of "Central Europe" may seem unclear. Before its dissolution in 1806, this area was largely comprised by the Holy Roman Empire. This collection of hundreds of states, ruled over by an emperor elected by a college of secular and ecclesiastical princes, stood for an ideal of political unity in a time of increasing political and cultural diversity.

The chronological limits 1680 to 1800 reflect the political and cultural situation relating to the Habsburg dynasty, which, except for a brief interruption in the 1740s, provided the titular rulers of this polity. The year 1683 marks the repulsion of the Ottoman advance into Europe at the siege of Vienna, after which the Austrian lands recovered, grew into a great power, and expanded eastward and southward. In 1805 Austria was decisively defeated by Napoleon, culminating an epoch in which the aftershocks of the French Revolution rolled through Central Europe, leading eventually to the dissolution of the Holy Roman Empire itself.

The choice of the term "Central Europe" instead of "Holy Roman Empire" is intended to evoke the changed situation of the later epoch. Both exhibitions consider art from Switzerland, the two modern German states, Austria, parts of Czechoslovakia, and Poland. But in the eighteenth century, the interests of rulers of lands within the Holy Roman Empire in territories outside became increasingly important. To mention Central Europe alone: the Habsburgs ruled over Austria and Bohemia, while expanding their Hungarian kingdom and gaining control over Galicia; the electors of Saxony became kings of Poland; the electors of Brandenburg ruled an expanding Prussia, from which land they also claimed a royal title; and the electors of Hannover were also kings of England. After 1648 the Swiss confederation was also independent from the Empire, even while the Swiss maintained many connections with the rest of the German-speaking world (see for example cat. no. 3). These circumstances suggest that a framing conception of a geographical rather than a strictly political nature is preferable to that of the Holy Roman Empire, an entity that was becoming ever more moribund in symbolic significance as in centralizing power.

While the making of art in the eighteenth century was enmeshed in these historical circumstances, the history of the region may be as unfamiliar as its art. A consideration of historiography may account, however, for the lack of knowledge and appreciation of Central European art. The historiography of eighteenth-

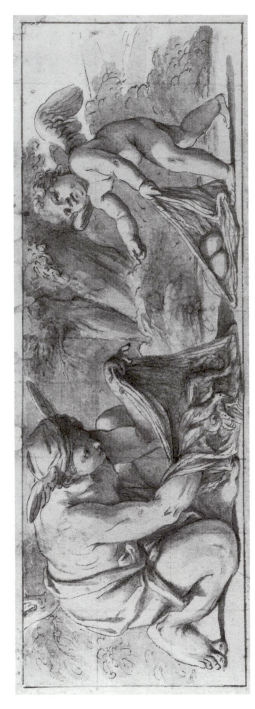

Figure 1. Marcantonio Franceschini, *Mercury Snares Birds—Cupid Hearts* (preparatory study for a painting in the Liechtenstein Palace, Vienna), pen and brown ink, 98 × 275 mm. The Art Museum, Princeton University; gift of Frank Jewett Mather, Jr., x1976–61b.

century Central European art suggests that other than objective aesthetic judgments led to the neglect of drawings from the period.

I. THE HISTORIOGRAPHIC SITUATION

The history of Central European art is a long chronicle of collaborations and rivalry between indigenous artists and talented emigrés from northern Europe and Italy. As in the preceding period, during the late seventeenth and eighteenth centuries many artists from outside the region continued to find employment in or send works to Central Europe. These include Italians, such as Giambattista Tiepolo or Giambattista Pittoni, or from elsewhere, such as Marcantonio Franceschini (fig. 1) or Andrea Pozzo, and Dutchmen such as Adriaen van der Werff. Indeed, one of Tiepolo's best-known cycles is the decoration of the prince-bishop's residence in Würzburg. Such projects as Tiepolo's fresco (fig. 2) contradict any lingering suspicion that only second-rank artists traveled to work in Central Europe. Würzburg may also be regarded as representing the rich opportunities available for artists: the Central European artistic boom provided some of the most promising commissions available at the time.[3]

This exhibition focuses, however, on the work of artists born in the region, regardless of where they were active. For not only did artists from Italy and elsewhere come to Central Europe, but artists from the region also played major roles abroad. These include Johann Carl Loth (cat. no. 28) in Venice (known there as "Carlotto"), Anton Raphael Mengs (cat. nos. 27, 55) in Spain and in Rome, Angelika Kauffmann (cat. no. 72) in Rome and England, Jakob Philipp Hacker (cat. nos. 93–95) in Rome and Naples, Johann Heinrich Füssli (cat. no. 79) in England, and even Johann Georg Wille and his circle in Paris (cat. no. 78).[4] Their accomplishments demonstrate both the growing cosmopolitanism of eighteenth-century culture in general and the important place of Central European artists within it. In this period Central Europe was undoubtedly not only receiving artistic impulses but transmitting them as well.

Yet in Anglo-Saxon art history, where Tiepolo's Würzburg ceiling might well be the best, if not even one of the only, well-known Central European monuments of the era, this message has evidently remained unintelligible to many modern scholars. From such evidence as the employment of illustrious foreign artists, false conclusions have been drawn about the absence of local talent—although similar observations could be made about the importance of "foreigners" in any other part of Europe in the eighteenth century. The depreciation of Central European art of the period that began in its own time, though mitigated in recent years, has continued to the present day.

It might have seemed that the publication of Joachim von Sandrart's *Teutsche Akademie* just before 1680 would have portended otherwise for the ensuing period. After all, Sandrart not only assimilated the humanist traditions of writing on art but also provided important early documentation of Central European artists. In his account German artists are promoted to their rightful place in relation to artists of other nations, and their drawings are also discussed.[5]

But at the same time, the cultural domination of the region by Italians and French, as well as the French military preponderance, helped reinforce cultural prejudices that made it difficult for locally produced art to gain critical recognition.[6] Early reactions to these attitudes can be seen in the writings of native scholars. In Austria, already in the 1690s, voices might be heard calling for an *Ehren-Ruff Teutschlands* (a call to glory of the German nation) in response to foreigners, and proclaiming the splendor of German architecture. At the same time, however, one must consider the arguments of Christian Thomasius, who bemoaned the cultural backwardness of Germans and their refusal to use German.[7] For the eighteenth century the stance of a figure like Frederick II ("the Great") of Prussia seems similarly characteristic. In Frederick a feeling of cultural inferiority—though ill-informed—was fatefully combined with military aggressiveness.[8]

This same lack of self-appreciation is evinced in the writing of Carl Heinrich von Heinecken, the director of the Dresden *Kupferstichkabinett* from 1746, and one of several authors of art historical books that appeared from the mid-eighteenth century in the wake of Johann Joachim Winckelmann.[9] Writing in the 1760s, Heinecken gave much information about German artists of past centuries. Nevertheless, he came to an admission that he found painful at a time when national pride had become fashionable. Although it might be wished that Germans had at least equalled, if not surpassed, the Italians, French, and Dutch in the visual arts, they formed the worst of all the schools of art.[10]

Thus while in the eighteenth century, biographies might already be compiled for the local artists of Nuremberg or Switzerland, and while authors such as Christian Ludwig von Hagedorn or Johann Caspar Füssli might celebrate the accomplishments of con-

temporary or recently deceased painters such as Georg Philipp Rugendas the Elder (see cat. no. 73), contemporary criticism did not encourage the appreciation of local art.[11] Winckelmann may have praised in passing Daniel Gran's ceiling painting in the Vienna Hofbibliothek (see. cat. no. 14), but his famed attack on rococo decoration had a more immediate and lasting impact on taste and the formation of opinions.[12] What were later described as the distinctive styles of the baroque and rococo long remained out of favor.

Winckelmann's classicism represents but one position in the critical debate that emerged in the eighteenth century. His views, which along with those of his friend Mengs favored the classicizing tendencies in eighteenth-century art, did not go unanswered. The classicism to which Mengs and Winckelmann aspired soon came to

Figure 2. Giambattista Tiepolo, *Head of a Bald Old Man with a Moustache, Seen from Above* (study for a fresco in the Residence, Würzburg), red chalk heightened with white on blue prepared paper, 229 × 175 mm. The Art Museum, Princeton University, bequest of Dan Fellows Platt, x1948–829.

be challenged by other points of view.[13] Yet even while they advocated a break from the canon of Winckelmann and Mengs, Goethe (who to be sure later stated his own classicist aesthetics) and like-minded contemporaries did not find a suitable substitute in the art of their day. They in fact showed little interest for the visual arts of their time aside from genre or landscape and promoted Gothic art as an authentic, "German" cultural form.[14] The baroque and rococo of the eighteenth century were regarded merely as derivative imports.

Therefore, it is not surprising that as the formal study of art history developed in nineteenth-century Germany, art of the preceding era was in general overlooked or disparaged. Measured especially against the age of Albrecht Dürer and the "Old German Masters" of the early sixteenth century, the succeeding periods did not seem to stand up. According to the general survey of painting published by Alfred Woltmann and Karl Woermann in 1888, eighteenth-century German painting had still not recovered from the disasters of the Thirty Years' War (1618–1648).[15] For Wilhelm von Bode, whose work greatly influenced both academic scholarship and museum collections, no sign of artistic revival was visible in the seventeenth or eighteenth century beyond the coarsened or eclectic products of the era after the war. In writings such as these, the scorn and incomprehension for the "baroque," especially in Germany, have been seen as reaching their apogee.[16]

Stimulated by the work of scholars and teachers such as Heinrich Wölfflin and Alois Riegl, art history came to recover the "baroque" as a distinctive style for the period of the seventeenth and eighteenth centuries, and eventually also the "rococo" for the eighteenth. The late nineteenth-century revivals of baroque and rococo motifs in decoration and architecture were further indication of a widespread reevaluation of these styles.[17] Just before the First World War, some significant essays appeared on the baroque and rococo in Central Europe.[18] Most notable among the efforts of this era was the large Jahrhundertausstellung of "German Baroque and Rococo" that took place in Darmstadt on the very eve of the war. In one of the extensively illustrated tomes that accompanied this exhibition, Georg Biermann remarked on the conscious effort being made to recover what he could rightly state was a neglected period.[19]

While the Jahrhundertausstellung represents a landmark in the recovery of this period, it was ill-timed for a favorable reception. As one of the few books produced in direct response to the exhibition stressed, the 1914–1918 war limited any effect it might have had. Moreover, even this critique could still not find a real "art history" in the period 1650–1800, in comparison with the coherent picture of development supposedly to be found in models elsewhere in Europe.[20] Rather, the moment was ripe for the ideology inherent in Georg Dehio's history of German art, in which the eighteenth century is treated in very cursory manner. From Dehio's chauvinistic viewpoint, only the supposedly distinctive architecture of the age was noteworthy.[21]

During the Weimar period, art of the "Romantic" era, including some works of the late eighteenth century, continued to be popular, and the rehabilitation of baroque and rococo architecture continued.[22] At this time some fundamental studies of drawings were written, for instance, Martin Weinberger's pictorial survey of German rococo drawings, as well as Karl Garzarolli-Thurnlackh's pioneering monograph on the graphic work of Martin Johann ("Kremser") Schmidt (see cat. nos. 26, 44, 45), and his general survey of Austrian drawings.[23] These studies complemented the work of other Viennese scholars during the 1920s and 1930s, as seen in the establishment by Hans Tietze and Franz Martin of the Austrian Baroque Museum and the compilation of the catalogue of the drawings of the "German School" in the Albertina in Vienna.[24]

Yet, despite these advances, a lack of enthusiasm for the figural arts persisted. Both Dehio's popular and frequently reprinted survey and Adolf Feulner's comments in the standard Handbuch der Kunstwissenschaft on painting and sculpture of the eighteenth century in Germany (conceived as the German-speaking lands) represented more widely held opinions. The notion that artists of the period were mere followers or epigones was still prevalent. In Feulner's opinion, painting, and implicitly drawing, stood far behind other German achievements in the visual arts of the time.[25] It is a testimony to the continuing lack of interpretive surveys of the period, as well as the absence of revision of earlier views, that Feulner's work is still frequently cited.

The growth of extreme nationalist art history during

the Nazi epoch further deflected the reception of the period. Symptomatically, Feulner fell back upon racist conceptualizations,[26] while Wilhelm Pinder's defense of the German baroque was a characteristically nationalistic reaction.[27] The most striking case in point is that of Hans Sedlmayr, who earlier had written pioneering studies of Austrian baroque architecture; now Sedlmayr glorified the Central European baroque with the questionable thesis that it was rooted in a national *Reichsstil*, which presumably foreshadowed the Third *Reich* he expressly celebrated at the moment of Austria's *Anschluss* with Germany.[28] Scholars educated in this climate found recourse to the language of *Blut und Boden* even after the "thousand-year" *Reich* had collapsed, discussing the *Stammesart* (tribal or racial character) of German baroque art, defending its value by reference to its supposed independence from other schools of art.[29] While Dürer could be idolized as typically German, the art of later ages, particularly those with supposedly strong "foreign" presences, received the kind of treatment that Pinder had to offer, and this particularly affected discussions of the figural arts.[30] In his 1943 survey of German drawings of the eighteenth century—the last general book devoted entirely to the topic—Bernhard Dörries accordingly states that eighteenth-century drawings do not seem important in comparison with those of the Dürer period nor are they as much beloved as German Romantic drawings.[31]

Starting with the exhibition of seventeenth- and eighteenth-century German drawings held in Berlin in 1947, post-war displays and publications have put the period in better focus. A spotlight was cast on the rococo in Central Europe by the 1958 Council of Europe exhibition in Munich, and numerous works have since focused on stylistic issues.[32] Monographs on major figures such as Franz Anton Maulbertsch have appeared since 1960.[33] From the 1960s, exhibitions and catalogues have drawn more attention to Central European drawings,[34] along with a number of studies of specialized problems related to this medium.[35]

Yet no satisfactory new overview of the art of the period has resulted in recent years.[36] It is indeed telling that several exhibitions of the 1970s and 1980s have continued to present art under the aegis of the better-known musicians or writers of the epoch, such as Bach

and Goethe.[37] In view of the continuing lack of revision in popular esteem or widespread scholarly attention, the catalogue of a very recent exhibition of German (in effect, Central European) drawings of the eighteenth century can thus correctly state that "the fact that too little attention has been given to the German painters and draftsmen of this period means that an unbiased assessment of this period has yet to be made." But even this relatively sympathetic summary can claim that no art of outstanding quality was produced in Germany at this time, that it lacked figures of outstanding genius.[38] This assessment is just one token indicating that the reception of Central European drawings of the late seventeenth and eighteenth centuries is still determined by criteria based on admiration for foreign artists.

II. THE HISTORICAL CONDITIONS

Even a brief summary of the general historical circumstances in which art was produced in the eighteenth century suggests that the imposition of such standards is inappropriate. For as the history of Central Europe does not follow the same patterns as that of England or France, the functions and designs of works of art were not the same. Certainly Central Europe could not claim a Watteau or a Reynolds, but it can also be said that France or England did not produce a fresco painter comparable to Maulbertsch.

Indeed, while models of historical and stylistic development have been proposed for France, England, and even Spain, no such paradigm can be found for Central Europe for the period after 1680, because there was no unitary political development in the region. No single centralized state developed, with one dominant religion, or allowing for the obvious conflicts of time, a single, relatively homogeneous series of forms of cultural expression.[39]

Therefore, the problem to be posed, if not completely solved, here is to find a flexible way of dealing with the various artistic forms that developed, almost mirroring, as it were, the continuing pattern of political, social, religious, and hence, cultural diversity. For while Brandenburg-Prussia evolved into a strong power, and the Habsburg lands increased their domin-

hemia: the principal goal in this region was to win back areas that had earlier been lost for the Roman confession. In this process of re-Catholicization, the older orders assumed a leading role in reviving local traditions of cult, monasticism, and pilgrimage, and employed art for these ends (see cat. nos. 29, 7, 15, 10, 15).

Elsewhere in Germany, the aphorism of Frederick II of Prussia that every prince wanted to have his own Versailles, or one might add, Vienna, strikes a true note. In emulation of the Habsburgs or Bourbons, a *Bauwurmb* set in: a mania for construction of palaces, residences, and even whole cities that carried away prelates and princes, regardless of their means or religious confession. Large residences were built and constructed in Bavaria, at Munich and Schleissheim; in Saxony, at Dresden; in Württemberg, at Stuttgart and Ludwigsburg; in Brandenburg-Prussia, at Potsdam and Berlin; and in many other places as well. This wave continued through to the mid-eighteenth century, involving many painters and decorators, some of whose work is to be seen in this exhibition (see cat. nos. 3, 12, 85, 89, 60, 56, 57, 6, 20, 28).

In the south German principalities of Swabia, Franconia, and Bavaria, where the local populations remained predominantly Catholic, artists were called upon to design and provide decoration for churches. These concerns occupied painters from the generation of Loth and Johann Melchior Schmittner (cat. nos. 28, 1) in the late seventeenth century through that of Januarius Zick (cat. no. 42) in the late eighteenth. Although the monasteries, which for example owned one half of the area of Bavaria, may have taken the initiative in this process, they were closely followed by the urban churches and orders. Moreover, the reconstruction or frescoing of many smaller parish churches and pilgrimage shrines, both in urban concentrations and in the countryside, attests to the genuine popularity of this movement.

Architects, stuccoists, and painters from both regional centers of decoration, like Wessobrun, and metropolitan areas were involved in this activity. So, for example, artists such as C. D. Asam, Franz Ignaz Günther, and Joseph Häringer (cat. nos. 11, 52, 53) resided in Munich, but traveled to complete commissions. The wealth of commissions in neighboring areas also enabled the city

ions to the south and east, Central Europe remained divided into a miscellaneous quilt of small and large states. Some cities, such as Hamburg, grew as centers of commerce, while other cities, such as Karlsruhe, were established as princely residences. The earlier division of religious confessions continued in the lands that now make up Germany, with Protestantism concentrated in the north and Catholicism in the south. As a result there existed varying, often quite different patterns of patronage and consequently of functions for art throughout the region.

The first burst of significantly new artistic activity after 1680 in this region is associated with the Habsburg monarchy. While in their domains certain traditional modes of artistic production continued (see cat. nos. 49, 30, 4), the Habsburg patrons asserted the increase in their power and the importance of their dynasty in response to the hegemonic threat from Versailles and in celebration of the new imperial dignity gained after defeat of the Turks. Their role in furthering the arts represents a revival of their own great traditions of patronage. In turn, the powerful aristocrats of Austria and Moravia, and the monastic orders, followed with efforts to repopulate, rebuild, and represent their power. The desire of all these groups to express a religion and dynasty spiritually renewed, triumphant, expanding, and safe from the Turkish and French threats, lies behind the creation and decoration of the many impressive palaces and monasteries in this period. (See, for example, the drawings related to decorative projects: cat. nos. 86, 12, 6, 14, 50, 16).

At the same time, the remarkable and original art that began to flourish in the lands of the Bohemian crown under Habsburg rule (Bohemia, Moravia, and until 1740 Silesia) expressed something other than the ideology of grandeur and rule. On the one hand, refeudalization, concentration of land holdings, and relative impoverishment of the cities, with an attendant and consequent growth of magnate and monastic holdings, created similar conditions in many of the eastern regions of Central Europe. On the other hand, however, the Habsburg rulers did not reside in Bohemia; instead there were prelates' and princes' palaces scattered throughout the land, as well as in Prague. Moreover, church building and decoration had a different impetus in Bo-

of Augsburg to retain its importance as an artistic center, while it declined in prosperity and general economic significance. Johann Rieger, Johann Evangelist Holzer, Johann Georg Bergmüller, Johann Wolfgang Baumgartner, and Matthäus Günther (cat. nos. 5, 33, 34, 8, 9, 39, 40, 63, 19, 20, 2) all lived in Augsburg yet journeyed out during the warm months of the year to work in churches and castles throughout the south German area.

Augsburg also remained an important German center of book and print production. Demands for works generally with a religious purpose, for individual prints of saints and related subjects, and for the illustration of theses and treatises, were answered by artists such as Franz Sigrist and Johann Gottfried Eichler (cat. nos. 41, 35, 36). The engravers Georg Rugendas, Johann Elias Ridinger, Baumgartner, and Johann Esaias Nilson (cat. nos. 73, 87, 88, 63, 65) on the other hand satisfied secular tastes for portraits, animal compositions, and battle pictures. The interest of wealthy bourgeois, seeking to adorn their houses as princes had done, was also sated by the interior designs popularized by such prints as those made in Augsburg after Franz Xaver Habermann (cat. no. 58).

The popularity of these genres in Augsburg points to a larger phenomenon evident throughout the region, but especially in the north: the creation of a widespread middle-class culture. Its origins are to be found in the sixteenth century, in Augsburg and Nuremberg. Now new centers for this culture appeared in cities that replaced the older metropolises, newly enlarged conglomerations such as Hamburg, Leipzig, or Zürich.

Several drawings created by these artists relate to two of the types of works most favored by the bourgeois public of the time, notably landscape and genre. The tradition of landscape has older roots. For its mid- and late-eighteenth-century variants, however, in the topographic varieties practiced by Hackert, Joseph Roos, or Adrian Zingg (cat. nos. 93–95, 91, 102) or the "Romantic" forms seen in Franz Kobell, Johann Christian Klengel, Martin von Molitor, Adam Friedrich Oeser, or Christoph Nathe (cat. nos. 98, 97, 104, 46, 99–101), the audience would probably have been increasingly middle-class. Similarly, while themes that might be considered genre had their courtly admirers,

works such as those by Daniel Chodowiecki, Georg Melchior Kraus, or Johann Conrad Seekatz (cat. nos. 84, 80, 77) seem to have been directed to a bourgeois audience.[40] Portraiture—exemplified here by Anton Graff, Johann Gottlieb Prestel, Johann Eliezar Schenau, and Johann Heinrich Wilhelm Tischbein (cat. nos. 68, 67, 66, 71)—found special resonance with a bourgeois public.

Earlier, humanism provided a heritage that was eventually shared by court and city, and on which broader artistic developments of the period after 1680 were based.[41] Now a distinctive literary culture, originating in bourgeois milieux but cherished by the courts, provided widespread cultural links. It is clear that there were close connections between the visual arts and literature. Besides the involvement as writers of painters like Mengs, there is a parallel phenomenon of writers active as artists, like Goethe. Some figures, such as Salomon Gessner and Friedrich "Maler" Müller (cat. nos. 96, 81), made considerable reputations in both media.

The forms of literary expression in this era trace a familiar trajectory from the epoch of the "baroque" through the steps traditionally referred to as "rococo," Empfindsamkeit, Sturm und Drang, classicism, and Romanticism. These are the terms used to plot the course of the movements of German letters from Friedrich Gottlieb Klopstock and Christian Fürchtegott Gellert through to Goethe. However, where there were earlier links with the tradition of humanist poetics and rhetoric, now literary theorists developed their own critical tradition. This tradition can also be traced from Johann Gottsched's translation of French classicism, to the literary theory of the Swiss critics Johann Jakob Bodmer and Johann Jakob Breitinger, and the criticism of Goethe and Schiller.

While Winckelmann had thus given an account of art history that still relied on considerations of rhetoric and literary criticism, Lessing's response separated the two realms of expression. The comparison, ut pictura poesis, upon which the humanistic discussion of the arts had been founded, and eventually assimilated in Central Europe, was thus exploded. Through Lessing's critique in Laocoön, and through the impact of the implications drawn from Kant's Critique of Judgment, art and literary criticism would go their own separate ways.

Moreover, the portrait drawings of Johann Georg Sulzer by Graff or Johann Gottfried Herder by Bierlein (cat. nos. 68, 70), and of the *philosophe* Julien Offray de la Mettrie by Georg Schmidt (fig. 3) attest to direct associations between artists represented in this exhibition and Enlightenment figures.

III. THE SIGNIFICANCE OF DRAWINGS IN THE EIGHTEENTH CENTURY: ACADEMIES, AMATEURS, THEORIES, PRACTICE, AND COLLECTIONS

A. DRAWING AND THE ACADEMY

Sandrart's *Teutsche Academie* again provides a starting point for the discussion of drawing in the following period. The term "academy" within the title articulates a conception that was a fundamental influence on artistic practice. For not only did the theoretical and historical sections of his book provide the intellectual bases for considerations of the visual arts in Germany, and hence for their claims for a higher social and intellectual status. Sandrart's book also sketched, however briefly, a course of study that could be realized in an actual academy. By its very compilation of visual, theoretical, and biographical material, it assembled resources for such an institution. Sandrart himself transformed this ideal into a reality. Almost simultaneously with the publication of his book, he established the first German academy of art in Nuremberg. This foundation started a long history of such institutions, with both theoretical and practical consequences for drawings.

The institutionalization of academies realized a widely held principle, that the visual arts share properties in common with the liberal arts. They too are rational endeavors, with techniques that can be learned, and a method for obtaining their ends. Through the academies, more artists became exposed to intellectual traditions and learning. And as proponents of a liberal art, they gained in social status.

In practice, the foundation of academies meant the rationalization and transformation of workshop methods of instruction. This is seen in the earliest German academies, in Nuremberg and Augsburg, which, until their reform later in the eighteenth century, resembled

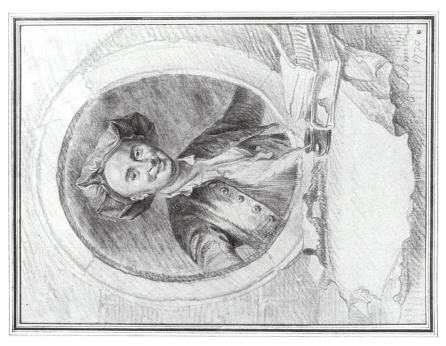

Figure 3. Georg Friedrich Schmidt, *Portrait of Julien Offray de la Mettrie*, red chalk and crayon, 320 × 250 mm. (sheet). The Minneapolis Institute of Arts, gift of David M. Daniels, 74.95.2.

Hence, rather than looking for too-direct connections between art and literature, clues for such a cultural nexus may perhaps be better sought in another cultural movement of the time to which they may be related: the Enlightenment. Enlightenment ideology seized upon some of the tools employed by the centralizing dynastic state—here the concept of "Enlightened Despotism" may be recalled; its methods are not unrelated to those of earlier efforts at propagating the faith of the Roman church. All put an emphasis on education. The state believed in the establishment of academic or educational institutions to increase its well-being, while the Church strove toward the propagation of the faith by means of pedagogic practices and theories. "Enlightenment" obviously implies clearing away ignorance. In these efforts art was to play a vital role. And in artistic instruction, drawings were of central importance.

Sandrart's establishment.[42] In keeping with the bourgeois culture of the centers in which they were formed, they were very much free associations of amateurs or artists who came together for instruction, mainly involving drawing, and discussion.

In this regard, the practices of the earliest German academies may not have been so different from what went on in the workshop of Loth in Venice. Loth's workshop seems to have employed a method of instruction emphasizing drawing from the model that continued to be used through the eighteenth century and is evident in the art of Mengs (see. cat. no. 55). Loth's practice was immediately emulated by the formation by his pupil Peter Strudel in Vienna in 1692 of a "house academy" that had wide influence. This was also probably the type of "academy" founded during the 1680s by the Dresden court painter Samuel Bottschild.[43] Significantly, Bottschild also compiled a manual, the *Kurtzer Unterricht*, with observations and rules for artists' education in Central Europe at this time.[44]

Soon thereafter other interests entered into the foundation of academies. What had begun as private initiatives quickly became public projects: indeed, in Dresden and Vienna the private academies of court painters were transformed into royal institutions. In this process of appropriation, as in other endeavors, the German courts emulated a model of state control and centralization that had led in the mid-seventeenth century to the creation of various academies by the French crown. Motivated as well by similar mercantilist commercial aims to improve the arts, and thus to become free from dependence on foreign suppliers, princely initiatives now led to the foundation of state academies, starting with one in Berlin in 1696 and continuing with Dresden and Vienna in ca. 1705. Significantly, these foundations occurred in just those realms—Brandenburg-Prussia, Saxony, Austria—which were responding in other ways to the challenge of France.[45]

Mercantilist interests also affected the later development of academies. These included foundations in Bayreuth and Mannheim in 1756 and 1769, in Mainz in 1757, in Düsseldorf in 1762, in Leipzig and Meissen in 1764, in Zweibrücken in 1773, in Kassel in 1775, and in Weimar in 1776, just to mention the major institutions. In many of these, the idea was to encourage an improvement in the standard of production of manufactures, and hence to aid commerce. Most closely related to the graphic arts are the examples of the "*Kaiserlich Franziscische Akademie*" in Augsburg, or the *Kupferstecherakademie* founded in 1766 in Vienna, where the quality of print production was to be improved to meet the challenge of competition, and in Augsburg's instance, to maintain its long preeminence in printmaking.[46]

Similar interests were clearly involved in the creation of the so-called "branch" or "craft" schools (*Fachschulen* or *Gewerbeschulen*) that followed the model of the academies. The close relationship of these sorts of institutions is demonstrated, for example, by the *Kunstakademie* founded at the end of the eighteenth century in Breslau (now Wrocław, Poland). This academy was first intended to be a *Gewerbeschule*, a trade or craft school.[47] In this kind of establishment, craftsmen were to receive regular instruction to improve the quality of their wares. This was the motivation behind an institution such as the school in Meissen, the site of porcelain manufacture, where the quality of design of this precious product was to be maintained.[48]

The policy embodied by these schools was seen, moreover, from a different aspect by some Enlightenment thinkers. Accordingly, they were regarded as serving not merely practical but also moral or ethical ends. As Josef Sonnenfels, who became secretary of the Vienna *Kupferstecherakademie*, noted, the strength of a state both reflected and depended upon the use of its art. This corresponded to the notions expressed by the theoretician Johann Georg Sulzer, that art could serve broader public educational ends.[49]

The very name of some of these establishments—*Zeichenschule*, or drawing school—indicates the significance of drawing in these institutions. In all such foundations, private and public, from Sandrart until the end of the eighteenth century and beyond, drawing had a central place in the curriculum. Because of the increased social and economic dimension brought on by the development of academies and trade schools in Central Europe, drawing had a social importance that exceeded even its traditional central role in the education of artists.

B. Drawing and Amateurs

Not only professional artists and craftsmen were draftsman in the eighteenth century. By the end of the era an ever larger spectrum of the population was learning how to draw. Once despised as a banausic activity, artistic endeavor, and especially drawing, had become a mark of culture.

In Central Europe the activity of individual Renaissance princes provided antecedents for this trend. Emperor Rudolf II Habsburg was but one of many rulers of the late sixteenth and seventeenth century who worked as artists.[50] While these sovereigns may have lived in a milieu of rulers who were also patrons, collectors, and amateur artists, the continuing miscomprehension of their involvement by their contemporaries suggests that personal participation in the arts could not yet expect to meet a generally favorable reception.

By the later seventeenth century the situation had changed. Already in the 1640s Duke Anton Ulrich of Braunschweig (Brunswick) received instruction in drawing as part of his education, indicating that this was not merely a matter of personal idiosyncracy.[51] From the 1660s there are written discussions in northern Europe of the inclusion of drawing in the education of aristocrats.[52] The Emperor Leopold I (1640–1705; r. 1658ff) is reported to have been a skilled painter himself; his installation of the famed architect Johann Bernhard Fischer von Erlach as instructor in perspective, as well as in the history and theory of architecture, for his son, the future emperor Joseph I (d. 1711), marks drawing instruction for princes as an established procedure in the region.[53] Later Habsburgs, such as Maria Theresia and her children, learned how to draw, and several of them became accomplished draftsmen.[54]

Their drawing was part of the increased and general personal involvement of rulers in the arts during the eighteenth century. One did not need to be a genuine princely virtuoso, as was the seventeenth-century Prince Rupert (of the Palatinate), the inventor of the mezzotint, to pursue painting. An example of such an amateur painter was Frederick William I of Prussia.[55] The ability to draw could indeed be an aid to a sovereign's supervision of the arts. Because of their passion for the details of designs, the sover-

eigns Augustus II ("the Strong") of Saxony and Frederick II of Prussia thus made drawings to indicate their architectural ideas.[56]

The growth in economic and social importance of the bourgeoisie, and their accompanying aspirations to cultural attainment, led to an interest and involvement in the arts far beyond their limited circles and purposes. Already in the late seventeenth century, Sandrart's text, and writings such as Georg Philipp Harsdörffer's *Frauenzimmergesprächspiele*, had made it *de bon ton* to discuss the arts knowledgably.[57] Gradually more than mere discussion was demanded. Dilettante draftsmen, of whom Goethe is the most famous, were now to be found among the middle classes as well as among aristocrats.[58]

Ultimately the growing and broad interest in drawings also became institutionalized in general education. New sorts of schools were established as part of the Enlightened reform of education. These were founded by the Habsburgs in the late eighteenth century, for example, on the model of the academies and the craft schools. Habsburg educational reforms included the institution of drawing as part of the curriculum: the upper levels of education were in fact often called *Zeichenschulen*, much as were artists' academies elsewhere.[59] According to this policy, not only artists or aristocrats but all who were to be educated were now to receive instruction in drawing.

C. Drawing in Theory and Its Relation to Practice

Even before these institutional changes took effect, the development of the literature of art in the German language indicated the diffusion of a different attitude toward drawing. An increasing volume of publications attests to a new context for the reception of art both among professionals and laymen. Sandrart had initiated this process whereby the practical discussion of the arts, already evinced by the writings of Dürer and his sixteenth-century followers, was incorporated into the humanist and primarily Italian tradition of the discussion of the arts. Notions that earlier might have been familiar only to artists and scholars were now made broadly accessible in German.[60]

In the course of the eighteenth century, many of the conceptions of drawing current in Italian or French literature on the arts were assimilated and disseminated in Central Europe. A compendium like Johann Georg Sulzer's *Allgemeine Theorie der Schönen Künsten* makes clear that stock notions of Italian art theory, like *disegno* and the idea of the *arti del disegno*, as well as debates concerning drawing, were translated into German. So, too, was the debate over *disegno* versus *colore*, as well as the concept of art as a form of beauty.[61] Drawing was regarded in theory as the foundation for the visual arts, and, as Winckelmann's writing amply demonstrates, discussions of the importance of drawing reveal a corresponding prejudice in favor of linear design over color.

Sandrart's book might be thought to stand at the beginning of another tradition of artistic literature as well. This is the tradition of the *Zeichenbuch*, the more practically oriented collections of prints with didactic texts that taught how to draw. Though obviously also useful for amateurs, these books evolved from being aids for instruction in workshop practice to stock educational apparatus in the eighteenth-century academy.[62] Many of the latter texts were, in fact, prepared by academy directors like Bergmüller (see cat. nos. 8, 9) or Johann Daniel Preissler.[63]

Significantly, both the discussions of drawing in theoretical literature and the method proposed in practical instructional aids were basically similar. Furthermore, the literature of art echoed the academies' specific statements about their curricular programs.[64] Together these theories and practices reinforced the development of a standard instructional procedure in Central Europe.

First, the student would start by copying drawings or prints (see fig. 4 for an example of this practice, which is perhaps a demonstration by Samuel Bottschild, the director of the Dresden academy). Beginning with geometrical forms, he would work up to more complex constructions, eventually to the human figure. Then he would turn to sketching objects in the round, primarily sculpture, and as classicist biases increased, from casts of antiquities. Finally, he would sketch from life, ultimately from the nude model.

As landscape drawing grew in popularity and began to be taught in academies, a similar literature and procedure was developed for this genre. This method is also reflected by the comments of authors such as Salo-

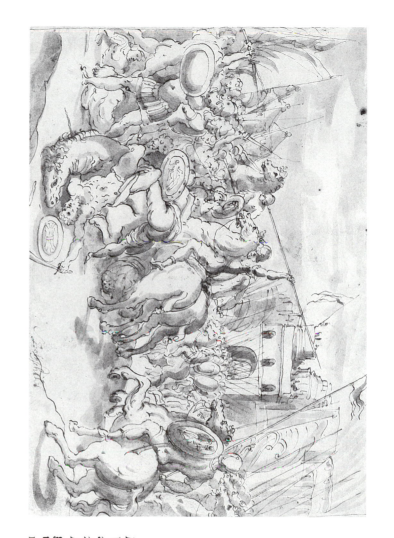

Figure 4. Samuel Bottschild, *The Victory of Scipio over Syphax*, pen and black ink, gray wash, 183 × 280 mm. The Harvard University Art Museums, Fogg Art Museum, gift of Belinda Lull Randall from the John Witt Randall Collection, 1898.174.

mon Gessner (see cat. no. 96), whose own education in landscape drawing was comparable.[65] Starting with geometrical forms, the artist would proceed through models taken from earlier landscape art and ultimately go out and sketch from nature, first details and then whole compositions.[66] Hence, although drawing after nature and still-life representation had a longer tradition in Central Europe—as seen, for example, in the studies *naer het leven* of Roelandt Savery—there was an added impetus for this genre in the eighteenth century. As with Savery, who drew from life peasants and their dwellings as well as landscape elements, the Bern *Zeichenschule* under Sigmund Freudenberger adopted similar practices for drawing peasants and their surroundings (fig. 5).[67]

Seen in comparison to the history of French or Italian drawings, the use of such procedures, especially for drawing from the nude model, is, of course, not that remarkable. After all, the Central European curriculum was quite similar to the academic practice that became standardized in the French eighteenth-century academy.[68] Seen within a Central European context, however, these practices were novel. Some new sorts of drawings, examples of which are visible in this exhibition, resulted from new procedures.

Specifically, before the late seventeenth century, drawings from the nude model are exceedingly rare in Central Europe. Afterwards they became quite common. Students' drawings do survive in fairly large numbers, and more significantly, so do demonstration pieces by academy professors, which, like drawings by the heads of ateliers, might have provided a lasting model for the workshop or academy.[69] Such circumstances seem to account for the survival of the unique drawings by Franz Xaver Messerschmidt and Matthäus Donner (cat. nos. 54, 51), for example, as well as the numerous nudes by Mengs (cat. no. 55).

Academic practices may have directly affected the stylistic development of landscape drawings in Central Europe. In this sort of drawing the study of nature replaces the study of the human form. Drawings by Franz Edmund Weirotter of individual objects such as rocks (cat. no. 92), in which the use of red chalk recalls the standard technique of life studies in France, may indeed be associated with a process of academic instruc-

tion. So, too, may the landscape drawings of Roos (see cat. no. 91), in which attention is given to the actual atmospheric qualities of a landscape. Although these drawings have their immediate antecedents in workshop practices, it may be remembered, especially in comparison with French customs, that in France this kind of drawing is in fact found in the ambit of the German Wille (fig. 6; cat. no. 78), the master of both Roos and Weirotter and a teacher who habitually took his students outdoors to make studies. The German Hackert also compiled sketchbooks of nature studies in France (see cat. no. 93).

D. Collections and Connoisseurship

The collecting of drawings in Central Europe began much earlier than 1680. Earlier traditions continued into the eighteenth century. However, the growth of collections in number, size, and quality, their separation from other ensembles to become independent entities, as well as the creation of a taste for the sketch-like design, attest to an increase in the appreciation of drawings as independent works of art.

As in earlier times, in the eighteenth century, drawings continued to be collected as part of a workshop's stock, along with prints and other works of art. This kind of collection may be regarded as a continuation of traditional practices, by which records of compositions or proposals for ideas were kept on hand. Almost all the important artists of this period—M. J. Schmidt, Paul Troger, Franz Xaver Wagenschön (fig. 7), to name a few—possessed such collections. The stock of one workshop might be passed on to another, just as one artist might buy the contents of another's workshop for his own study purposes: for example, M. Günther acquired the works of Holzer (cat. nos. 33, 34).[70] The transmission of drawings from one workshop to another also accounts for the survival of many sheets from the workshops of the sculptor Thomas Schwanthaler and his followers (see cat. no. 49).

The accumulation of drawings as examples intended for the instruction of workshop assistants resulted in collections of considerable size. These collections might include not only works by the head of the workshop but by other artists as well; they might contain groups

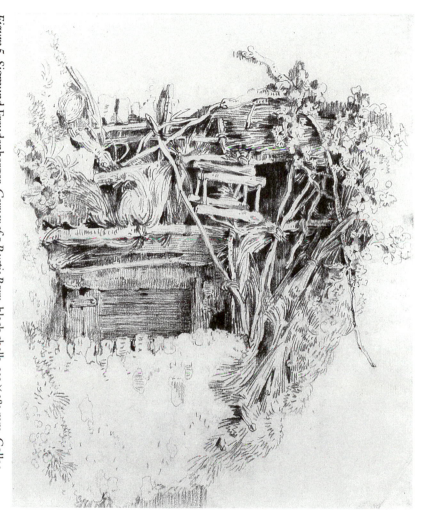

Figure 5. Sigmund Freudenberger, *Corner of a Rustic Barn,* black chalk, 232 × 283 mm. Collection of Andrew Robison.

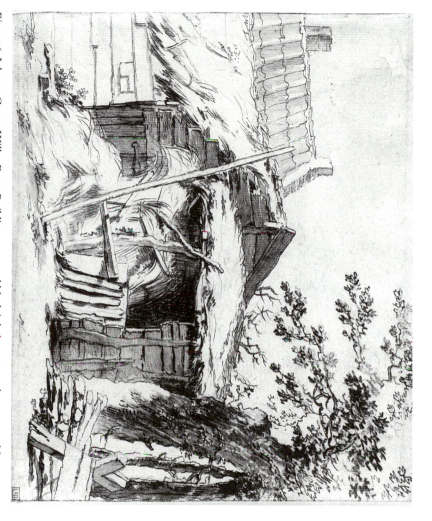

Figure 6. Johann Georg Wille, *Farm Buildings,* pen and black ink, brown wash over graphite, 230 × 278 mm. University Art Museum, University of Minnesota, Minneapolis, Minnesota, General Budget Fund, 62.13.

of Georg Philipp Rugendas in Augsburg; and of the painter Martin Knoller, now largely in the monastery of Stams in the Tyrol, and of Martino Altomonte (see cat. no. 6) in Melk and St. Florian.[71]

Academy collections grew out of a use of drawings for similar purposes. In the academy, drawings also served as models and as demonstration pieces: a collection of drawings provided a stock for copies. Sulzer, in fact, designates a collection of drawings along with prints and instructional books on drawing as one of the requisites of an academy.[72] This sort of collection provided the foundation, for instance, of the holdings of the Kunstbibliothek in Berlin, and of the present Akademie der bildenden Künste in Vienna. In the latter institution, the survival of drawings from Strudel's home academy and even Loth's workshop further evinces the connections that existed between academy and workshop practices.[73]

Some of the princely collections of the eighteenth century in Central Europe undoubtedly followed a similar pattern, influenced by their Enlightened aims to establish institutions for the public good. The formation of a large collection by the Elector Carl Theodor in Mannheim, now one of the main bases of the graphic collection in Munich, is related to the foundation of the Mannheim academy, which was established in the same year. Academy students were to use drawings in the elector's collection as models for their own work.[74]

The establishment of a princely *Kupferstichkabinett* or *Zeichnungs-und Kupferstichkabinett* represents a significant development in the appreciation of drawings, as well as prints, as independent media of value in themselves. The independent *Kupferstichkabinett* betokens a change from the status of drawings in the princely *Kunstkammer* of earlier days, where, along with other precious and rare objects, they could serve general purposes of representation, or contemplation. Bound in books that were kept in the *Kunstkammer*, or in the prince's library, drawings could also be consulted for study or instruction; some royal and princely collections of the late seventeenth and early eighteenth century, such as that of the kings of Prussia in Berlin, or the print collection assembled by Pierre-Jean Mariette for Prince Eugene of Savoy, now in Vienna, belong to this category.[75]

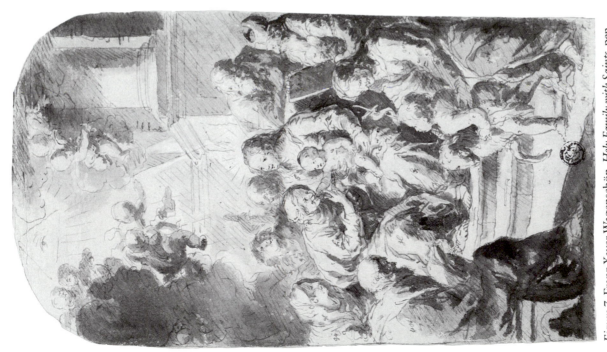

Figure 7. Franz Xaver Wagenschön, *Holy Family with Saints*, pen and brown ink, gray wash over traces of graphite, 232 × 130 mm. The Art Institute of Chicago, Leonora Hall Gurley Memorial Collection, 1922.3315.

of loose sheets as well as drawings bound into compendium volumes. Several of the collections in present-day Central European museums owe their existence ultimately to workshops of the eighteenth century. These include the collections of the sculptors Andreas Schweigl and Johann Joseph Winterhalter the Elder, and of the architect Franz Grimm, now in the Moravská Galerie, Brno; of Lambert Krahe in Düsseldorf, of the sculptor Martin von Wagner in Würzburg, and even

As part of the reorganization of the Dresden collections, however, Augustus II split up the *Kunstkammer*, establishing in 1720 an independent *Kupferstichkabinett*. Though it might be considered to have precedents in the purchase by the city of Basel of the Amerbach Kabinett in 1661,[76] and is also based in part on the Parisian model of the independent *cabinet des dessins* and *cabinet des estampes*, established by Louis XIV in 1671 and 1667 respectively, the foundation of the Dresden *stichkabinett* represents a landmark in the history of the graphic arts. Not only did this foundation lead to the growth of a large, systematic museum devoted solely to these media, but it set a trend for independent graphic arts collections in Europe. The establishment of similar collections in Vienna in 1738 and Munich in 1758 followed the lead of Dresden and reflected the new status of drawings as precious objects, worthy of collecting in their own right.[77]

The development of independent drawings collections in the eighteenth century, though related to the tradition of the *Kunstkammer*, is therefore a significant phenomenon. Not only rulers of large states but people of varied social status formed important collections. Most famous of these was that amassed by Duke Albert Casimir of Saxe-Teschen in the second half of the eighteenth century and early nineteenth century, the main basis of the present Albertina in Vienna. At considerable expense, Albert built up a collection of outstanding quality, which at his death amounted to 13,000 items.[78] Even larger was the extraordinary *Kupferstichkabinett* assembled by Franz Friedrich Anton of Saxe-Coburg-Saalfeld (1750–1806), the basis of the Coburg *Kunstsammlungen*.[79] This duke gathered 190,000 to 300,000 objects.[79] Other outstanding drawings collections formed by aristocrats during the eighteenth century include that assembled by Count Brühl in Dresden, now part of the Hermitage museum in Leningrad.[80] During this era bourgeois connoisseurs also joined the ranks of major collectors of drawings. Foremost among eighteenth-century collectors of this stamp is probably Johann Friedrich Städel, whose collection of drawings provided the core of that in the Städelsches Kunstinstitut in Frankfurt.[81]

The growth of collecting by individual connoisseurs such as these led to the development of new attitudes toward drawing. Besides their practical purpose, drawings were sought because of an interest that, to use a term created at the time, may fairly be described as aesthetic. Drawings began to be collected for some of the reasons that are still expressed today, such as their unique quality of revealing the spontaneous process of creation. The drawing or sketch was also believed to preserve aspects of the "unfinished," the *non finito*. Drawings could thus stimulate the participation of the viewer's imagination to conjure up or complete the image.[82]

Evidence for the development of these attitudes is found in Central Europe no less than elsewhere. At the beginning of the era, at the same time that similar tastes began to be expressed by writers such as Roger de Piles in France, Sandrart had already remarked on the way in which sketches, which reveal the master in the heat of imagination, were sought after by collectors with more passion than were finished paintings.[83] In the middle of the century, Heinecken noted that sketches and unfinished drawings appealed to every viewer more than completely executed sheets.[84] Later on, as a more classicizing taste was replacing that for sketches and studies, J. C. Füssli also commented similarly, if disapprovingly, on the taste of those connoisseurs who would not accept a work that did not have the stamp of a study thrown down on the page with fire and hastiness.[85] In addition to an interest in drawings, the increased appreciation for oil sketches as autonomous works of art may also be related to the taste for the sketch-like, seemingly spontaneous creation.[86]

The development of connoisseurship also involves an activity associated with another meaning of this term, that is, the development of expertise implied in the acquisition of familiarity with drawings. The evolution of this aspect of connoisseurship may also be seen as an historical tendency that culminated in the age of Winckelmann: whatever the accuracy of his judgments, Winckelmann associated definite period or stylistic notions with specific traits found in works of art.[87] The remarks of Winckelmann's associate and disciple Oeser (see cat. no. 46), however uncritical, indicate that similar distinctions were being applied to drawings: Oeser associated definite aesthetic or stylistic qualities with different kinds of drawings.[88]

Connoisseurship, implying a gain of expertise, like collecting on a large scale, can also be related to the development of a lively market for drawings in the eighteenth century, although this subject has only recently begun to receive its rightful attention in art historical literature.[89] Not only were agents like Pierre-Jean Mariette involved in the process of assembling collections for Prince Eugene of Savoy or the Saxon court.[90] Many other dealers, such as Christian von Mechel in Basel, Domenic Artaria in Mannheim and Vienna, the Weigels in Leipzig, and Johann Heinrich Frauenholz in Nuremberg, were involved in the circulation of drawings as commodities. The role of dealers in the art market has further significance for the history of collecting, since figures like Artaria established their own collections as well, much as Mariette had done.[91]

It would seem that in contrast with their relative dearth in earlier periods, the making of sketches, in the sense of ideas quickly jotted down, increased at this time. Moreover, the deliberately sketch-like drawing, a work that self-consciously revealed the rapidity of its execution, now came into fashion.[92] This type of deliberately sketch-like drawing, in which the calligraphic quality and rapidity of design may suggest that the work was made for its own sake, is exemplified by sheets by Paul Troger (cat. nos. 31, 32, 74) in this exhibition.

In addition to this type of work, other drawings, more finished in appearance, were demonstrably made for collectors. Such is the case of the drawing by Christian Dietrich in this exhibition (cat. no. 76), which comes from Mariette's collection. It is likely that other finished drawings, of genre subjects, exemplified here by Seekatz (cat. no. 77), of portraits, seen here from the hand of Johann Friedrich Bierlein (cat. no. 70), and of landscapes, illustrated here by Johann Christian Dietzsch (cat. no. 90), Hackert (cat. nos. 94, 95), and Nathe (cat. nos. 99–101), and most likely also by Klengel (see cat. no. 97), Zingg (cat. no. 102), and Kobell (cat. no. 98), were made for similar reasons.

V. Functions, Genres, and Style

A. Functions, Genres, and Forms of Drawing

Mention of the creation of drawings for collectors or the market leads directly into a consideration of the

question of their function in the eighteenth century. Some types of drawing, namely the academic study and the sketch-like drawing, have already been discussed because they represent comparatively new developments. But drawings also continued to serve traditional purposes. Most drawings, aside perhaps from certain genres such as landscape, were still made as part of a preparatory process for the creation of a work in another medium. Drawings of the eighteenth century are therefore characterized by a wide range of functions, traditional and relatively new. These, together with the variety of historical circumstances in which they were made, and the conventions determined by the genres to which they belonged, led to an extraordinary diversity of forms.

The genre of landscape drawings can be found in a wide range of types. Finished sheets for collectors, with views that are topographic or thoroughly composed, have already been mentioned; they are exemplified by the works by Hackert, Klengel, Kobell, or Nathe in this exhibition (cat. nos. 94, 95, 97, 98, 99–101). The academic studies of Weirotter or Roos (cat. nos. 92, 91), however, were obviously connected with instructional ends. These types of drawing have more in common with the studies from nature by Hackert, discussed above. But besides the often careful designs found in Hackert's Boston sketchbook (cat. no. 93), many artists throughout the century, from Johann Alexander Thiele (cat. no. 89) to Caspar David Friedrich (cat. no. 105), made fleeting studies from nature executed in what may be called a sketch-like manner. As in Friedrich's work, these motifs may recur in later paintings.

Differences may also be discerned among the portraits exhibited here. While Bierlein's work (cat. no. 70) may be regarded as a finished work made for sale, this is probably not the function of the equally finished watercolor portrait by Chodowiecki of his daughter (cat. no. 69), or the accomplished red chalk drawing of Guillaume Wieling by Tischbein (cat. no. 71), done on a large sheet of folded paper. Graff's posthumous portrait of Sulzer (cat. no. 68) may have been a record of an earlier, larger composition, probably a painting, while the drawing of a head by Balthasar Denner shown here (cat. no. 61) may have been an elaborate study from life for a portrait. Yet other drawings by

Denner are much more fleeting studies, meant as sources of ideas for the preparation of his characteristic painted studies of heads. Sketches in other media, such as the self-portrait in brush and chalk by Prestel (cat. no. 67), may have served a similar preparatory function.

These sorts of contrasts are also to be found in drawings of lowlife or genre subjects. While the peasant drawings of Seekatz (cat. no. 77) are probably finished compositions, a brush drawing of a peasant woman by Kraus (cat. no. 80), like many other sheets by the artist, is probably an independent study. The graphite sketches by Rugendas (cat. no. 73) of men in camp were no doubt made to be used in larger paintings.

The question of preparatory designs demands more consideration than this brief overview can provide. Drawings were intimately involved in the process of preparation of paintings, sculpture, interior decoration, and prints, especially of what might be traditionally called "history" or narrative subjects.

The expansion of large-scale fresco programs throughout the region necessitated a large amount of preparatory activity, and preparatory drawings are thus much more abundant from the period after 1680 than from that before. Because of the necessity of painting on wet plaster, frescoes obviously cannot be painted without substantial prior planning, and the investment of money and energy demands considerable forethought.[93] One of the leading considerations in the paramount domain of history painting was the choice and representation of subject matter. At all stages of the preparatory process, drawings were employed, and regardless of the growing use of the oil sketch, drawings were the predominant expressive medium. Drawings were utilized to compete for commissions, to impart information to the patron, to indicate the pictorial program, and to cement the contract.[94]

Accordingly, various types of drawings evolved to fit these purposes. While terminology in such matters is imprecise, and a variety of words in German (*Entwurf, Riss*, etc.) continued to be used, the terms advanced by Filippo Baldinucci, which were widely current in the eighteenth century and have often been applied by art historians, may help to distinguish further among these sorts of drawings.[95] A compositional design might be a *pensiero*, a fleeting drawing recording a sketch or first idea. It is possible to consider drawings exhibited here by Franz Anton Maulbertsch or C. D. Asam (cat. nos. 23, 12) as belonging to this category. Alternatively, a compositional design might be a proper *disegno*, a carefully executed drawing, such as is seen here in examples by M. Günther (cat. nos. 19–21), by C. D. Asam (cat. no. 11), by Melchior Steidl (cat. no. 2), Felix Anton Scheffler (cat. no. 15), and Götz (cat. no. 17). As exemplified by drawings by M. Günther in the United States (fig. 8), these drawings are sometimes large, quite detailed, squared for transfer to the wall that was to be painted, and therefore quite close to the finished fresco. In such a form it might even be legitimate to consider this type of drawing a *modello*, meaning a drawing "executed with considerable care for the patron, to give him as full an idea as possible of the appearance of the projected final work," although the appropriateness of this widely used term is not absolutely clear (see especially cat. no. 21).[96]

Studies for parts of frescoes are also frequent; they can originate at various stages of the design process. One such drawing for a fresco is the sheet by Johann Rudolf Huber shown here (cat. no. 3), which seems to work out in detailed execution a corner of a design for a ceiling, which may be suggested in a sketch on the verso. Studies, often less elaborately executed, also exist for individual figures or groups in a larger design. The former category is represented in this exhibition by a drawing by Georg Anton Urlaub (cat. no. 18), the latter by a sheet by Gran (cat. no. 14).

Much the same sequence and variation can be found within drawings for painted altarpieces. These range also from the preliminary, sketch-like idea, seen here in a drawing by Bergmüller (cat. no. 9), to drawings used for working out ideas, exemplified by Maulbertsch (cat. no. 24), studies of individual figures within a painting, as by Petr Brandl (cat. no. 7), to the more finished design, also represented by Bergmüller (cat. no. 8). Of special interest here is a drawing that was presented for the negotiation of a contract by Georg Wilhelm Neunhertz (cat. no. 10), and also one demonstrably used in correspondence with a patron to work out details of a commission, the drawing by Gottfried Bernhard Götz of *St. Ambrose* (cat. no. 16).

The use of three-dimensional models in the sculptor's

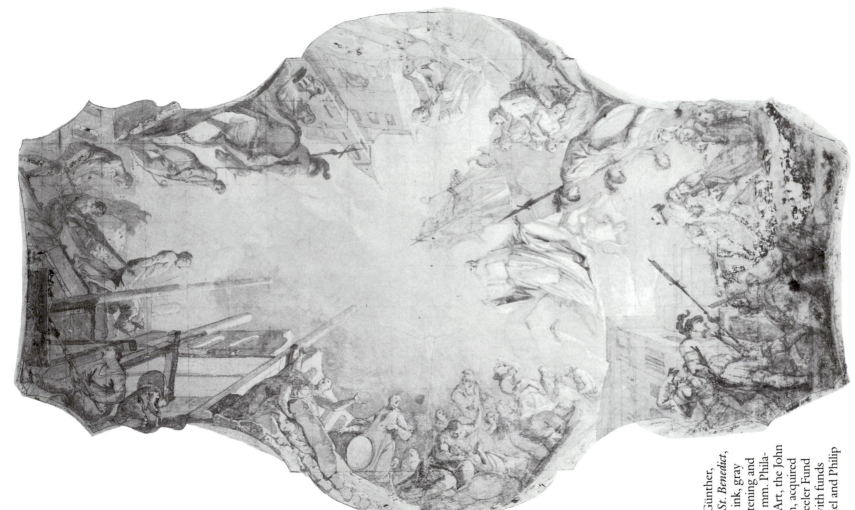

Figure 8. Matthäus Günther, *Scene from the Life of St. Benedict*, 1745, pen and brown ink, gray washes, white heightening and black chalk, 733 × 516 mm. Philadelphia Museum of Art, the John S. Phillips Collection, acquired with the Edgar V. Seeler Fund (by exchange) and with funds contributed by Muriel and Philip Berman, PAFA 112.

preparatory process, the very fragmentary remains of material from sculptors' workshops, and the relative paucity of detailed scholarly studies of the sculptor's process as it pertains to Central Europe make the determination of the use of sculptors' drawings much more difficult. Nevertheless, the recent attention to such materials, via analogies to sculptors' practices elsewhere, and the presence of rare examples of sculptors' drawings in the United States, allow not only for the deduction of hypotheses similar to those made about drawings for paintings.[97]

The sequence of drawings by sculptors visible in this exhibition starts with drawings available in the stock of a workshop, such as those recorded by Schwanthaler (cat. no. 49). Comparable in this regard to a *primo pensiero* is what appears to be a demonstration piece made by Messerschmidt (cat. no. 54). A secondary phase in sculptors' drawing practices might involve the rough, preliminary idea for a composition, as the drawing on the verso of a sheet by G. Donner (cat. no. 50) suggests. These ideas were then further refined in later sketches, such as that by Donner on the recto (cat. no. 50). The academic study by M. Donner (cat. no. 51) also indicates the way in which a model might be posed in the actual position of a figure in a sculpture and suggests that this technique of composing from a living model may have been as common here as it was elsewhere in Europe. After further intermediary studies, often modeled or carved in three dimensions, finished compositional studies were prepared, most likely for presentation to the patron: the drawing by F. I. Günther (cat. no. 52) represents this kind of design. Finished studies of this nature might also have been presented to establish the design for contractual purposes, as seems the case of the drawing by Joseph Häringer (cat. no. 53). Finally, as the inscription on the drawing by Vincenz Fischer (cat. no. 59) suggests, finished drawings that were supplied for commissions may in turn have provided workshop stock.

The drawings presented here by Fischer and Egid Quirin Asam for the ceiling of a Jesuit church (cat. nos. 59, 13) demonstrate the proximity of this kind of sculptors' drawing to designs by painters. Architectural drawings of the period reveal a similar sequence of pre-

paratory categories.[98] Indeed, given that many artists like the Asam brothers worked in a number of media and created combinations of sculpture, painting, architecture, and interior decoration, it is difficult to make sharp distinctions between different sorts of drawings. A drawing like that by Johann August Nahl (cat. no. 56) combines elements of architecture, painting, and interior design. That by Habermann (cat. no. 58) indicates furniture and wall panelling.

Habermann's drawing was in fact made for an engraving to be used by other artisans. Indeed, many drawings done in the eighteenth century are designs for prints. Several of the German cities remained important centers for the production of prints and grew increasingly important, as the century progressed, for illustrated books. Augsburg, where the print after Habermann was engraved, became a center for the manufacture of ornamental designs, while, as noted above, it also played a dominant role in book, thesis, and portrait print production.[99] These categories are represented by drawings by Eichler, Sigrist, Baumgartner, and Nilson (cat. nos. 35, 41, 39–40, 65). Artists in other regions also accommodated a large demand for prints, although more needs to be determined about the market for their works. Sheets by Chodowiecki, Rode, Zick, J. M. Schmidt, and Johann Christoph Liška (cat. nos. 69, 43, 42, 44–45, 29) demonstrate that many draftsmen throughout the region supplied drawings for separate prints and for book illustrations. However, their audiences were varied: while Chodowiecki's and Rode's designs may have been made for the middle classes, it is unlikely that either Liška's or Schmidt's designs (cat. nos. 29, 44–45) were directed at the same group.

B. PROBLEMS OF STYLE

Such differences of function point to the considerable problems that attend any discussion of style in drawings of the late seventeenth and eighteenth century. A traditional, formalist approach to style, conceived as a system of coherent forms, shatters against the huge diversity of appearance found in drawings at this time. Just as it fails to deal with the particularities of art in the preceding period, this sort of conceptualization of

style has no way of accounting for the assortment of genres, modes, and social and cultural settings of art that conditioned the production of drawings in the period 1680–1800.[100]

Geographical and chronological determinations are not of much help here, either. An imprecise division may perhaps be drawn according to confessional differences along the Main River, with the Reformed population to the north and Catholics to the south. The often very peripatetic careers of artists within and across these regions, however, tend to form interconnected patterns of patronage throughout. In the south, the Asam brothers worked for secular patrons in an area extending from the Tyrol (see cat. no. 12) to the Palatinate (see further cat. no. 13), and for ecclesiastical commissions, including pilgrimage, parish, cathedral (cat. no. 11), and cloister churches from Swabia to Silesia. In the north, Nahl was active in Potsdam (cat. no. 56) and Kassel. Further, strict chronological distinctions give no more clue than do regional ones. Stylistic currents were not only broadly shared but plural: what can be regarded as vastly different tendencies appear simultaneously.

Hence, problems also derive from the use of period terms related to stylistic conceptualizations. To a certain extent, drawings might be seen as conforming to trends that are often used to describe the history of eighteenth-century art. A progress through the baroque, to the rococo, to neoclassicism might be marked by the drawings by Huber, Nahl, and Friedrich Heinrich Füger (cat. nos. 3, 56, 48). These familiar stylistic terms do not, however, adequately describe a great mass of drawings. Many of the achievements in a genre, portraiture, and landscape simply do not fit under these rubrics.

As with considerations of the preceding period of art in Central Europe, a problem persists in transferring art historical terminology adopted for one area to another.[101] Feulner's division of periods of painting into "*Spätbarock und Regence*," "*Rokoko*," and "*Louis XVI*" exemplifies an inappropriate borrowing of French period terms for eighteenth-century art in Germany, over which the Regency and Louis XVI held no direct sway: regardless of its admiration for French art, Central European culture had its own distinctive character.[102]

Concepts better fitting the particularities of Central Europe might be found by reference to other aspects of the culture, including its literature. Even themes that are associated with the literary movements of the time, such as *Empfindsamkeit, Sturm und Drang*, and Romanticism, are to be found in art. The representation of sentimental lovers, of mysterious and possibly violent struggles of emotion and action, or of the place of man in the grandeur of nature, are elements present both in works of literature, and in art, as seen in a number of drawings here (cat. nos. 96, 82, 103, 102).

It is nonetheless questionable how many problems this sort of approach resolves. Within discussions of literature itself, it has long been apparent that these general terms are problematic.[103] Thus it might seem that at most the visual arts draw on certain themes that are shared in common with literature. Larger stylistic notions are comparable only in the roughest way. Moreover, the development of independent critical traditions in the eighteenth century suggests that, however seductive the desire might be to relate the course of literary history closely to that of art history, a great deal of caution is advisable.

For similar reasons, care is needed when attempting to apply to the visual arts a stylistic system related to rhetorical or poetic considerations. In *Drawings from the Holy Roman Empire*, it was argued that in the period before 1680, artists began to assimilate and approximate stylistic attitudes that originated in the humanistic tradition of education, attitudes that while grounded in rhetoric had been transferred to poetics and literature. Accordingly, for this earlier period it has seemed legitimate to relate the mode of representation of a work of art to the genre to which the work belongs. In this way an explanation can be offered for the variation in visual appearance that exists in works done by one artist for a single patron during the same period. For example, a mannered mode of presentation, full of what might be called visual ornament, is necessitated by a higher genre such as history; similarly, an ideal form of imitation, one that draws upon the artist's imagination rather than studies from nature, is appropriate to this genre. Conversely, lower genres have less visual ornament and allow for a "naturalistic" approach.

Such distinctions can be found to apply to works of

art in the eighteenth century. A contrast might be drawn between the classicizing figures of Füger (cat. no. 48) and the landscapes of Von Molitor (cat. no. 104), for example. Moreover, it might seem that the establishment of academic institutions from ca. 1680 might be expected to increase the reliance of artists on an implicit conceptualization of stylistic decorum that called for forms to be fit to tasks, according to an implicit or explicit hierarchy of genres, for both of these rhetorical or poetic notions can be associated with the ideal embodied in the academy.[104]

Several complications affect the interpretation of eighteenth-century art according to this preexisting scheme, however. One basic problem is that no uniform model related to the French academy can be found in Germany. Artists often attended academies after they had been formed in the atelier, in order to gain contacts, to make an effective entrée into an increasingly competitive art world, or to obtain cachet.

Figure 9. Caspar Franz Sambach, *Academic Study*, Szépművészeti Múzeum, Budapest, inv. no. 833.

The various academies, while sharing similar objectives, adopted different ways of realizing them according to their individual circumstances. The different techniques of drawing (and painting) taught in the academies led to the creation of formal differences in the visual arts that are at least as noticeable as any that stem from modal and generic variation.[105] Thus even within the same academy, for example, in Vienna, one finds in place of a standardization of technique the production of strikingly different drawings. The linear studies of Caspar Franz Sambach (fig. 9; cat. no. 22), may be related to the linear drawing style of Troger (cat. nos. 31, 32, 74), that this academy professor seems to have adopted from Venetian artists, while the later nude study by Messerschmidt (cat. no. 54) employs chalk, more familiar in academic studies found elsewhere, as in France, whence Jacob Schmutzer derived the style, as in France, whence Jacob Schmutzer derived the style, which he introduced to the Vienna *Kupferstecherakademie* (fig. 10).

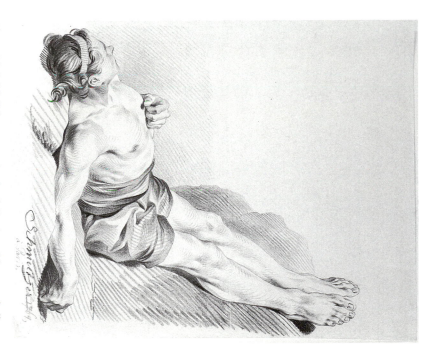

Figure 10. J. M. Schmutzer, *Academic Study*, red-brown chalk, 520 × 411 mm. Collection of Mr. and Mrs. Martin S. Baker.

With all due reservations about the direct relation between literary theory, academic institutions, and artistic practice, it may nevertheless be possible to elicit from them a model for considerations of drawing. The notion of modes of address or expression may still account for variations in formal appearance. These conceptualizations may be related to the purpose for which a drawing was made.

Where earlier the stylistic mode of a drawing may best be related to its genre, here the stylistic determination may be more closely related to a work's function, as distinct from its genre. Differences in function help to account for differences in appearance seen in drawings done at approximately the same time by the same artist in the same genre and even in the same technique. For instance, Georg Schmidt's portrait of the *philosophe* La Mettrie is executed in a meticulous red chalk technique, using probably conté crayon as well (see fig. 3), while his portrait of a man in a tricorn hat (cat. no. 64) is very loosely executed in red chalk, with broad hatching and outlines. The fictive oval casement frame, the books, ink, and paper in the foreground, and space left on the paper for an inscription all suggest that the La Mettrie drawing was for a print, while the informal character of the anonymous man in a tricorn suggests it was done as an independent study. Other differences can be perceived between contemporary drawings in the same technique that were designed by Götz for frescoes as opposed to easel paintings (cat. nos. 16, 17). Other distinctions can be made between works by J. M. Schmidt and Hackert (cat. nos. 26, 44–45, 93–95) seen in this exhibition.

The notion of function can also be more broadly defined, to apply to other issues of artistic choice. For instance, Maulbertsch's seemingly insubstantial manner of drawing for an early fresco project may be regarded as a mode adopted in order to suggest the luminous effects that the artist seems to strive for in paint (see cat. no. 23). Such a consideration also has broader ramifications for the critical assessment of individual works. Surely it would be inappropriate to expect that this sort of drawing by Maulbertsch would resemble an academic study, much less to hold it up to a standard of formal qualities based on an appreciation of another eighteenth-century artist whose drawings were in-tended for a different purpose in a different medium. The suggestions offered here can only be proposed as alternative hypotheses for resolving some of the special problems of Central European drawings from 1680 to 1800. They point to a framework for approaching questions of artistic production and style in which an understanding of many different aspects of history can come into the play of interpretation, and even ultimately into the assessment of individual works of art. A more flexible approach is needed that employs not only the traditional instruments of art historical analysis—localization by author, nationality, region, date, and genre—but also considers generic, institutional, technical, functional, and even broader cultural or social circumstances.

VI. A SELECTION FROM AMERICAN COLLECTIONS: THE STUDY AND COLLECTING OF CENTRAL EUROPEAN DRAWINGS

Not the least of difficulties involved in such a project is locating and identifying the material. Literally thousands of drawings in European collections still await publication, and even identification. Just to mention German holdings, large repositories of drawings, such as the *Kupferstichkabinett* in Coburg, the collection of the Städtische Kunstsammlungen, Weimar, the Halm-Maffei Sammlung of the Staatliche Graphische Sammlung in Munich, and the so-called *Zweite Garnitur* in the collections in Dresden, Leipzig, West Berlin, and Düsseldorf, all await proper study. What might be called archaeological activity in these collections will undoubtedly make many important discoveries.

American collections are admittedly not as rich in these drawings as are those in Europe. They have, however, not been as thoroughly excavated as those abroad. The endemic neglect of Central Europe has left much to be done.

To date, American exhibitions of Central European drawings of this period have been partial and sporadic, and scholarship even more so. Emigration from Europe from the 1930s brought to the United States not only collections such as that of William and Eugénie Suida, whose holdings are represented in numerous drawings exhibited here (cat. nos. 6, 7, 12, 22, 24, 25, 32,

Figure 11. Otmar Elliger the Younger, From the Revelation of Saint John (4: 1–8), pen and ink, gray wash and lead white, 140 × 207 mm. The Art Institute of Chicago, Leonora Hall Gurley Memorial Collection, 1922.2083.

44, 47, 86), but also several scholars who did some of the first work on Central European drawings in this country. These include Alfred Neumeyer, who in 1939 presented German drawings from the largest collection of Central European drawings in the United States, that in the Crocker Art Museum, Sacramento, although he did not value later German drawings as much as earlier ones.[106] In 1949 Ernst Scheyer organized an exhibition of "German Paintings and Drawings from the Time of Goethe in American Collections," which included some sheets from the second half of the eighteenth century.[107]

Among American-born art historians very few have occupied themselves with this material, however.[108] Among his many contributions, in 1956 the late Edward Maser organized a show of eighteenth-century prints and drawings, with material drawn from American collections. In 1972 Kent Sobotik also included some representation of American holdings in an exhibition devoted to Central Europe 1600 to 1800. None of these exhibitions was thus devoted exclusively to drawings of the period 1680 to 1800, and none was accompanied by more than a brief, and only partially illustrated catalogue. Moreover, many drawings were not presented in these efforts; in the last two decades alone many new sheets have been unearthed, or acquired, by American collections. Yet the more recent acquisitions of American collections have often been published in accession reports at best. Otherwise, except for their occasional inclusion in monographic studies, very few other drawings from eighteenth-century Central Europe in the United States have been mentioned in scholarly studies.

Hence there remains much to be found in American collections. Besides the drawings shown here, the Crocker Art Museum, the Harvard University Art Museums, and private collectors possess numerous sheets of interest. The Gurley and Deering collections of the Art Institute of Chicago, the largest collection of drawings in the United States, have only recently begun to be surveyed. In Chicago there are sheets by Wagenschön (see fig. 7), Otmar Elliger (fig. 11), and Anton Kern (fig. 12), to mention a few drawings by artists of the period not exhibited here.[109]

This exhibition can therefore be regarded as giving an impression of the holdings of Central European drawings from 1680 to 1800 in American collections. It contains a representative sampling of sheets by rela-

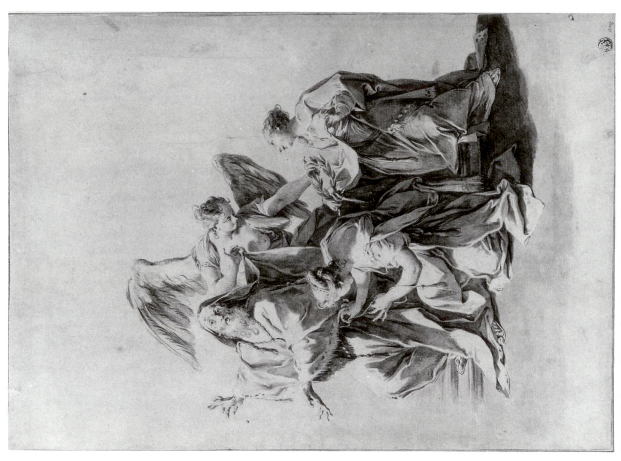

Figure 12. Anton Kern, after Giovanni Battista Pittoni, *Epitaph of Charles Sackville*, brush and red-brown wash heightened with white gouache over traces of black chalk, 401 × 288 mm. The Art Institute of Chicago, Leonora Hall Gurley Memorial Collection, 1922.3799.

tively important artists. Nevertheless, drawings by many of the major artists of the time may be seen in the United States, with the exception of certain notable figures such as Paul Egell, Johann Michael Rottmayr, and the Zimmermann brothers, whose works are concentrated in a few collections in Europe.

On the other hand, there may be several surprises here. Drawings can be found in America by artists such as the Donners and Messerschmidt by whom no authentic works on paper are known in Europe. Major works thought to have been lost, such as Hackert's sketchbook, have also been brought to light; other im-

portant drawings, such as sheets by Asam, Scheffler, and Schwanthaler, can be identified. Furthermore, the largest cache of drawings by the most prolific fresco painter of the eighteenth century in Central Europe, Matthäus Günther, is in America.

This exhibition of drawings may not itself cause a revision of impressions of art in Central Europe. It will probably not cause a reorientation of the studies of the eighteenth century that led to the neglect of the material in the first place. But if it gains not merely new admirers for these drawings, but more importantly, some new attention, then at least one aim will have been served. The history of eighteenth-century culture in Europe needs to attend to its visual manifestations in Central Europe as well as to the more celebrated musical, literary, and philosophical accomplishments.

Finally, attention to Central European drawings may even contribute to the recent reinvigoration of eighteenth-century studies. As we mark a year commemorating the beginning of the Revolution in France, it need not be forgotten that much history, and history of art, also took place to the east. The history of art, even in its so-called newer manifestations, too often plows over the same fields, leaving potentially fruitful areas untilled. It is hoped that this exhibition and catalogue, like *Drawings from the Holy Roman Empire*, will not only help open up another territory for investigation but perhaps will also change some perspectives on more familiar sites as well.

NOTES

1. Princeton 1982. The exhibition to which this catalogue was related was also shown in Washington, D.C., and in Pittsburgh.

2. While introductions to various recent exhibition catalogues and monographs have offered some generalizations, Dörries 1943 remains the last independent overview of drawings of this period. Some general observations are also included in Garas 1980, which book however deals exclusively with material from the Budapest collection.

3. A critique of deprecatory views of the period before 1680, such as those to which reference is made here, and a revised account of this period, are offered in Princeton 1982, pp. 4–8, and more extensively in Kaufmann 1988, pp. xix–xxxvii.

For the lure of opportunities available in Central Europe, and an outlook on shifting patterns of patronage, see Haskell 1980, pp. 293–96, 310–16. This view contradicts the assertions about artists' opportunities stated, for instance, by Thomas Gaehtgens, in London 1985, pp. 8ff, and repeated in Gaehtgens 1987, pp. 9f.

4. See Becker 1971.

5. Sandrart 1675.

6. Lhotsky 1941, p. 363, notes that while French was the dominant language at most German courts, so much Italian was spoken in Vienna that the Tuscan ambassador complained in a letter of 1675 to Grand Duke Cosimo III that he scarcely had a chance to practice German.

7. The reference here is to the patriotic tract written by Hans Jakob Wagner, tutor of the future Emperor Joseph I. Wagner's *Ehren-Ruff Teutschlands*, written in the 1680s and published in 1692 (see Wagner von Wagenfels 1692), protests against French influence and Francophile imitators. For Thomasius, see also the challenge to the imitation of French customs in Thomasius 1970, pp. 5–49.

8. Frederick II's views on German literature and learning, and the contemporary responses to them, are conveniently assembled (albeit with Frederick's words translated from his beloved French into German), in Steinmetz 1985; Thomasius 1970, pp. 5–49.

9. For a brief introduction to some of this literature, see Schlosser-Magnino 1904, pp. 480–81, 492–98.

10. Heinecken 1768, p. 111:
"Es wäre wohl zu wünschen, dass man von den Deutschen, meinen Landsleuten, im Betracht der bildenden Künste, sagen könnte: sie hätten, wo nicht die Italiener, Franzosen und Niederländer übertroffen, doch wenigstens es eben so weit als sie gebracht. Allein, es ist auf keine Weise zu läugnen, dass wir unten allen obgenannten Schulen, im allgemeinen Verstande zu reden, noch die schlechtesten sind.

Diese Wahrheit wird sonderlich zu den jetzigen Zeiten, da der Nationalstolz recht Mode geworden, sehr vieln nicht gefaln."

11. See Hagedorn 1762, esp. pt. 1 for comments on Brandl et. al., also Füssli 1795.

For further references and brief characterizations of these sorts of writings, see Schlosser-Magnino 1964.

12. Winckelmann's praise of Daniel Gran and his critique of what corresponds to rococo design appear in his famed *Gedanken über die Nachahmung der griechischen Werke in der Malerei und Bildhauerkunst*, reprinted in Winckelmann 1969, pp. 36ff.

See in general for Winckelmann and his impact on contemporaries, Justi 1956.

13. Hatfield 1943.

14. Goethe's remarks on German architecture appear tellingly in an anthology of writings on German culture promoted by Johann Gottfried Herder (Herder 1773). Two essays, "Strasbourg Minster" and "On German Architecture," are available in translation in Gage 1980, pp. 115–23. For this theme in general, see Robson-Scott 1965.

Goethe's changing relation to the art of his time is discussed most convincingly by Herbert von Einem, in London 1972, pp. xxxv–xlv.

15. Woltmann and Woermann 1888, 3, pt. 2, pp. 1004f.

16. E.g., Bode 1891, p. 167. In his introduction to *German Baroque Drawings*, London 1975, n.p., Dieter Graf comments on how Bode's remarks characterize the reception of the period at this time; Graf's discussion is paraphrased here.

17. While there has been extensive treatment of the Gothic revival, and while even the Renaissance revival in Germany has received some atten-

tion, e.g., Milde 1981, the revivals of the baroque and rococo have not been so thoroughly studied.

Harries 1983, p. 2, briefly points out the relationship of the change of taste for the baroque and rococo to the change in historians' attitudes to these styles.

18. For example, the groundbreaking work of Hans Tietze in the articles "Programme und Entwürfe zu den grossen österreichischen Barockfresken," and "Wiener Gotik im 18. Jahrhundert" (see Tietze 1911, 1909).

19. Darmstadt 1914, pp. 111f.

20. Christoffel 1923, pp. 7–8.

21. Dehio 1919. Biermann's *Deutsches Barock und Rokoko* has in fact been called "another chauvinistic work" in Gay 1969, p. 647.

For the general issue of nationalistic art history during this period, see Larsson 1985, pp. 169–84.

22. Harries 1983, p. 3, briefly discusses some of the pertinent literature. For "baroque" architecture, notable works include Sedlmayr 1925; Sedlmayr 1930.

23. Weinberger 1923; Garzarolli-Thurnlackh 1925; Garzarolli-Thurnlackh 1928.

24. For the background of the *Barockmuseum*, see Vienna 1934; for the collection of German drawings in the Albertina, see Tietze 1933.

25. Feulner 1929, p. 146.

26. Feulner 1942. Detlef Hoffmann, in Darmstadt 1980, pp. 24ff., deals with this issue in relation to the interpretation of German eighteenth-century genre painting.

In the context of a discussion of the literature on eighteenth-century art in in Germany, Peter Gay has noted that, "the difficulty with much recent writing on German literature and art is that it is colored by the Nazi experience— the later editions of works first written in the 1920s often reflect their authors' subservience to the new regime, and books written by older men after 1945 often reflect hasty revision of their ideology." See Gay 1969, p. 647.

27. For Pinder's comments on the baroque, see Pinder 1965. (Although Pinder claims, p. 2, that the text was essentially written in 1911 and little changed since then, he also remarks, p. 26, that it was last looked over in 1943, when the text would have been made ready for printing.) For a general treatment of German art history in the Nazi period, with references to Pinder and the literature on him, see Dilly 1988.

28. Sedlmayr 1938, pp. 126–40; reprinted in Sedlmayr 1960, 2, pp. 140–56. Sedlmayr's sympathies at the time of the writing of this essay are revealed in Sedlmayr 1938a, pp. 9–27. The evocation of Dehio in these pages suggests the common direction of Dehio's, Sedlmayr's, and Pinder's work.

Hellmut Lorenz, in Vienna 1986, 7, pp. 21–30, gives a critique of the "nationalist accents" he finds in the work of Sedlmayr and Bruno Grimschitz. For Sedlmayr's earlier contributions, see Sedlmayr 1925; Sedlmayr 1930.

29. E.g. Tintelnot 1951; Tintelnot is significantly the editor of the *Festschrift* for Dagobert Frey, published in Breslau in 1943; Frey's ideological stance and wartime activities are also discussed in Princeton 1982, p. 6, and in Kaufmann 1988, pp. XXVI, XXXIV, n. 20, with further references.

30. This point has been made in reference to the historiography of the period before 1680 in Princeton 1982, p. 6, and in Kaufmann 1988, pp. XXIII–XXVI.

31. Dörries 1943, p. 7.

32. See Möhle 1947; Munich 1958; Hegemann 1958; Rupprecht 1959; Bauer 1962; and Bauer 1980, where references to further literature are given.

33. E.g. Garas 1960.

34. Significant exhibitions of the 1960s include Nuremberg 1962; Stuttgart 1964; and Augsburg 1968.

A major catalogue of this period is that of the collection of the German-isches Nationalmuseum, Nuremberg, by Monika Heffels (see Heffels 1969).

35. E.g. Hamacher 1987a.

36. Tilman Falk, summarizing the recent literature and exhibitions on the subject in his foreword to Augsburg 1987, p. 5, also says that "Zusammen-fassende neu Literatur gibt es kaum," and notes that "Es besteht also durch-aus ein Nachholbedarf an wissenschaftlicher Erforschung und öffentlicher Präsentation."

37. Among the examples of this sort are Bremen 1971; Leipzig 1985; Nurem-berg 1985; Nuremberg 1987. These methods of presentation continue one suggested by many earlier examples, including even an exhibition in Detroit in 1949 on "Paint-ings and Drawings from the Time of Goethe in American Collections."

38. See London 1985, pp. 8–9; and Gaehtgens, in Berlin 1987, p. 9. A compa-rable view can be seen in the writings of art historians from the German Democratic Republic: see the remarks by Peter Betthausen, director of the Nationalgalerie, East Berlin, with regard to the period from 1780, in New York 1988, p. 21.

39. While the specialized literature on eighteenth-century history is obvi-ously quite large, this task is not made easier by the continuing absence of a good work on eighteenth-century German cultural history, as was noted twenty years ago by Peter Gay in his extensive bibliographic surveys (see Gay 1966 and 1969, 2, p. 647). For general orientation the works listed by Gay, loc. cit., and 2, p. 576, as well as 1, p. 440, must therefore still be consulted. For an overview in English, the reader must have recourse to such studies as Bruford 1935 and Holborn 1964, as well as material such as that collected in Fauchier-Magnan 1958.

For Austria (the Habsburg lands), Wangerman 1973 may be consulted; see also the essays in *Das achtzehnte Jahrhundert und Österreich* 1985, and es-pecially the essay by R. J. W. Evans, pp. 9–31, with many further references.

The situation is similar, if not worse, in English-language art history. Here the only standard work, the volume in the Pelican History of Art series, rep-resents opinions and a state of research that are effectively more than a gener-ation old: Hempel 1965 was published when the author (b. 1889) was nearly eighty.

40. See Hoffmann in Darmstadt 1980; and for a broader conceptualization of changes of taste in relation to audience in general, see Mattenklott 1984, pp. 31–43.

41. This summarizes the argument presented in Princeton 1982, pp. 12–14.

42. For the Nuremberg academy a primary source is Will 1762; see further Schrötter 1908. For Augsburg, see the comprehensive study, Bäuml 1950.

43. For Strudel's academy in Vienna and its relationship to Loth's work-shop, see Koller 1970, pp. 5–74. For Dresden, see Wiesner 1864, which, however, has only a slight amount of material on Bottschild's academy and its immediate successor under Heinrich Christoph Fehling. Bottschild is a worthy topic for a monograph.

44. See Ehrenstrahl 1918; Josephson 1959 established that Bottschild was the author of this tract.

For the relation of Bottschild's treatise to those of Ehrenstrahl, Sandrart, and Johannes Schefferus, see Ellenius 1960, pp. 22ff.

45. For the imperial academy in Vienna, see Lützow 1877 and Wagner 1967. For the Berlin academy, see Müller 1896; Oettingen 1900; and Wiesinger 1979, pp. 80–93.

For Dresden, see Wiesner 1864.

For Sandrart's and the early German academies, see also the summary in Pevsner 1973, pp. 115–24.

45. The Mannheim academy is discussed in Grotkamp Schepers 1980. This work contains much information on the other academies and drawing schools of the time, and a convenient listing of the dates of their foundation. Some other foundations are discussed in Peters 1973, pp. 1–30; Schmidt 1944, pp. 33–87; Knackfuss 1908; and Fleischhauer 1958 and Petermann in Stuttgart 1959, pp. 56–70, and 71–81.

For the Vienna *Kupferstecherakademie*, see Lützow 1877, pp. 37ff.; for the Augsburg *Franziszische Akademie*, see Freude 1909.

For the academies discussed in this paragraph in general, see Pevsner 1973, pp. 140ff.

47. Scheyer 1961, pp. 15ff.

48. For this point in regard to these institutions in general, see the discussion in Pevsner 1973, pp. 152ff.

Schulze 1940, p. 41, notes for example that "Fast alle Handwerker deren gegenstand in die Zeichenkunst einschlägt, verlangten Unterricht bei Oeser."

49. See Kroupa 1986, esp. pp. 150ff.; Günther Heinz, in Melk 1980, pp. 181–99. [Kroupa, p. 229, cites an essay "Poznámky k Sonnenfelsově koncepci umění," *Uměleckohistorický sborník*, Brno 1985, pp. 195–209.]

50. See Kaufmann 1988a, pp. 24–26, for this situation.

51. See Heusinger, in Braunschweig 1983, pp. 23–25.

52. For this subject, see Ellenius 1960, pp. 223ff.

53. For Leopold as a painter, see Spielman 1977, p. 34; for Fischer as Joseph I's tutor, see Aurenhammer 1973, p. 24.

54. Evidence of their accomplishments was presented in the exhibition "Maria Theresia und ihre Zeit." See Vienna 1980, p. 111, cat. no. 15.10; p. 216, cat. no. 36.03; p. 217, cat. no. 36.05, ill.; p. 346, cat. no. 13a and b, ill., with further annotation.

55. For Frederick William I's art, see Klepper 1959, pp. 36f.

56. For designs by Augustus II, see Hentschel 1969.

57. See Princeton 1982, p. 14, and Ellenius 1960, pp. 223ff.

58. For this topic, see Kemp 1979, pp. 8ff. Much more work is needed on the subject of Kemp's book, however.

59. For the *Zeichenschulen*, see Kemp 1979, pp. 184ff.

60. See for the earlier development, Princeton 1982, pp. 12–14, 17–19, 21–23, with further references.

61. Cf. Sulzer 1794, 5, pp. 749ff.

62. See Dickel 1987.

63. For Preissler, see Dickel 1987, pp. 192–208; for Bergmüller, see Bergmüller 1723.

64. For this subject in general, see Bannes 1962 and Monnier 1977.

For practices in the individual academies, see for example Grotkamp Schepers 1980, pp. 67ff.; Koller 1970, p. 13; Lützow 1877, pp. 31ff.; Will 1762, p. 22; Wiesner 1864, pp. 47ff; Scheyer 1961, p. 18; Bäuml 1950, 40ff., 61ff. et passim; Müller 1896, pp. 18ff.; Wiesinger 1979, pp. 80–85.

For eighteenth-century theoretical pronouncements on the subject, see Sulzer 1794, 1, p. 13; Hagedorn 1762, pt. 2, pp. 510ff.; Mengs 1780, 2, pp. 217–91.

65. See Salomon Gessner, in Füssli 1770, pp. xxxvff.

66. Preissler 1759 proposes a method of procedure and offers a system of illustrations that are similar to those found in Preissler 1740. The frequency of editions of these works attests to their popularity.

67. A preliminary orientation to the attribution and character of Savery's *naer het leven* drawings, on which there is a growing body of literature, can be obtained from the fundamental articles of Joaneath Ann Spicer: see Spicer 1970, 8, pp. 3–30; 1970, 18, pp. 270–75.

Schmidt, in New York 1988, pp. 39–47, discusses the issue of drawing from nature in the late eighteenth century and notes an increase in this activity, citing Goethe's description (ca. 1770) of the way in which Hackert's drawing from nature was regarded as a novelty.

For Freudenberger, see in general Huggler 1976.

68. See the introduction by James Henry Rubin to Princeton 1977.

69. A concentrated group of examples of this sort can be found in the *Nachlass* of drawings from the Preissler workshops and the Nuremberg academy in the Herzog Anton Ulrich Museum, Braunschweig.

70. See Garas 1980, p. 23.

71. For the collections in Brno, see Kroupa 1985; Kroupa, in Kroměříž 1982; and Kroupa 1986.

For the Düsseldorf collection, see Düsseldorf 1968, as well as the introduction by Dieter Graf to London 1973; and especially E. Schaar and D. Graf, in Düsseldorf 1969.

For the drawings collection in Würzburg, see Würzburg 1982, which contains drawings particularly pertinent for this exhibition.

For Martino Altomonte's material in St. Florian and Melk, see Aurenhammer 1955, 32, pp. 242ff., and more completely Aurenhammer 1965, pp. 72–80. The largely intact collection of Martin Knoller, part of which is in the Landesmuseum Ferdinandeum, Innsbruck, still awaits thorough investigation.

72. See Sulzer 1794, 1, p. 12.

73. For Strudel, Loth, and the Vienna academy, see Koller 1970. For more on the history of the collections of the Vienna academy, consult the information in the standard histories by Lützow 1877 and Wagner 1967. For Berlin, Müller 1896.

74. For the Mannheim collection founded by Carl Theodor, see the introduction by Dieter Kuhrmann, in Munich 1983, esp. p. 7; Hans Albert Peters, in Düsseldorf 1988, pp. 3–5; and also Schulze Altcappenberg, Düsseldorf 1988, pp. 7ff., which essay contains much of further interest, as well as many references pertaining to the topic of drawings collections at this time.

75. For the Berlin collection, see Peter Dreyer's introduction and catalogue to Berlin 1982, particularly pp. 5–12; for Prince Eugene's collection, now in the Österreichische Nationalbibliothek and the Albertina, see Günther Hanman, in Gutkas 1985, pp. 349–58, with references to earlier literature. Another modern collection that derives in part from the dissolution of the holdings of an earlier princely library is that in Braunschweig. For an incomplete study of the origins of this collection in the library, see Wolfenbüttel 1979.

76. For this foundation, see Basel 1975, pp. 3–4.

77. For the Dresden graphic collections and their impact, see the good overview by Werner Schmidt in Essen 1986, pp. 277–79.

For the collecting of later drawings in Dresden, see Schmidt in New York 1988, pp. 57–59.

78. An orientation to the history of this collection is conveniently provided by Walter Koschatzky, in Washington D.C. 1984, pp. 13–20.

79. For this collection, see Joachim Kruse, in Detroit 1983, pp. 20–24.

80. See Dresden 1972, esp. Jiri Kusnecow, pp. 8–9; and idem, in Florence 1982, p. 10.

81. For an idea of Städel's collections of German drawings of the period, see Schilling 1973.

Woeckel on Ignaz Günther (Woeckel 1975). Material pertinent to this exhibition is to be found in Reichersberg 1974, pp. 126–32, and in the monograph on Andreas Thamasch, Gauss 1973, pp. 59–66.

Recent helpful literature on the subject includes Munich 1988, containing a thorough bibliography compiled by Annemarie Seling, pp. 266–73, and the article by Peter Volk, pp. 9–13; also Volk 1985, pp. 46–55; and especially the essays collected in Volk 1986.

These works make up for the fact that the only comprehensive treatment of the sculptors' drawings, Gradmann 1943, is inadequate and includes scant material on Central Europe.

98. This is again a topic that needs further systematic discussion. Nerdinger and Zimmermann 1986 provides a survey of the history of German architectural drawing, and the catalogue of architects' drawings, Berlin 1979a, also offers many examples. For the eighteenth century, it is necessary to consult monographic treatments such as that by Heckmann 1954, pp. 11–13, where distinctions in the stages of architectural drawings are made, or for that matter Sedlmayr 1932, esp. pp. 106–8, where a slightly different series of divisions is made.

99. For an overview of eighteenth-century German engravings, see most fully Grosswald 1912. For illustrated books, see Ruemann 1931; and Lanckorońska and Oehler 1932.

100. See further the general critique of these sorts of notions in Kubler 1962, pp. 5ff.

101. For further discussion of these issues, see Princeton 1982, pp. 19–20.

102. Feulner 1929. Problems of terminological confusion seem endemic to the study of this field, as witness those attending the classification scheme even in the recent exhibition, New York 1988.

103. For this issue in literary criticism, see for example the essays collected in Wellek 1967.

104. The theoretical bases for these notions, and the argument that they are associated with the academic ideal symbolized in the personification of Hermathena, are worked out most extensively in relation to art at the court of Rudolf II in Kaufmann 1982, pp. 119–48. These notions are applied in Kaufmann 1988a, as well as more broadly in Princeton 1982, pp. 21–25.

105. This discussion of the diversity of techniques in the academy could well be extended; in the meantime the discussion here may be regarded as a response to the suggestion made about the ineffectiveness of education in the German academies, in London 1988, pp. 8–9. The subject of technique also deserves further attention.

106. Sacramento 1939. Neumeyer included German masters in his second group, which he explicitly mentioned as being made up of "lesser value than those in group one, but still of importance" (n.p.).

107. See Scheyer 1949.

108. It is significant that the only living scholars active in America to have published major works on eighteenth-century German art are the architectural historian Christian F. Otto (Otto 1979) and the German-born philosopher Karsten Harries (Harries 1983).

109. The author is at present involved in a project to make an inventory of these previously uncatalogued drawings in Chicago; plans are also being made for a complete catalogue of the German drawings in Sacramento.

82. For this notion, see Rothstein 1976, pp. 307–32; this idea is employed for the interpretation of eighteenth-century art in Bryson 1981, pp. 102f. See in general for the topic of the sketch, Rudolf Wittkower, in New York 1967, pp. xxif.; Bushart 1964; Edward A. Maser, in Los Angeles 1968, n. p. [pp. 7–16]; Rotterdam and Braunschweig 1983; and the essays in the related symposium volume Klessmann 1984, which contains many further references.

83. For De Piles, see Bryson 1981. Sandrart's remarks are quoted in Klessmann 1984, p. 8.

84. Quoted in Koschatzky 1986, p. 39, and cited further, in Düsseldorf 1988, by Schulze Altcappenberg, who, pp. 12–14, discusses some of the factors that shaped this taste.

85. Quoted in Garas 1980, p. 23.

86. The argument for the oil sketch as an autonomous work of art is advanced by Bushart 1964.

87. In an as yet unpublished paper, Jeffrey Muller has traced the development of principles of connoisseurship in the early modern era.

88. Schulze Altcappenberg, in Düsseldorf 1988, p. 14, calls attention to Oeser's remarks on this subject to Christian Ludwig Hagedorn.

89. See Wüthrich 1956; Tenner 1966; Vienna 1981; and most recently Luther 1988, where these and other references are to be found.

90. On Mariette's dealings with Dresden, see Marx 1979, pp. 77–87.

91. For Frauenholz, see Luther 1988. The remains of the Artaria collection are now in the Albertina.

92. For the relative dearth of such studies earlier, see Princeton 1982, p. 14; for their proliferation in the eighteenth century, see the discussions mentioned in n. 83, above.

93. See, for example, the comments attributed to Martin Knoller on fresco painting, Reisberger, ed., n.d.; Popp 1904, pp. 120–28; also in Tintlenot 1951, pp. 307ff.

94. The general observations in this and the following paragraph summarize the exceedingly useful treatment by Hamacher 1987a, where references to further literature can be found; see also Hamacher 1987. Augsburg 1988, pp. 97–113, has also provided useful special studies of the work of M. Günther, who is well represented in the current exhibition (cat. nos. 19–21) and in American collections in general (fig. 8).

An overview is also provided by Bruno Bushart, in Volk 1986, pp. 257–64. Many related issues are also discussed in the essays found in Klessmann 1984.

95. Hamacher 1987a, pp. 77–85, gives the most extensive account of terminology; her distinctions are followed here. Bushart, in Volk 1986, p. 257, is more skeptical.

96. The definition of "*modello*" employed here is that of Rudolf Wittkower, in New York 1967, p. xx. Maser, in Los Angeles 1968, pp. 10–11, also adopts Wittkower's terminology, adding that "it is upon the final worked-out 'Modello' that the contract is based."

It should be noticed, however, that this definition is not exactly that of a writer on the subject such as Baldinucci 1681, pp. 99–100. See also Hamacher 1987a, p. 100, and further for the problem of taxonomy, Bauer 1978.

97. Monographic treatments of Central European sculptors' drawings include those of Klaus Lankheit on Paul Egell (Lankheit 1954) and Gerhard P.

Catalogue

Notes on the Use of the Catalogue

TECHNIQUE: Descriptions of media and support are those of the owner, corrected or augmented by the author.

MEASUREMENTS: Height precedes width; inches precede millimeters.

WATERMARKS: All visible watermarks are described; comparisons to or identifications with watermarks in Briquet or other sources are noted.

INSCRIPTIONS: These are in one of the same media as the drawing unless otherwise noted; however, the medium of the inscription is always given. When the inscription is believed to be an actual signature by the artist, the words "signed" or "monogrammed" are used. Similarly, "dated" indicates a belief that the date on a drawing was placed there by the artist. Abbreviations have been expanded in brackets.

PROVENANCE: Where a Lugt number is given, a collector's stamp appears on a drawing in the location indicated.

EXHIBITIONS AND LITERATURE: Full citations for abbreviated forms appear in the Bibliography of Sources Cited. Exhibition citations include references to catalogues; if no catalogue was published, the citation is given in full in the entry; exhibition catalogues are not repeated under Literature.

I.
History
A. Designs for
Ceilings and Altarpieces

Johann Melchior Schmittner (Schmidtner)

(1625–1705)

A painter primarily of altarpieces, Schmittner was born in 1625 in Augsburg. According to the historian Paul von Stetten, he was trained during a stay of fifteen years in Italy, and returned to Augsburg to gain great fame. His works indicate that he responded to artistic influences from Joachim von Sandrart and Johann Heinrich Schönfeld. Paintings by his hand are to be found in Ellwangen, Haitingen, and Constance. Schmittner died in Ausburg in 1705.

1. The Betrothal of the Virgin

Black chalk with brush and gray wash and white heightening, partially discolored (over graphite?), on gray-tinted paper
9 5/16 × 8 1/4 (237 × 209)

The Art Institute of Chicago; Leonora Hall Gurley Memorial Collection, inv. no. RX 16751.1833

Monogrammed in brown ink, lower right: *JMS* (ligatured); inscribed on verso in brown ink, top center: *Johann Martin Schöpf;* bottom right: *no. 110; Johann Martin Schöpf*

PROVENANCE: Unknown collector PH; William F. Gurley

Earlier inscriptions on the verso, probably made by former owners, attributed this drawing to Joseph Schöpf (1745–1822), most likely on the basis of an interpretation of the monogram. Yet the drawing cannot be compared to any known drawings by Schöpf, which are to be seen primarily in the artist's *Nachlass* in the Cistercian Abbey of Stams, and in the Tiroler Landesmuseum Ferdinandeum, Innsbruck.

Rather than resembling the work of this collaborator of the late eighteenth-century fresco painter Martin Knoller, who himself was a promoter of the neoclassical style in Austria, this sheet can be better situated in the late seventeenth century. The flowing lines and swaying, elongated figures with fleetingly represented faces are found in other drawings by Schmittner that are done in a similar technique.[1]

Not only does the monogram found on the sheet seem to conform to Schmittner's, but its style also resembles that of his few known drawings. An inscription on the verso by Rolf Biedermann in fact recognized that it was a work by the Augsburg artist Johann Melchior Schmittner.

Schmittner's other original drawings are preparatory designs for altarpieces; the paintings to which they are related follow them closely.[2] It is reasonable to assume that this drawing of the *Betrothal of the Virgin*, with its framing units of columns before an archway, may also have served such a purpose. Unlike Schmittner's other similar designs this work is not squared for transfer, however, so that its function remains somewhat unclear.[3]

Because of the rarity of drawings by Schmittner—few are known besides copies after works by other artists—it is difficult to date this work more precisely than to the time of his other works in ca. 1680. Comparisons made by Rolf Biedermann between Schmittner's typology of figures and symmetrical compositions and those of Johann Heinrich Schönfeld (1609–1684) apply to this work as well.[4] Biedermann's further observations about the relation of the drawing to later works by Johann Rieger (see cat. no. 5) are also relevant. In this way, the drawing may be regarded as providing a link between the tradition established by Schönfeld and the later flowering of art that was to occur in Augsburg from ca. 1700.

1. Compare, for example, a drawing of the *Seven Gifts of the Holy Spirit*, Augsburg, Städtische Kunstsammlungen, inv. no. G 4464-67, best illustrated in Augsburg 1987, no. 61, ill. p. 133.

2. Compare, for example, the painting in the former Spitalkirche (now the Franciscan church) in Ehingen that is related to Schmittner's Augsburg drawing (Augsburg 1987). Both are illustrated in Bruchsal 1981, cat. nos. A 75a and A 75b, ill. pp. 111, 112.

3. Besides the Augsburg drawing, see Schmittner's other known compositional design—for a *Holy Family* in Darmstadt, Hessisches Landesmuseum, inv. no. 527, best illustrated in London 1975, cat. no. 84, pl. 36.

4. First noted by Rolf Biedermann in Augsburg 1968, p. 245, under no. 331.

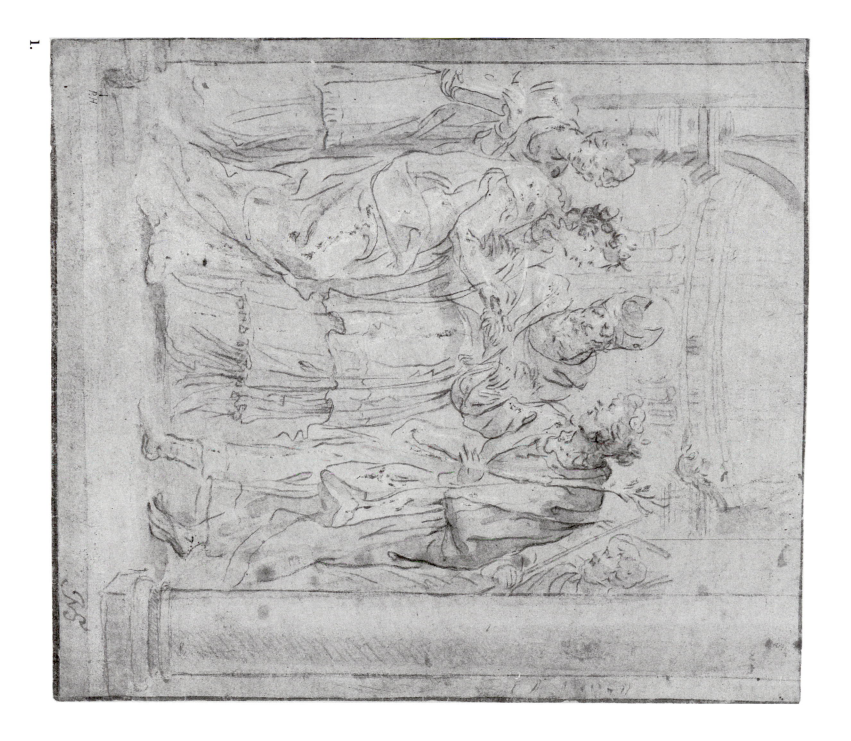

MELCHIOR MICHAEL STEIDL
(1657–1727)

Born in Innsbruck in 1657, Steidl was trained by the Munich court painter Johann Andreas Wolff (1652–1716). He became a master in Munich in 1687, and after marrying the daughter of the painter Hans Michael Tobrias (Dobries), he joined the painters' guild there in 1688.

Starting with the collaboration with his fellow Tyrolean Johann Anton Gumpp (1654–1719) in painting at St. Florian (1690–95), Steidl executed frescoes in Lower and Upper Austria, for example, at the Benedictine monasteries of Kremsmünster (1696) and Lambach (1698–99). His center of activity then moved to Bavaria, where he worked in the Carmelite church in Straubing in 1702, and in the Obermünster in Regensburg in 1704. Later he received important commissions for frescoes in Franconia, at Würzburg (1706), Bamberg (1707–9), and Banz (1716; altarpiece of 1723 also there). Sites elsewhere where he worked include the Schöneberg near Ellwangen (1711–12) and the St. Moritz church in Augsburg (1706, 1714–15). Steidl may thus be considered the most important representative of the school of fresco painters resident in Munich around 1700, as well as the initiator of the eighteenth-century tradition in Augsburg.

He died in Munich on August 4, 1727.

2. Christ in the House of Mary and Martha (Christ at the Feast of Simon)

Pen and brown ink, with white heightening, on gray-brown paper, squared in pen and brown ink
8⁵⁄₁₆ × 18¹¹⁄₁₆ (212 × 475)
Squaring numbered from left, in brown ink: 1–3; vertically: 1–8; scale indicated in brown ink at bottom center. Inscribed, lower right corner: N 5.
Signed and dated in brown ink, lower center: *Dises ist gemalt worrn / in Rögenspurg bey die H[eiligen]. P[atribus]. Cordeisser [Cordeiller?]. a[nno] 1699 / in di [?] Julij. Steidl*

The Metropolitan Museum of Art; Bequest of Harry G. Sperling, 1975.131.237

PROVENANCE: Unidentified collection De B. (collector's mark on verso, not in Lugt); Harry G. Sperling

Previously attributed to Peter Strudel, this drawing can be better assigned to Melchior Steidl on the basis of its lengthy inscription, as well as on considerations of style and biographical evidence. While it is hard to decipher, the name found in the inscription can be better read as *Steidl* than as *Strudel*. Similar signatures are found on other sheets by the artist.[1]

The unconnected and often spotty heightening found in this drawing, as well as the indication of shaded areas by means of both wash and pen hatching, appear in other drawings by Steidl. They are, however, uncharacteristic of Strudel, whose style of drawings derives instead from his teacher Loth (cat. no. 28), and is characterized by an even greater reliance on white heightening, not only to indicate highlights but to build up the mass of the figures. Conse-

quently, undisputed drawings by Strudel evince starker contrasts between heightened and shaded areas, in place of the gradual transitions found in Steidl's drawings.[2] These differences point to Steidl as the author of this sheet, where the treatment of profiles of figures and voluminous drapery also resemble features in his authentic drawings.[3]

The inscription on the Metropolitan Museum drawing referring to work done in Regensburg in 1699 can also be related to the activity of Steidl. While Strudel was working in Vienna during this period, Steidl's range of activity extended from Upper Austria to Franconia. From 1698 Steidl is known to have executed frescoes in the Cloister Church of Lambach, not far from Regensburg in Upper Austria; in 1704 he was in fact documented as being in Regensburg itself, where he painted in the Obermünster.[4]

From the squaring and numbering on the drawing, as well as the scale, it would seem that this relatively large sheet was used for a fresco in Regensburg. The inscription indicates the work was done for the *Cordeisser* or *Cordeiller*, that is, for the Franciscans, identified by these terms because of their rope belts. The subject matter, depicting a feast, is conceivable for a refectory. No such fresco however is visible in the convent or church of the Franciscans in Regensburg, the *Minoritenkirche* and *Minoritenkloster* (both now form the Stadtmuseum), nor is one recorded: the church and convent were redecorated in the early nineteenth century. It would thus seem that the drawing provides evidence for a hitherto unknown commission from the Franciscans, which would provide an important link with Steidl's return to work in Germany. If Steidl did receive a commission in Regensburg prior to 1704, this might account for his being asked to work there later.

The Metropolitan drawing is the best of several sheets by the artist in American collections.[5]

1. Though not completely identical, an exceedingly similar signature is found for instance on a drawing of the *Presentation of the Virgin in the Temple* in Stuttgart, inv. no. C 23/70 (illustrated in Stuttgart 1964, no. 17, ill. no. 21.)

Meinecke-Berg 1971, pp. 170–71, no. 3, places this drawing close in date to frescoes executed by Steidl at Lambach beginning in 1698, which would make the Stuttgart and Metropolitan drawings close in date.

2. In these regards the recto of a drawing representing *Venus and Vulcan* is exemplary of Strudel's style (Brno, Moravská Galerie, inv. no. B 2311; illustrated most recently in Brno 1985, cat. no. 1, ill. p. 9, and also found in Garzarolli-Thurnlackh 1928, pl. 8.

3. Compare, for example, Steidl's drawings for Ellwangen, as in Budapest, illustrated in color in Garas 1980, ill. no. 2.

4. For Steidl's work in the Regensburg Obermünster, see Meinecke-Berg, p. 136, cat. no. 7.

5. Other drawings by Steidl in American collections include sheets in the Pierpont Morgan Library, New York (inv. no. 1981.33, *Orytheia and Boreas* [?]), and at the Stanford University Museum of Art (inv. no. 65.79, *Assumption of the Virgin*).

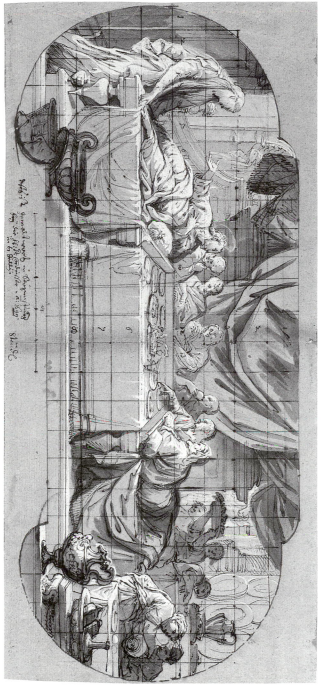

JOHANN RUDOLF HUBER
(1668–1748)

The son of an innkeeper, Johann Rudolf Huber was born in 1668 in Basel. He trained there in 1682–3 with a portraitist named Caspar Meyer, and studied in Bern until 1687 with Josef Werner (1637–1710), the future director of the Berlin academy. In the same year, he traveled to Milan to work with Pieter Mulier, called Tempesta, later visiting Mantua, Vicenza, Padua, Venice, Florence, and Rome. In 1693 he returned to Basel via Lyon and Paris. In 1694 he became *Grossrat* of the Basel guild, the *Himmelzunft*.

In 1688 he was painting portraits of the family of the margrave of Baden-Durlach, who resided mainly in Basel. In 1696 Huber became court painter of Duke Eberhard Ludwig IV of Württemberg, working in the *Altes Schloss* in Stuttgart. In 1700 he was again in Basel, and carried out portrait commissions in Durlach and Rastatt. Huber was *Bauinspektor* of the margrave's palace in Basel. From 1702 on he worked for a few months of every year in Basel, Bern, and other places in Switzerland, finally settling entirely in Basel in 1738, where he became a member of the city council in 1740. He died in Basel in 1748.

Huber's daughter married his pupil, the painter Johann Ulrich Schellenberg.

3. Design for the Corner of a Ceiling, with Balustrade Putti, and other Figures (recto); Ceiling Design with Heraldic Creature (verso)

Recto: pen and brown ink, pink, yellow, blue, and brown washes; verso in graphite
Inscribed in graphite on the verso: *Hofmahler Huber*
13 1/8 × 10 9/16 (333 × 268)

Collection of Professor Julius S. Held

PROVENANCE: Count Franz Joseph von Enzensberg (Lugt 845, on verso)

EXHIBITION: Binghampton 1970, no. 83, p. 20, ill.

The inscription on the verso of this drawing identifies it as the work of Johann Rudolf Huber, who was painter both to the court of Württemberg in Stuttgart and to the court of Baden-Durlach, in Basel. No similar drawings by the artist exist in Stuttgart, however, nor are any to be found in Karlsruhe, the residential city founded by the margraves of Baden-Durlach.[1] In the large body of material related to Huber in the collection in Basel, there is also no directly similar sheet that could verify the attribution.[2] The closest comparable sheet in Basel depicts a ceiling design without figural decoration: only the use of rocaille forms is specifically related.[3]

A note by Heinrich Geissler on the mat of the drawing reads, "Gumpp? (vgl. Innsbruck, Ständehaus)." While this association with Johann Anton Gumpp does not provide an accurate identification, as the sheet is not comparable to his known drawings, it at least places the sheet in its proper historical context, around 1700.[4]

The heavy balustrade with its garland, shell, and volute ornamentation is datable to the period ca. 1700, and compa-rable, as noted, to the design by Huber in Basel. The composition seen with perspective *di sotto in su* also is common for this time period, when such ultimately Italianate inventions were quite popular. The appearance of a figure with a trumpet, probably a personification of Fame, might also be associated with a work done for a princely house.

The graphite drawing on the reverse suggests the appearance of a whole ceiling of which this recto may have been a corner. It has a not easily decipherable creature in the center, which may be a heraldic beast. There also seems no reason to doubt the veracity of the graphite inscription, by an older hand, on the verso.

Nevertheless, a problem also exists to determine for which courtly project this ceiling design could have been made. Huber's own record of his paintings makes no mention of ceilings.[5] There is no evidence for his having done this work for the court of Württemberg, which he served from 1696. He is documented as having painted ceilings in the last years of the seventeenth century in the schloss in Stuttgart; however, the few panels with scenes of the deeds of Hercules, photographed before the destruction of the interior, do not conform to the Held design.[6]

On the other hand, Huber also stood in close relation to the court of Baden, whose service he entered in the mid-1690s after his stay in Stuttgart. In 1701 he became *Bauinspektor* for the new construction of the margrave's palace in Basel.[7] Although no traces of frescoes by him survive there, it is possible that this drawing was done in connection with this activity.

3 (verso).

In any instance, Huber was a many-sided artist, who undoubtedly designed other architectural projects as evinced by surviving drawings.[8] If the Held drawing is to be accepted, as seems most reasonable, it represents an important addition to the artist's oeuvre.

3 (recto).

1. A letter to the author from Heinrich Geissler, dated March 18, 1988, reports on the holdings in Stuttgart; one of June 20, 1988, from Johann Eckart von Borries discusses those in Karlsruhe. The letters also mention the artist's service for the courts of Württemberg and Baden-Durlach.

2. This point was made in a letter of March 9, 1988, from Yvonne Boerlin [-Brodbeck] to Heinrich Geissler, and confirmed by the author of this catalogue from study of the drawings in Basel.

3. Öffentliche Kunstsammlung Basel, Kupferstichkabinett, inv. no. 1907.95.93, graphite, brush and washes, 292 x 415 mm.

4. In a letter to the author of March 18, 1988, Geissler again expressed his feeling that the attribution was connected with the Gumpps. For drawings by Gumpp, see Aurenhammer 1958, figs. 16–18; Krapf 1979, and Vienna 1980a.

5. Abschrift von Herrn Prof. Dr. Daniel Burckhardt-Werthemann auch einem von Herrn Ernst in Winterthur geliehenen Bilderverzeichnis von Hubers Hand (photocopy in Historisches Museum, Basel; copy in Kunstmuseum Basel, Kupferstichkabinett).

6. For Huber's work for the Württemberg court in the Stuttgart schloss and elsewhere, see the documentation discussed in Fleischhauer 1958, pp. 134f.; the Hercules panels that were photographed are illustrated figs. 70, 71.

7. For this activity, see Rott 1917, pp. 138–40. Von Borries also draws attention to this possibility in his letter.

8. This is also the opinion of Y. Boerlin [-Brodbeck], Basel, who called my attention to another drawing with an architectural frame in a private collection in Chur, Switzerland.

JOHANN JOSEF WALDMANN
(1676–1712)

Johann Josef Waldmann was born in Innsbruck in 1676. Son of the painter Michael Waldmann the Younger (1640–1682) and grandson of Michael the Elder (1605–1658), he probably received his education as an artist from his uncle Kaspar Waldmann (1657–1720), with whom he often collaborated.

Johann Josef Waldmann's first recorded work is a title page of 1695, and throughout his relatively short career he made designs for prints. He settled in Innsbruck by 1698, and married there in 1712. He designed triumphal arches for state entries in Innsbruck in 1705, 1707, and 1711. In addition to his altarpieces, which are recorded, he also painted frescoes, which still survive in castles near Rotholz (1706) and in Rattenberg (1709–11), both in the Tyrol. He died in Innsbruck in 1712, having played a leading role in the development of ceiling painting in the Tyrol in the late seventeenth and early eighteenth centuries.

4. Allegory of the Magdalene's Salvation

Pen and brown ink with gray wash, over traces of graphite, squared in red chalk, on cream-colored paper
19⅛ × 10 (485 × 254)
Inscribed in brown ink, lower left: *J. Waldmann*

Harvard University Art Museums, Fogg Art Museum, 1964.108, Gifts for Special Uses Fund (through the Frederick E. Weber Charities Corporation)

PROVENANCE: Walter Goetz, Paris

The inscription on this drawing points to its execution by Johann Josef Waldmann, an important Austrian fresco painter active in the Tyrol, ca. 1700. Hans Aurenhammer, former director of the Österreichische Galerie, Vienna, has confirmed this attribution.[1] The stylistic characteristics of this sheet indeed seem to conform to those known from other drawings by the artist: the type of angel, with his distinctive coiffure surmounted by a cruciform tiara, is found in a design for a frame, while other angels and general similarities in the whole composition are seen in an allegory of dawn by Waldmann.[2] In this drawing, as in other sheets, there are recollections of the work of Waldmann's stepuncle, Kaspar Waldmann.[3]

The imagery relates to the Magdalene. She is identifiable as the small female figure in the background, bottom center, praying before a cross that is placed in a cave: this scene probably is meant to show her repenting in the wilderness. The central female figure who ascends on clouds to be received in heaven by the Holy Trinity is also to be identified as the Magdalene: an angel beside her carries her familiar attribute, the ointment jar, while another putto to the right holds a thonged scourge, referring to her acts of penance. The angel to her right bearing a horn of plenty may refer to the sustenance she received in heaven. Below this group another putto casts down lightning bolts against personifications of erotic love (a blind cupid) and deceit (a woman with a mask). The angel at bottom left holds a chart on which possibly an inscription was to be placed.

Aurenhammer has suggested that the drawing was a preparatory design for an altarpiece, or perhaps also for a ceiling. Given the perspective from which the scene in the drawing is viewed, the latter possibility is unlikely. The unusual shape of the composition points rather to an altarpiece; contours of the frame moreover are marked on the verso, where apparent size notations (417 × 69) are to be found. The squaring in red chalk suggest that the drawing was used in the process of making a painting, but no similar composition by Waldmann is known.

1. In a letter of July 8, 1963, to Walter Goetz.
2. Innsbruck, Tiroler Landesmuseum Ferdinandeum, inv. nos. T 854 and T 856. For illustrations of these drawings see Aurenhammer 1958, figs. 28, 30, although the features visible in this drawing are hard to discern in the reproduction. These drawings are also noted by Hans Aurenhammer in his letter.
3. For the relation of Johann Josef Waldmann's drawings to those of Kaspar Waldmann, see Aurenhammer 1958, pp. 40–41; comparisons can be made especially to Kaspar Waldmann's drawing of the Madonna as Queen of Heaven (Innsbruck, Tiroler Landesmuseum Ferdinandeum), Aurenhammer 1958, p. 119, cat. no. F 2; ill. fig. 20.

Johann Rieger was born in 1655, probably in Dinkelscherben. He worked from 1680 to 1683 as an apprentice with his cousin Johann Georg Knappich. In 1692 he was in Rome, where he was known by the name of "Sauerkraut" in the *Schildersbent*, the guild of northern artists.

On July 1, 1696, he obtained the right to practice painting in Augsburg. Paintings attributable to his hand date from 1698 on. Altarpieces by him are to be found in Würzburg, Augsburg, Constance, Friedberg, Dillingen, and Weissenhorn.

In 1710 Rieger became first Catholic director of the Augsburg academy. He died on March 3, 1730, in Augsburg.

5. The Holy Trinity and the Holy Family with Saints Elizabeth and Zacharias and the Infant St. John above the Seven Sleepers of Ephesus

Pen and brown ink, brown and gray washes
12⅛ × 7⅞ (308 × 200)
Signed in dark brown ink, lower right: *Rieger f./J. Scheffer*

University Art Museum, University of Minnesota, Minneapolis; Hylton A. Thomas Collection, 70.3.127

PROVENANCE: Hylton A. Thomas

Edward A. Maser first correctly identified the signature on this drawing as that of Johann Rieger.[1] The signature in dark brown ink is comparable to that found on a drawing by Rieger of the *Adoration of the Heart of Jesus* in Munich.[2]

Stylistic features also relate the drawing exhibited here to other known works by the artist. The composition of the Minneapolis sheet, with its division into groups on clouds and on earth, and its construction of figures out of wash, is also found in the *Adoration of the Heart of Jesus*. The very fluid use of the pen, which moves around and over the figures, avoiding precise outlines, is also found in another drawing of *St. Leonard Freeing a Prisoner* possesses similar figure types.[4]

The second inscription on the sheet identifies the subject, the seven sleepers of Ephesus, which Maser also recognized. Five figures are shown recumbent on the ground, in a cave-like structure, while two seem to awake. In a cloud there is a gathering of saints, including most likely Joseph and Zacharias, as Elizabeth and John the Baptist adore the Virgin and Child. Within a gathering of angels are seen God the Father and the Holy Spirit.

The story of the Seven Sleepers is most commonly known from the *Golden Legend*. There it is related that seven young men—usually identified as Maximianus, Malchus, Martinianus, Dionysius, Johannes, Serapion, and Constantinus—were walled up in a cave during the time of the persecution of Christians under the Emperor Decius, ca. 250, to awake some two hundred years later under Emperor Theodosius.

The seven sleepers are included both in the Roman martyrology and the Byzantine church calendar, where they are regarded as saints.[5] Though infrequently represented in the art of the seventeenth and eighteenth centuries in western Europe, they were in fact revered in southern Germany, where there is at least one pilgrimage church devoted to them.[6]

It is possible that the Minneapolis drawing, whose rounded top suggests that it was a design for an altarpiece, was drawn with an altar dedicated to these saints in mind. If so, there is no indication that the altar was ever executed; the draftsmanship suggests, in any event, that this is a preliminary design.

Because of the relative rarity of the artist's works and the lack of dated drawings, this sheet is also difficult to place chronologically. If its association with the German cult of the Seven Sleepers is correct, then it may be dated to after Rieger's return to Augsburg in 1696. Although Rieger's work merits further research, it is already clear that he was highly regarded in his own time, receiving important commissions for the decoration of churches in Germany around 1700.[7] This work might perhaps date from Rieger's tenure as Catholic director of the Augsburg academy, when the prestige of this position would have brought him additional commissions.

1. Letter to the University of Minnesota Gallery of July 5, 1984.
2. Staatliche Graphische Sammlung, inv. no. 7839, pen and brown ink, gray wash, over red chalk, 443 x 293 mm.; watermark: WS over snake.
3. Staatliche Graphische Sammlung, inv. no. 7068, pen and gray-brown ink, gray and blue wash, red and yellow watercolor, 345 × 774 mm.
4. Augsburg, Städtische Kunstsammlungen, inv. no. G. 9614, illustrated and discussed in Augsburg 1968, no. 308, pp. 235–6, ill. 222.
5. For the legend and the iconography of the Seven Sleepers of Ephesus, see among other sources Koch 1873 and Künstle 1926, pp. 532ff.
6. The Church of St. Peter and Paul in Rotthof, in the vicinity of Griesbach, Lower Bavaria, now dedicated to Saints Peter and Paul, was formerly the *Wallfahrtskirche Hl. Siebenschläfer*. The high altar of 1757 there by Johann Baptist Modler depicts them. See Eckardt 1929, pp. 266ff.
7. See for this point, Kosel 1976, pp. 245–64.

Martino Altomonte was born in Naples on May 8, 1657. Despite his birthplace and name, he was actually of Germanic parentage, the son of Michael Hohenberg, a baker from the Tyrol who worked in Italy. He was trained in Rome beginning ca. 1672–74 by the renowned ceiling painter Giovanni Battista Gaulli, called "Baccicio," and probably also studied with Carlo Maratta.

Upon Gaulli's recommendation, he was sent in 1684 as an Italian painter to the court of the king of Poland Jan Sobieski, who had just won his famed victories over the Turks, at Vienna and elsewhere; it was on his journey north that he Italianized his name from Johann Martin Hohenberg. In Poland Altomonte worked on portraits and battle pictures at Wilanów and Żółkiew. He also apparently executed a large number of altarpieces. Although he was retained as court painter by Augustus of Saxony on Sobieski's death in 1696, Altomonte thereafter went to Vienna, where he was probably present from 1699.

Altomonte spent the rest of his career in Austria. He became professor at Peter Strudel's academy in Vienna in 1707. He took part in the decoration of many of the projects, which the efflorescence of artistic activity encouraged, including executing frescoes for the schloss in the Augarten near Vienna (1708), the residence of the bishop of Salzburg (1709ff), frescoes in the lower Belvedere for Prince Eugene of Savoy (1716), as well as for cloisters in Upper Austria such as St. Florian, Stadl-Paura, and Kremsmünster (from 1719 to 1728). During this period, as well as in his later years, Altomonte also produced altarpieces for churches in Vienna, Heiligenkreuz, Zwettl, Lilienfeld, Vienna, Graz, Wilhering, and elsewhere.

Martino Altomonte died in Vienna on September 14, 1745. His son, Bartolommeo Altomonte, was also an important painter, especially of frescoes, beginning as an assistant to his father.

6. A Battle of Alexander (The Battle of the River Graniscus)

Pen and brown ink, gray and brown wash, over graphite (or black chalk?)
Irregularly shaped, largest dimensions 10 9/16 × 11 1/2 (269 × 292)
Inscribed in brown ink, upper right corner, recto: *No. 4*; inscribed in graphite on verso: *ALTOMONTE*

Collection of Robert and Bertina Suida Manning

PROVENANCE: C. Wiesböck, Vienna (Lugt 2576, on verso); William and Eugénie Suida

EXHIBITION: Lawrence, Kansas 1956, no. 1, p. 7

The attribution and dating of this work can be established by comparison to drawings by Altomonte of ca. 1710. Its formal qualities resemble those described by Getrude Aurenhammer with regard to Altomonte's designs for the prince-bishop's residence in Salzburg (in 1965, in Viennese private collections): like them, it is a loosely executed pen sketch, with sparse interior drawing and generous washes that in part exceed the contours of forms.[1] With these drawings it also shares military subject matter, which in the designs for Salzburg is connected with the life of Alexander the Great.[2] Moreover, the morphology of some of the elements, for instance the representation of a palm tree by means of large drooping fronds of wash, is similar to that found in a drawing of an apotheosis (*The Reception* [Aufnahme] *of Mars into Olympus*) of approximately the same date as the sheets for Salzburg.[3]

In fact, it is most likely that the Manning drawing is a design for the central canvas set in the ceiling of the former *Konferenzzimmer* of the Salzburg Residence. It possesses a similar provenance to a design for this ceiling, a medallion of the punishment of Damon and Timotheos; while that drawing is inscribed *No. 3*, the Manning drawing is inscribed with a *4*, further suggesting that it may have been of the same series.[4] Most importantly, it contains many details of the ceiling painting of the *Battle of the River Graniscus*.[5]

The drawing and the painting have the same irregular octagonal format, with scalloped corners and rounded sides. Both show battle scenes from a vantage point taken from slightly below. In each coulisses are formed by a figure on foot to the right and a palm tree to the left; in the foreground of each lie fallen warriors. As in the painting, the center of the drawing depicts a melee of men on horseback, in which a man with a sword opposes a warrior who brandishes a spear in his right hand and holds a shield in his left. In each work, winged figures identifiable as Victory and Fame are seen above the warrior, who is probably Alexander. They crown Alexander with a wreath and trumpet his glories.

The many differences in detail between the drawing and the painting suggest that the Manning drawing was a preparatory sketch or perhaps a design of the overall composition for the patron's approval. It is known that Altomonte did present such drawings to the Archbishop of Salzburg, Count Franz Anton Harrach.[6] In most other instances where Altomonte drawings can be related to his completed paintings, variations have been noted between the preliminary and final compositions; some further step has to be assumed as existing between them.[7] In this case there may well have existed an oil sketch that was closer in appearance to the finished ceiling painting: one such oil sketch connected with Altomonte's work for the Salzburg Residence survives.[8]

From July 1709 Altomonte was involved in the decoration of the reception rooms in the archbishop's palace. He collaborated with Johann Michael Rottmayr in painting scenes from the life of Alexander the Great that were completed by 1711.[9] The theme of this cycle was most likely chosen to represent a "mirror of the princes," for the reigning archbishop. Other scenes more appropriate to his ecclesiastical state were also included.[10]

The particular scene depicted in this drawing represents the first major battle waged by Alexander against the Per-

sians after he invaded Asia. It follows the accounts of the battle at the crossing of the river Graniscus of Plutarch (*Life of Alexander* xvi), and especially of Arrian (*The Anabasis of Alexander*), who says of the conflict (1:15:4): "It was a cavalry battle, with as it were, infantry tactics, horse against horse, man against man, locked together..." The moment depicted may be that where Alexander dashes into the midst of the foe, slaying Mithridates, receiving a blow from the sword of Rhoesaces, and narrowly escaping Spithridates's thrust.

Hans Aurenhammer has suggested that this scene adopts a similar composition from the Alexander cycle by Charles Lebrun that could have been known from a print by Gérard Audran. He also suggests that it reflects on the personality of the prince of the church as a virtuous hero who overcomes all his opponents.[11] It is, however, also likely that the representation of a European conqueror of Asiatics had a particular resonance for an Austrian prelate, who had indeed previously been bishop of Vienna at a time when the Habsburgs were pushing the Ottomans back in the Balkans, and extending their own empire.

In any instance, the identification of this drawing establishes an important point of reference for Austrian ceiling painting at the turn of the seventeenth century, when it was still in the thrall of Italian, here Neapolitan, influence (Luca Giordano) and French or Roman academic ideals.

1. Gertrude Aurenhammer, "Martino Altomonte als Zeichner und Graphiker," in Aurenhammer 1965, p. 77.
2. Illustrations of comparable drawings for Salzburg are found in Aurenhammer 1965, fig. 67 (formerly private collection, Vienna; now collection of the Prince of Liechtenstein), and Aurenhammer 1958, fig. 80.
3. This drawing, formerly in the collection of Ludwig von Baldass, is illustrated in Garzarolli-Thurnlackh 1928, fig. 20.
4. For particulars of the drawing of Alexander's cavalrymen, mentioned in note 2 above, see Aurenhammer 1965, p. 163, cat. no. 302: both sheets come from the Wiesböck (nor "Wieshöck," as in Aurenhammer) collection.
5. Illustrated in Aurenhammer 1965, fig. 20.
6. See Aurenhammer 1965, pp. 26–27. Aurenhammer 1965, pp. 129–30, cat. no. 44, proposes that this sketch for an allegorical ceiling painting was painted in oil, but allows that the term "*schizzo*," by which the sketch is referred to in a contemporary document, also may indicate a drawing; as the work in question no longer exists, there is no way of saying that it was an oil sketch, rather than a drawing like the one exhibited here.
7. See Aurenhammer 1965, "Altomonte als Zeichner," p. 79.
8. An oil sketch exists for *Alexander Severs the Gordian Knot*, for the *Antecamera*: see Aurenhammer 1965, pp. 30, 130, cat. no. 45, fig. 3s, and most recently Vienna 1977, cat. no. 4, pp. 21–24, color ill. fig. 4.
9. See the documents published in Tietze 1914, p. 4, and further Aurenhammer 1965, pp. 27ff, 130–31.
10. See Aurenhammer 1965, p. 27, and Hubala 1981, pp. 51ff, 158.
11. Aurenhammer 1965, pp. 30 and 27.

PETR BRANDL
(Ca. 1668–1735)

Petr (Peter) Brandl was baptized in Prague on October 24, 1668, the son of a tailor and innkeeper of peasant origins. Probably in 1683 he started his studies as an artist with Christian Schröder (ca. 1655–1702), the inspector of the royal picture gallery and court painter. He married in Prague in 1693. After a number of contretemps, occurring in part because he had been trained by someone who was not a member of a guild, Brandl managed to join the Old City painters' guild in 1694 with the help of Johann Rudolf Byss, a Swiss painter who was a leading artistic personality in Prague. From this time date the first paintings that may be attributed to him.

Brandl was active as a painter of altarpieces, Biblical, mythological, and genre paintings, and also excelled as a portraitist. His pictures were made for a variety of patrons and churches in Prague and elsewhere in Bohemia. The high point of his career was reached in the years 1711–28, as marked for instance by the cycle of paintings he made for the church in Břevnov (Ger., Breunau) west of Prague in 1718.

Although Brandl has been called the most important artist of the "high baroque" in Bohemia, and is certainly the most important painter of the early eighteenth century there, he died forgotten and in poverty in Kutná Hora (Ger., Kuttenberg) in 1735.

7. Kneeling Male Saint (recto and verso)

Recto: black chalk, white heightening, brush with dark brown oil emulsion, on light gray-brown paper; verso: black and white chalk, with white heightening
11 5/8 × 7 1/2 (294 × 190)

Collection of Robert and Bertina Suida Manning

PROVENANCE: Unidentified collector (collector's mark, beehive, verso, lower left); William and Eugénie Suida (?)

EXHIBITION: Sarasota 1972, cat. no. 50, p. 24, ill. p. 61

Kent Sobotik was the first to notice that this sheet could be attributed to Petr Brandl.[1] Sobotik made a persuasive comparison of the recto of the Manning drawing to a study in Prague of a kneeling man attributed to Brandl.[2] Both drawings are done in a similar combination of oil, white heightening, and black chalk, on brown paper, and evince what Sobotik calls identical contours and highlights.

Sobotik's association of the Manning drawing with a painting by Brandl of ca. 1711 is also convincing. He has likened it to an All Saints' altarpiece located on the first altar to the right in the St. Jacob's church of the Old Town, Prague. As he rightly remarks, the saint (Peter?) in the bottom left corner of this painting is identical in pose to the drawing, save for the position of the hands and the book.[3]

Sobotik's observation of this connection with the altarpiece not only strengthens the attribution of the Manning and Prague drawings, which otherwise seemed unique in Brandl's oeuvre, but also may cause the dating of the Prague sheet to be revised. Jaromír Neumann, who first attributed the Prague drawing to Brandl, associated it with his altar-

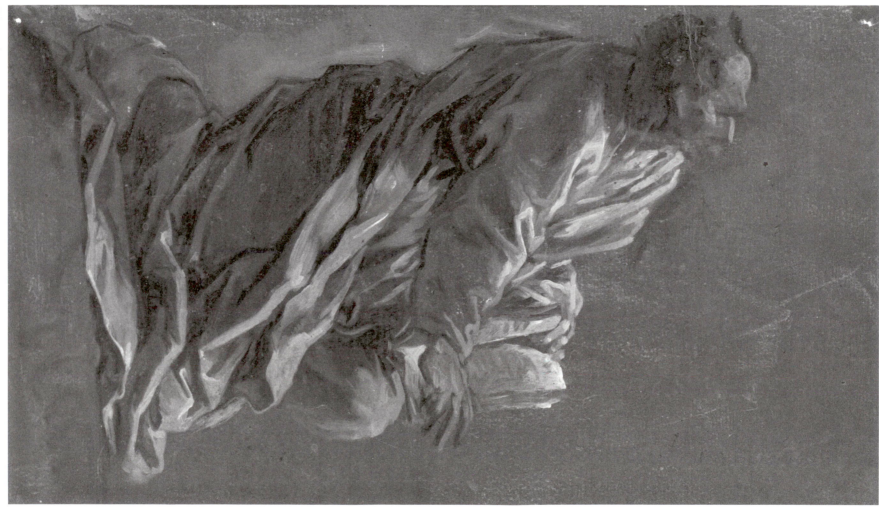

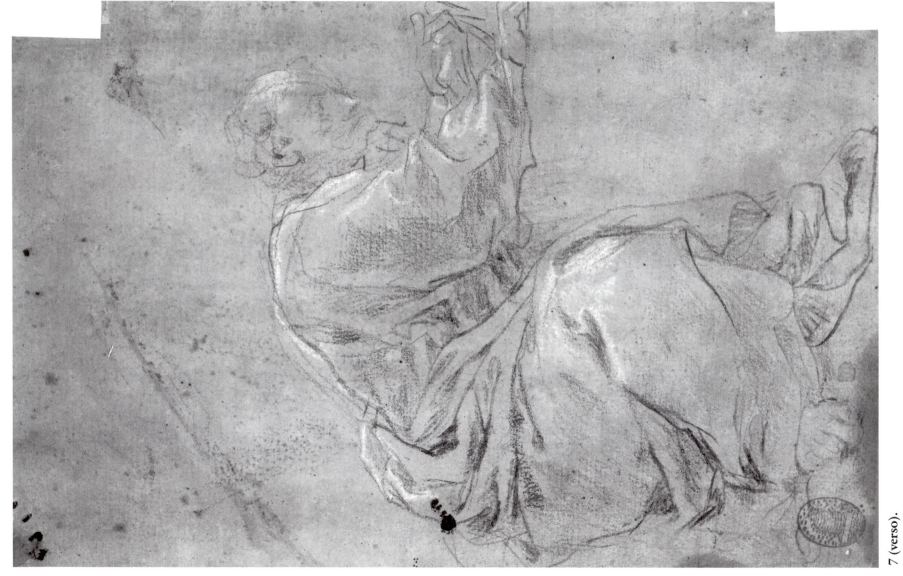

Petr Brandl

7 (verso).

48

pieces in Břevnov of 1718 and 1719, and in part with his history of Joseph in Egypt of 1721: he therefore dated it ca. 1720.[4] Pavel Preiss, while accepting this dating, noted that what seemed to be a technique unique in Brandl's oeuvre made precise dating difficult, and that similar figure types and analogous light effects were also to be found in Brandl's pictures from the first decade of the eighteenth century.[5] The probable dating of ca. 1710 for the Manning sheet corroborates this last insight.

The existence of these two drawings in similar technique may call for a more general reconsideration of Brandl's procedures as a draftsman. Since some differences do exist between the figure on the recto of the Manning sheet and that in the painting in Prague, not only in the position of the book but also in the patterning of the folds, it is not likely that the New York drawing was done after the painting. Yet it differs from all other previously identified drawings by the artist.

These are done instead in black chalk, with white chalk highlights, as is the drawing on the verso, or in a few instances in pen and ink and brush and wash.[6] The drawing on the verso may, however, not be so easily connected with any known painting by Brandl. It may represent a preliminary idea for a painting, perhaps even for one of the figures in the All Saints' altarpiece, but there is no way of determining this point.

Following remarks by Brandl's biographer Johann Quirin Jahn to the effect that the artist merely threw his preliminary ideas down on paper, Neumann has interpreted the paucity of surviving drawings securely attributed to Brandl and the existence of substantial pentimenti in his paintings as an indication that he worked his ideas out on the canvas.[7] Preiss has also noted that it is astonishing that no oil sketches are known by Brandl, as free improvisation with the brush in small format, allowing for painterly spontaneity and lively facture, would have corresponded to Brandl's temperament.[8]

With the recent rediscovery of a large group of Brandl's drawings, including that exhibited here, these questions now also must be reconsidered. Indeed, it seems possible to attribute yet another drawing of a man with upraised hands, which is done in similar technique to Brandl.[9]

Studies such as the one on the recto of the Manning sheet may have served the purpose of converting sketches of hands or heads, or of full figures, in chalk or pen and brush, into a form that would suggest more closely the effects of color, light, and shadow in the finished work. This aim, rather than the free transcription of ideas, may also have been the purpose of the Prague drawing. Brandl's working process may therefore have been more complicated than has been supposed, involving a number of stages before the artist ever worked at the easel, where he may have continued to alter his design, up to the final execution in paint: differences do exist between this drawing and the related painting, after all. In this procedure, this type of drawing may well be conceived as having replaced certain kinds of oil sketch.

1. In Sarasota 1972.
2. Prague, Národní Galerie, inv. no. K 5414, best illustrated in Preiss 1979, p. 93, ill. no. 26.
3. Best illustrated in Neumann 1970, fig. 303.
4. The drawing was first published as Brandl's work in Milan 1966, p. 92, no. 289; Neumann's dating, not completely correctly reported by Sobotík, appears in Prague 1968, pp. 148–49, cat. no. 114.
5. Preiss 1979, p. 92.
6. Besides the drawings illustrated by Neumann, other sheets have recently come onto the market: in 1987 a group of eleven drawings by Brandl was offered by Thomas Le Claire in Hamburg (see Le Claire 1987). Another drawing of a putto in black chalk on blue paper very similar to this group is in a private collection, Princeton.
7. Neumann, in Prague 1968, p. 143.
8. Preiss 1979, p. 92.
9. Nuremberg, Germanisches Nationalmuseum, inv. no. Hz. 4373.

Johann Georg Bergmüller

(1688–1762)

Johann Georg Bergmüller was baptized in Türkheim in Swabia on April 15, 1688. After first studying with his father, Bergmüller received financial support from Duke Maximilian Philipp of Bavaria, enabling him to study with the Munich court painter Johann Andreas Wolff from 1702 to 1708. In 1708–09 Bergmüller worked in Düsseldorf; in 1710 he worked in Kreuzpullach near Wolfratshausen. In 1711 he obtained court funds to take a study trip to the Netherlands.

In 1712 Bergmüller settled in Augsburg, married, obtained the rights to become a master and a citizen. In 1715 he attended the Augsburg academy, of which he became (Catholic) director in 1730, a post he retained until his death. In 1739 Bergmüller was named court painter to the bishop of Augsburg.

During his mature period in Augsburg, Bergmüller created numerous frescoes and altarpieces in Swabia, Bavaria, and the Tyrol. As a teacher, he helped train Johann Evangelist Holzer (*q.v.*), Gottfried Bernhard Götz (*q.v.*), and Johann Georg Wolcker. Bergmüller was also distinguished as the writer and illustrator of a number of theoretical tracts.

He died in Augsburg in 1762.

8. St. Martin and other Saints Appealing to the Virgin

Pen and brown ink, brown and gray washes, blue, pink, red, and orange watercolor, white heightening, on white paper
13⅜ × 7⅞ (340 × 200) (lower edge trimmed)
Signed and dated in dark brown ink, lower left: *Joh Georg Berckhmüller fec. Anno 1715*

Crocker Art Museum, 1871.60

PROVENANCE: Fürst Carl zu Schwarzenberg (sale, Rottes Collegium, Leipzig, November 8, 1826, no. 3018); C. Rolas du Rosey (Lugt 2237, right center; sale, R. Weigel, Leipzig, September 5, 1864, p. 474, no. 5072); R. Weigel; Edwin Bryant Crocker

EXHIBITIONS: Sacramento 1939, group 2, no. 46; Lawrence, Kansas 1956, no. 6, ill. p. 11; Baltimore 1959, no. 260; Sarasota 1972, no. 61; Claremont, California 1976, no. 7, ill. p. 55; Sacramento 1983, no. 35 ill.

LITERATURE: Sacramento 1971, p. 148

The association of this drawing with a representation of St. Martin is based on the prominent depiction of the bearded figure in ecclesiastical garb, wearing crucifixes, who kneels atop the stairway surrounded by clouds in the left of the drawing. He is identified as a bishop by the mitre held by an angel to the right of his head, and by the crozier, held by another angel, to which he points: Martin was Bishop of Tours. Other angels hold a sword and cuirass, alluding to his origins as a Roman legionary. The seated man with staff holding a cloak on the lower step refers to a story from the saint's life, according to which just before his conversion the saint shared his cloak with a naked beggar.

It has accordingly been suggested that the Sacramento sheet, signed and dated by Bergmüller in 1715, is closely related to a drawing of *The Glorification of St. Martin* in Nuremberg, which has been identified as a preparatory design for the high altarpiece, dated 1714, which was set up in 1731 in the parish church in Merching.[1] The general format of both compositions is indeed similar, as is the prominent place given in each to the bishop saint and the beggar.

Several arguments speak, however, against the association of the two drawings with the same project. The Sacramento drawing is dated a year later than the painting. Even though it has been suggested that it may represent a later, rejected version for the Merching painting, and while it is known that Bergmüller frequently backdated his works, there is no reason to doubt the date on the Sacramento sheet.[2] It shares compositional elements and its figure style with other signed and dated drawings by Bergmüller of the period 1714–15.[3]

More important, the Sacramento drawing reveals significant differences from the Nuremberg sheet. Many more saints are present. These include, to the right of St. Martin, St. Michael, shown with his shield inscribed, "Qui ut Deus," combatting a devil; a female saint with cross, sword, and palm to St Michael's right, who is most likely St. Margaret; another armed warrior saint above St. Michael, who may be St. George; and, kneeling with a jar of ointments before the Virgin as she holds the Christ Child's feet, St. Mary Magdalene. These deviations from the Nuremberg composition also do not tend in the direction of the finished painting in Merching, but rather serve to diminish the prominence of St. Martin: it is not even clear if the work for which this drawing was made was dedicated to that saint alone. It is perhaps more likely that it had a joint dedication.

The colorful elaboration of this drawing, which is much more complex in technique than other comparable drawings of the period by the artist, nevertheless suggests that this drawing was a *modello* for an altarpiece, perhaps unexecuted. It represents an attractive example of the artist's early style, executed soon after he had become an independent master in Augsburg (1713), and its high degree of finish may be related to the care the artist put into trying to win early commissions, or satisfy his first patrons.

1. The relation to the drawing in Nuremberg, Germanisches Nationalmuseum, inv. no. Hz 4043, was first suggested by Kent Sobotik in Sarasota 1972, no. 61. For the identification of the Nuremberg project, see Heffels 1969, no. 15, pp. 30–31, ill. p. 31.

2. For these arguments about dating and the project, see Sacramento 1983, p. 51. The issue of back-dating is also more problematic than there allowed: see the next entry.

3. For example, Stuttgart, Staatsgalerie, Graphische Sammlung, inv. no. C 2856, *Mary with Saints Aloysius and Stanislas as Intercessor for the Souls of the Poor.* Illustrated in Stuttgart 1984, no. 54, ill. p. 102, signed and dated *J. G. Berkmüller fecit Anno 1715*; Vienna, Graphische Sammlung Albertina, cat. no. D 162, *Death of the Virgin*, signed and dated *J. G. Berckmüller Fecit A 1714.*

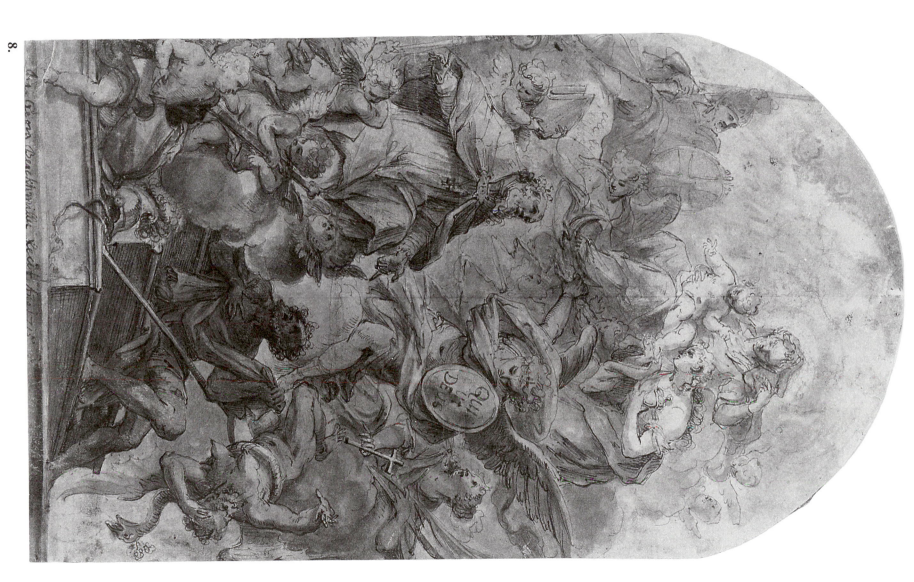

9. St. Amandus, Bishop of Worms, Threatens Dagobert, King of the Franks with Punishment for his Sinful Ways

Pen and brown ink with gray wash (over gray wash?), squared in graphite; outline of composition strengthened in black ink
10⅝ × 5⅞ (270 × 150)
Watermark: A rosary (only one half shows; resembles W. A. Churchill, *Watermarks in Paper in Holland, England, France, etc., in the XVII and XVIII Centuries*, Amsterdam 1935, no. 514)

Harvard University Art Museums, Fogg Art Museum; Gift of Belinda Lull Randall from the John Witt Randall Collection,1898.114

PROVENANCE: Lindner, Leipzig (no. 6); John Witt Randall; Belinda Lull Randall

EXHIBITION: Lawrence, Kansas 1956, no. 5

LITERATURE: Mongan 1940, 1, p. 209, no. 404

The unusual shape of this drawing and its technique, with outlines and interior features drawn in brown ink with gray wash, are quite close to those of a sheet in Nuremberg representing the *Virgin and Child with Interceding Saints*, monogrammed by Bergmüller and dated 1724.[1] The Fogg drawing also shares with the Nuremberg sheet formal characteristics such as the summary indication of facial features with pointed traits.

The Nuremberg drawing has been identified by Monika Heffels as a preparatory design for the painting on the altar of Our Lady of the Snows, in the former Benedictine Abbey Church of the Holy Cross, Donauwörth,[2] and the Fogg drawing most likely served a similar function. Its composition agrees in most respects with a painting by Bergmüller on the adjacent altar in the same church.[3]

The second altarpiece, in a chapel off the right side aisle of the Holy Cross Church in Donauwörth, depicts Amandus of Maastricht, the seventh-century Bishop of Worms, threatening Dagobert, King of the Franks, with eternal punishment on account of sinful conduct.[4] The choice of this rare subject can most likely be related to the wishes of the patron of the work, Abbot Amandus Roels, whose namesaint is depicted in the altarpiece. It was during the term of office of Abbot Amandus that the cloister church of the Holy Cross was rebuilt beginning in 1717, frescoed beginning in 1720, and outfitted with altarpieces between 1723–35.[5] The altar of St. Amandus bears the arms of Abbot Amandus.[6]

Although it is similar to the Nuremberg sheet, the date of the Fogg drawing and the related painting in Donauwörth cannot be determined with complete certainty. A chronogram on the altarpiece of Our Lady of Snows indicates it was executed in Augsburg in 1723.[7] The drawing of the same subject in Nuremberg is dated 1724, however; Heffels suggests that the date on the drawing may have been added lat-er, in the case that the painting itself was not backdated. Similar features in the Fogg sheet support her reasoning that the squaring and the absence of incisions on the Nuremberg drawing rule against its being a repetition by the artist for the purposes of making a print,[8] and one might add that the squaring also rules out its having been made as a *ricordo*. Similarities with the Nuremberg design suggest that the Fogg drawing served a similar function, and it was probably also a preparatory drawing for an altarpiece of the same approximate date.

In any event, the Fogg drawing reveals different characteristics from those of the Sacramento sheet also exhibited here (cat. no. 8). The Fogg drawing lacks the color, elaborate finish, and full signature of the Sacramento sheet. Some of these discrepancies may result from the difference in the date of execution. Since, however, the Sacramento drawing was also most likely executed in connection with the design for an altarpiece, some of the most evident differences, including the lack of signature, may also be related to slightly divergent functions. It is possible that the squaring on the Fogg sheet indicates that it too was meant to be employed in the process of transferring the initial design to the canvas, and was thus also what can be called a working drawing.

1. Nuremberg, Germanisches Nationalmuseum, inv. no. Hz 4138. See Heffels 1969, no. 16, pp. 31–32; also illustrated in London 1975, cat. no. 16, pl. 19.
2. Heffels 1969, p. 32.
3. For this altarpiece, see Horn 1951, p. 120, fig. 79.
4. An anonymous note on the mat of a photograph of the drawing in the Zentralinstitut für Kunstgeschichte, Munich, correctly identifies it as an "Entwurfziechnung" [*sic*] for the altarpiece of St. Amandus of Maastricht. Perhaps because of the saint's gesture, the scene had previously (e.g. in Lawrence, Kansas 1956, no. 5) been interpreted as "*A Bishop Saint Gives His Blessing to a King.*"
5. For information on the church, see Anonymous 1984.
6. See Horn 1951, p. 122; the painting is illustrated on p. 120, fig. 79.
7. It is signed "G. BergMILLer eLaboraVIt AVgVstae VInDeL." The capitalized letters, MDLLLLVVVVIII, add up to the date 1723.
8. Heffels 1969.

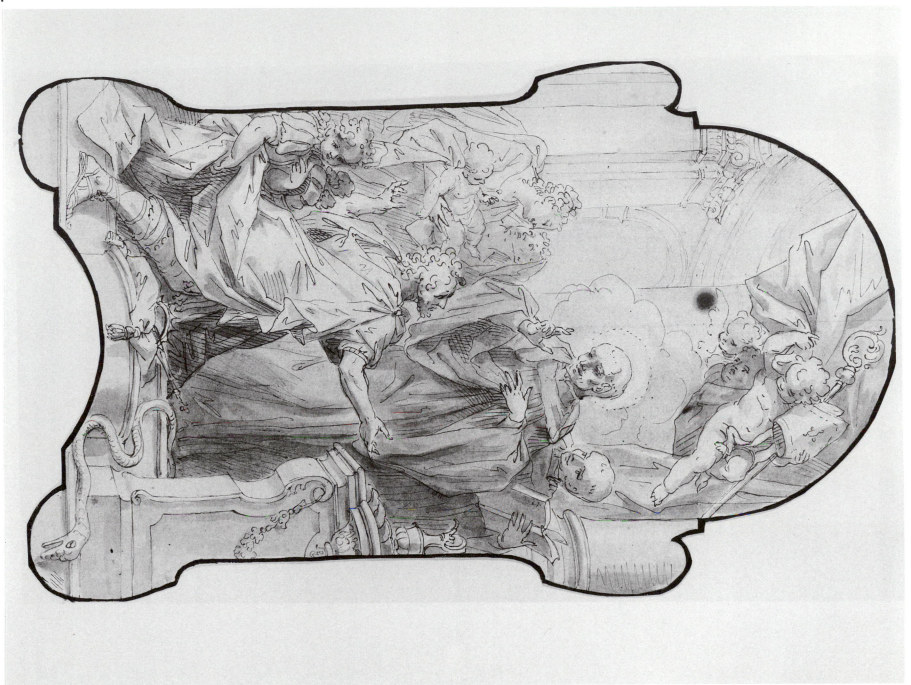

GEORG WILHELM NEUNHERTZ
(1689–1749)

The grandson of the famed painter Michael Lukas Leopold Willmann (1630–1706), and son of Christian Neunhertz, painter to the court of the prince-cardinal of Breslau (Wrocław), Georg Wilhelm Neunhertz was born in Breslau in 1689. He was instructed first in his grandfather's workshop in the Cistercian monastery in Leubus (Lubiąż), and after the death of his grandfather and parents, he was taken on by Willmann's stepson, Johann Christoph Liška (q.v.), who was Willmann's chief heir. At his death Liška in turn left Neunhertz his utensils, collections, and sketches.

Neunhertz is next recorded in 1724 in Prague, where he married and became a member of the Old City painters' guild. From this first stay in Prague, the only major works known are a portrait of the idiosyncratic patron Count Franz Anton Sporck, dated 1725, and an ecclesiastical commission (see below).

In 1728 Neunhertz returned to Silesia. There he executed frescoes in cloisters in Liebenthal near Löwenberg (Lubomierz near Lwówek), in Grüssau (Krzeszów; 1733–35), and in Sagan (Żagań; 1736). He also carried out a major cycle in Ląd in Poland in 1731.

In 1737 Neunhertz settled again in Prague, working from 1743–44 in Strahov. During this sojourn he executed important projects in Silesia (Grüssau/Krzeszów, 1737) and Poland (Rydzyna, 1745–46; Gostyń, 1746). One of the last exemplars of the early rococo in central Europe, he died in Prague on May 24, 1749.

10. The Disputation of St. Catherine of Alexandria

Pen and black ink with gray wash over graphite and black chalk, on white paper

13⁵/₁₆ × 7¹¹/₁₆ (345 × 215) (dimensions of paper)

Signed and dated in brown ink on recto, lower left: *GWF 9bertz. féc./Ao. 1727.* Inscribed in brown ink on the verso: *Bezug (?) geschlossenem Contract ist dieser Riss zu verfertigen für hundert gulden Rheinisch worauf gegeben worden durch den frater Fabiany im Nahmen des (Litb[?]) Herrn Geistlichen Vatter 60 Gulden Rheinisch Item den 9. Marty 10 R quod est...* [Signature crossed out]

National Gallery of Art; Gift of C. G. Boerner, 1983.43.1

PROVENANCE: private collection, Prague (auction, Franz Malota, Vienna 1919, no. 68 [?]); C. G. Boerner, Düsseldorf (*Neue Lagerliste Nr. 77*, 1982, no. 18, p. 20, ill. p. 21)

This drawing illustrates a familiar subject from the life of St. Catherine of Alexandria, who stands in the right center of the sheet. She is identifiable by the princess's crown she wears, by the cross she holds aloft, and by one of her attributes in the right foreground, the wheel of her prospective martyrdom, on which rests an executioner, armed with a fasces (she was ultimately beheaded). The man gesturing to her left is seated on a throne in what the cupola-covered space suggests is a public place, and his sceptre further identifies him as a ruler; according to the legend, he is the Emperor Maxentius. The statue of Diana, visible in the background, is one of the idols to whom she refused to sacrifice. St. Catherine is depicted in the pose of an orator, trying, her gesture with the cross upraised suggests, to convert the emperor, and confuting the host of men (fifty according to the story) who, dressed in togas and holding books, are identified as sages. These philosophers (or orators) were converted by her when they were called in to dispute with her, and hence burned at the stake.

A previous owner (Boerner) correctly identified this subject and deciphered the signature employing an unusual monogram form on the recto as that of Neunhertz; a possible connection with frescoes in Silesia has also been hypothesized.[1] The format of the drawing, with rounded top and bottom, seems rather to indicate the form of an altarpiece: indeed a painting with similar format and subject by Neunhertz survives *in situ* above the easternmost altar against the north wall of the church of Our Lady of the Snows (Marie Sněžné; Ger., Maria Schnee) in the New Town (Nové Město), Prague.

A document published by O. J. Blažíček states that a new altar dedicated to St. Catherine, Virgin and Martyr, was set up in this church in place of an existing altar at the beginning of June 1727. This source indicates that 100 gulden had been paid to Neunhertz for the image of the saint, which he had painted "amidst doctors in disputation."[2]

Since Neunhertz has dated the recto 1727, the inscription on the verso can therefore most likely be interpreted to the effect that the National Gallery design was a contract drawing for the painting in the church of Maria Schnee. The inscription refers to a "*geschlossenem Contract*" for which Neunhertz was to receive one hundred gulden, and indicates that according to it he was to provide a design. "*Dieser Riss*" identifies the Washington drawing as this design. Documents published by Blažíček indicate that by March 9 the artist had received seventy gulden of the amount due, which was paid in full by June.

Variations exist between the drawing and the painting. In the finished work, St. Catherine is placed more to the foreground, and her arms gesture somewhat differently. They suggest that alterations were made during the course of execution, perhaps at the behest of the patrons, the "*Heiligen Vatter*" of which the inscription speaks.

To date little is known about the early work of Neunhertz; only a portrait of Count Franz Anton Sporck, a drawing, and the documented painting in Maria Schnee have been linked with his first stay in Prague.[3] The Washington drawing thus provides significant information about Neunhertz's first important commission. Because of its relatively long inscription and its connection with other documents, it is also informative about the general process by which altarpieces were commissioned and executed in Prague.

10.

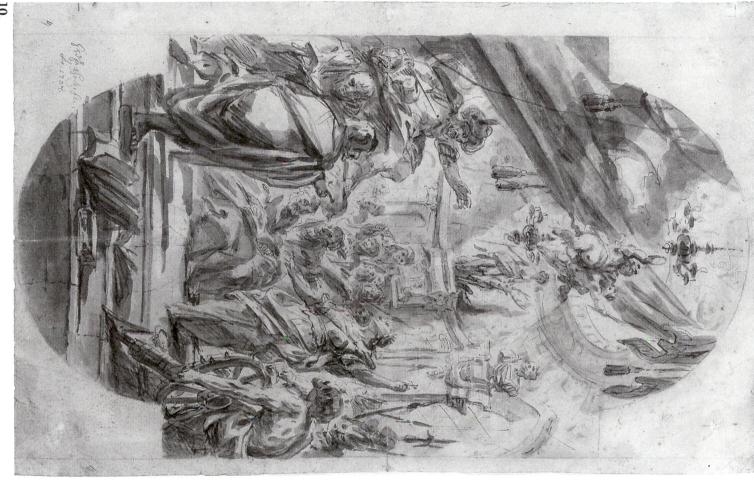

1. Boerner 1982, p. 20, suggests some relation may exist with frescoes for the Benedictine nunnery in Liebenthal near Löwenthal (Lwówek), where it is said that Neunhertz executed his first great commission. While the reading of the inscription is correct, the comparison adduced from the first monograph on the artist, Dobrzycka 1958, p. 67, does not correspond to the unusual form found on the sheet.

2. Blažíček 1954, p. 336:
Anno 1727 ad initium junii deposito veteri appositum est novum altare S.

Catherinae Virginis et Mart. diversorum benefactorum expensis. Imaginem eiusdem sanctae inter doctores disputantes effigiavit dominus Neunhertz, 100 fl. exsolutam. Aliae expensae in liquido efferunt 182 fl. 48 kr., insimul 282 fl. 48 kr. non computata arcularii et bini statuarii, ac laboris solutione per 13 menses prolongati.

3. See Preiss 1962, pp. 90–93.

Cosmas Damian Asam

(Ca. 1686–1739)

Cosmas Damian Asam was baptised in Benediktbeuren on September 28, 1686. His father was the painter Georg Asam (1649–1711), his mother the daughter of the Munich court painter Niklaus Prugger, his brother Egid Quirin Asam (q.v.), and his cousin Nikolaus Gottfried Stuber (1688–1749). From 1702 he is evinced as an assistant of his father, and from 1707 documented as having carried out works on his own. In 1713 Cosmas Damian Asam visited Rome, where he won the first prize for painters in a competition held by the Accademia di San Luca.

Asam had returned north by 1714, when he executed the frescoes in the cloister church of Ensdorf in the Upper Palatinate. The sequence of important churches decorated by Asam begins with Weingarten (1717) and continues through Weltenburg (1721), Freising (1723–24), Einsiedeln (1724–27), Mannheim (1728), and Alteglofsheim (1730). Asam also executed major commissions in the Tyrol (Innsbruck, 1722–23, and 1734), in Bohemia (Břevnov; Ger. Breunau, 1726–28, and St. Nicholas in the Old City, Prague, 1735–36), and in Silesia (Legnickie Pole; Ger., Wahlstatt, 1733). After decorating the church of St. John Nepomuk with his brother, next to his house in Munich (begun in 1735), he died on October 6, 1739. Asam was the leading frescoist of the early eighteenth century in Germany. His pupils and collaborators include Christoph Thomas Scheffler (1699–1756), Felix Anton Scheffler (q.v.), Otto Gebhard (1703–1773), and Matthäus Günther (q.v.).

11. St. Corbinian of Freising and the Bear

Pen and gray ink and gray wash
$5^{5}/16 \times 10^{1}/16$ (135 × 255)
Inscribed in graphite, verso, lower left: *M. de Bye*; in center: *o 1670*

University of Michigan Museum of Art; Gift through the estate of Edward Sonnenschein, 1970/2.58

PROVENANCE: Edward Sonnenschein, Chicago

LITERATURE: Taylor 1974, p. 24, no. 65, ill. p. 69

This scene depicts a story from the legend of the life of St. Corbinian, who is seen in the left center of the drawing, attired in the traveling garb of a bishop. The setting is a mountainous landscape, with herdsmen visible in the background: Corbinian points to a man, known in the legend as Anserich, who wields a flail against a bear in the right center. Behind the bear another man prepares a saddle, while excited horses are seen to the left. The story is that on his journey through the Alps to Rome Corbinian tamed a bear who had torn apart a packhorse; Corbinian then had the pack laid on it and drove it along with the other horses on his way.

Although Mary Cazort Taylor corrected the previous identification of this drawing and noted that it was a preparatory study for one of the frescoes depicting the life of St. Corbinian that decorates the cathedral at Freising, it has gone unnoticed in the literature on Cosmas Damian Asam. The drawing is, in fact, a study for the seventh scene in the tribunal of the north side of the nave of the cathedral. The

fresco follows the composition of the drawing quite closely. Putti by Egid Quirin Asam holding a bridle and pointing to the bear hold up a *titulus* labelled *Ursum cicurat*—he tames the bear—below it.

A fresco on the ceiling of the tribunal ajacent to this scene most likely adds an allegorical dimension to the episode. This fresco depicts a youth who takes a yoke upon his shoulders. An allusion is thereby made to the words of Jesus in the Gospels (Matthew 11:29–30): "Take my yoke upon you, and learn of me; for I am meek and lowly in heart; and ye shall find rest unto your souls. For my yoke is easy, and my burden is light." The taming of the bear may thus stand for the imitation of Christ.[1]

Asam's frescoes were executed according to the desires of the prince bishop of Freising, Johann Franz Eckher von Kapfing, who was already familiar with the brothers' work. They formed part of a plan to redecorate the entire church in order to celebrate the millenium of the arrival of St. Corbinian there, in what became the saint's burial church, and also the fiftieth anniversary of the prince bishop's own ordination. After the Asams submitted designs along with explanations for the frescoes, a contract was approved in March 1723: among other things it was determined that Cosmas Damian was to execute twenty frescoes of the life of St. Corbinian, the patron of Freising Cathedral. The frescoes were to be completed in time for the celebration, on St. Jacob's day, July 25, 1724.

Further documentation allows for fairly precise dating of the progress of Asam's work in Freising. On September 21, 1723, historian Karl Meichelbeck, another old acquaintance of the Asams, supplied documents related to the *Acta* of St. Corbinian. It was probably at this stage that Cosmas Damian began the preparation of studies for the individual scenes from the life of the saint. Meichelbeck also notes in his autobiography (on February 3, 1724) that he supplied most of the subjects for the pictures and all of the inscriptions (*picturas plerasque et inscriptiones omnes ego dictavi*); Meichelbeck conversed with Asam on March 8, 1724, about them, and suggested improvements on March 9. On March 15 he also suggested the publication of an illustrated life of the saint, corresponding to the fresco cycle. Information from April 1724 suggested that the frescoes were first executed in grisaille and were probably close in appearance to sketches such as the one exhibited here. Finally they were completed in color, but received with some objection as to their decorum and chiefly their historical accuracy.[2] This led to changes, among them the alteration of the hair of Anserich in the fresco to match that of the tonsure of a monk.

The drawing in the University of Michigan Museum of Art is one of seven such sketches of scenes for Freising that have survived. Two studies with figures within these scenes

11.

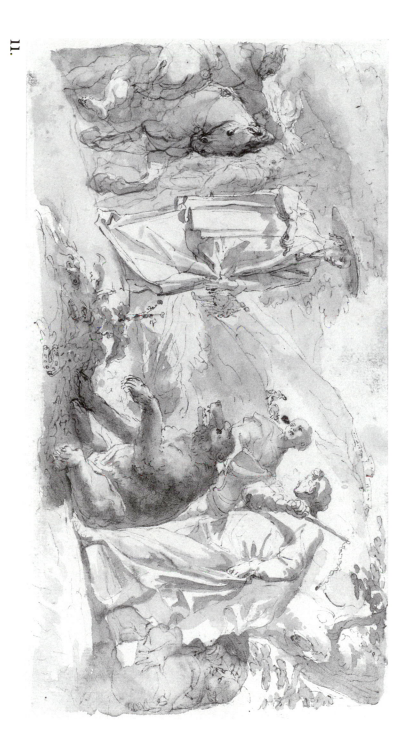

are also known; they give further evidence of the careful process with which this important series was carried out.[3]

1. For the iconography of the scene of the taming of the bear, see Glaser 1983, p. 196.

2. For this information, see most completely Benker in Glaser 1983, esp. pp. 172 ff. For the Freising frescoes, see also recently Trottmann 1986, pp. 102–3. Supplementary information on the decoration of Freising is also derived from Kloster Aldersbach 1986, pp. 230–36, with many details and full bibliography.

3. All the other drawings for Freising are in the Staatliche Graphische Sammlung, Munich; for them see most completely Kloster Aldersbach 1986, pp. 313–15, cat. nos. Z 16–Z 23.

12. David with the Head of Goliath

Brush and gray wash, over graphite
Irregular; 7⅝ × 6 (194 × 151)
Inscribed on verso in graphite: *cyn aus groden (?)/XVII Nr.*

Collection of Robert and Bertina Suida Manning

PROVENANCE: Art market, Innsbruck, until 1910 (inscribed in graphite on verso: *Gekauft Innsbruck 1910*); William and Eugénie Suida (inscribed in graphite on verso: *Prof. Dr. W. Suida*)

LITERATURE: Garzarolli-Thurnlackh 1928, p. 32, n. 1.

Karl Garzarolli-Thurnlackh assigned this depiction of *David with the Head of Goliath* to the Austrian artist Johann Michael Rottmayr, by reference to a sketch of *Judith with the Head of Holofernes* in Innsbruck, which is inscribed *Rothmayr*.[1] The two drawings represent Old Testament heroes holding decapitated heads, and evince a similar figure type. They are also closely related in medium and technique, displaying a very free manner of handling the brush, which evokes figures with delicately applied washes. The drawing in the Manning collection was acquired in Innsbruck.

It was, however, already recognized in the 1954 exhibition devoted to Rottmayr that the inscription on the Innsbruck drawing, still shown there as the artist's work, was not by his hand.[2] In his comprehensive monograph on Rottmayr, Erich Hubala demonstrated that this drawing was in fact a sketch made by Cosmas Damian Asam for the corresponding mural medallion executed in the *Landhaussaal* of the Tyrolean estates in Innsbruck.[3]

Scholarship on Asam has also reclaimed for the artist the drawing in Innsbruck, along with two related sheets in the same collection that represent the young Isaac and Jacob and Rachel at the well, and established them as studies for frescoes in the *Landhaussaal*.[4] Asam negotiated for a commission for these paintings in 1733, and executed them in 1734; he received 887 gulden for his work. The Old Testament figures he painted there stand for the riches of various regions of the Tyrol.[5]

The drawings that Asam made for the frescoes possess many of the same luminous qualities, characteristic of the artist's late phase, that Bernhard Rupprecht has seen in the frescoes.[6] Bruno Bushart characterized Asam's late drawing style, as exemplified by the drawings for the *Landhaussaal*, as one of purposeful simplicity, with quick application of brush and metal (lead) point. Bushart has also noted that the most pictorially complete drawings in Asam's oeuvre, and also some of his best qualitatively, are those for independent frescoes, such as the *Landhaussaal* medallions.[7]

It therefore seems reasonable to attribute to Cosmas Damian Asam the Manning *David with the Head of Goliath*, which shares so many of the characteristics that have been associated with these drawings, and to associate it with his work for Innsbruck. Bushart has noted stylistic variations among the drawings for Innsbruck, and has suggested that these may be related either to the patron's wishes or to the question of execution in fresco.[8] Some differences also exist between the *David* and *Judith* drawings, for instance in the amount of graphite visible and the way in which the composition seems to materialize out of the furious maze of lines. It is possible, therefore, that the sketch of *David and Goliath* represents an alternative, unexecuted design for the Innsbruck *Landhaussaal*.

1. Innsbruck, Landesmuseum Ferdinandeum, inv. no. (19) BD 19. Garzarolli-Thurnlackh 1928, calls the Manning drawing a *Gegenstück* to the Innsbruck drawing, which is illustrated as fig. 11. The Manning drawing is inscribed on the verso in graphite: *Rottmayr Garzarolli*, and further *vgl. 2. Ferdinandeum Innsbruck*.

2. Salzburg 1954, p. 59, cat. no. B 16, ill. fig. 34.

3. Hubala 1981, p. 252, cat. no. NZ 101, ill. fig. 411; the corresponding fresco is illustrated as fig. 412.

4. For the Judith drawing, see further Schoener 1966, pp. 56–57, no. 48; Ettlingen 1982, p. 94, ill. p. 95; Kloster Aldersbach 1986, p. 322, cat. no. Z 53 (catalogue entry by Bärbel Hamacher), ill. fig. 9, p. 60. The Isaac and Rachel and Jacob drawings are best illustrated in Ertlingen 1982, pp. 91, 93; for literature on them, see Kloster Aldersbach 1986, p. 322, cat. no. Z 52 and p. 323, cat. no. Z 54.

5. For the frescoes, see the information brought together in Kloster Aldersbach 1986, pp. 261–62, cat. no. F XXIII.

6. Rupprecht 1980, p. 170.

7. Bushart, "Asam als Zeichner," in Kloster Aldersbach 1986, pp. 61, 54.

8. Bushart, Kloster Aldersbach 1986, p. 56.

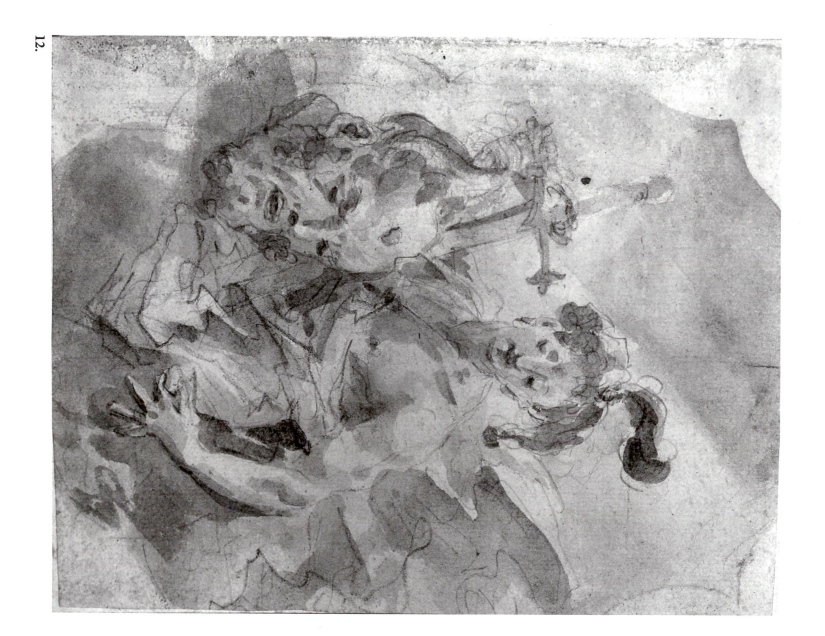

(1692–1750)

Egid Quirin Asam, the younger brother of Cosmas Damian, was baptized in Tegernsee on September 1, 1692. In 1708 he is recorded along with his brother as assisting his father, the painter Georg Asam, in decorating the Maria Hilf pilgrimage church in Freystadt. From July 25, 1711, until 1716, he was apprenticed to the Munich court sculptor Andreas Faistenberger.

Although also known as a painter, Egid Quirin was active chiefly as an architect, sculptor, and stuccoist. In these capacities he often collaborated with his brother Cosmas Damian in the decoration of churches in Bavaria and the Lake Constance area. Besides the St. John Nepomuk Church in Munich, the major works from his hand include the altarpieces in Rohr (ca. 1721), Weltenburg (1721), and Osterhofen (ca. 1730).

After completing some of his brother's projects, Egid Quirin Asam died in Mannheim in 1750.

13. Scenes from the Life of St. Ignatius (Study for the Frescoes of the Jesuit Church in Mannheim)

Black chalk, gray wash, traces of blue wash, heightened with white, brown, golden ocher, green, blue, and red watercolor, the central portion of the lantern cut out, shifted slightly, and reattached; mounted on blue paper
Inscribed lower left: *VI* (*NI ?*); signed lower right: *E.Q. Asam* [note: the drawing is displayed in such a way that the signature appears upside down, at the upper left; descriptions in this entry are made as if the signature were in the lower left] inscribed on verso: *14 A 12*
16¼ × 11⅞ (412 × 302)

National Gallery of Art; Ailsa Mellon Bruce Fund, 1973.2.1

PROVENANCE: De Mestral de Saint Saphorin; Janos Scholz, New York; Herbert E. Feist, New York (New York 1973–74, no. 50); purchased, 1974

EXHIBITIONS: Washington, D.C. 1974, no. 10, p. 45, ill. p. 44 (catalogue entry by Konrad Oberhuber); Bruchsal 1981, 1, pp. 68–69, cat. no. A 6, ill. p. 68; Washington, D.C., National Gallery of Art, October 8, 1985–February 18, 1986, "Survey of Old Master Drawings from the National Gallery of Art" 2

LITERATURE: Lankheit 1975, pp. 34–40, ill.; Rupprecht 1980, p. 234, ill. p. 235; Kloster Aldersbach 1986, p. 334, cat. no. U 6 (catalogue entry by Bärbel Hamacher)

This important drawing is the design for the decoration of the spandrels, cupola, and lantern of the dome for the Jesuit church in Mannheim. The church was founded by the Prince Elector Carl Philipp of the Palatinate, and though construction on the building began in 1733, the decoration of the ceiling with frescoes and stucco commenced only in 1748. From March 1749 Egid Quirin Asam received payments for doing the stuccoes and frescoes, obtaining *in toto* 10,500 gulden. Work was incomplete at Asam's death on

April 29, 1750; Philip Hieronymus Brinckmann (1709–1761) completed the pictures in the pendentives.[1]

In the bottom left spandrel St. Luke can be seen, identifiable by his symbol, the ox, in the bottom right corner, and by an angel who holds up a painting of the Virgin; another angel supports his Gospel book. In the bottom right spandrel, St. John appears holding his Gospel and with his symbol, the eagle. Between them, over the arch corresponding to the arch over the entry to the choir of the church, is a cartouche, left open for a coat of arms, surmounted by an elector's hat, and with the chain of the order of Hubertus hanging below; angels to the right and left trumpet forth the fame of the elector. To the left of the dome is a figure with an anchor, Hope; in the center atop an arch leading from the nave is a figure with a cross in her right hand, a chalice in her left, and a church behind her, Faith, perhaps even the Catholic Faith. The remaining female to the right, with babes at her breast, is Charity. The figure in the left top spandrel probably represents Asia, while the personification in the right upper spandrel holding a torch on a globe, with a sickle in her right hand and a cornucopia beside her, is probably a personification of Europe.[2]

In the lantern or central portion of the dome is a representation of God the Father, shown descending; the dome itself is divided into eight compartments of unequal width in which are depicted scenes from the life of St. Ignatius Loyola. Beginning with the scene above Faith, at the top of the drawing over the arch leading from the nave, is represented the conversion of the saint to a knight of Christ at the appearance of St. Peter to cure a wound he had received while a soldier at the siege of Pamplona. There follow in clockwise order the saint laying his weapons before the image of the Madonna of Serrato, St. Ignatius standing at the door of a church as he contemplates giving his clothing to a beggar; the ordination of the saint by a bishop in Venice; the confirmation of the Order of the Society of Jesus in 1540 by Pope Paul III; St. Ignatius preaching; and, at the bottom, over the arch leading to the choir, the saint on his deathbed, receiving the last rites.[3] The ceilings of the church were destroyed during the Second World War, but descriptions and reproductions of the paintings in the dome proper in general agree, with certain modifications, with the National Gallery drawing.[4]

The full design, elaborate execution, size, presence of a signature, change in the design of the cupola, and suggestion of alternative solutions for the pendentives (continents or evangelists) indicate that this drawing was most likely presented to the patron of the decoration, Prince Elector Carl Theodor for approval.[5] Lankheit also suggests that the placement of the signature on the sheet in such a way that the composition is turned on its head, so that the electoral arms can be read properly, leads to this conclusion. He further

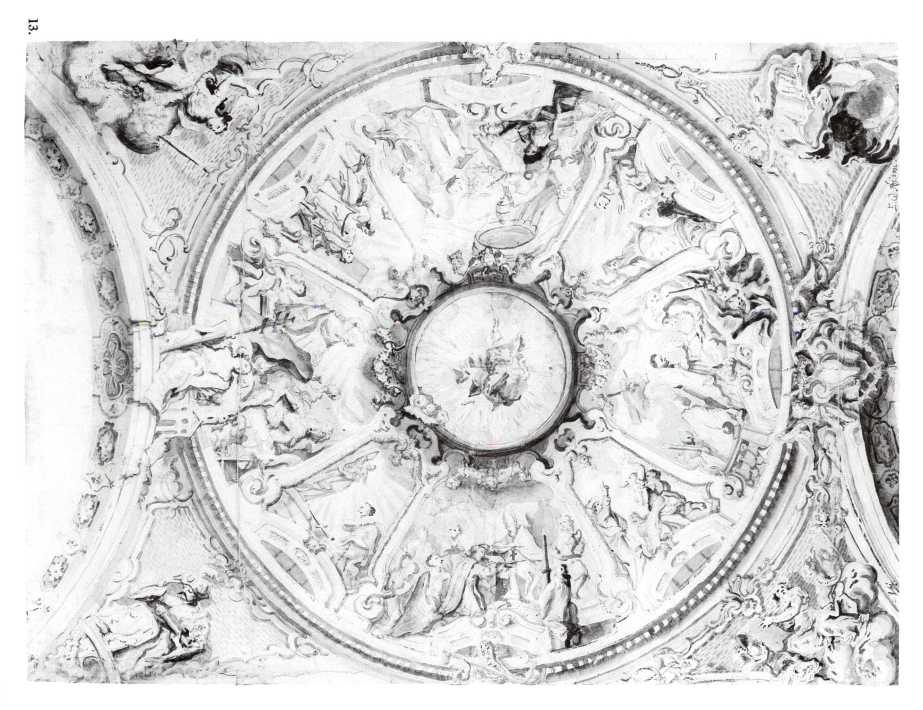

argues that the inscription *N. 1* indicates that more than one design, perhaps even an alternative drawing, were made for the ceiling of the church.

For the fresco the alternative of representing the four continents in the spandrels was chosen. As in Scheffler's program of similar date for the Jesuit church in Brno (see cat. no. 15), the presence of the four continents with depiction of the saint is related to the common Jesuit iconography of the world mission of the Jesuit order to spread the doctrines of the faith.

It has often been noted that Asam adopted the compositional scheme of dividing the dome into compartments from solutions formed by his brother Cosmas Damian in the 1730s. This late drawing also demonstrates that Egid Quirin's style as a draftsman evinces a similar transformation to that found in his brother's work (see cat. nos. 11 and 12), to a luminous manner created by brush and wash or watercolor.[6]

This drawing is important as probably the last preserved work by the brothers Asam, as the only surviving design for a ceiling painting by Egid Quirin Asam, and finally as a key document for a major commission.

1. For information on the church and its decoration, see the literature cited above, as well as in the succeeding notes, and further Gerich 1908, pp. 208–14; Wagenmann 1919; Walter 1928.

2. With the exception of the identification of the personification of Europe, these descriptions in general follow Oberhuber, in Washington, D.C. 1974, and Lankheit 1975, p. 37, as opposed to those in Bruchsal 1981, which, not noticing the figures of Hope and Charity, notes that the figure of Faith is a personification of Ecclesia, and mistaking the gender of one of the personifications in the spandrels, calls them all evangelists.

3. There is again disagreement about the identification and order of these scenes in Washington, D.C. 1974, and Bruchsal 1981; I have in general followed the clear discussion of the iconography in Lankheit. Lankheit 1975, p. 40, n. 12, notes that Gerich 1909, pp. 149 ff., pointed out the textual and pictorial sources for the scenes.

4. Lankheit 1975, pp. 138–39, discusses the differences between the drawing and the frescoes. The differences between the drawing and the frescoes in the pendentives and base of the dome that Oberhuber, Washington, D.C. 1974, notices are most likely the result of changes made in the design by the artist who executed them, namely Brinckmann.

5. Cf. Oberhuber, Washington, D.C. 1974, for this point. Hamacher 1987a, pp. 90ff., lists many of these characteristics as those of the *Gesamtentwurf*, often prepared for the patron.

6. See Rupprecht, in Bruchsal 1981, and Hamacher in Kloster Aldersbach 1986.

Daniel Gran
(1694–1757)

The son of the imperial cook, Daniel Gran was baptized in Vienna on May 22, 1694. Upon the death of his parents, he is said to have received his first artistic instruction from the celebrated Augustinian preacher and writer Abraham a Sancta Clara. Thereafter he was apprenticed to Adam Pankraz Ferg, the father of the better known Franz de Paula Ferg, and then to Johann Georg Werle. Gran's first secure works are signed and dated frescoes in the library in Schloss Pottenbrunn near St. Pölten.

With the support of Prince Adam Franz Schwarzenberg, Gran traveled to study in Italy, returning to Vienna in 1723. Thus began a flourishing career, at first, until 1735, for the Schwarzenberg court, as well as for his chief work, the imperial library in the Hofburg, which he finished in 1730. Gran was named imperial court painter in 1730. His later career was spent working mainly for religious houses throughout Austria and Bohemia.

In 1751 Gran declined an invitation to become head of the Vienna academy, and during the last years of his life settled in St. Pölten, where he died in 1757. Among his more celebrated pupils were Adam Friedrich Oeser.

Gran was a leading painter of the early eighteenth century in Austria. His great impact among artists of the next generation is indicated by the restoration of his imperial library frescoes by the preeminent fresco painter Maulbertsch (*q.v.*) in 1769.

14. Music-making Angels (recto); Scenes of a Saint's Life (verso)

Pen and brown ink, black chalk (graphite?), gray wash (recto); black chalk (graphite ?) (verso)
$15^{3}/8 \times 9^{7}/8$ (390 × 250)
Inscribed in black chalk on verso: 5/4/9/

Private collection

PROVENANCE: Curtis Baer; Dr. and Mrs. George Baer, Atlanta, Georgia

EXHIBITIONS: Cambridge, Massachusetts 1958, pp. 69–70, no. 57; Atlanta 1985, pp. 92–93, no. 50, ill.

Andrew Robison first recognized that this previously anonymous drawing was by Gran. He based his attribution on a convincing comparison to a study sheet of angels in Budapest, and has been supported in his opinion by Heinrich Geissler.[1] Another sheet of model designs with angels very similar in appearance to that in Budapest is in the Manning collection.[2] Another such drawing in the United States is in Chicago (fig. 13).

The drawing on the recto is evidently a study on which the artist has been working out his ideas. Its combination of media corresponds to Gran's working method of beginning with preliminary sketches in graphite, which are then elaborated. The indication of an arch above the angel to the left, and the positioning of the angels on cornices, suggest that it may have been a design for a ceiling.

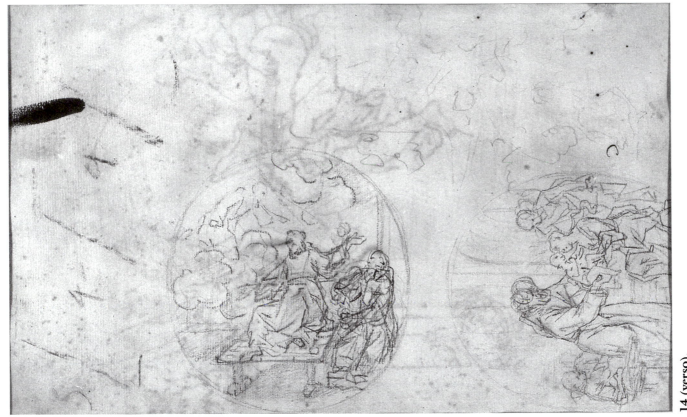

14 (verso).

Eckhart Knab remarks that all of Gran's drawings are to be considered in connection with pictures or pictorial ideas, and it is reasonable to assume that this preparatory study also is.[3] Eric Zafran has identified it with preparatory designs for figures on the dome fresco at Breitenfurth of 1730–32, where similar music-making angels appear.[4] None is identical in pose, however, and the motif recurs in a fresco at Sonntagberg, dateable 1741–43. Moreover, the combination of wash and pen and the softer modelling and outlines of the figures are not seen in the drawing with which Zafran compares this one, nor for that matter in other earlier drawings by Gran.

The drawing in Budapest to which Robison has related this sheet is also dateable ca. 1739, although the exact dating of such designs may be difficult to determine.[6] Other drawings with a similar combination of wash and ink are, however, to be placed in 1743–44.[7] Given the relation of this drawing to frescoes in Sonntagberg as well, it seems better to date this sheet toward 1740. As no angels appear on cornices in the frescoes to which it may be best compared, it may well be that this drawing was made for a hitherto unidentified work.

The drawing on the reverse is also unique in Gran's oeuvre, if it is indeed by the artist, and it cannot be associated with any known works by him.

1. The Budapest drawing is best illustrated in Garas 1980, no. 5. Robison's oral comments are recorded by Zafran, Atlanta 1988, who also notes Geisler's support in a letter of November 27, 1984.

2. This sheet was exhibited by Maser, in Lawrence, Kansas 1956, p. 10, no. 18, as *Studies of St. Michael Fighting the Dragon*, with the comment by E. A. Maser that they were "single figures connected with Gran's fresco in the Cathedral of St. Pölten"; this observation is in part correct in that one of the figures may be so designated, but the figures on the Manning drawing, like those on the Budapest sheet, may be associated with more than one painting.

3. Knab 1953, p. 167.

4. For the drawings for Breitenfurth, see the illustrations in Knab 1977, figs. 73–75.

5. See Knab 1977, p. 166, cat. no. F 63, fig. 144.

6. Knab 1977, p. 197, cat. no. Z 59, dates it ca. 1739; Garas 1980 proposes a dating in the 1730s, but in Salzburg 1981, p. 24, no. 6, notes that since the motifs on the drawing are used so often and at such varying times, the dating is problematic.

7. See Knab 1977, pp. 197–98, cat. no. Z 62, fig. 57.

Figure 13. Daniel Gran, *Sketches of Angels and Putti*, pen and brown ink, gray wash, 267 × 201 mm. The Art Institute of Chicago, Leonora Hall Gurley Memorial Collection, 1922.992.

Son of the painter Johann Wolfgang Scheffler, and younger brother of the well-known painter Christoph Thomas Scheffler (1700–1756), Felix Anton Scheffler was born in 1701 in Mainburg, near Freising in Bavaria. He was first trained by his father, and probably ca. 1720–25 by Cosmas Damian Asam (q.v.). Between 1725 and 1729 he collaborated in Stuttgart with the Württemberg court painter Christoph Groth (1688–1764).

In 1730 Felix Anton Scheffler worked with his brother in decorating the church of Peter and Paul in Neisse (Nysa, Silesia), but when Christoph Thomas settled in Augsburg, Felix Anton remained in Silesia. His frescoes are found mainly there, in works executed in Breslau (Wrocław) in 1734 and 1747, in Hirschberg (Jeleniá Góra) in 1751, and in Bohemia (in Braunau/Broumov, 1748; Prague, 1750; Jemnischt/Jemništĕ, 1754), and Moravia (Brünn/Brno, 1744/45). After Christoph Thomas Scheffler's death in 1756, Felix Anton returned to Bavaria, completing the frescoes in the Jesuit church at Landsberg am Lech, and working at Baumberg an der Alz in 1756–57. Felix Anton Scheffler died in Prague in 1760.

15. Allegory of the World Mission of the Jesuits

Pen and black ink, gray wash, heightened with white, over black chalk, on blue paper, squared in black chalk, the heavens also indicated in black chalk, on blue paper

$13^{5/16} \times 12^{13/16}$ (338 × 325)
Inscribed in black ink in the flames: *IHS*; inscribed in black ink in the book: *EXERCITIA*

The Metropolitan Museum of Art; Gift of the Estate of James Hazen Hyde, 59.208.95

PROVENANCE: James Hazen Hyde

EXHIBITION: New York, Cooper-Hewitt Museum, February 19–May 19, 1985, "The Continental Image: Allegorical Representations of the Four Continents"

The inscription on the book and the monogram of the name of Ignatius within the flames identify the saint depicted as St. Ignatius Loyola, the founder of the Jesuit order. *IHS* is a symbol for the Society of Jesus, and *EXERCITIA* must refer to the saint's *Spiritual Exercises*. The rock on which he rests his text stands for the cave at Manresa where he went into retreat.

In the corners of the composition, angels with flames on their heads carry torches to the four corners of the earth, symbolized by personifications of the four continents. These are from the bottom left Europe, with bull, church, and imperial crown; America, with feathered headdress and elephant; Africa, a dark-skinned figure with spear and crocodile; and Asia, with turban and horse. The torches and flames, seen setting afire some of the hearts of these figures such as Asia, symbolize the fire of Christian faith and love being spread to the four continents.

The drawing therefore allegorizes the worldwide mission of the Jesuit order, based on an interpretation of Luke 12:49. This theme provided a common program for Jesuit ceiling programs,[1] most familiar perhaps in Andrea Pozzo's main fresco in the Church of San Ignazio, Rome, and it could have been communicated directly to Central Europe by Pozzo himself, who traveled north soon after completing the fresco in 1699.

Although it was originally attributed to the French artist Claude Louis Desrais, notes on an old mat suggest that the connection with Central Europe was already recognized by Linda Boyer Gillies, who attributed it to J. E. Holzer, and by an anonymous scholar, who suggested the name of Johann Christoph Handcke. In 1984 Lawrence Turčić recognized the connection with Scheffler. Turčić's insight can be supported by comparison to a signed drawing by Scheffler of 1757 for a fresco at Jemništĕ castle.[2]

The squaring and round shape of this drawing also suggest that it is connected with a fresco. It seems likely that it served as a preparatory design for a fresco in the vault of the first bay of the north aisle in the Jesuit church in Brno (Brünn). Although this church was destroyed in 1944, and photographs of it are inaccessible in western Europe or the United States, detailed descriptions of the frescoes as they once appeared correspond almost exactly in detail to the Metropolitan Museum drawing.[3]

Scheffler's fresco was executed 1744–45 with it seems few changes from this drawing. The fresco was Scheffler's first major work in Moravia; it has been described as representing a dramatic expansion beyond the fictive picture frame.[4] The recovery of this drawing, probably of the same date as the fresco, represents an important addition to his oeuvre as a draftsman.

1. For the iconography of this theme, see Braunfels 1974, 6, p. 572. For its use as a ceiling program by the Jesuits, see Schiller 1976, 4 p. 108.
2. Vienna, Graphische Sammlung Albertina, inv. no. 4:379, cat. no. 2020, best illustrated in Preiss 1979, p. 144, ill. no. 45.
3. See Dubowy 1925, p. 208.
4. See Dubowy 1925; for illustrations of Scheffler's earlier work in Silesia, with which this may be contrasted, see Grundmann 1967, pp. 78–86, 235–44.

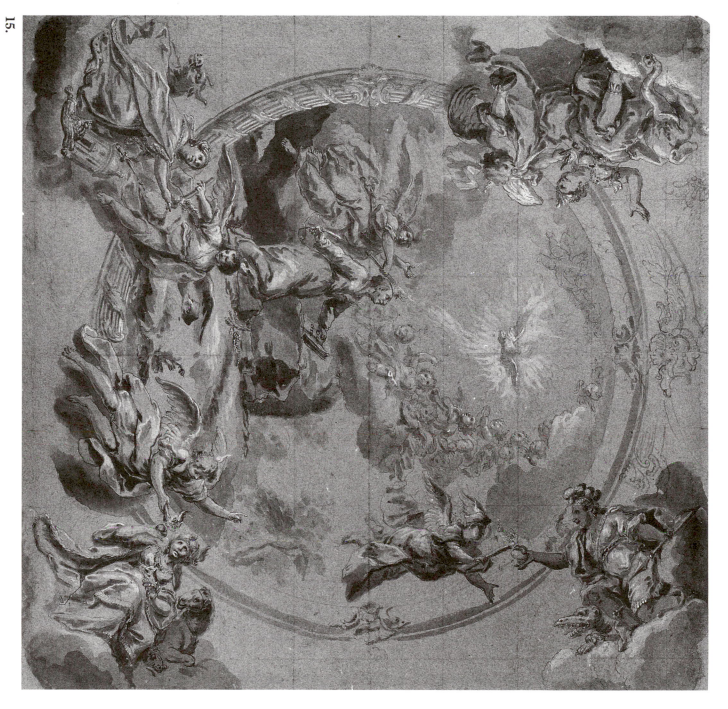

Gottfried Bernhard Götz (Göz)

(1708–1774)

Gottfried Bernhard Götz was born at Velehrad (Welehrad) in Moravia in 1708. The son of Sebastian Götz, he attended elementary school and then the Jesuit gymnasium in Uherské Hradiště (Ger., Hungarisch-Hradisch) 1718–23. After perhaps returning to Velehrad in 1723, he was apprenticed to the painter Franz Gregor Ignaz Eckstein in Brno (Ger., Brünn) from 1724 until 1728.

In 1729 or 1730 Götz moved to Augsburg, where he first collaborated with Johann Gregor Rothbletz until 1733. In that year, after probably studying with Johann Georg Bergmüller at the Augsburg academy, he gained the right to be a master. In 1734 he collaborated with Cosmas Damian Asam at Ingolstadt.

In 1744 Götz was named court painter and engraver to the Holy Roman Emperor Charles VII Wittelsbach, although he was also later favored by Maria Theresia as well. In 1745–47 Götz worked on a commission for the cloister of Admont in Styria. After further activity as a fresco painter in Swabia, he died in Augsburg in 1774. His pupils included Franz Ignaz Oefele and Franz Anton Zeiler.

16. St. Ambrose
(St. Ambrose Suppressing Heresy)

Pen and brown ink, gray wash, heightened with white, squared in graphite, with composition framed in brown ink
8¹¹⁄₁₆ × 5 (205 × 128)
Inscription in brown ink on book, lower left corner: *ARIVS*

National Gallery of Art, Ailsa Mellon Bruce Fund, 1983.26.1

PROVENANCE: Sale, Sotheby's Arcade Auctions, New York, January 20, 1983, no. 657 (not illustrated)

The saint standing gesturing rhetorically before a wall can be identified as Ambrose by his priestly garments, and primarily by the man on whom he treads in the foreground. This figure grasps an open book inscribed *Arius*; he is struck down by a bolt coming from the book, undoubtedly that of good doctrine or the Bible, which is held by the saint.

One of the four Fathers of the Latin church, Ambrose combatted the heresy of Arianism, whose adherent he is shown overcoming. Arius held that the Logos was not coeternal with the Father, and that there were three steps (hypostases) to the Trinity. Against this theology Ambrose preached a Trinitarian doctrine that seems to be symbolized by the equilateral triangle emanating light in the upper left of the drawing. This may stand for the coequal nature of the triune persons of the Trinity, as it circumscribes small representations of the Son, with crucifix, the Holy Spirit, represented by the bird/dove at the apex of the triangle, and the Father.

St. Ambrose closely resembles in subject, technique, dimensions, and style two other drawings of Latin church fathers, a *St. Gregory* in Augsburg, and a *St. Augustine* (Stuttgart, private collection), one of the Greek church fathers *St. Basil* (Frankfurt am Main, Städelsches Kunstinstitut), as well as a drawing of a doctor of the church, *St.*

Cyril of Alexandria in Nuremberg.[1] The Augsburg drawing is inscribed *Göz inve...*, and paintings by Götz related to the Nuremberg and Frankfurt drawings survive.[2] These drawings are preparatory designs for a series of twenty-four fathers and doctors of the Church commissioned by Abbot Anton II von Mainersberg for the library of the cloister at Admont in Styria and executed by Götz between 1745 and 1747.[3]

It is, in fact, highly probable that the Washington *St. Ambrose* is the drawing of this subject that Götz mentions in a letter of the end of May 1745, saying he has sent it to the abbot.[4] In a letter of May 24, 1745, Abbot Anton communicated to the painter that the sketch for the painting with the depiction of St. Ambrose pleased him entirely, and sent it back.[5] A painting of this theme existed in Stift Admont until it was destroyed in a fire in the *Naturhistorisches Kabinet* there in 1865, along with a painting of St. Augustine.[6]

Although the drawing sent to the abbot was approved by him, and its squaring suggests that it was used for a painting, like the *St. Basil* and *St. Cyril* drawings, it nevertheless reveals certain changes. Götz has used white body color to cover over some of the foliage to the upper left, and has otherwise drawn a wall made out of a series of rather rococo C-curves over the foliage there. It is likely that these changes appeared in the painting, as a similar composition with a saint standing before a wall is also found in the painting of *St. Bernard of Clairvaux* executed somewhat later in the series.[7]

The Washington drawing is thus not only an important addition to Götz's oeuvre but also a key drawing in the evolution of the Admont series, as it helped to determine approval for the continuation of the project.

1. For the Augsburg drawing, see most recently Biedermann 1987, pp. 270–71, no. 129; for the Nuremberg drawing, inv. no. Hz. 3974, see Heffels 1969, pp. 106–7, no. 130, ill.; for the Frankfurt drawing, inv. no. 14361, see Schilling 1973, p. 127, no. 882. The drawing of *St. Augustine*, which I have not seen, is discussed in Isphording 1982, 1, p. 225, cat. no. A II 18, ill. 2, 1984, fig. 109. Isphording discusses the other drawings in his catalogue as well.
2. For the *St. Basil* and *St. Cyril* paintings (Admont, Stiftssammlungen, and St. Michael bei Leoben, Parish Church), see Isphording 1982, 1, p. 136, cat. no. A 9, and 2, pp. 140–41, cat. no. A 11, ill. figs. 19, 23.
3. For this series, see Isphording 1982, 1, pp. 50–55, and also especially Mayr 1903, pp. 3ff.
4. The letter mentioning a *delineatio s. Ambrosij* is published in Mayr 1903, pp. 22–23, and in Isphording 1982, p. 342.
5. A summary of the letter referring to the *Skizze und Concept zum Gemälde mit der Darstellung des hl. Ambrosius* is published in Wichner 1888, p. 109, and Adriani 1935, p. 85, and summarized in Isphording 1982, 1, p. 342, who, p. 51, also adds the information that the drawing pleased the abbot "*genzlich* [sic]."
6. See Isphording 1982, cat. no. C1.
7. See Isphording 1982, 2, fig. 22, for an illustration of this painting.

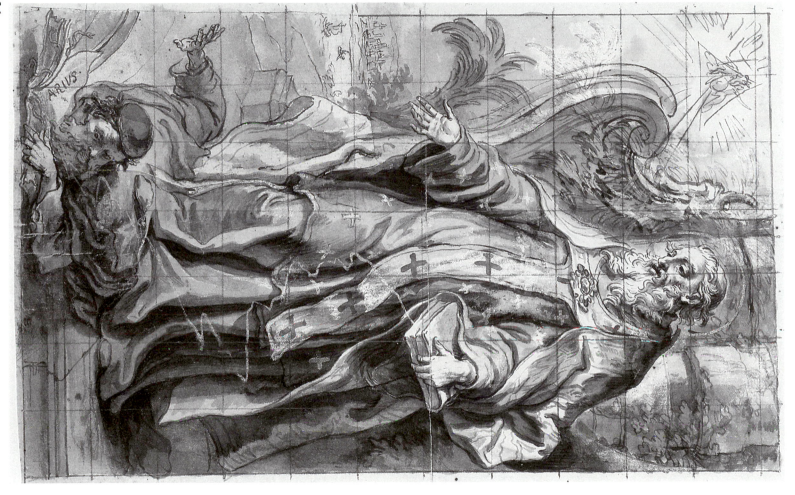

17. The Adoration of the Eucharist

Pen and brown and black inks, gray wash, with white heightening, squared in graphite.
8¼ × 6¼ (206 x 159)
Inscribed (?) above: *zu...chor*

The Metropolitan Museum of Art; Gift of the Estate of James Hazen Hyde, 59.208.100

PROVENANCE: James Hazen Hyde

EXHIBITION: New York, Cooper-Hewitt Museum, 1987, "The Continental Image. Allegorical Representations of the Four Continents," (no cat.)

LITERATURE: Isphording 1982, pp. 54, 215, cat. no. A I 4, vol. 2, fig. 93

This drawing is a preparatory design for the fresco on the ceiling of the eastern, apsidal choir of the church in Habstal near Sigmaringen in southwestern Germany. Götz's painting formed part of a major redecoration in 1748 of this church, which formerly belonged to Dominican nuns: his contribution included three ceiling frescoes, the central one of which, over the western nuns' choir, is dated 1748. Although Isphording notes that in the fresco a lightning bolt directed against the evil figure in the bottom of the composition emanates from the right hand of St. Michael, the ceiling otherwise seems to correspond closely to this drawing, including its indications of stuccoed ornament.[1]

Starting from the bottom, Götz's drawing depicts a personification of evil holding a snake and a torch, chased by a dog, standing for the Dominicans (*Domini canes* = the dogs of the Lord), all shown falling out of the composition; the torch, another Dominican symbol, stands for the faith that sets the world afire. Above them are found personifications of the four continents, grouped around a globe. At far left is Asia, a censer in her right hand and a turban on her head, with a pyramid seen behind her; next comes Europe, a coronet on her head, and a papal tiara and crowns at her feet; then is seen a swarthy figure of Africa, with a feathered headdress; America, with a feathered turban and parrot, kneels to the right. Putti pull back a curtain to reveal St. Michael, who points to a monstrance, which is the focus of the composition. This monstrance, within which the Eucharist glows, is held in the right hand of the central figure of Faith, who points to it with her left. To her right hand is Charity (Love), with a child at her breast; to her left is Faith, with an anchor.

The subject represented is the adoration of the Eucharist by the world. As is noted by Isphording, whose explication of the iconographic elements of the composition is followed here, the theme of the veneration of the Eucharist is found frequently in German ceiling paintings of the period.[2] Other variations of the theme can be found in ceiling paintings by

Franz Martin Kuen of 1753 in the parish church in Fischach, and in the parish churches in Kirchdorf and Hebertshofen of 1753 and 1754 by Johann Baptist Enderle.[3]

Stylistically, the Metropolitan Museum design may be compared to drawings for Birnau, such as that for altarpieces of *The Lactation of St. Bernard* and *The Death of St. Bernard*, where washes and white heightening are applied in a similar, exquisite manner.[4] The artist completed his best-known paintings at Birnau, and the Metropolitan Museum drawing shows him approaching the heights achieved there.

1. To judge at least from a photograph, in Anonymous 1948, fig. 228, p. 131; this volume provides further information on the church.
2. Isphording 1982, cat. no. A I 4, and p. 118, n. 296.
3. See the illustrations in Dasser 1970, figs. 6, 7, 14.
4. Nuremberg, Germanisches Nationalmuseum, inv. no. Hz. 3974, Isphording 1982, 1, pp. 227–28, cat. no. A II 22, 2 fig. 113; Munich, Staatliche Graphische Sammlung inv. no. 31 961, Isphording 1982, 2, p. 227, cat. no. A II 21.

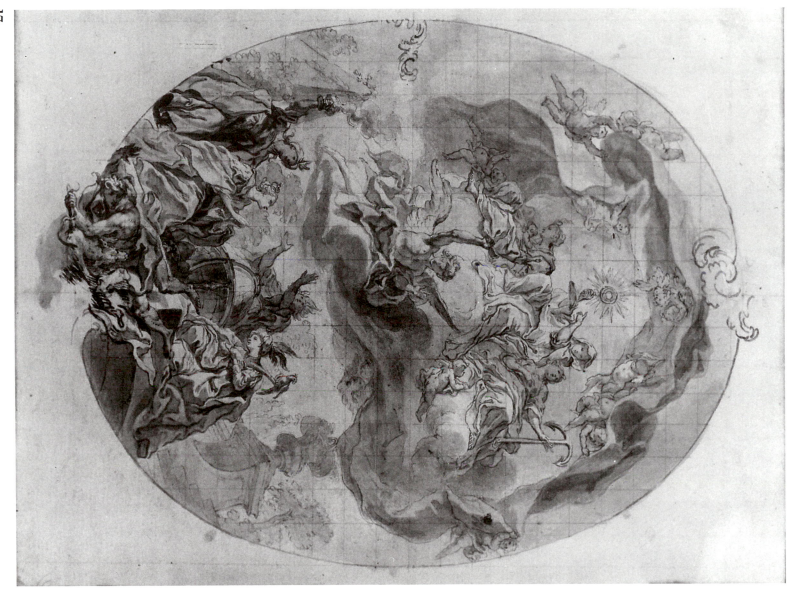

GEORG ANTON URLAUB

(1713–1759)

Georg Anton Urlaub came from a family of painters who were active in Franconia, including his grandfather Egidius Urlaub (1621–1696) and his father Georg Sebastian Urlaub (1685–1763). The eldest of nine children, two others of whom also became painters, he was born in Thüngersheim near Würzburg in 1713. In 1737, presumably after he had obtained his earliest instruction from his father, the prince bishop of Würzburg, the important patron Friedrich Karl von Schönborn, awarded him a scholarship to study at the Vienna academy. He returned to Würzburg in 1741 and was put to work in the Residence; he was officialy named court painter in 1742.

In 1774 he fled from the prince bishop's service to study further at the Accademia Clementina in Bologna, where he won prizes in 1745 and 1747. In 1749 he was in Venice. He may have returned to Würzburg with G. B. Tiepolo and his sons, and in any instance was back in Franconia in 1751. During the 1750s he executed a variety of commissions in the area around Würzburg. Urlaub died in Würzburg on February 20, 1759.

18. St. John the Evangelist

Pen and brown ink with brown wash and white heightening, on gray-blue paper
11 3/8 × 7 5/8 (288 × 183)
Inscribed in brown ink, top center: *S. Ioan: Ev:*; in red chalk: 4; traces of an inscription, upper right corner.

National Gallery of Art; Julius S. Held Collection, Ailsa Mellon Bruce Fund, 1984.3.70

PROVENANCE: Kunsthaus Rosen, Berlin (sale, November 24–25, 1958, no. 596); C. G. Boerner, Düsseldorf; Julius S. Held

EXHIBITIONS: Washington, D.C. 1966, p. 14, no. 37, ill.; Binghamton 1970, pp. 22–23, no. 102, ill.

LITERATURE: Knott 1978, p. 256, cat. no. Z. 264.

This drawing probably belonged to a group of depictions of the four evangelists. It closely resembles a sheet representing *St. Luke Painting the Virgin* in size, medium, inscriptions, and style, and shared a similar history until 1959.[1]

These drawings have been grouped by Nagia Knott with a series of studies for the Carthusian church of Engelgarten, Würzburg, which was destroyed in 1853. The frescoes were executed 1753–54, and a series of drawings probably for the pendentives of the dome of the church can be connected with these on the basis of an inscription.[2] Although the Washington drawing lacks this inscription, it is exceedingly close in appearance to the related sheets. Since it is also lacking an indication of the framing element of the pendentive, it may even have been a preliminary idea for one of these designs.[3]

Stylistically this drawing belongs to the most fruitful period of Urlaub's career, soon after his collaboration with Tiepolo in Würzburg. While it still obviously reveals the impact of the Venetian master, it differs in the application of wash, and the somewhat smoother and longer lines. These differences may reflect Urlaub's attention to other artists such as Antonio Guardi while he was in Venice; and indeed A. Morassi, in speaking of the related drawing in the Wallraf collection, has chosen to emphasize Guardi's influence, rather than Tiepolo's, on the artist.[4]

1. Paul Wallraf Collection, London, illustrated in Venice 1959, no. 116, and discussed in Knott 1978, p. 255, cat. no. Z. 263.
2. Knott 1978, pp. 253–54, cat. no. Z. 254ff.
3. For good color illustrations of two of the Engelgarten Evangelist drawings, see Sieveking 1976, pp. 741–56, especially figs. 2, 3.
4. In Venice 1959.

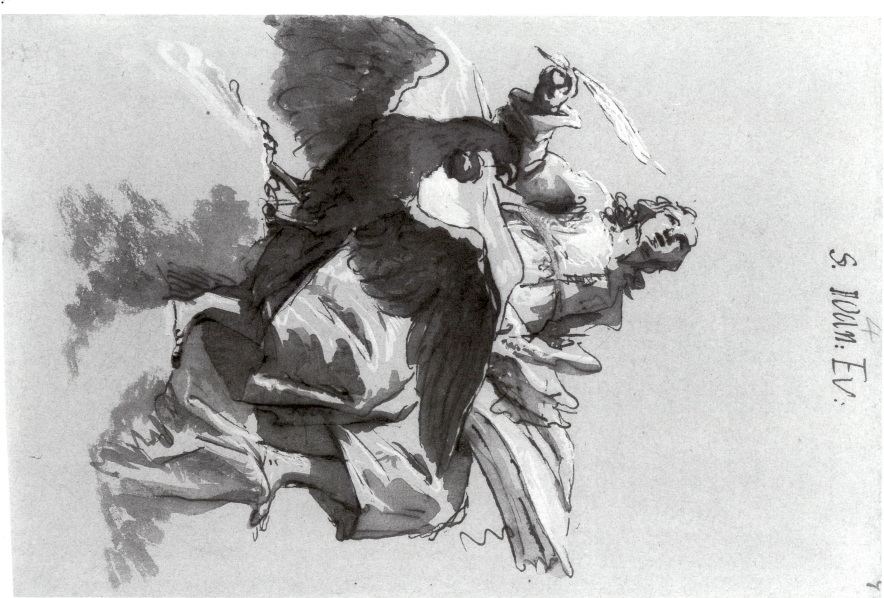

S. IOUM: EV:

MATTHÄUS GÜNTHER
(1705–1788)

Matthäus Günther was born on September 7, 1705, in Trischengreith on the Hohenpeissenberg, near Wessobrun south of Munich. It has recently been determined that his younger brother was the Bruchsal court sculptor Johann Joachim Günther. From 1710 to 1720 Matthäus Günther was an acolyte in the pilgrimage church in Peissenberg, after which he became an apprentice of Cosmas Damian Asam. He assisted Asam in painting the cathedral in Freising, 1723–24 (see cat. no. 11).

On January 11, 1731, Günther obtained the right to be a master in Augsburg. On January 18 he married the widow of the painter Ferdinand Magg, and June 22 took on as the first of his recorded apprentices his stepson Franz Xaver Magg. In 1730 Günther began his activity as a frescoist, an activity that would see him complete commissions for sixty-five projects, fifty-seven of which survive.

In a career that spanned nearly six decades, Günther executed frescoes and altarpieces in a region extending from the southern Tyrol to lower Franconia. His major ecclesiastical projects include the decoration of churches in Neustift near Brixen (Bressanone, 1736–38), Rottenbuch (1738–42), Amorbach (1745), and Rott am Inn (1761), among others. He also carried our projects in the castles in Stuttgart (1757) and Ludwigsburg (1759). He was the most prolific eighteenth-century fresco painter in Central Europe.

Highly regarded in his time, Günther became the Protestant director of the Augsburg academy in 1762. He was also associated with the Kaiserliche Franciscische Academie there. After having retired to the region where he was born, he died in Wessobrun on September 30, 1788.

19.

19. St. Albinus Frees a Prisoner

Pen and brown ink, gray wash, heightened with white, over a graphite underdrawing, squared in graphite, on paper covered with a yellow ground, the composition enclosed by brown wash
11 5/16 × 18 3/8 (287 × 466)

The Pierpont Morgan Library; Gift of a Trustee, inv. no. 1985.76

PROVENANCE: Edmund Schilling, London

EXHIBITION: Augsburg 1988, pp. 195–96, no. 9, fig. 97 (entry by Rolf Biedermann)

This drawing is a preparatory design for the fresco in the vault of the second bay in the north aisle of the church of the Augustinian Canons Regular dedicated to the Assumption of the Virgin, in Neustift near Brixen (Bressanone), in the southern Tyrol, now the Trentino-Alto Adige area of northern Italy.[1] An elderly saint is represented standing before the throne of a ruler. The saint points to a tower to his right, from which a number of prisoners escape. Other men pray at the saint's feet: the finished fresco shows them enchained as prisoners.

As Rolf Biedermann suggests in the catalogue of the recent exhibition devoted to Günther, it is uncertain if the St. Albinus represented is the French St. Albin of Angers or Albuin of Brixen: the story is not known as pertaining to either

saint's life. Since Albuin is a local saint, Biedermann notes he is perhaps the more likely choice, and suggests that the scene is probably a parable on the power of Faith to break even secular power.

Günther received the commission to decorate the church when he visited Neustift in 1735, arriving there on August 16. According to the terms of negotiation, which were provisorily concluded on October 16, he was to receive 560 gulden for a pictorial program determined by the canons: this was to represent saints who had been a pope, a cardinal, an archbishop, a bishop, a church father, and a martyr. Günther himself proposed St. Albinus.[2]

This design, along with two other drawings, was probably prepared in Augsburg, where the artist returned in the winter of 1735–36. It indicates familiarity with the shape of the field for the finished fresco, a knowledge of the church that Günther could have obtained on his visit to Neustift in 1735. The fresco was then executed according to his design, and the work was finished on September 23, 1736.[3]

Although the squaring suggests that the drawing was used for transfer to other dimensions, numerous changes exist between the design and the fresco. The point of view has been altered; the age of the saint has been changed; the halberdiers on the left of the drawing are missing, and the composition has been somewhat compressed. While Biedermann notes that the repoussoir figures in the left foreground indicate a new striving in Günther's art toward the depiction of spatiality in an otherwise parallel composition that lacks tension, it is precisely these features that are missing in the completed painting. Biedermann follows Hermann Gundersheimer in suggesting that the fresco was executed essentially with workshop assistance, although it is likely that these changes were suggested by Günther himself.

In any instance, there can be no doubt about the authenticity of this drawing, a handsome sheet by Günther for an important early commission.

1. For an illustration of the fresco, see Augsburg 1988, fig. 98.
2. For the fresco cycle and the negotiations related to it, see Gundersheimer 1930, pp. 19ff.
3. For the account of the progress of the design for the fresco, see Hamacher 1987, pp. 25–26. Hamacher, pp. 100–102, cat. nos. 10–11, discusses two other drawings for Neustift, but at the time of writing was unaware of the existence of the Morgan Library sheet.

20. Assembly of the Gods (Deities on Olympus)

Pen and black ink, gray, brown, yellow, pink, and blue washes, gray and white body color, over black chalk and graphite
$15\frac{3}{4} \times 20\frac{3}{8}$ (400×517) (dimensions of the sheet); $14\frac{3}{8} \times 18\frac{1}{2}$ (365×470) (dimensions of the image)

Philadelphia Museum of Art; John S. Phillips Collection, acquired with the Edgar V. Seeler Fund (by exchange) and with Funds Contributed by Muriel and Philip Berman, 1984–56–105

PROVENANCE: Pennsylvania Academy of Fine Arts

EXHIBITIONS: New York 1959, p. 56f., no. 48, fig. xlv; Philadelphia Museum of Art, 1984, "Old Master Drawings 1550–1850"; Philadelphia Museum of Art, 1988, "Recent Acquisitions II: Prints, Drawings, Photographs"; Augsburg 1988, pp. 243–44, cat. no. 44, ill.; also p. 337, under cat. no. 121

LITERATURE: Benesch 1947, opposite p. 50, fig. 4; Zahlten, in Bruchsal 1981, pp. 123–26, ill. 119; Hamacher 1987, pp. 146–47, cat. no. 46, ill. 61; Hamacher in Augsburg 1988, p. 100

This drawing depicts a fictive structure seen in orthogonal projection in such a way that it seems to extend to the heavens. On the corners of the balcony stand personifications of the Four Seasons colored to resemble statues on socles adorned with their attributes. The building opens up to reveal a banquet of gods. Seated on clouds are in clockwise order from the left corner, Bacchus, Venus with Cupid, Pluto, Vulcan at his forge, Diana with her quiver, Neptune, Saturn devouring his children, Juno next to Jupiter on his eagle, Mercury, Minerva with her owl, Hercules, Mars, and Apollo encircled by the zodiac, all accompanied by other deities or demigods less easily identifiable; Iris, goddess of the rainbow and messenger of the gods, floats in the center of the composition.

Benesch first remarked on the Michelangelesque qualities of the architecture of the building, and his comments on the relation of this kind of architecture to Padre Andrea Pozzo's fictive architecture and its appearance in Günther's ceiling design of 1733 for Sterzing, also in the Philadelphia Museum of Art, are also pertinent here. Echoing Benesch, Zahlten has called attention to the connections with Pozzo's ideas, which may have been familiar to Günther through Cosmas Damian Asam and Bergmüller, or through Paul Decker's *Fürstlicher Baumeister oder Architectura Civilis* (Augsburg 1711).[1] Most recently Biedermann has stated that the correspondences with these sources are insufficiently persuasive, and that it is conceivable that Günther was stimulated by a ceiling design by Götz.[2]

For Benesch this kind of design recalled the interior of baroque libraries, and he therefore sought to identify the Philadelphia drawing as a project for the "*Serenissimi Bibliothekzimmer*" in the New Palace at Stuttgart, where Günther painted frescoes from 1753 to 1762. In his survey of ceiling de-

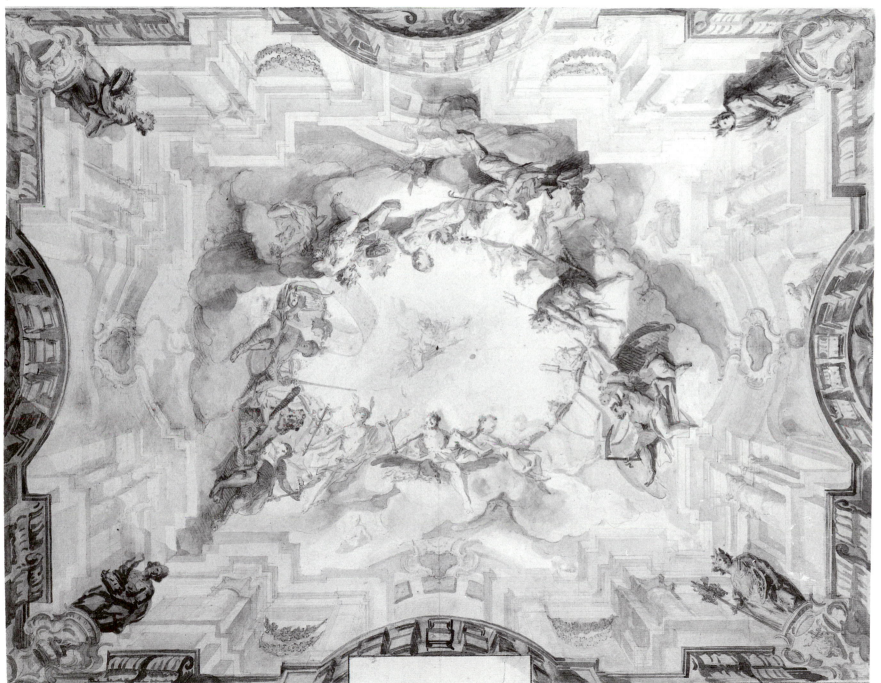

Designs for Ceilings and Altarpieces

Matthäus Günther

signs by Günther with profane subjects, including those works in Stuttgart that were destroyed by fire in 1762, Zahlten however cast doubt on Benesch's hypothesis. For Zahlten the fictive architecture seen in the Philadelphia project is too monumental for the rococo decoration of the walls of the palace, as seen in a drawing by the architect Philippe de la Guépière, and in the pictorial motifs correspond in no way to a library program, but rather to a festival or dining room.

Zahlten thus brought the drawing into connection with the *Festsaal* of the schloss in Sünching, where Günther received a commission in 1761, and where the Olympian gods and Four Seasons are also represented. He suggested that the disposition of architectural elements in the drawing corresponds better to the actual architecture of Schloss Sünching than to what is known of the castle in Stuttgart, and that the proportions of the design also mirror those of the existing fresco.[3] Hamacher and Biedermann have followed Zahlten's arguments.

As Zahlten admitted, however, this identification remains hypothetical. Zahlten himself noted that the theme corresponds to that found in a birthday celebration of 1757 in Stuttgart for Duke Carl Eugen of Württemberg, with whose celebrations Günther was involved in 1756. Furthermore, the location of ceilings with such subject matter is by no means so fixed as Zahlten suggests. Although the banqueting theme might lead to an association with a dining room, representations of the gods in conjunction with the seasons or elements are ubiquitous in Central European palace design from the sixteenth century and may occur in many different settings, so that the question must remain open, with consideration still being given to Benesch's suggestion.[4]

In any event, this design differs from the other sheets by Günther exhibited here in that it lacks squaring. This would reinforce the hypothesis that the other Günther drawings in this exhibition, whatever their other uses, were working drawings, whereas this one may have served solely as a presentation design. This function is also suggested by the colorful character of this design worked up in what may more accurately be called watercolor, which differs from the other examples in pen and ink seen here. Although, as Hamacher remarks, it is difficult to determine the exact use of this sheet, its situation in Günther's corpus as a draftsman suggests that it may be called a *modello*, if this term be defined as a "small sketch executed with considerable care for the patron, to give him as full an idea as possible of the appearance of the projected final work."[5]

21. The Martyrdom and Glory of Pope Sixtus II

Pen and brown ink, brown and gray washes, squared in red chalk 28¾ × 20¼ (733 × 516) (dimensions of the sheet); 24¹⁵⁄₁₆ × 12¹³⁄₁₆ (633 × 325) (dimensions of the image; irregular)
Inscribed in brown wash, lower right: *MK* (ligatured), and in brown ink on step, lower left: *M Knoller 1748*

Philadelphia Museum of Art; John S. Philips Collection, acquired with the Edgar V. Seeler Fund (by exchange) and with Funds Contributed by Muriel and Philip Berman, 1984-56-111

PROVENANCE: Anonymous collector MK (Martin Knoller?); Pennsylvania Academy of Fine Arts

EXHIBITIONS: Philadelphia Museum of Art, 1984, "Old Master Drawings 1530–1850"; Augsburg 1988, p. 260, cat. no. 55, ill.

LITERATURE: Benesch 1947, opposite p. 51, fig. 6; Hamacher 1987, p. 77, cat. no. 57, pp. 159–60, ill. no. 77

This drawing depicts a series of scenes pertaining to Saint Sixtus. In the lower register to the left is shown a bound figure in ecclesiastical garb being brought before a statue of an armored warrior holding a spear, probably representing an idol of Mars; an altar is placed before the statue, and a man with covered head and toga, depicted as a pagan priest, stands beside it. To the left another man raises his right hand in which he holds a baton or staff, evidently giving a command for execution, as a scene of beheading is shown in the background at right. In the center of the drawing, St. Sixtus is depicted holding in his right hand a martyr's palm. Next to him are a papal crown and an angel with the instrument of his martyrdom, a sword; the Holy Trinity welcomes him into heaven. At the top of the drawing (seen upside down from the point of view of the scene in the bottom register), the saint is shown praying in prison, where he is guarded by two soldiers; his leg is attached to a ball and chain.

This drawing is a design for the parish church of Moorenweis in Upper Bavaria, as Benesch first noticed.[1] Now a small village near Geltendorf in the vicinity of Fürstenfeldbruck, west of Munich, Moorenweis belonged at the time to the Abbey of Wessobrunn, the famed home of stuccoists and painters with which Günther was long associated. Abbot Engelbert Goggl of Wessobrunn (1770–81) in fact gave Günther a number of commissions during the 1770s.[2] The fresco is signed and dated 1775 on the block to which Sixtus is chained at the top of the composition.[3]

Though it agrees with the fresco in many particulars, the drawing's relation to the completed painting is not certain. Like his drawing for Amorbach, also in Philadelphia (see fig. 8), this sheet may have been described as a *Zeichnungsmodello*, but similar problems attend the determination of its function.[4] The squaring in red chalk would suggest that the composition has been designed for transfer into other di-

1. Benesch 1947, pp. 50–51; Zahlten, in Bruchsal 1981, p. 124.
2. Biedermann's point is made in Augsburg 1988, in reference to a drawing in Augsburg illustrated in color in Augsburg 1987, cat. no. 130.
3. See Zahlten, in Bruchsal 1981, pp. 125f., for these arguments, and p. 120, fig. 14, for an illustration of the Sünching ceiling.
4. See, for example, Kaufmann 1988, p. 291, for a similar subject that is perhaps to be associated with the decoration of the rooms for the imperial collections.
5. Hamacher, in Augsburg 1988, p. 100. For the discussion of the notion of *modello* used here, see the introduction.

78

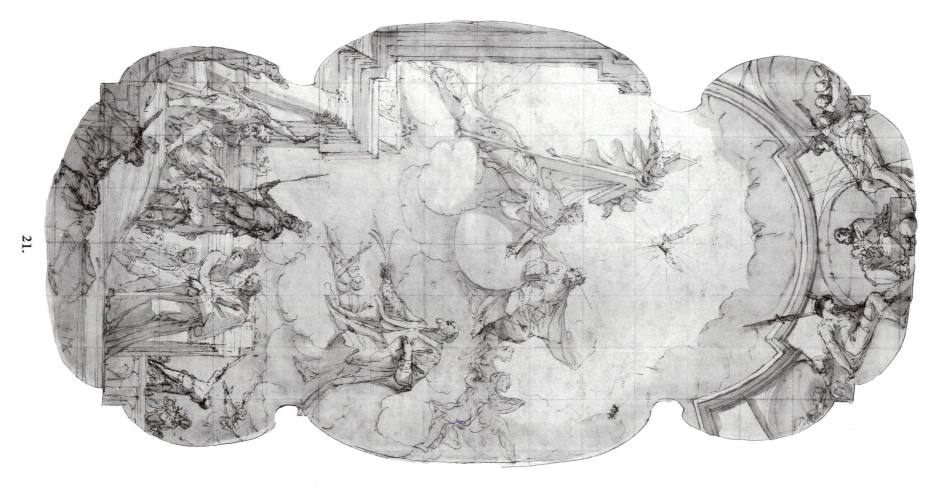

Designs for Ceilings and Altarpieces

79

mensions, possibly a fresco, and the large size of the draw-ing also points to the possibility that it was used for a larger project.

Substantial differences exist, however, between the fin-ished fresco and the drawing. As in other drawings by the artist, the figures for the drawing are placed nearer to the fic-tive surface of the sheet, and they are not as foreshortened. The recession of architectural elements is also greater in the painting, where larger portions of the fictive architecture are depicted. The illusion of space in the completed painting is therefore greater, and accordingly the scale of the figures in relation to the space smaller. The poses, gestures, and even positions of many figures have been altered in the painting: these include the soldier at the bottom center of the compo-sition, the saint himself in the middle, and Emperor Valerian in the left foreground, among others. Furthermore, several figures have been added to the fresco: there appears a soldier in the bottom left corner of the composition. An angel with a cross is drawn behind the saint in the center, and most im-portantly, the Virgin has been added as an intercessor.

It is of course possible that Günther added figures in the course of the execution of the fresco, assuming that he worked out his ideas as he painted, as he seems to have done with other projects (see the discussion of cat. no. 19). How-ever, since the changes in this instance involve more than the accommodation of figures and architecture to the surface of a ceiling, and include such substantial iconographical addi-tions as outlined above, the existence of some further pre-paratory designs is perhaps more possible here than it is in the case of some of his other projects.

Benesch has judged the contrast between the drawing and the fresco to be one in which the composition has "lost some of its quiet balance in the executed fresco, which is more Rococo."5 Some of the differences he sensed may re-sult from the differences of medium, working method, and function. Inspection of the actual fresco, rather than repro-ductions of it, seems to the present author to reveal those qualities of the "dawn of a new era," or the neoclassic, which Benesch sees in the drawing, rather than the rococo.

In any case one can only agree with Benesch's general de-scription of the stylistic changes evident in the increased lin-earity of the drawing and the relative clarity of its design. As these do contrast with studies for earlier frescoes, the draw-ing therefore provides a fine example of Günther's later style.

However, the relationship of the painting to the drawing may be explained, it is clear that the drawing is by Günther and fits well within the development of the rest of his work. The inscription "M Knoller 1748," which was first noticed by the present author, must be a later addition, despite the diffi-culty of distinguishing between the ink on it and that used in the rest of the drawing.6 The fresco, as noted, dates from 1775, and the handwriting does not resemble that found on

authentic drawings by Knoller. The style of draftsmanship is also not Knoller's.7 It is possible that this inscription is a later elaboration of the monogram *MK* found in the bottom right corner, although the authenticity of this inscription is also uncertain, as is that on three other sheets in Philadel-phia.8 Since related inscriptions do recur on five drawings with similar provenance, it is possible that the linked initials *MK* may be a collector's mark.9

1. Benesch 1947, p. 51, calling the church "Morenweis."
2. Besides the paintings in Moorenweis, Goggl commissioned frescoes from Günther for a Kreuzbergkapelle near Wessobrunn in 1771, and for St. Ottilien near Rott am Inn, east of Munich, in 1775; see Gundersheimer 1930, pp. 62, 90, n. 138, and Simon 1984, p. 84. This connection is also mentioned briefly by Zahlten in Augsburg 1988, p. 39.
3. The signature reads *M Gündter Pinxit 1775* (the M and G are ligatured). The reading in Gundersheimer, recorded at a time when the fresco was overpainted, is not strictly accurate. For the full inscriptions, see Augsburg 1988, p. 368.
4. See Matsche, "Unerkannte Entwurfszeichnungen von Matthäus Günther für Neustift," in Netopil 1983, esp. p. 173.

Bushart, in Volk 1986, p. 257, has pointed out, however, that while terms have not been lacking to describe Bavarian rococo sketches, their applica-tion is difficult. Moreover, as Johannes Zahlten has implied, the role of oil sketches in Günther's work, especially in relation to highly finished drawings such as this one, is also problematic, compounding the difficulty of devel-oping an exact terminology for his work. ("'Invention' aus zweiter Hand? Zur Entstehung der Ölskizze bei Matthäus Günther," in Klessmann 1984, pp. 124–30, including the "Nachtrag" provoked by the discussion at the symposium). The general historical question of terminology is discussed by Bauer 1978, pp. 45–57.

The issue of determining the relationship of Günther's oil sketches to his drawings is clearly involved in the case of Amorbach, as an oil painting by Günther for the fresco on the ceiling for the choir of the abbey church sur-vives, indicating that he did make preparatory paintings as well as drawings for his work at Amorbach. If an oil sketch had existed for the ceiling of the nave, it is more likely that it, rather than a drawing, would have served as a *modello* to be presented to the patron for approval.

The squaring in black chalk (for transfer) also suggests that a large sheet for Amorbach (Philadelphia Museum of Art, fig. 8) may have been employed during the process of execution. The condition of the drawing (it has been badly damaged at the bottom) also possibly attests to its having been used as a "working drawing."

Differences also exist between the fresco and the drawing. The fresco relies on a combination of several points of view and perspectival systems to ac-commodate figures placed around the periphery, while in general its com-position conforms to one overall point of view, with one vanishing point in the center, addressed to a viewer entering from the west. On the other hand, all the figures in the drawing are less foreshortened: presented parallel to the picture plane, they appear flatter. This contrast suggests that the art-ist developed the illusionistic effects either as he worked on the fresco or at a further intermediary stage in the design.

The transformation of many details and the introduction of new ele-ments into the finished fresco also suggest that the artist continued to make changes during the actual painting of the ceiling. St. Benedict's gesture and pose, that of Totila, of St. Placidus, of the man on the right being resuscitated, just to name a few details, are all characterized differently in the fresco than in the drawing. Some new figures, such as that identifiable with the *Bau-meister* Häffelein, have even been added in the fresco. However, since in most other particulars the fresco closely resembles the drawing, these addi-

tions do not necessarily argue for the existence of another drawing or oil sketch before the final execution. It is therefore possible to regard the Philadelphia drawing for Amorbach as representing the penultimate step in the design process.

These issues surprisingly are not discussed in Harnacher 1987.

5. See Benesch 1947.

6. Inspection of the drawing under high magnification with the conservator of the Department of Prints and Drawings of the Philadelphia Museum of Art failed to reveal any obviously visible distinction between the two.

7. This statement is based on the author's study of the artist's *Nachlass*, which has been substantially preserved in the collection of the Cistercian abbey at Stams in the Tyrol.

8. The same mark is found on 1984-56-107, 1984-56-108, 1984-56-109, and 1984-56-110.

9. Besides its appearance on the sheet discussed here, the inscription in brown wash *MK* is also found on the following drawings in the Philadelphia Museum of Art: 1984-56-107; 1984-56-108; 1984-56-110. Drawing 1984-56-107 also bears an inscription in red ink by another hand *MK 1742*; this inscription most likely does not refer to Knoller, who was born in 1727, and stands to be another later elaboration.

In any instance, it is difficult to imagine how Knoller could have acquired Günther's drawings; their paths might have crossed in 1775, when Knoller was working in Munich, but Günther did not die until 1788, and most of Knoller's material ended up in Stams. Thus there is almost no drawing material by Knoller to be seen outside of Stams, or the Tiroler Landesmuseum Ferdinandeum in Innsbruck, with a provenance from Stams.

No mark *MK* resembling that found on the Philadelphia drawings is recorded by Nagler 1857–79, or Lugt.

Rolf Biedermann, in Augsburg 1988, also raises the possibility that this is a collector's mark.

CASPAR FRANZ SAMBACH
(1715–1795)

Caspar Franz Sambach was born January 6, 1715, in Breslau (Pol. Wrocław), the son of a shoemaker. He began instruction in drawing in 1722; in 1729 he became the pupil of J. Reinert, and then of J. H. De L'Epée, a student of Daniel Gran (q.v.). He assisted De L'Epée in Opava (Ger., Troppau) in 1730, perhaps in Buda, and in the meantime also studied the liberal arts. After possibly a sojourn in Bratislava (Ger., Pressburg) with Raphael Donner (q.v.), he came to Vienna, where he executed wax reliefs in his workshop. He studied in the Vienna academy under Paul Troger (q.v.) from 1740, winning the first prize in drawing in 1744; he assisted Troger in painting in Győr (Ger., Raab) in 1744–5.

Sambach's independent career began in the 1740s and besides altarpieces and frescoes consisted of grisaille imitations of bas reliefs. His most important frescoes were executed chiefly in Hungary and Moravia, e.g., in Székesfehérvár (Ger., Stuhlweissenburg, 1749), and in Sloup (1751–54).

In 1758 he became a member of the Augsburg academy, and in 1759 of the academy in Vienna, gaining admission through a project done in collaboration with F. A. Maulbertsch (q.v.). He became professor of history painting at the Vienna academy in 1762, and in 1773 director of the reunited Vienna academies. His productivity as an artist diminished with his activity as a teacher and administrator. He died on February 27, 1795, in Vienna; his son was the painter Christian Sambach.

22. Assumption of the Virgin

Pen and black ink, gray wash; marked with a scale, or for squaring, at bottom in brown ink
Inscribed in gray wash, lower right: 1766
15 9/16 × 9 1/16 (395 × 229) (irregular, cut at top)

Collection of Robert and Bertina Suida Manning

PROVENANCE: William and Eugénie Suida (inscribed in graphite on verso: *Prof. Dr. W. Suida*)

According to a note in graphite on the verso, the attribution of this sheet to Sambach was proposed by Karl von Garzarolli-Thurnlackh.[1] This attribution can be supported by comparison of details to secure sheets by the artist in the Graphische Sammlung Albertina, Vienna. The angels with their peculiar heads and somewhat odd foreshortening, as well as the putti, are found in an *Apotheosis of a Martyr Saint*; the use of pen and black ink, elongated figures, placing of crossed legs, long outstretched arms, and drapery forms are found in a *Conversion of Paul*; and some of the male types, with their pronounced gestures, are found in the foreground of *Christ Preaching to the Multitude.*[2]

The large scale, high finish, and shape of this drawing suggest that it was a design for an altarpiece. The marking at the bottom may also indicate that it was used as a preliminary design. An altarpiece with the subject of the Assumption of the Virgin was in fact documented as having been painted for the Church of the Virgin in Buda, the coronation church of Hungary.[3]

A receipt for payment for this altarpiece is, however, dated August 12, 1757, nine years earlier than the date on the drawing.[4] This may indicate that the Manning drawing is a later *ricordo* of the finished work, or that the commission took some years to execute; the earliest documents referring to the appearance of the painting seem to date from the 1770s.

If the date on this drawing was placed there by the artist, and it does appear to be in the same wash as that found on the rest of the sheet, then it supplies an important point of reference for the artist's work. As Waltraut Kuba-Hauk states, the ordering and dating of Sambach's drawings is difficult, as the only secure points of reference are the artist's few autograph dated works.[5] Since works by Sambach from the period of his professorship at the Vienna academy, from 1762, are quite scarce, this hitherto unpublished sheet assumes further significance.

1. "*Sambach (Garzarolli)—20.*"
2. Vienna, Graphische Sammlung Albertina, cat. no. D 2090c, D 2095, D 2096a.
3. See Kuba-Hauk 1978, 1, pp. 261–62; 2, p. 379, with further literature.
4. For the subject of the painting, see Dlabacz 1815, 3, p. 15, no. 3.
5. Kuba-Hauk 1978, 1, p. 307.

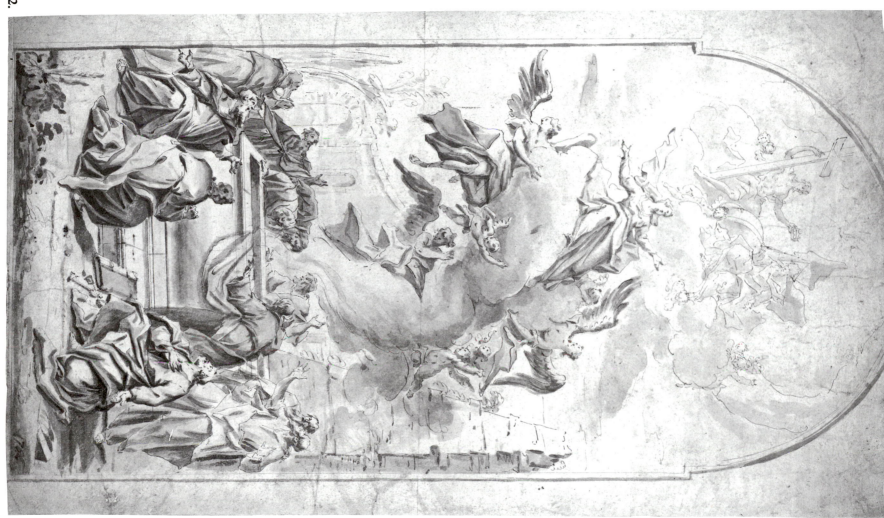

FRANZ ANTON MAULBERTSCH
(1724–1796)

Baptized in Langenargen on Lake Constance on June 7, 1724, Franz Anton Maulbertsch received his first artistic instruction in his father's workshop. On October 5, 1739, he was recorded as a student in the Vienna academy, where he studied until 1745.

Maulbertsch's first altarpieces are datable to 1748–49, at which time he was already listed as a *Mahler* in the register of names of the academy. In 1750 he won the first prize for painters and in 1752 began the first of his great series of frescoes with works in Vienna and Lower Austria. Though he failed to be elected professor of painting in the academy in an election held in 1757, he was accepted as a member of that body two years later, becoming a member of the council of the Vienna Academy of Engravers in 1770 and artistic adviser for the painters of the newly united Academy of Fine Arts in 1773. Later honors included membership in the Berlin academy in 1788, and in the same year appointment as director of the newly founded artists' pension fund, the *Pensionsgesellschaft bildender Künstler*.

Maulbertsch's work as a frescoist and painter of altarpieces in Dresden, the Tyrol, Lower Austria, Hungary (including modern Slovakia), Bohemia, and Moravia extends from the 1750s to the 1790s. His most important pupils, at times collaborators, were Johann Bergl and Joseph Winterhalter (*q.v.*). He died in Vienna on August 7, 1796.

Maulbertsch may be considered one of the major artistic personalities active in Central Europe in the period 1680 to 1800. He is considered one of the finest colorists in the history of art, as well as one of the great masters of fresco painting.

23. Flora

Pen and brown ink and wash, on buff-colored paper
12 × 9 (300 × 229)

Harvard University Art Museums, Fogg Art Museum; Friends of the Fogg Art Museum Funds, 1954-77

PROVENANCE: Lucien Lefèvre-Fornet, Paris; purchased, 1954

EXHIBITIONS: Lawrence, Kansas 1956, p. 12, no. 31; Baltimore 1959, p. 65, no. 268

LITERATURE: Schwarz 1959, pp. 14–15, ill. fig. 4, p. 13; Garas 1960, pp. 33, 201, no. 47, fig. 51; Garas 1974, p. 256

The execution of this drawing with thin translucent washes brings to mind the luministic effects of Maulbertsch's frescoes and oil sketches. As in his painted works, particularly from the earlier part of his career, Maulbertsch manages to suggest with a minimum of linear means the presence of beings whose existence is suffused with a brilliant light. Here he evokes a female figure floating in clouds, as a winged genius brings her a basket of flowers, while a putto floats above.

Heinrich Schwarz, who claimed to have discovered this sheet, first proposed that it was a sketch of a detail for a ceiling fresco by the artist. Garas also called the drawing a partial study for a painted ceiling. The location of the scene in the heavens would seem to support the association with a typical eighteenth-century design of this sort. No surviving paintings by Maulbertsch can be directly linked with this drawing, however. Its exact function, and even its subject, can only be hypothesized. The closest comparisons to the subject are to be found with figures dispensing flowers on the ceiling of a fresco from 1765 in the schloss at Halbturn in Burgenland, Austria, but none of the figures in the fresco can be directly related to the poses seen in the drawing.[1]

In the absence of firmly dated sheets from his early career, an exact chronology of Maulbertsch's drawings, and consequently the dating of this example, must be constructed by allusion to his paintings. Referring to the Halbturn fresco and other commissions that Maulbertsch received about the same time, Schwarz dated the Fogg drawing to the mid-1760s.[2] Garas has more convincingly associated this drawing with a series of oil sketches and drawings from the period 1752–55, and fixed it at 1753–54.

In particular, the Fogg sheet is very close in technique and dimensions to a drawing dated by Garas ca. 1754 (Karlsruhe, private collection), with which it also shares formal characteristics. The characteristics of Maulbertsch's drawing style are well described by Garas in reference to other works assigned to the years 1753–54, primarily on the basis of association with a drawing in Budapest for a fresco in the church "Am Hof" in Vienna (for a drawing of this church see cat. no. 86). These features are exemplified by a design in the Albertina,[3] whose similarities with the Fogg sheet include such qualities (more obvious in the original than in the reproduction) as the use of washes to indicate broad contrasts of light and shade, the presence of thin, finely drawn outlines, and the characterization of faces with barely suggested traits. Though not adduced by Garas in comparison to the Fogg sheet, a drawing for an altarpiece of the *Adoration of the Shepherds* in St. Michael's Church, Vienna, datable to 1753–55, seems to clinch the dating, as both share a common female type, in addition to these characteristics.[4]

1. The Halbturn fresco is illustrated in color in Garas 1974, pl. 39.
2. Besides Halbturn, Schwarz 1959, pp. 14–15, mentions works done in Bratislava and at Louka (Ger., Klosterbruck), which no longer survive.
3. Inv. no. 25.398, illustrated in Garas 1960, fig. 49.
4. Now Wrocław, Biblioteka Zakładu Narodowego im. Ossolińskich, illustrated in Garas 1974, p. 24, fig. 11.

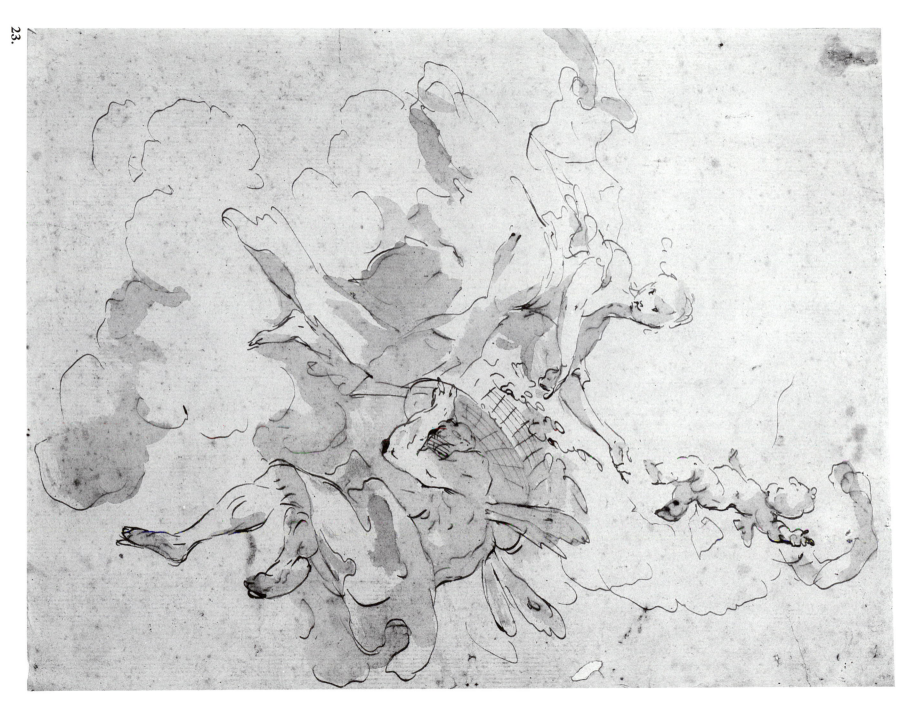

24. The Education of the Virgin by St. Anne

Pen and brown and black ink, gray wash, graphite
10⅞ × 6⅛₆ (276 × 170)
Signed in brown ink, lower left: *Maulbercht.*; inscribed in gray wash, lower center: *à la Cathedrale de Raab*; inscribed lower left corner: *b*

Collection of Robert and Bertina Suida Manning

PROVENANCE: Probably Bergmann Collection, Vienna (auction, Vienna, Wawra, 1889); William and Eugénie Suida

EXHIBITIONS: Vienna 1937, no. 43; Lawrence, Kansas 1956, p. 12, no. 29

LITERATURE: Garzarolli-Thurnlackh 1928, p. 63, ill. 91; Garas 1960, pp. 108, 218–19, cat. no. 243, fig. 242; Garas 1974, p. 257; Pavel 1978, p. 66

This drawing represents the Virgin, who kneels in prayer at the feet of St. Anne. As angels at the top of the drawing attend the scene, an angel at the bottom left proffers a basket with what seems to be yarn, since a distaff lies at his feet. Behind the Virgin, to the side of the open doorway, are tablets with the Ten Commandments.

The inscription at the bottom, by a hand other than that of the artist, who signed the sheet, would seem to indicate that it was connected with the Cathedral of Győr (Ger., Raab) in Hungary. On commissions from Bishop Ferenc Tichy, Maulbertsch painted frescoes for this church in 1772 and 1781, and also executed altarpieces for it in 1774.[1] Garzarolli-Thurnlackh recognized that this drawing was a design for an altarpiece, as its shape implies; he also suggested, however, that it was possibly connected with the undocumented work of Joseph Winterhalter in Raab, with a date in the mid-1780s.

No altarpiece with the theme found here, the Education of the Virgin, is documented for Győr. On the basis of similarities of composition and details, Garas correctly identified this drawing as a design for a picture in the parish church of St. Nicholas, now the cathedral, in České Budějovice (Ger., Böhmisch Budweis), where Maulbertsch is documented as having painted an altarpiece of St. Anne during the period 1770–71.[2] Whereas Garzarolli had also related this drawing to a sketch in the Albertina, Garas, in reiterating the comparison, correctly associated the Albertina sheet with a fresco dated 1770, formerly in the Court Church (*Hofkirche*) in Dresden (destr. 1945).[3]

The outlines of figures in the Manning drawing have been corrected in black ink over finely drawn graphite; changes are noticeable particularly in the arms and legs of the angel to the lower left, and in the apparent addition of angels' heads in the center of the composition. Significant transformations are revealed in the finished painting. Where these angels' heads are absent, the angel at bottom left has

been turned further toward the picture plane, and he holds the basket differently.[4] Hence it seems that the Manning drawing represents an earlier stage in the working out of the composition and is perhaps related to the period of negotiations between the painter and the parish church between June and September 1770.

Although the two drawings by Maulbertsch in this exhibition seem to have functioned for different sorts of paintings, they nevertheless can serve to demonstrate the change from the earlier stage of his career evident in his art ca. 1770. The clearer composition, greater calm of the figures, their increased monumentality, and more regular, even classical positioning correspond to features found in works of what has been described as the onset of the artist's "middle" period. As Garas has discussed, these qualities also correspond to a more general transformation in art in Central Europe away from the rococo to what has been regarded as an incipient classicism.

1. For these works, see Garas 1960, p. 220, no. 262, p. 224, no. 308, and p. 221, nos. 278–80, with documents xlv, p. 250, liv, p. 252, and lxxxiii, p. 262.
2. For the documentation of the altarpiece, see Garas 1960, document xli, p. 249.
3. This drawing (Vienna, Graphische Sammlung Albertina, inv. no. 23.4999) is illustrated, without exact identification, in Garzarolli-Thurnlackh 1928, fig. 91; the figures to which it is related can be seen to the left of an illustration of the St. Benno Chapel, in Garas 1974, fig. 50, p. 74.
4. The painting is illustrated in Pavel 1978, fig. 76, where it is said to be from Maulbertsch's workshop and dated 1772. There seems no reason, however, either for this dating or to doubt Maulbertsch's personal participation in the execution of the painting.

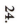

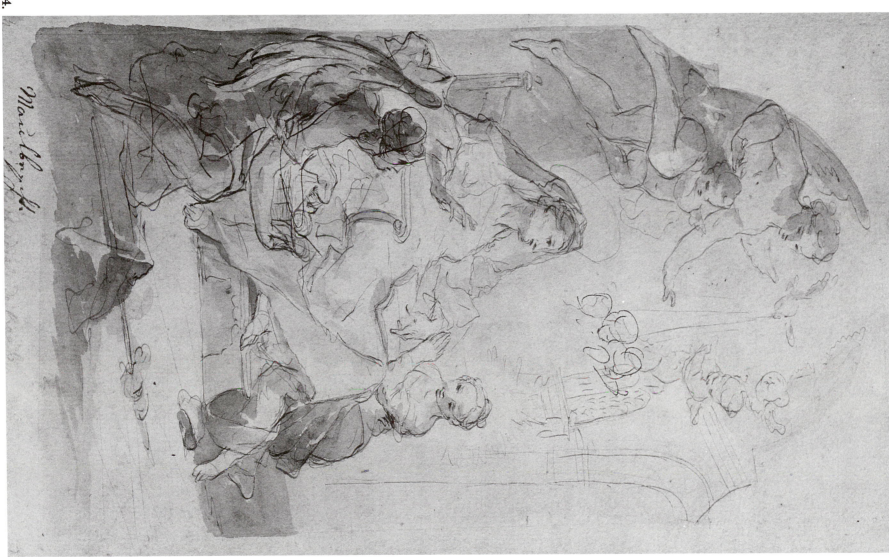

JOSEPH WINTERHALTER
(1743–1807)

Joseph Winterhalter was born on January 25, 1743, at Föhrenbach near Donaueschingen. His father was the sculptor Johann Michael Winterhalter (1706–1759) and his uncle the sculptor Josef (1702–1769), to whom he was sent in Olomouc, Moravia (Ger., Olmütz), to receive his first instruction as an artist. He then went to Brno (Ger., Brünn) to study painting with Joseph Stern (1716–1775), and through Stern came into contact with many of the leading Central European artists of the day. In fact, he worked with one of them, Maulbertsch (*q.v.*), from at least 1763, assisting in many major projects that Maulbertsch carried out during the late 1760s, and then again in 1777.

Winterhalter resided and married in Znojmo (Ger., Znaim) in 1773. He became one of the busiest painters in southern Moravia, where he executed frescoes in Jemnice (Ger., Jemnitz) 1774, in Brno-Zábrdovice (Ger., Obrowitz) 1775 and again 1781–82, his master work, in Rajhrad (Ger., Raigern) 1776, and Brno (Ger., Brünn) 1781.

At Maulbertsch's death in 1796, Winterhalter carried out a number of projects his master had conceived, including the decoration of the ceilings of the Cathedral of Szombathely (Ger., Steinamanger) in Hungary. He also painted the ceiling of the cloister in Geras, Austria, with a design taken from Maulbertsch. Winterhalter died in Znojmo on February 17, 1807, one of the last exemplars of the great tradition of "baroque" ceiling painting in Central Europe.

25. Three Donors of Zábrdovice

Pen and brown ink, brush and brown washes, graphite, on beige paper
8½ × 13⁷⁄₁₆ (216 × 340) [sight]
Signed in dark brown ink, upper left: *Joseph Johann Winterhalter*

Collection of Robert and Bertina Suida Manning

PROVENANCE: Johanna Aigner, Vienna; by 1932, William and Eugénie Suida

EXHIBITIONS: Vienna 1937, p. xxv, no. 119; Lawrence, Kansas 1956, p. 16, no. 62, ill. p. 5

LITERATURE: Braun, in Thieme-Becker 1947, 36, p. 87; C. Hálová-Jahodová 1947, pp. 216, 226, ill. p. 227; Garas 1959, p. 227; Garas 1980, pp. 84–85, 86; Maser 1960, pp. 134–35, fig. 9; Garas 1980, n. p. (under no. 52)

Although Maser after having exhibited this drawing as a work by Winterhalter later published it as a Maulbertsch, it is not only an authentic design by Maulbertsch's most important pupil and follower but also a touchstone for the attribution of further drawings to Winterhalter. The signature on this sheet is identical to one found on a depiction of *Moses and the Burning Bush* in Budapest.[1]

The figures in the Manning drawing correspond to depictions of the founders of the former Premonstratensian cloister, now a military hospital, in Zábrdovice, formerly a suburb of Brno that has since been effectively conglomerated into the city.[2] Garas, who first correctly identified their location in

the refectory of the cloister, also first identified the subjects as, to the left, Johannes Bohuslav Morkovszky, from the west wall, and from the east wall, the first founder of the cloister, the knight Leon, and the second founder, his wife Rigka. In his autobiography, included in a history of art in Moravia compiled in manuscript by V. Cerroni, Winterhalter mentions that he had executed these paintings.[3] They are datable 1778–79.[4]

It was in the making of this type of figural design in grisaille that Winterhalter particularly prided himself.[5] To judge from the published photographs of some of the frescoes, however, the stances of the figures were considerably changed from the drawing to the fresco. This work thus served as a preliminary design for approval; the differences seen in the pedestals below each of the figures suggest that they may have been intended to provide alternative solutions.

Despite resemblances to similar figures in works by Maulbertsch, exemplified by his frescoes in Sümeg, Hungary, these works can be distinguished not only qualitatively but stylistically from the drawings of his teacher.[6] While employing a similar handling of wash and line, they lack some of the plasticity of Maulbertsch's designs. Nevertheless, in contrast with Winterhalter's frequent copies or emulations of other draftsman's works, this drawing represents a further development from Maulbertsch's work of the 1760s and 1770s (for which see cat. no. 24).[7] As a certain signed and dated sheet by the artist, it also forms a basis for the determination of Winterhalter's drawing style.

1. *Szépmüvészeti Múzeum*, inv. no. K. 57.46, best illustrated in Garas 1980, no. 52.

2. Some of the frescoes are illustrated in Hálová-Jahodová 1947, p. 227. She reports that the previously damaged paintings had been destroyed by a bad restoration in 1939 (p. 216). The room is not at present accessible.

3. Garas 1959, p. 84; Braun and Hálová-Jahodová had previously noted the connection with Winterhalter's work at Zábrdovice.

4. Hálová-Jahodová 1947, p. 216, dates them 1778–79, but is somewhat confusing about the location of the frescoes. Maser, in Lawrence, Kansas 1956, had dated them 1781 and associated them with the library; Garas 1959, p. 78, establishes the date as ca. 1775.

5. See Garas 1959, p. 86, and n. 16.

6. Garas 1959, p. 85, draws the comparison with Sümeg, and makes this qualitative distinction.

7. Another example of this sort of emulation, a work done in Troger's manner, is found in Sacramento, Crocker Art Museum, inv. no. 1871.1302, *The Holy Family*, pen and dark brown ink, 207 × 162 mm., there as Franz Xavier Winterhalter.

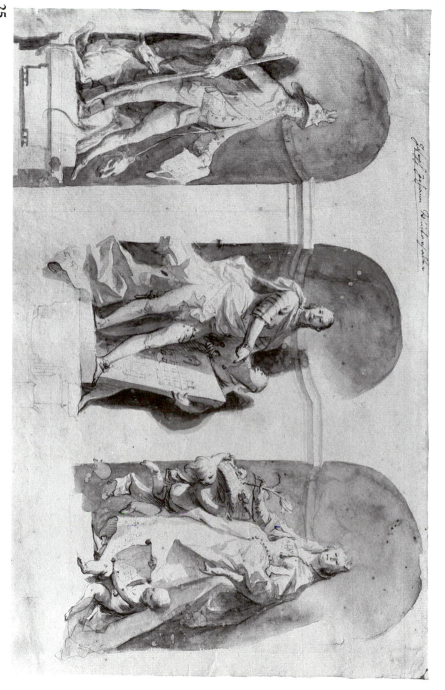

MARTIN JOHANN SCHMIDT
(1718–1801)

Martin Johann Schmidt is better known by the name of "Kremser Schmidt," which derives from the town of Krems, on the Danube in Lower Austria. Krems is located near his birthplace of Grafenwörth, where the artist was born in 1718.

Schmidt was an apprentice of his father, a sculptor, and then of Gottlieb Starmayr, who worked in nearby Stein on the Danube. Schmidt set up his own studio there in 1745, the year in which he received his first important church commission for side altars in the parish church, whose high altar he also painted later.

His career extends from this period until his death in Stein in 1801. Schmidt was a prolific painter chiefly of religious works, but also of portraits; he produced graphic works as well. In 1768 Schmidt was accepted in the academy in Vienna as a history painter.

Schmidt's works seem to respond to the popular, and especially to the bourgeois, religious currents of his time.

26. Miracle of St. Joseph of Calasanz

Pen and brown ink, black, gray and red wash, white heightening, on paper prepared with gray ground
10¹/₁₆ × 7¹/₈ (256 × 181)
No watermark
Numbered in pen and brown and black ink, upper right: 110

The Pierpont Morgan Library; Gift of the Fellows, 1965.4

PROVENANCE: Ludwig Guttenbrunn; Baronowitsch Collection, Moscow

This composition depicts Joseph of Calasanz, the bald saint identified by his habit and halo, presenting a dead child to the Virgin and Christ Child. The Christ Child raises his hand in blessing, suggesting that the child will be revived. Angels in the upper right corner, a weeping woman, probably the child's mother, and other children in the bottom of the drawing attend the scene.

The presence of many children, and the books placed prominently in the left foreground, allude again to the saint. A nobleman born in 1556 in Spain, Joseph Calasanz (Calasanza, Casalanz) became a priest and established free public schools in Rome for the education of the poor; he also founded a society that became the Piarist Order (also known in English as the Clerks Regular of the Pious Schools), which was especially dedicated to education.

The Piarist Order spread after Joseph's death in Rome in 1647. The Piarists flourished in Central Europe, where, especially in the Czech lands and in Hungary, they could participate in the process of re-Catholicization after the expulsion of, respectively, Protestants or Turks.

The Morgan Library drawing is associated with a painting by Schmidt for the Piarist church in his home town of Krems, one of the Piarists' many newly founded or rededicated structures with which artists became involved. The finished third side altar on the right hand side of the nave, approach-ing the high altar, depicts the same subject.[1] It is possible that the dedication of an altarpiece depicting the saint's miracles can be related to a renewed veneration that occurred after his canonization on July 16, 1769.

The Morgan drawing is one of three drawings (the others are in the Albertina and the monastery of St. Florian) that can be related to this painting; the St. Florian drawing is dated 1784.[2] Garzarolli-Thurnlackh has singled out this composition as especially revealing of Schmidt's repeated use of the same graphic model types. Stylistic characteristics from the Albertina drawing, and consequently from the Morgan design, are found throughout Schmidt's oeuvre.[3] These qualities can also be observed in regard to the composition of the *Baptism of Christ* of 1773 exhibited here (cat. no. 44), wherein elements are also comparable to other later works by Schmidt.[4]

The version that is closest to the painting is apparently that in the Albertina, where a large angel appears, showing his back to the viewer.[5] The Albertina drawing also reveals a number of other changes from the first version in St. Florian, where a couple of putti are found instead of the angel. The Christ Child is brought closer to the Virgin; the saint is set clearly on steps; a column is evident to his right, where five children, not the six of the earlier version, are shown, and from which a standing child to the left has also been eliminated; the pose of the weeping woman has also been made more upright.

Further changes from the Albertina drawing are found in the Morgan Library drawing. The position of the dead child has been reversed, as has the stance of the angel to the right, who now looks adoringly at the Virgin. Two more children have been eliminated on each side of the composition, and the woman's face has been covered. The Virgin is also more clearly separated from the saint. The result is a tighter, more centered and balanced composition. At the same time, in contrast with the other versions whose combination of Venetian compositional character and Rembrandtesque light effects was noted by Garzarolli-Thurnlackh, the figures in the Morgan version are somewhat more tightly constructed.

However, the application of additional washes, in comparison with the treatment in the other drawings, lends this version a more coloristic effect. In this regard, it would seem to approximate even more closely an oil sketch. It is thus possible that the Morgan drawing either was a presentation drawing to the Piarist patrons of the painting or represents a later reworking of the Albertina composition.

The provenance shared by this drawing with that in the Albertina may also suggest something of its function. These drawings belonged to a volume of sheets from a Moscow collection, to which they were sold with Schmidt's knowledge by his pupil Ludwig Guttenbrunn. Their finished appearance may explain the album's attractiveness as a collector's item.[6]

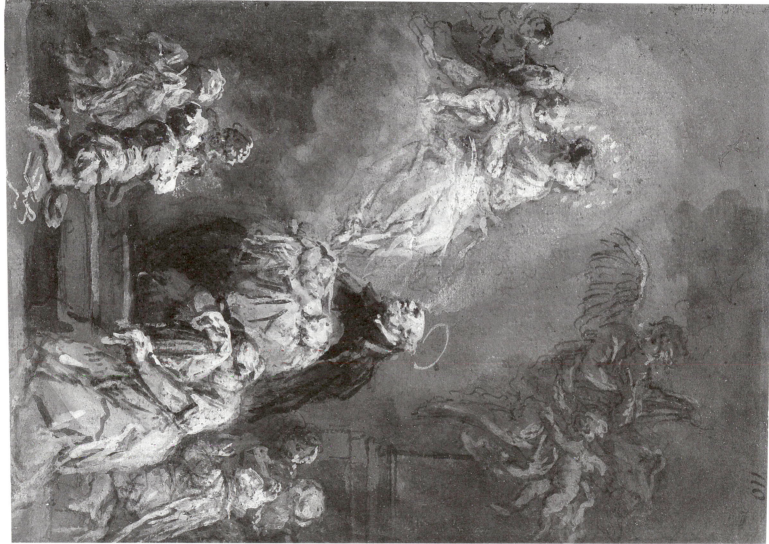

1. See Tietze 1907, 1, p. 224.
2. The other versions are in the collection of the Abbey of St. Florian, Upper Austria (illustrated in Garzarolli-Thurnlackh, 1925, fig. 87, identified by the artist and dated 1784, and in the Graphische Sammlung Albertina, Vienna, inv. no. 24673, cat. no. 2159).
3. See Garzarolli-Thurnlackh, in Dworschak 1955, p. 110.
4. Compare to a painting ca. 1790 of the same subject, Munich, Bayerisches

Nationalmuseum, inv. no. 67/12, where the stance of the Baptist and Christ, the grouping of figures around the central pair, the angel to Christ's left, and even the mother and child in the center of the composition are all similar.
5. Garzarolli-Thurnlackh, in Dworschak 1955, p. 110, makes this observation.
6. The Morgan drawing is numbered 110; the Albertina drawing 109; these may be markings from the Baranowitsch collection. For the history of the Baranowitsch collection see Garzarolli-Thurnlackh 1925, pp. 85ff.

Anton Raphael Mengs

(1728–1779)

Anton Raphael Mengs was born March 12, 1728, in Ústí nad Labem (Ger., Aussig) in northern Bohemia, near the Saxon border, and began his artistic training in Dresden under the tutelage of his father, Ismael. He made his first trip to Rome in 1741 and studied with Marco Benefial (1684–1764), in whose workshop he remained until 1744. He then returned to Dresden, where he stayed until 1746, when a stipend from Augustus III, prince elector of Saxony and king of Poland, enabled him to return to Rome. After he had converted to Catholicism and married Margarita Guazzi in 1749, he was again returned to Dresden.

In Dresden Mengs received a large number of commissions and quickly rose from being a court painter to the rank of first painter of the Saxon court. He received financing in response to his own suggestion to journey again to Rome, where he arrived in 1752. In the same year he became a member of the Accademia di San Luca, and henceforth received important commissions, such as that for the decoration of the Villa Albani. During the 1750s Mengs associated with Johann Jakob Winckelmann, who had come to Rome in 1755.

In 1761 Mengs left Rome to serve as court painter to Charles III of Naples, newly established as king of Spain. He remained in Madrid until 1769. After a long journey he returned to Rome in 1771, became director of the Accademia di San Luca, and worked in the Vatican. Recalled to the Spanish court, he was again in Madrid between 1774 and 1777. His last years, until his death in 1779, were spent in Rome, where he established an enormous studio.

Together with Winckelmann, Mengs formed the nucleus of a group that sponsored a change in attitude toward the arts that can be associated with neoclassicism. His importance in this movement stems not only from his peripatetic activity as a painter but also from his role as a teacher and as a theorist, the author most notably of *Gedanken über die Schönheit* (Zurich 1762).

27. The Lamentation

Black and white chalk, somewhat discolored, on faded blue paper, mounted on canvas, stretched
62⅛ × 41¼ (1578 × 1048) [sight] [82 × 62 inch frame]
Mat inscribed in paint: *HVIC TABVLAE DUM DVCET ARVDINE TRACTVS/MENGSIVS INFELIX PROH DOLOR EMORITUR*

Museum of Fine Arts, Boston; Gift of Mrs. George L. Nichols, 1922.77

PROVENANCE: Marchese Rinuccini, Florence; Mrs. George L. Nichols; Mrs. George H. Chickering, gift, 1922

EXHIBITIONS: Providence 1957, p. 15, cat. no. 100, ill. p. 23; Cleveland 1964, no. 27; Storrs, Connecticut 1973, cat. no. 101, fig. 28

LITERATURE: Providence 1957, p. 317; Madrid 1980, p. 98, under cat. no. 37; Chicago 1978, p. 35, under cat. no. 21

Mengs's biographer de Azara reports that at the last moments of his life the artist "finished a pencil drawing, of the Deposition, in a different manner than that which is in the King's chamber." Azara mentions that "all Rome is admiring that prodigy of the Art, and the Marquis Rinuccini of

Florence, has offered a thousand scudi for the drawing and has obtained it." Other sources confirm that Mengs was commissioned to execute a painting of this subject for Rinuccini, who later paid the executor of the estate for the cartoon of it; contemporary newspaper accounts also indicate that the cartoon was very well received when it was publicly displayed in 1781 in Florence.[1]

The provenance and apparently contemporary inscription on the mat leave no doubt that the Boston *Deposition* is the highly prized sheet which the Marchese Rinuccini acquired in 1780. In rough translation it reads: "While for this picture he was drawing the last strokes with the pen, unhappy Mengs, alas! woe! perished." This inscription was probably formulated with the advice of Lord Cowper.[2]

During his first sojourn in Spain in the years 1761–69, Mengs had painted the same subject for the bed chamber of the king, along with four other depictions of the Passion of Christ.[3] It is this painting, originally in the Palacio Real, to which Azara refers in his commentary on the Boston drawing. Rinuccini evidently desired to have a painting made to complement the copy of Raphael's so-called Canigiani Madonna that he also owned.

Several changes exist between the Spanish composition and the completed design in Boston, and a group of preparatory studies exists for the Boston cartoon. Besides the drawings and painting mentioned by Steffi Röttgen in her forthcoming monograph on the artist, these include a pen drawing in the David and Alfred Smart Gallery, University of Chicago. They attest to the artist's careful working procedure, and to the stages before the completion of this design.

This design was not only cherished in its own time, but it may be regarded as a masterwork in the medium. Although it may have functioned as a cartoon, it can stand on its own as a highly finished work of art.[4] As such it is a worthy summary of Mengs's career, and of his contribution to neoclassicism.

1. The early unpublished sources for the painting are to be printed in the forthcoming monograph on Mengs by Steffi Röttgen, to which the reader is referred for this information. I am grateful to Dr. Röttgen for sharing this information with me, and for supplying me with further bibliographic information on the painting.
2. For this and other similar information, the source is Röttgen.
3. See Madrid 1980 for fuller information on this picture and the related works.
4. Röttgen also comments, independently, in her forthcoming monograph, that "wie bei keinem anderen Werk stellt sich hier die Frage nach dem Eigenwert des Kartons in Mengs's Oeuvre."

92

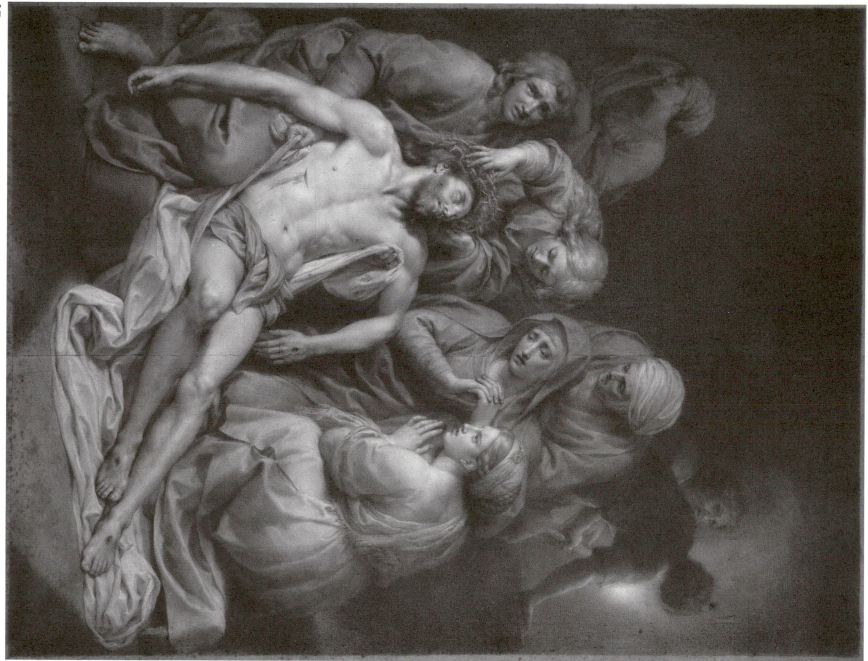

B. Other Designs for
Paintings, Books, Prints,
and Independent
Drawings

JOHANN CARL LOTH

(1632–1698)

Born in Munich in 1632, Johann Carl Loth received his first artistic training from his father, the painter Johann Ulrich Loth. In 1655 he went to Italy, first to Rome, but by 1656 was in Venice, where he worked in the studio of Pietro Liberi. By 1663 he was already being called a "great miniaturist" by local artists, evidently excelling in a genre that his mother, who was the daughter of a Munich sculptor, had also practiced.

In Venice Loth established his own workshop, and became known as "Carlotto." Along with Liberi and Antonio Zanchi, Loth was the most sought after and celebrated artist active in Venice during the second half of the seventeenth century. He was commissioned to paint a large number of altarpieces in Italy and Bavaria, and was favored by the grand duke of Tuscany. Loth died in Venice in 1698; the inscription on his tombstone records that he was ennobled by the emperor.

Pupils who worked in Loth's Venetian workshop included many of the artists who were to be cornerstones of eighteenth-century Central European and especially Austrian painting: Peter Strudel, J. A. Weissenkirchner, J. M. Rottmayr, and Daniel Saiter are among them.

28. Solomon Worshipping Idols

Pen and brown ink, white heightening, with frame outlining whole composition in brown ink, on grayish paper
5 1/8 × 7 3/8 (131 × 188)
Inscribed in brown ink, upper center: *Salamone*; and in brown ink, lower center: *di Carlo lott*

The Metropolitan Museum of Art; Gift of Cephas G. Thompson, 87. 12. 70

PROVENANCE: Cephas G. Thompson

LITERATURE: Metropolitan Museum of Art Drawings 1895, no. 740; Ewald 1965, p. 137, cat. no. Z 5, ill. pl. 54; Pigler 1974, I, p. 173

The inscription at the top of this drawing indicates that this is a depiction of a story of King Solomon, the man with the crown seated in the center. Surrounded by his wives, one of whom is on his lap holding a statuette, he is urged to worship idols: two of the women to the right of the drawing gesture to the statue at the right. The scene, represented from the Bible (1 Kings 11), is encountered frequently in seventeenth- and eighteenth-century art, according to Pigler; another depiction of the same tale is in this catalogue (cat. no. 42).

A painting of the identical scene by Loth exists and helps verify the attribution suggested by the inscription.[1] The Metropolitan Museum drawing in general resembles the composition of the painting, with seated figures grouped around a central king, a kneeling woman in the lower right and an idol in the upper right corner of the drawing. It is possible that the drawing was conceived as a design for the painting, but enough differences exist between the two so as to make it difficult to determine the exact function of the Metropolitan Museum sheet with certainty.

The broad painterly execution found here is typical of Loth's drawing style. Loth builds up the composition from colored paper with white heightening fluidly applied within a minimal amount of outline. This style is ultimately derived from the Venetian tradition of draftsmanship and is comparable to the drawings of artists such as Marco Bassetti.

In the absence of many firmly situated drawings, and also many dated paintings by the artist, it is difficult to date the Metropolitan's sheet with precision. The technique found in the New York drawing and the more refined figures, as well as the tighter handling and compact composition, contrast with the broad wash technique associated with Loth's earliest drawings.[2] These qualities place the drawing late in Loth's career.

Loth assumed a prominent position in Venice at the same time that he maintained contact with his native Bavaria, to which he continued to supply works of art. Many Austrian and German artists such as Peter Strudel and Johann Michael Rottmayr, who were to gain importance ca. 1700, came to study with him, and he passed his later style of drawing on to them. Thus, it is often difficult to distinguish Loth's authentic drawings from the more general style of drawing in Central Europe, which this drawing may be said to characterize.

1. Collection Marquess of Exeter, Burghley House. See Ewald 1965, p. 67, cat. no. 99a, ill. pl. 54.

2. For example, a drawing in the Metropolitan Museum of Art, representing *The Sacrifice of Isaac*; Ewald 1965, p. 136, cat. no. Z 1a, ill. pl. 67.

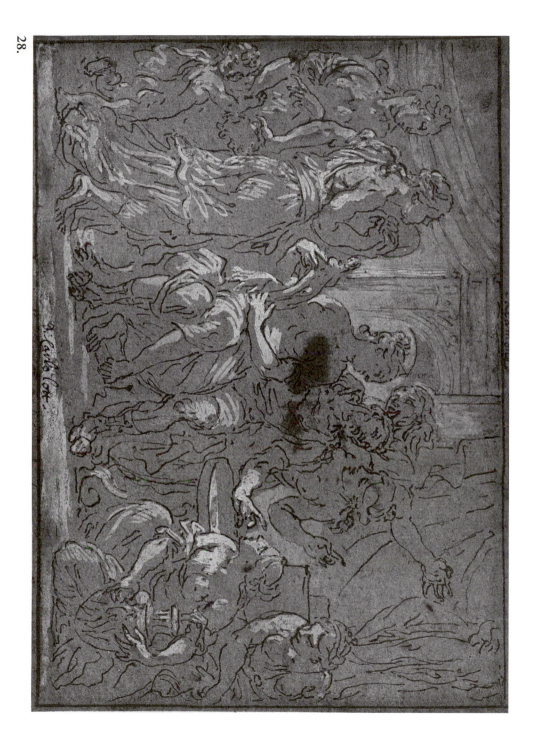

Johann Christoph Liška
(Ca. 1650–1712)

Johann Christoph Liška was born ca. 1650, probably in Breslau (now Wrocław, Poland). He was trained by his stepfather, the famed Michael Lukas Leopold Willmann (1630–1706; see Princeton 1982, p. 196), who facilitated his career, especially by gaining commissions from the Cistercian Order with which Willmann was closely associated; Liška later became Willmann's heir.

After a sojourn in Italy, presumably of six years' duration, and a period of collaboration with Willmann in Silesia, Liška settled in Prague around 1689. In Bohemia Liška carried out works for the Cistercians in Osek (Ger., Ossegg), 1696 and Plasy (Ger., Plass), 1700–01 for the Capuchins in Mnichovo Hradiště (Ger., Münchengrätz), ca. 1699, for the *Kreuzherren*, or Knights of the Cross, in Prague, 1700–02, for the Premonstratensians, in Prague, 1696, for the Minorites, Prague, after 1702, and for the Ursulines, in Prague, until 1710. In 1706 Liška returned to Silesia to take over Willmann's workshop in Lubiąż (Ger., Leubus). He died there in 1712.

One of the most important painters active in Bohemia and Silesia around 1700, Liška exerted an influence on his pupil Neunhertz (*q.v.*), as well as on numerous other artists, including Brandl (*q.v.*).

29. The Blessed Humbelina

Pen and black ink, brush and black and gray washes
5⅝ × 4 (143 × 101)
Inscribed in black ink below center: *B. Humbelina*

The Art Institute of Chicago; Leonora Hall Gurley Memorial Collection, 1922.3387

PROVENANCE: William F. E. Gurley (Lugt 1230b, bottom right)

LITERATURE: Biedermann, in Augsburg 1987, p. 88

Figure 14. Jakob Andreas Friedrich, after Johann Christoph Liška, *The Blessed Humbelina*, engraving, from Augustinus Sartorius, *Cistercium Bis-Tercium*, Prague 1708.

A note on the mat by Rolf Biedermann first correctly identified Liška as the author of this drawing, which had been regarded as the work of an anonymous artist and then given to Jonas Umbach.[1] It is one of two sheets by the same hand in the Art Institute of Chicago with similar dimensions and media.[2] The second sheet represents the Blessed Henry with Saint Bernard of Clairvaux.[2]

While Biedermann has subsequently specified the purpose of the drawing, his remarks can be enlarged. It is one of the fifteen drawings prepared by Liška for illustrations of the German edition of a history of the Cistercian Order written by Father Augustinus Sartorius to commemorate the six-hundredth anniversary, in 1698, of the founding of the Prague Order. The original Latin edition was published in Prague in 1700, but embellished by engravings in the German version of 1708.[3] Liška's designs were executed as engravings by Jakob Andreas Friedrich in Augsburg; other designs were prepared by Johann Rieger (*q.v.*) and Andreas Jahn. Besides the drawings in Chicago, three other sheets by Liška for this project have survived.[4]

The drawing exhibited here served for an illustration (fig. 14) placed between folios 88 and 89. The engraving is in the same direction as the print and follows its dimensions closely. The drawing leaves a space open at the bottom, which is occupied by the name of the saint, but which is filled with lengthy inscription in the print.

Information on the saint can be gained both from the texts and from the caption to the illustration. Humbelina was the only sister of St. Bernard, nearest to him of his siblings in age, and quite similar to him in appearance and manners. According to her biographer, she would have followed Bernard to his retreat with his companions if her sex had allowed. However, she married the grandson of a Burgundian duke, the brother of the duke of Lorraine, upon the urging of her father. In imitation of her brother and out of piety, she founded a cloister of Cistercian nuns, of which she became mother superior. She died in 1141; her descendants include members of the ducal house of Lorraine.

The drawing is nearest in style to other sheets by the artist for the project, including the design for St. Luitgard. It is

98

much more lively in appearance than the print by Friedrich executed later. In this regard, its dramatic treatment of light and shadow and fluid handling approximate the baroque bravura of the artist's oil sketches.

This type of design contrasts with other types of prepara-tory studies by the artist, for example a preparatory study in chalk in the Manning collection, New York.

29.

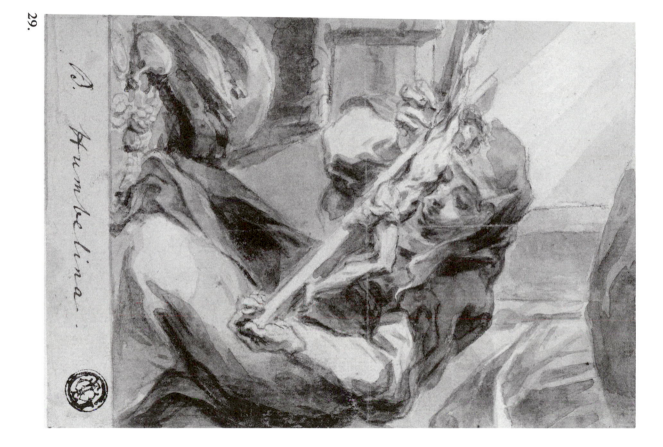

1. "*not Umbach Lischka for Cisterciens* [illegible]./*Biedermann.*"
2. Inv. no. 22-3492, inscribed *B. Henricus königl. Prinz aus Frankreich,/ und S. Bernardus, als sein heiliger Vater und Lehrmeister.*
3. See Sartorius 1700, published in German, Prague 1708.
4. See Biedermann in Augsburg 1987; these include representations of the Blessed Ida and Elizabeth in Augsburg, Städtische Kunstsammlungen, inv. no. G.3130—58, 1987, cat. no. 39, ill. p. 89, and also in Preiss 1979, p. 82, ill. p. 83; *St. Peter of Chateauneuf,* Frankfurt am Main, Städelsches Kunstinstitut, inv. no. 14331, ill. in Schilling 1973, 1, p. 170, cat. no. 1743, 2, ill. 162, fig. 1743; *St. Lutigard with Christ on the Cross,* Nürnberg, Germanisches Nationalmu-seum, inv. no. Hz. 4268, ill. in Preiss 1979, p. 8, with further references p. 84.

Josef Ferdinand Fromiller
(1693–1760)

The son of Benedikt Fromiller, a painter who was named *Landschaftlicher Maler* of Carinthia in 1708, Josef Ferdinand Fromiller was born in Klagenfurt in 1693. He studied painting first with his father and then with Ferdinand Steiner, whose workshop he left in 1713, perhaps to travel to Munich. From 1716 on he is evinced in Carinthia, and his first major works, the frescoes in Schloss Trabuschgen, date from this year.

Thereafter, Fromiller painted a number of frescoes in various places in Carinthia, including in Stallhofen (funerary chapel, schloss, 1717), in Maria-Saal (pilgrimage church, 1716), in Ossiach (after 1750), and in Klagenfurt (various public buildings, 1739–40, 1759). He also painted histories, genre subjects, portraits, and made numerous etchings. Fromiller is also the author of the *Gründliche Anleitung zu der Edlen Reis und Mahl Kunst...* of 1744.

Josef Ferdinand Fromiller was named *Landschaftlich* painter of Carinthia in 1733 and bought a house in Klagenfurt in 1734. This recognition as official painter confirmed his status as the most important artist active in Carinthia in the first half of the eighteenth century. Fromiller died in Klagenfurt on December 9, 1760.

30. St. Luke Painting the Virgin

Red chalk and brown wash, heightened with white
5⁷⁄₈ × 8¼ (149 × 209)
Signed and dated in red chalk, upper left: *Joseph Fraumillr 1717*; inscribed in brown ink on verso: 65

Collection of Mr. and Mrs. Martin Baker

PROVENANCE: Unidentified collector (drystamp star C on mount); sale, Christie's Amsterdam, November 30, 1987, no. 189

The date on this signed drawing indicates that it was executed at the time of the earliest independent commissions given to the Carinthian painter Josef Ferdinand Fromiller. During the period in which it was made, he worked for Franz Anton Stampfer, decorating the ceiling of Schloss Traubuschgen in Obervellach, Carinthia, signed and dated 1716, and the wall and ceiling paintings in the Stampfer chapel in the nearby church of St. Mary, Stallhofen, signed and dated 1717. A signed drawing of the *Annunciation* dated 1717 is also known.[1] Since the drawing in this exhibition represents another early example, it provides an important reference point for knowledge of the artist's relatively rare work as a draftsman.

This drawing differs in style, if not technique, from some of the artist's more familiar later drawings.[2] The catalogue of the sale in which it was recently purchased suggests that it was possibly inspired by an Italian prototype. Fromiller's style seems to be derived from such earlier sources. He employs an identical red chalk and wash manner, achieving similar painterly effects, for later works that are based on other prototypes.[3] Like many artists, Fromiller learned his trade by copying, and it is also true that about the time he

drew this sheet, he copied Rubens's Medici cycle in paintings for the walls of Schloss Traubuschgen.

However, the freshness of the execution suggests that it may be an original invention rather than a copy; no prototype has yet been found, and if one exists, this work has been successfully transformed into a plausible personal statement. This drawing depicts St. Luke steadying his right hand with a maulstick, as he uses a brush to paint the Virgin and Child; two angels look upon the scene. As the subject refers to painting, and the drawing is signed and dated, it is possible to hypothesize that it had some personal significance for the artist, like many other such sheets referring to the arts that were given as gifts or drawn in *Stammbüchern*.[4] The small size and signature also suggest that it was either given as a gift or formed part of a *Stammbuch* (or *album amicorum*, autograph album).

1. For this drawing, now in a *Klebeband* in the Carinthian Landesarchiv, fol. 90, see Thaler 1978, p. 30.

2. For a sampling of these, see Garzarolli-Thurnlackh 1928, pls. 42–47.

3. See Thaler 1978, p. 231.

4. For the subject of representations of themes regarding the arts in drawings given as gifts or appearing in *Stammbücher* of an earlier time, see Peter Raupp, in Stuttgart 1979, 2 (1980), pp. 223–30.

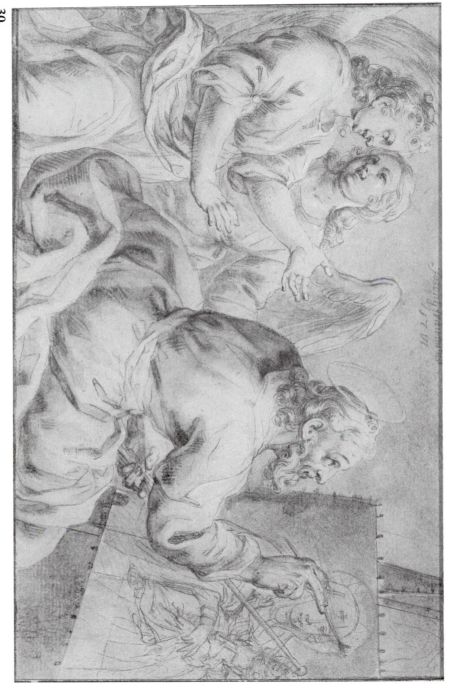

Paul Troger was baptized on October 30, 1698, in Welsberg near Zell in the Pustertal, South Tyrol. He received his first artistic instruction from Matthias Durcher, and after entering in the service of the Firmian family, was sent to study with Giuseppe Alberti in Cavalese. Probably upon Alberti's death in 1716, he obtained the support of the Prince Bishop of Gurk in Carinthia, enabling him to study in Italy, first in Venice, and then in Naples and Rome. He returned to the South Tyrol in 1722 to paint his first major work in Kaltern (near Bozen; It., Bolzano), and was again in Italy 1722–26.

In 1726 Troger was appointed court painter of the Bishop of Gurk, executing some works there. In 1727–28 he moved to Salzburg, where he painted his first large ceiling frescoes. In 1728 Troger settled in Vienna, where he joined the academy in 1745 and attained the post of *Kammermaler*. In 1751 Troger became professor there and served as director from 1754 to 1757. He died in Vienna on July 20, 1762.

During his period in Vienna, Troger was a prolific painter of altarpieces and frescoes, executing works in a region extending from the South Tyrol through Austria and Moravia to Hungary. These works, including paintings in St. Pölten, Melk, Altenburg, and Zwettl, give him, along with Daniel Gran, a key role among painters in Central Europe in the early and mid-eighteenth century. His significance for the history of painting is enhanced by his importance as a teacher at the academy, where he had an impact on the formation of many major younger artists, including Franz Sigrist (q.v.), Franz Anton Maulbertsch (q.v.), Caspar Franz Sambach (q.v.), Johann Jakob Zeiller, Martin Knoller, Josef Ignaz Mildorfer, and Christoph Unterberger.

31. Apollo Slaying the Pythian Dragon (recto); The Transformation of the Sisters of Phaëthon (the Heliads) (verso)

Recto: pen and brown ink; verso: pen and brown ink, and graphite
8 1/8 × 12 3/4 (205 × 320) (sight)
Inscribed in graphite on upper left, verso, 7 (!) 96
Unidentifiable watermark (wreath with bell?)

Museum of Art, Rhode Island School of Design; Anonymous gift, 62.040

PROVENANCE: Carlo Prayer (Lugt 2044, lower left, recto); F. Asta (Lugt 116a, lower right, recto); Herbert N. Bier, London

This previously unpublished double-sided drawing can be attributed to Paul Troger. It possesses similar characteristics to authentic sheets by this important Austrian draftsman, and especially those of his Italian period.[1] The very summary, vibrant pen stroke, which actively articulates forms, is common to his work. This use of the pen is encountered especially in certain early drawings by the artist, where the outlines of forms are at times not always completed.[2] The conception of landscape elements, especially trees, with looping strokes for leaves, and vibrant crosshatching on the trunk, is also common to Troger's work.[3] The working pro-

cedure, seen especially on the verso, in which a preliminary drawing is laid on in graphite and then developed in pen, is also typical.[4] Resemblances of the wildly agitated figures and the fanciful subject to a *capriccio* by Troger datable ca. 1728 suggest that it may even be dated somewhat later, slightly after his return from Italy to Austria.[5]

During Troger's sojourn in Italy from 1717 to 1725 or 1726, he began what was to become a large collection of drawings, including sketchbooks of sheets that are now scattered throughout European collections, though many of them are in Budapest and Vienna. This drawing resembles some of those sheets, both in subject matter and style, and the presence of drawings on both sides speaks for the possibility that the Providence sheet derives from a sketchbook itself.

The drawings on both sides are both linked iconographically to the sun god Apollo. On the recto can be seen an archer firing his bow at a dragon; a figure in the right background is most likely a river god, adding another touch of the antique to the scene. The subject depicted is Apollo slaying the Pythian dragon, a tale most familiar from Ovid (*Metamorphoses* 1: 438–51).

The scene on the verso shows a woman being transformed into a tree. Herbert Bier, a former owner, noted that it could be a depiction of Apollo and Daphne, which, in fact, is the ensuing story in Ovid.[6] Yet Apollo is not seen pursuing or grasping Daphne; moreover, more than one female is present, and several may be changing into trees. The women also seem to be expressing grief, and they are grouped around a tomb. These details correspond much better to the story of the transformation of the Heliads into trees after the death of their brother Phaëthon, known from Ovid (*Metamorphoses* 2:314ff.) and Philostratus (*Eikones* 1: 11); all were children of Apollo.

The function of designs on this sheet may be similar to that of the other Troger drawings exhibited here (cat. nos. 32, 74). Bier suggested that one side was possibly a design for an etching, but no print of either subject was executed by or after Troger. Nor is he known to have executed paintings of these subjects, so that it cannot be demonstrated that the drawings on the Providence sheet were done as compositional sketches for commissions. Nevertheless, both sides of the sheet are at least as freely composed as the Manning drawing (cat. no. 32), and they likewise may be independent inventions.

1. Eckhart Knab has also concurred (orally) that this sheet derives from Troger's early Italian period.
2. For example, drawings of *The Flight into Egypt* and of *The Martyrdom of a Bishop Saint* in Budapest, Szépművészeti Múzeum, inv. nos. 1916–II and 1916–12; the first of these is well illustrated in Garas 1980, no. 12.
3. As, for example, in a drawing from the Artaria collection now in the Albertina, inv. no. 27032.
4. Troger's concentrated and considered working procedure from a graph-

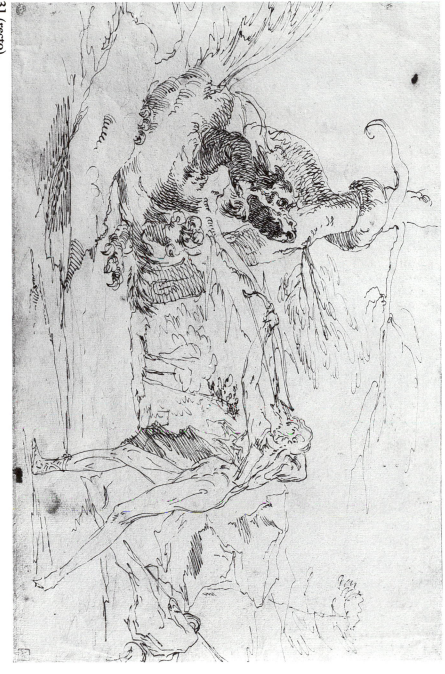

ite preliminary sketch is noted by Knab, in Altenburg bei Horn 1963; pp. 147–48.

5. Very similar qualities are found in a drawing from the Artaria collection in the Albertina, inv. no. 27012, a *capriccio* best illustrated in Garzarolli-Thurnlackh 1928, fig. 64. Aschenbrenner and Schweighofer's dating of this drawing ca. 1728 (in Aschenbrenner 1965, p. 149), is preferred.

6. According to information in the records of the Rhode Island School of Design.

32. Leda and the Swan

Pen and brown ink, traces of graphite
5 1/8 × 7 7/16 (132 × 189) [sight]

Collection of Robert and Bertina Suida Manning

PROVENANCE: William and Eugénie Suida (*Prof. W. Suida* inscribed in graphite on verso)

EXHIBITIONS: Lawrence, Kansas 1956, p. 15, no. 57; Sarasota 1972, pp. 30–31, cat. no. 68, ill. p. 65

This drawing provides a good demonstration of Troger's early development as a draftsman. Kent Sobotik, commenting on it in an exhibition catalogue in 1972, noted that its style and subject indicated a dating of ca. 1724, during Troger's visit to Rome. The angular and somewhat stiff treatment of drapery and fine ductus of line that are seen in drawings from Troger's Roman sojourn are also evident here.[1] The very loose treatment of line, however, is close to drawings dated before 1724, so that it is possible that this drawing was done even earlier.[2]

The subject also appears frequently in seventeenth- and eighteenth-century art, and it is also encountered elsewhere in the work of Troger. A representation of Jupiter in the form of a swan wooing Leda was also depicted by Troger in a drawing in a private collection in Vienna that must be dated to the artist's Italian period.[3]

The Manning drawing differs somewhat from the copies Troger made during his visit to Italy. While the composition is centered on the sheet, as it is on some of the copies, thus suggesting that it may be taken from a pre-existing design, it lacks the clear delineation of a border that Troger inserts in such copies. No prototype is known, nor has any painting or print executed after this sheet been found. Certain fresh qualities evident in the execution of the drawing, such as the billowing smoke, and the loose hatching, are not present in Troger's copies.[4]

It is possible that this striking drawing was an independent compositional sketch. Eckhart Knab has remarked that the majority, or at least very many, of Troger's drawings originated from joy in inventing and designing, in the graphic transcription of ideas. This sheet exemplifies the calligraphic nature of Troger's draftsmanship, with its reliance on and love of line for its own sake.[5]

1. The comments made by Klára Garas on a drawing of *The Annunciation to Joachim and Anna*, Budapest, Szépművészeti Múzeum, inv. no. 878, in Garas 1980, no. 10, are pertinent here.
2. Compare, for example, a drawing in the Albertina, *Bishop Saint and Nun*, inv. no. 4346, Aschenbrenner 1965, cat. no. 171, ill.
3. See Aschenbrenner 1965, cat. no. 109, ill.
4. As in the drawing mentioned in note 1. Other examples of Troger's copies of Italian wall paintings are found in private collections in the United States.
5. Knab, in Altenburg bei Horn 1963, p. 147.

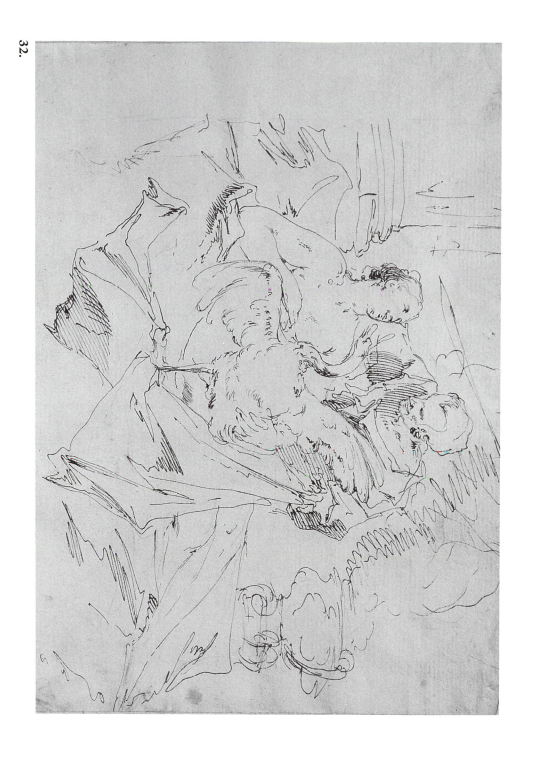

I.E. Holzer inv. et fecit.

Figure 15. Johann Evangelist Holzer, *Adoration of the Shepherds,* etching, 169 × 115 mm. Augsburg, Städtische Kunstsammlungen, G 4500.

Born the son of a miller in Burgeis in the South Tyrol in 1709, Holzer first studied art at the cloister school at Marienberg, and in 1724 was apprenticed to Nicholaus Auer in St. Martin in Passeier-Tal. In 1728–30 he became an apprentice to Jospeh Anton Merz in Straubing; his first works date from this time. He then moved to Augsburg and worked there with Johann Georg Rothbletz.

In 1731–32 Holzer studied with Bergmüller (q.v.) and probably collaborated with him on facade frescoes and altarpieces. He also designed book illustrations and executed etchings. He gained a great reputation during the 1730s, collaborating with leading artists such as Johann Elias Ridinger (q.v.), Georg Philip Rugendas (q.v.), and others, receiving commissions from elsewhere, and working for the Augsburg publishers.

In 1737 he painted a surviving, though damaged, fresco in the summer residence of the prince bishop of Eichstätt, and was consequently named the prince bishop's court painter. From 1737 to 1740 he also worked on the decoration of the cloister church of Münsterschwarzach, which was destroyed in the early nineteenth century. Summoned in 1740 by Clements August, the prince-elector of Cologne, to decorate his hunting castle at Clemenswerth, he died in Clemenswerth in 1740.

Holzer's early death cut short a career whose promise can now best be envisioned on the basis of his one surviving fresco that remains in good condition, at St. Anton, Partenkirchen (1736). He was regarded as a genius in his own time and had a great impact on Augsburg painters throughout the century.

33. Adoration of the Shepherds

Pen and brown ink, gray wash over black chalk, incised (with quill or stylus?); verso rubbed with black chalk
6 × 4½ (152 × 107)

Crocker Art Museum, 1871.65

PROVENANCE: Prague, Ritter von Lanna (?); probably R. Weigel, Leipzig; Edwin Bryant Crocker

EXHIBITIONS: Sacramento 1939, group 2, no. 51 (as *Adoration of the Magi*); Minneapolis 1961, no. 43; Sacramento 1971, no. 83, ill. p. 124 (as *Adoration of the Christ Child*); Reno 1978, no. 6, ill. (as *Adoration of the Christ Child*)

LITERATURE: Mick 1984, pp. 26, 99 (under cat. no. 20)

An etching signed "*Ioh. Holzer inv. et fecit.*" (fig. 15) reproduces this drawing in reverse, indicating that it is an original study for the print by the artist. The blacking on the back of the drawing and the light incision with some tool, stylus or quill, suggest that the sheet was used directly in the preparation of the etching.

The Sacramento drawing thus offers important information that allows hypotheses to be made about the variety of Holzer's working procedures. For some etchings of rather complicated content for which he provided the invention, such as his *Vision of St. Augustine* of 1734, Holzer also seems to have made oil sketches, as well as earlier preparatory stud-ies in chalk.[1] For other projects to be executed by printmakers, as in the next example in the present exhibition (cat. no. 34), he made broadly drawn designs, with pen outlines and rather freely applied washes, leaving it to the printmaker to interpret the translation into hatched lines and onto the plate. For etchings that he himself made, such as that related to this Sacramento sheet, Holzer seems to have relied on a drawing fairly close in appearance to the final etching. Holzer's etching has transformed the shadowed areas indicated by washes in the drawing into a pattern of hatching and crosshatching of varying density according to that found in the preparatory study, creating a subtlety of distinction not found in Steinberger's etching after Holzer's design (see for example fig. 16), but approximating the drawing itself.

The etching for which this Sacramento drawing was made forms a pair with a representation of the *Adoration of*

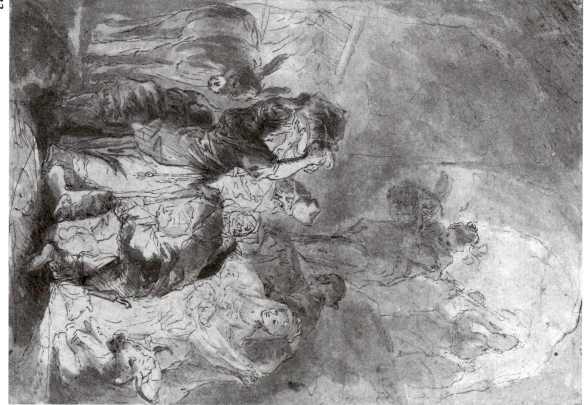

the Magi, for which a preparatory drawing also survives.[2] The subject of this pair makes clear that the Sacramento drawing, and the etching based on it, must depict the related subject of the *Adoration of the Shepherds*. The characters wearing turbans and seemingly exotic clothing are pastoral types, and not magi; a further clue to their identification is the shepherd's crook in the right foreground of the drawing.[3]

The etchings of the *Adoration of the Magi* and the *Adoration of the Shepherds* have long been prized. Many copies were made of them in the eighteenth century,[4] and Johann Wolfgang von Goethe, an avowed admirer of the artist, owned

good impressions of these particular prints.[5] Twentieth-century scholars of Holzer's work have praised them especially.[6] The relatively worked-up drawing and its more elaborate pendant from the Schmid collection may indeed have been regarded as finished works of art, like the oil sketch for the St. Augustine etching, and preserved because of this reason.

Some of the praise for Holzer has come for what has been regarded as his adaptation of the so-called "Rembrandt" manner of printmaking, in the use of which he is supposed to have been one of the first artists in eighteenth-century

Southern Germany. (For another example of this trend, see cat. no. 76). Holzer's use of chiaroscuro, his subtly differentiated handling of light sources, and his use of silhouetted figures in the foreground have all been seen as derived from Rembrandt. More perceptively, Ernst Neustätter has noted that analogies extend beyond Holzer's graphic technique and are found in his paintings, for example, in the treatment of light in Holzer's frescoes in Partenkirchen.[7] This seems a better way to express those ineffable effects that are visible in what to this writer, as to earlier observers, is Holzer's astonishingly beautiful accomplishment in paint, a glimmer of whose beauty is caught even in the luminescent qualities of this small drawing.

Though Neustätter dates the etching of the same subject, implicitly, later than 1736, Mick's suggestion of ca. 1733 is probably preferable, given the figure types, which are not so comparable to those of Holzer's slightly later works.

1. An example in a private collection of the finished etching by Tobias Lobeck of Augsburg is illustrated in Mick 1984, p. 40; see also p. 41 for the preparatory study in red chalk on blue paper (Stuttgart, Staatsgalerie). A painting of the same subject also exists in the Crocker Art Museum, 1872.389; see Chicago 1978, no. 11, pl. 9; and Crocker Art Museum 1979, no. 45, ill. p. 137. Although the dimensions of the painting differ from those of the etching, the claim to invention in the signature on the painting "*J. Holzer inv. et pinx*," strongly suggests that it was used as a preparatory study for the print. For the interpretation of the meaning of the signature "*inv*." on paintings, see, however, Bushart 1964, esp. p. 167.
2. Collection Anton Schmid, Vienna (formerly private collection, Vienna; now collection of the Prince of Liechtenstein), illustrated Mick 1984, p. 28. The etchings are discussed most thoroughly by Neustätter 1933, pp. 85–87.
3. The subject seems to have continued to cause confusion as late as 1971, where in the checklist of the Crocker's drawings, p. 153, it still bears the apparently traditional title *Adoration of the Magi*.
4. See Neustätter 1933, pp. 101–2, n. 216, for a list of copies after these etchings.
5. For Goethe's admiration of Holzer, and his collecting of these etchings, see Mick 1984, pp. 26–29, and p. 99, cat. no. 18.
6. See Neustätter 1933, pp. 86–87, and Mick 1984, p. 26.
7. Neustätter 1933, p. 87.

34. Adoration of the Shepherds

Pen and brown ink, brown wash
5¾ × 9½ (145 × 240)
Inscribed in another brown ink, lower left : *I. Holzer inv. & del.*

Crocker Art Museum, 1871.64

PROVENANCE: Johann Andreas Pfeffel (? [inscription on old mat]); C. Rolas du Rosey (Lugt 2237, bottom right corner; sale, R. Weigel, Leipzig, September 15, 1864?); Edwin Bryant Crocker

EXHIBITIONS: Sacramento 1939, group 2, no. 50; Lawrence, Kansas 1956, cat. no. 23; Sarasota 1972, no. 64; Claremont, California 1976, no. 33, ill. p. 62

LITERATURE: Sacramento 1971, p. 153; Mick 1984, pp. 35, 99 (under cat. no. 20), ill. p. 34

This drawing is a preparatory design for an etching by Johann Christoph Steinberger, signed *I. C. Steinberger* and inscribed *I. Holzer inv.* (fig. 16), that reproduces it in reverse.[1] This relationship helps explain the inscription "*inv. & del.*" on the sheet in Sacramento, perhaps a later addition (it is in another ink), repeating the claim for Holzer's invention, and also noting that he executed the drawing. Holzer provided both the narrative subject and the framing elements, as they are done with the same ink using the same strokes.[2] The framework includes along with more specifically pastoral elements, such as the shepherd's staff, hat, horn, garland, pipes, and crook, C- and S-curve plant-like and rocaille ornament of the sort disseminated by Augsburg printmakers.

The drawing for the *Adoration of the Shepherds* is the only known preparatory study for a group of scenes from the life of Christ and of John the Baptist produced by the Augsburg publisher Johann Andreas Pfeffel.[3] The inscription on an old mat may refer to this collaboration, or may indicate that Pfeffel owned the drawing. Holzer lived in Pfeffel's house in Augsburg in the late 1730s.[4]

Figure 16. Johann Christoph Steinberger, after Johann Evangelist Holzer, *Adoration of the Shepherds*, engraving. Munich, Staatliche Graphische Sammlung, 1997:1.

Because of his dating of this period of residence, Albert Hämmerle has dated the prints in the period 1736–38.[5] Noting that they combine all kinds of motifs from Holzer's fresco and panel paintings from the years 1730–36, Ernst Neustätter dates the series hypothetically (*vermutlich*) around 1736.[6] E. W. Mick places them ca. 1733.[7] The preparatory drawing, however, in addition to revealing what seems to be a different stylistic phase from that of the other sheet in Sacramento, employs the same broad use of wash combined with summary yet sure execution of features in pen as in other drawings by Holzer datable to 1736–37, indicating that a later date is preferable.[8]

Like other compositions in the series, this design was evidently quite popular.[9] A fairly free copy after Steinberger's print was drawn by the Augsburg printmaker Johann Jacob Ebersbach (fl. 1717–54).[10] Ebersbach's drawing replaces the figures in the background left of the etching with buildings, extends the wall to the right, adding a tree, and replaces the cartouche and plants at lower right with a broken plinth and tree trunk. This procedure attests to the widespread use of Holzer's inventions by other eighteenth-century artists, including most notably Matthäus Günther (q.v.) This in turn provides testimony to the notion that his light-filled designs were communicated not only through the intermediary etching.

1. Kent Sobotik, in Sarasota 1972, seems first to have recognized this connection.
2. Neustätter 1933, pp. 84–8, who evidently did not know this drawing, suggests that it has been embellished with symmetrical ornament "*nach Art der 'Arabesques'*" by the etcher.
3. The first state of the print is illustrated here; a second state, bearing the inscription *IAP excudit*, also exists (example in Augsburg, Städtische Kunstsammlungen, Graphische Sammlung, inv. no. G 20048).
Neustätter 1933, pp. 84–85, refers to two series of prints and lists ten subjects; Mick 1984, p. 99, cat. no. 20, mentions nine subjects.
4. Hämmerle 1928 dates this stay 1736–38; Mick 1984, p. 102, cat. no. 54, pp. 737–40.
5. Hämmerle 1928, p. 153.
6. Neustätter 1933, p. 84.
7. Mick 1984, p. 34.
8. For comparable material, see *Christ and the Woman at the Well* (Darmstadt, Landesmuseum) and *The Brotherly Love of Castor and Pollux* (Innsbruck, Tiroler Landesmuseum Ferdinandeum) dated respectively 1736 and 1737 by Mick 1984, ills. pp. 59, 74.
9. See Neustätter 1933, p. 101 n. 204, for examples of other copies after Holzer prints in the series.
10. Berlin-Dahlen, Stiftung Preussischer Kulturbesitz, inv. no. KdZ 7030; signed J J. Ebersbach.

34.

I. Holzer inv. & del.

(Johann) Gottfried Eichler the Younger

(1715–1770)

Johann Gottfried Eichler the Younger belonged to a dynasty of Augsburg painters, of which the most notable member was his father, Johann Gottfried Eichler the Elder (1677–1759), the Protestant director of the Augsburg academy of art. He was born in Augsburg in 1715, and probably studied with his father. He may have continued his studies in Holland but was certainly in Vienna and Nuremberg, since he became draftsman in nearby Erlangen. He married in 1747. In 1750 he returned to Augsburg, where he remained until his death on October 22, 1770.

While Eichler was highly regarded as a portraitist, he was chiefly active as a draftsman supplying designs for the publishers in Augsburg. Among his major book projects are his designs for the Hertel edition of Cesare Ripa's *Iconologia* (1758–60), and his illustrations for Paul von Stetten's *History of Augsburg*. He also produced designs for craftsmen, and many *Thesenblätter*, a genre of print explained in the following entry.

35. Design for a Thesis (Thesenblatt) with the Empress Maria Theresia

Pen and black ink, gray washes
24⅝ × 17⅞ (625 × 454)
Signed and dated in black ink, lower right: *G. Eichler jun delin/1742*; inscribed (by the artist) at the top, above the baldachin: *Disjunctas bello, CONCORDIA, junge coronas*; on the curtain in the upper left corner: *Acie ferri*; on the curtain in the upper right corner: *Acie consilii*; on the base to the left: *ex umbris clarior*; on the banderole held by the putti to the left of the throne: *Hac Mundo Pacem Victoria*; on the ball held by Fortune: *Auspice Virtu Comite Fortuna*; on the steps in the background to the right: *His monstris fugatis*; near the figure of Time: *Meliora redibunt*; on the steps of the throne: *Hanc justa per arma tuere*; on the steps to the lower right: *Felix Catastrophe*; on the ship lower left: *Exercitium concordia*; on the book lower right: *Cuique suum*; near Mars lower right: *depositis armis placidus/fert ostia terris*; on the molding, bottom left: *Revirescent*; bottom right: *Pace virente*; below: *Meta lactatur adepta/ iam tuta quiescat*; lower left: *Hoc Fulmine/ fervor*; lower right: *Adversis urgetur in altum*

Cooper-Hewitt Museum; Gift of Eleanor and Sarah Hewitt, 1931-64-136

PROVENANCE: Peoli Collection; Miss Sarah Cooper Hewitt

EXHIBITIONS: American Federation of Arts 1953; New York 1959, cat. no. 80

LITERATURE: New York 1962, no. 76, p. 106, ill. p. 88

The complicated allegory in this drawing relates to the reign of the Empress Maria Theresia, who can be recognized as the monarch shown holding a scepter and orb. She is depicted seated upon a throne covered by a baldachin, with an imperial double eagle on the cloth of honor behind her. The inscriptions and personifications, mainly identifiable through reference to Cesare Ripa's *Iconologia* (an edition of which the artist illustrated), refer to the virtues of her government. Together they function almost as devices alluding to the histor-

ical situation, in particular to the conclusion of peace treaties in 1742, the date of the drawing.[1]

The inscription at top, "Harmony, join together the crowns separated by war," most likely refers to the consolidation of the crowns of the Habsburg lands, or to the conclusion of peace with Prussia. To Maria Theresia's right can be seen a figure of Victory offering an olive branch to Peace, with a caduceus, a symbol of peace as well as commerce or enterprise, as its text reads "with this victory peace for the world," again a reference to the conclusion of peace. This message is also suggested by the soldiers who flee in the right background, with the *titulus* "these monsters having been put to flight" below them; better times are also suggested by the rising sun to the left, which is accompanied by the words, "brighter from the shadows." Behind the figure of Time in the group in the lower part of the composition is a figure of Time, behind whom the inscription, "Better things shall return," also refers to the coming of happier times.

To Maria Theresia's right are figures of Fortune and Truth, who are described by a traditional inscription referring to Fortune accompanying Virtue. The text directly below the empress refers to her just defense through arms. The inscriptions placed above and below the composition, near the empty cartouches, again refer to imperial virtutes.

The attributes of the arts are scattered around a personification of a woman holding the fasces and wearing a crown, who probably stands for a unified Europe but may more particularly allude to the unity of the state. The motto on the ship, most likely the ship of state, translates as "the harmony [or with the harmony] of the armies," again suggesting the flourishing of the arts that will occur with the reestablishment of peace.

In the group at bottom right can be discerned a resting figure of Mars, the god of war: putti with the mercantile attributes play around him. The inscription, "When arms have been put aside, peaceful, he will open the gates to the world," refers to another role for Mars as a promoter of commerce. To the left, the phrase, "to each his own," again may allude to a more harmonious disposition of power relations, and the writing on the molding immediately below, "they will be restored as peace flourishes," again refers to the traditional message of the flourishing of arts and commerce in peacetime.

The key to the interpretation of the allegory, and its manifold inscriptions, is given by the lines on the steps of Maria Theresia's throne, especially the words "Happy Catastrophe." In the context of the peaceful imagery with which the drawing abounds, this probably alludes to the conclusion of the treaties, signed in Breslau (Pol., Wrocław) on June 12, 1742, and Berlin on July 28, 1742, that ended the Silesian war with Frederick II ("the Great") of Prussia. According to the

Other Designs for Paintings, Books, Prints, and Independent Drawings

(Johann) Gottfried Eichler the Younger

36. Moses and Aaron before Pharoah

Pen and black ink, gray wash
9⅑⁄₁₆ × 7⅝ (243 × 194)
Signed and dated, lower left: *G. Eichler jund* [sic] *f. 17...*

The Spencer Museum of Art, University of Kansas, 77.111

PROVENANCE: Loewi-Robertson, Inc., Los Angeles; state purchase, 1977

LITERATURE: Biedermann 1985, pp. 22–29

The subject of the drawing is an infrequently depicted episode from the Bible, the appearance of Moses and Aaron before Pharaoh (Exodus 7:10–12). At God's command Moses and Aaron demand he let their people go. Pharaoh in turn asks for proof of their divine mission, whereupon Aaron casts down his rod, which turns into a snake.

Although no print after it has yet been found, Eichler's drawing was most likely made as a design for an engraving, as Biedermann noted, recognizing its connection with another work for such a purpose. It is executed in a similar medium, is done in a similar format in approximately the same dimensions, and the visual style resembles that of another Old Testament scene by the artist, now in Augsburg. [1] This drawing of the *Reconciliation of Jacob and Esau* was used as a sketch for no. 153 in the series of engravings *Imagines* published by Johann Georg Hertel, with whom Eichler often collaborated.

As Biedermann also notes, the unconfined composition, with its ornamental projections, assymetrical balance, and light and decorative character, takes on the appearance of a *rocaille* cartouche. This fine example of the artist's style therefore serves as well to exemplify rococo design in Augsburg.

1. Inv. no. G.14057, pen and black ink, gray wash, with red chalk on the verso, 25.9 × 19 cm, illustrated and discussed in Augsburg 1987, p. 248, cat. no. 118, ill. p. 249.

terms of the peace, Silesia was ceded to Prussia; the reading of the print would suggest that the motivation for this sacrifice was to reinforce the strength of the empire itself.

The extensive texts and the empty spaces inside the drawing indicate that it was a preparatory design for a print. The large size of the sheet rules out the possibility of its having been used for a book illustration. The theme and compositional format of the drawing point rather to its probable function as a design for a thesis (*Thesenblatt*). [2]

Thesenblätter (among their other names) were large prints produced to announce the ceremonial "Promotion" of candidates for degrees in universities of the sixteenth to eighteenth centuries. They indicated the theses that a candidate had announced to defend and the place and time of their event, and were often decorated with depictions of the prince or ecclesiastical dignitary under whose auspices or patronage the promotion was to occur. In this instance, the inscriptions and portraits pertaining to Maria Theresia show her as the patron of the proposed promotion.

Eichler is known to have prepared such designs. Another allegorical composition with portraits of Maria Theresia and the emperor Francis I containing a similar message about their peaceful reign has recently come to light. [3] No example of a print executed after the drawing exhibited here has yet been found, however.

1. The 1758–60 edition of Ripa illustrated by Eichler in which many of these personifications can be found has been reprinted, with notes in Maser 1971.
2. I am grateful to Wolfgang Seitz, director of the Forschungsgemeinschaft "Die Graphischen Thesenblätter des 16.-18. Jahrhunderts," Augsburg, for information on the subject communicated in a letter of May 17, 1986.
3. Sale, Christie's London, April 19, 1988, no. 161; ill. The drawing is described as "A Monument to the House of Austria," and signed and dated 1746. On the monument is inscribed *Asperal mox positi/ mitescent Saecula/ bellis.*

112

Karl Marx (Marcus) Tuscher
(1705–1751)

Born in 1705 in Nuremberg, Tuscher was raised in the city orphanage. In 1717–18, with the support of the curator of the orphanage, C. B. von Geuder, Tuscher began studying with Johann Daniel Preissler, the director of the Nuremberg academy. Upon completion of these studies in 1728, Tuscher went to Rome, where he worked for a number of years, leaving for Florence in 1731 in the company of Johann Justin Preissler. Tuscher served Baron Philip von Stosch, the noted antiquarian, in Florence, and was also named a member of the academy there in 1732. During the next nine years, he was active in Cortona, where he became a member of the "Etruscan Academy" (see cat. no. 37). Livorno, Naples, and Rome.

In 1741 Tuscher traveled to London via Paris. Not succeeding in his intentions of founding an art academy in England, Tuscher was, however, engaged to provide illustrations for a book to be presented to King Christian VI of Denmark. While at work on the book, he was called to Copenhagen as court painter and was named professor at the Danish academy of drawing and painting in 1748. Besides his work as a painter, he was involved during this period in the design of architecture, sculptural monuments, festival decorations, and urban plans. Tuscher died in Copenhagen in 1751.

work in the chapel at Ledreborg, Denmark, that was executed in 1745.[3] The Sacramento design may also be regarded as exemplifying the sort of appeal exerted by Tuscher, which caused him to be called to Copenhagen to become head of the academy there.

A portrait drawing of Johann Georg Bünzel that demonstrates another side of Tuscher's abilities is also found in Sacramento.[4]

1. Statens Museum for Kunst, Kobberstiksamling, TV 519, no. 41, inv. no. 7221, sold at auction at Weigel, November 28, 1864, no. 228, acquired by J. A. Boerner; and no. 40, sold at Weigel, no. 227; and no. 16, inv. no. G 82203, sold at Weigel, no. 225, acquired by J. A. Boerner.
2. Inv. no. G82203; *DIVVUS MARCUS EVANGELISTA/DUCITE PARTES AQUE* (?) ΜΑΡΚΩΣ/ΤΟΥΣΧΗΡΟΣ/ΖΩΓΡΑΦΟΣ ΝΟΡΙΚΟΣ (?) / ΑΚΑΔΕΜΙΚΟΣ [sic] ΗΤΡΟΥΣΚΟΙΣ]/ΕΠΟΙΕΙ (Markos Touscheros/Zographos Norikos [?]/ Akademikos Errouskos Epoiei).
3. Copenhagen, Statens Museum for Kunst, Kobberstiksamling, TV 519, no. 24.
4. Crocker Art Museum, inv. no. 1871.122.

37. Mathematician

Pen and black and gray ink, gray wash, heightened with white
Signed and dated in black ink on rock, lower center (in Greek):
ΜΑΡΚΩΣ/ΤΟΥΣΧΗΡΟΣ/ΕΠΟΙΕΙ. ΧⒽΗΗⒹΙΙΙΙ
(Markos Touscheros epoiei. 1744)
4 7/16 (113) diameter

Crocker Art Museum, 1871.997

PROVENANCE: probably R. Weigel, Leipzig

LITERATURE: Sacramento 1971, p. 164

This drawing probably belongs to a group that passed through the hands of the dealer Rudolf Weigel: several of them were sold at auction in 1864 and are now in Copenhagen.[1] One of these drawings, of the evangelist Mark, bears a similar inscription in Latin and Greek.[2] Its proud designation of the artist as a "Nuremberg painter" and "Etruscan Academic" suggests some of the spirit in which the sheet exhibited here was also made. The date beside the Greek text on the Sacramento drawing also indicates that it was made during the artist's sojourn in Italy.

The representation of a mature man who conforms to the type of a scholar, contemplating a geometric figure, fits the sheet's academic intentions. The subject is not yet precisely identifiable, however. It is possible that there is some personal reference or identification intended, as in the related drawing in Copenhagen, where the artist's name saint, Mark, is depicted.

The figural type of a mature man with curly hair and beard and the manner of modelling found in this sheet are also seen in a study for the *Ascension of Christ*, a design for a

37.

Other Designs for Paintings, Books, Prints, and Independent Drawings

115

Franz Xaver Karl Palko was born in Breslau (Pol., Wrocław) on December 3, 1724. He probably received his first instruction from his father, the painter Anton Palko, and perhaps from his brother, Franz Anton Palko (1717–1766), with whom he is sometimes confused but who specialized in a completely different genre, namely portraiture.

Franz Xaver Karl Palko was trained by Antonio Galli Bibiena, and in 1745 ended his studies at the Vienna academy with distinction. He painted the high altarpiece of the Trinity Church in Bratislava (Ger., Pressburg), a city where his brother and father were also active. By 1749 he was living in Dresden, where he worked for Count Brühl and frescoed the interior of the court church. He was named Saxon court painter in 1752.

In 1753 Franz Xaver Karl Palko settled in Prague, where he became one of the leading lights of fresco painting in Bohemia with his work in the church of St. Nicholas on the Small Side (Cz., Sv. Mikuláš na Malé Straně). He settled in Munich probably in 1762 and was appointed Bavarian court painter in 1764; he died there on July 18, 1767.

38. St. Jerome in the Wilderness

Pen and brown ink, on cream paper
13 1/8 × 8 1/4 (333 × 210)

Harvard University Art Museums, Fogg Art Museum; Gift of Belinda L. Randall (from the John Witt Randall Collection), 1898.37

PROVENANCE: Professor Lindner, Leipzig (note by Randall on old mat: *Pen Drawing by Sebastiano Ricchi for his St. Jerome / Cabinet of Professor Lindner at Leipsic cat. 878*); John Witt Randall (no. 291); Belinda Lull Randall

The use in this drawing of hatching and crosshatching applied with firm strokes in brown ink is reminiscent of the technique of printmaking, and its figural and landscape elements, which derive largely from North Italian art, recall the work of Paul Troger. (It is noteworthy that John Witt Randall's notes on the mat indicate he thought it a work by Sebastiano Ricci.) In fact, this style of drawing seems to have been promoted by Troger during the years he served as professor at the academy in Vienna. Troger made similar minutely executed drawings in a technique emulating prints, not only as preparatory designs but also as demonstrations for his pupils, who seem to have avidly copied them.[1]

Important clues to the attribution of the Fogg drawing are provided by four other sheets representing the same subject. The first of these drawings, whose location is unknown, is almost identical in most particulars to that in the Fogg, but bears the inscription "C. Palco."[2] There also exists another pair of related drawings that depict St. Jerome in the wilderness, with a lion at his feet; the composition of this second pair varies somewhat from that of the Fogg sheet and its double. While the unsigned version of this second pair, which is similar in dimensions to the Fogg sheet, was recently on the art market with an attribution to Paul Troger,[3] the second version of this composition (location unknown) is also inscribed "Carl Palco," and this variant may share a similar history with the Fogg drawing's mate.[4] Yet another version of this second signed sheet exists in Augsburg.[5]

Although Palko's drawings are close in appearance to Troger's, and the inherent difficulty therefore of distinguishing between the two draftsmen is understandable,[6] the traits of the Fogg drawing, as indeed of all the other drawings of St. Jerome, nevertheless match those of Palko's known etchings and drawings. The web of hatching used to create almost a sculptural sense of plasticity of form recurs in Palko's interpretation of Troger's drawing style. Other details, such as the depiction of feet, also point to Palko's authorship: similar elements are seen in his etching of *Christ and the Woman at the Well*.[7] St. Jerome's physiognomy in the Fogg drawing is particularly close to that of Joseph in Palko's drawing of the *Education of the Virgin*.[8] Even some of the anatomical inaccuracies and the limitation of space that Pavel Preiss observes in Palko's drawings in a print manner, especially in the *Education of the Virgin*, can be found in the Fogg *St. Jerome*.[9] Although he recognizes that the authorship of drawings by artists in Troger's circle is hard to determine, Preiss also notes that the lines are much more subtle in the drawing formerly on the market than those found in Troger's drawings and lack their kinetic energy (*Wucht*).[10]

It is likely that the Fogg drawing, as well as the other versions of the subject, are connected with the design for a print. In addition to their general technique, all are bordered by a thin line in pen, which suggests the outlines of a finished composition, or a plate mark. An etching depicting St. Jerome in the wilderness, seated on a rock, his lion at his feet, comforted by an angel, is recorded in the catalogue of a collection of ca. 1800.[11]

It is thus possible that the two versions of the composition of St. Jerome represent alternative designs for the print.[12] Palko evidently did work out his ideas for etchings in more than one stage. For the design of Palko's well-known etching of *Christ and the Woman at the Well*, a preparatory watercolor and an inscribed (?) pen drawing in the "print manner" of hatching and crosshatching are to be found.[13] If the Fogg sheet belongs to such a sequence of preparatory ideas, it might represent an earlier solution in the process, since the published description of Palko's etching is closer to the design of the second group of three. It is also possible that the pairs of compositions are inventions for independent prints that were perhaps not executed.

More problematic is the determination of the relationship of the Fogg drawing, the sheet recently on the market, and that in Augsburg to the two inscribed sheets whose whereabouts are unknown. Palko's drawings were highly es-

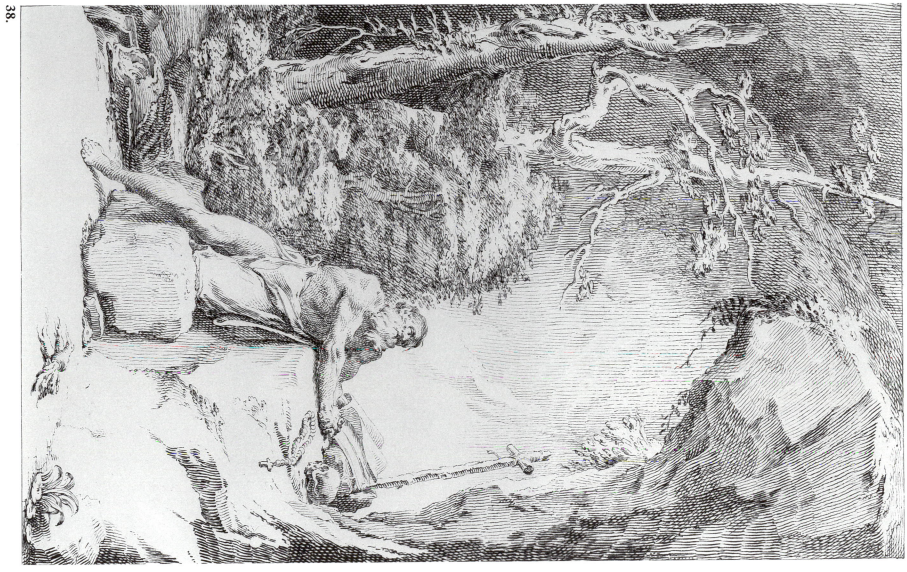

teemed in the eighteenth century, when they were sought after by collectors of such prominence as Pierre-Jean Mariette.[14] His reputation seems to have continued into the nineteenth century, to the extent that other drawings were attributed to him.[15]

Enough differences exist, however, both in the relation of the scale of the figures to the whole composition, in the density of lines, and in the individual strokes of the hatching, particularly in the foreground, to suggest that neither the Fogg drawing nor its double of unknown location is simply a copy after the other. Nearly identical repetitions of the same drawing associated with Palko seem to exist.[16] It is possible that both pairs of compositions of St. Jerome are original works by Palko, as is perhaps the drawing in Augsburg, which also reveals variations from the other related designs. In leaving the paper visible to provide a bright accent in the right foreground, and avoiding some of the density of hatching found in the version of unknown location, the Fogg *St. Jerome* seems closer to other original drawings by Palko, such as the *Education of the Virgin*. Pavel Preiss also regards the Fogg version as *"derber und kräftiger,"* the replica of a painter like Palko, and not a copy of another drawing.[17]

However this problem may be resolved, the date of Palko's designs for etchings, and his drawings in a print manner, can be established at ca. 1745, or somewhat later. The close resemblance to Troger drawings in other sheets from this period lends support to this dating.

1. See for this point Garzarolli-Thurnlackh 1928, pp. 50–51, n. 4, ill. 66.
2. Present location unknown; I am grateful to Dr. Pavel Preiss for showing me a photograph of this drawing, as well as its companion, also discussed in this entry, and for sharing with me information about prints by Palko. Dr. Preiss, who is preparing a monograph on the Palkos, notes that he obtained the photographs in question from Julian Stock of Sotheby's, London.
3. Pen and brown ink, 342 × 211 mm. Present location unknown; in 1987 with Thomas Le Claire, Hamburg. See Le Claire 1987a, no. 38, ill. p. 79, as Paul Troger. The statement that a partial copy of this drawing is published in Aschenbrenner 1965, cat. no. 280, is incorrect; the drawing there corresponds only in its general subject and style with that formerly owned by Le Claire.
4. Present location unknown; photograph with Pavel Preiss, who will be discussing it in his forthcoming book on the Palkos.
5. Städtische Kunstsammlungen, inv. no. G,5225–78, published as Paul Troger and illustrated in Augsburg 1987, p. 382, cat. no. 185, ill. p. 383.
6. Garzarolli-Thurnlackh 1928, p. 57; Garas 1961, p. 241; Preiss 1975, pp. 104–5; Jávor 1984, pp. 197ff.
7. Illustrated in Swoboda 1964, p. 222.
8. Amsterdam, Rijksprentenkabinett, inv. no. 69:92, pen and dark brown (black) ink, and wash, over graphite, on white paper, 330 × 241 mm.; illustrated in Preiss 1975, fig. 49, and in color in Preiss 1979, p. 154, no. 48.
9. Preiss 1975, p. 75.
10. Letter to the author of July 17, 1987.
11. Huber [1801], 1, pt. 2, p. 619, no. 3573:
 St. Jérôme dans le désert, assis sur une roche, son lion couché à ses pieds, réconforté par un Ange, eau forte sans marque. petit in 4to.
12. This is also Preiss's suggestion (orally, and in his forthcoming book).
13. The watercolor from the Artaria (earlier Lanna) collection, now probably in Vienna, Graphische Sammlung Albertina, is illustrated in Haberditzl 1923, p. 160 (no.33). The pen drawing, from the *Nachlass* of Martin Knoller, is in the collection of the Cistercian Abbey in Stams, Tyrol, vol. 16, no. 1507; it is signed "Carol Palck fecit."
14. See Preiss 1975 for Mariette's appreciation of Palko.
15. Such is the instance of another drawing from the Randall collection, also in the Fogg Museum, inv. no. 1898.541, which according to Randall's notes on an old mat bore an attribution to Palko. Preiss (in his letter) notes that this is a copy after a composition by Pellegrini.
16. Seated putto, versions in Prague, Národní Galerie, inv. no. K 4513, illustrated in Milan 1966, fig. xcii, no. 496; also formerly Malota collection, illustrated in Preiss 1975, fig. 46.
17. Letter to the author of July 17, 1987.

Born in 1712 at Ebbs near Kufstein, in the Tyrol, Baumgartner began his artistic carrier by studying *Hinterglasmalerei*, a technique of painting on the reverse of glass, in Salzburg. In 1733 he obtained permission to reside in Augsburg, testifying that by this time he had traveled in Italy, Austria, Hungary, and Bohemia. It is possible that he then received some artistic instruction from J. G. Bergmüller (*q.v.*).

In 1746, having been sponsored by a publisher for whom he had supplied prints, Baumgartner obtained citizenship in Augsburg; in the same year he also became a master. Baumgartner executed many oil sketches for the design of an extensive religious didactic tract, and also painted ceilings in Baitenhausen, Bergen, and Meersburg. He died in Augsburg in 1761.

Baumgartner is considered one of the leading artists of the Augsburg "rococo." His preparatory drawings for prints by Augsburg publishers were particularly renowned.

39. The Large Boar Hunt (St. Deicolus)

Pen and brown ink, gray wash, with white heightening, on blue paper, incised; verso covered with red chalk
20½ × 28⁹⁄₁₆ (521 × 735) (two sheets attached together)

WATERMARKS: two identical crowned coats of arms with the letters M and L (?), at lower left and lower right

Cleveland Museum of Art; Dudley P. Allen Fund, 67.22

PROVENANCE: Boerner 1966, nos. 42, 47, color illustration after title page; Boerner 1966a, no. 5; purchased 1967

EXHIBITION: Cleveland Museum of Art, "Treasures on Paper. Masterpieces from the Collection of Prints and Drawings," May 10–July 24, 1988 (no cat.)

LITERATURE: Rowlands 1970, p. 294

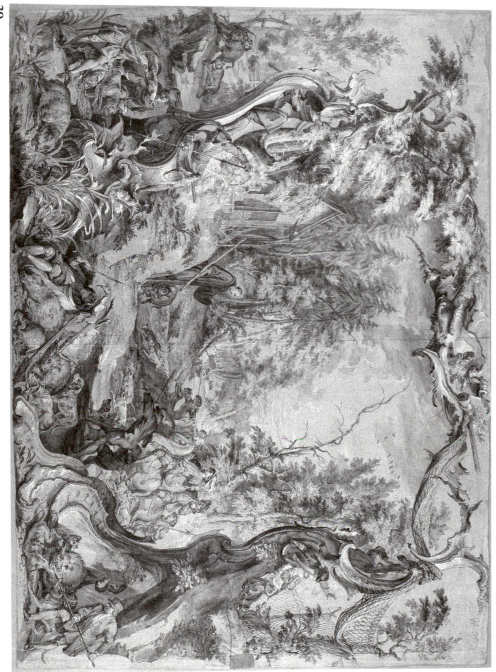

This finely elaborated and richly detailed sheet shows details of a boar hunt, in which even the rococo ornament has been animated and peopled by hunters and their quarry. In the middle ground toward the center, a hermit in a cassock kneels before a hut and raises his hand to stop the hunt, as a boar stands at his feet. This hermit has been correctly identified by Boerner, the previous owner, as St. Deicolus.

Deicolus (the Latin Deicola; died January 18, 625), otherwise known as Desle, or in Irish Dicuil, was an Irish monk who followed St. Colomba first to East Anglia and then in 585 to France, where he lived for twenty-five years at Luxeuil, before retreating to a hermitage in a forest, where he was to build a new monastery. The drawing depicts an event from his life that occurred when a boar hunted by Clotarius II sought refuge at the cell of Deicolus, who saved its life; the king, upon learning who the hermit was, bestowed on him many gifts and favors.

The copious incisions on the recto and the red chalk on the verso of the drawing were employed to transfer the composition. It was used for a print made by the firm of Joseph Sebastian and Johann Baptist Klauber, who, according to Annette Geissler-Petermann, recorded it in their 1770 list of publications in *Novus Catalogus Imaginum*. There it is listed among a series of thirteen sheets with depictions of the hunt, personified by Biblical figures, saints, and historic persons.

Another monogrammed and incised drawing of similar dimensions for the same series, which depicts Eleutherius, twelfth bishop of Rome, as a birdcatcher, was sold at auction in London and also passed through the hands of Boerner.[1] An engraving of St. Hubert from the same series is also known.[2] Impressions of the St. Deicolus and Eleutherius compositions have not yet been found, however.

Geissler-Petermann dates the suite 1747–48.[3]

1. See C. G. Boerner 1981, no. 28, ill.
2. Frankfurt am Main, Städelsches Kunstinstitut, inv. no. N 50501, according to Boerner 1981.
3. Annette Geissler-Petermann's information is represented in a letter of October 10, 1980, to Elizabeth Llewellyn of Sotheby Parke Bernet, London, a copy of which is in the curatorial files of the Department of Prints and Drawings, Cleveland Museum of Art.

40. Vision of a Saint

Pen and black ink, gray wash, white bodycolor
14 3/8 × 21 1/2 (365 × 546)
Dated (?) upper left center: *M CD DCLXVI*; various numbers and letters inscribed on tablets and scrolls, upper right center, upper right, and lower right

Crocker Art Museum, 1871.67

PROVENANCE: R. Weigel, Leipzig (?); Edwin Bryant Crocker

LITERATURE: Sacramento 1971, p. 147 (as "von Kifstein in Tirol," referring to the artist's birthplace)

Although the date at the top of the drawing is somewhat ambiguous, this little-known and effectively unpublished sheet is certainly a splendid example of the work of Johann Wolfgang Baumgartner. It shares many of the qualities familiar from the artist's designs for prints. These include its large scale, use of body color along with ink and wash, expressions on the face of the saint, and intermingling of narrative and ornamental elements.[1]

The horizontal format and compositional design of this sheet, in which two architectonic groupings of ornamental elements inhabited by figures provide a framework for the central narrative depiction, resembles especially the appearance of these features in a suite of three drawings connected with an engraved series of the four elements with depictions of saints.[2] As exemplified by another drawing exhibited here (cat. no. 39), Baumgartner frequently made such designs with lives of the saints, if such is the protagonist here, for engravings. The inscriptions and date on the Sacramento drawing also point to its use as a print.

The date, which might be read 1666, cannot be connected with the execution of the drawing but might rather refer to the saint, episodes from whose life are shown here along with various allegorical personifications. The exact subject and dating of this design have, however, not yet been determined.[3] It is exhibited here partly in the hope that more information may now come to light about this attractive sheet.

1. These characteristics are evident in many of the drawings for prints by Baumgartner in the Graphische Sammlung Albertina, Vienna: see Tietze 1933, cat. nos. 1182–88.
2. *Earth with St. Rosalie of Palermo as Protector against Earthquakes*, Achenbach Foundation for Graphic Arts, inv. no. 1969.31, illustrated in Claremont 1976, pp. 8–9, no. 4, ill. p. 63; *Air with St. Sebastian as Protector against the Plague*, Augsburg, Städtische Kunstsammlungen, inv. no. G.520–48, most recently in Augsburg 1987, cat. no. 99, ill. p. 211; *Water with St. Francis Xavier as Protector against Shipwrecks*, Stuttgart, Staatsgalerie, Graphische Sammlung, inv. no. C 82/111, illustrated in Stuttgart 1984, no. 67, ill. p. 113.
3. A letter from Bruno Bushart in the files of the Crocker Art Museum has been interpreted to mean that an engraving after this design exists in the Graphische Sammlung, Staatsgalerie, Stuttgart, but according to an oral communication to the author from Heinrich Geissler, the information regarding this print does not relate to the Sacramento drawing, which remains to be identified with some other print.

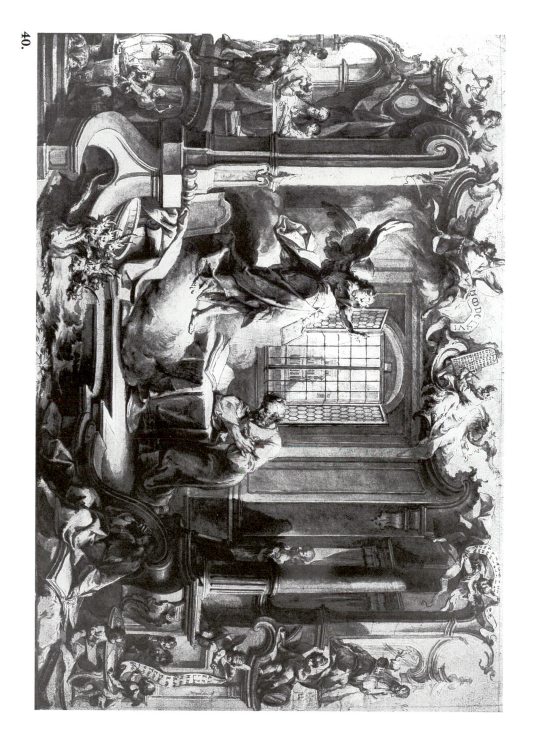

Franz Sigrist was born in Alt-Breisach am Rhein on May 23, 1727. Probably as a result of the occupation of Breisach by the French, he came to Vienna in 1744, and was enrolled in the drawing class at the imperial academy there on December 1 of that year. He is already recorded as being a history painter in 1749, and in 1752 he won second prize in a yearly competition.

Sigrist moved to Augsburg in 1755, becoming professor at the *Franciscische Akademie* and episcopal court painter. During these years he painted oil sketches for Joseph Giulini's large-scale collection of depictions of saints, in which project Baumgartner (*q.v.*) also participated. From ca. 1755 he prepared drawings for the Hertel publishing house, and also executed frescoes in Swabia.

In 1763–64 Sigrist returned to Vienna, working on a series of paintings for the imperial family. He also painted frescoes in 1781 in the lyceum in Eger (Ger, Erlau), Hungary, where his work shows a turn away from his earlier style toward the classicism of the end of the century.

Sigrist died on October 21, 1803, in Vienna.

41a. Design for a Book Illustration (Allegory of Faith ?)

Pen and black ink, gray wash with touches of discolored brown wash, over graphite underdrawing, on paper covered with thin pink wash; verso rubbed with red chalk

4 × 6 (103 × 152)

Inscribed in black ink, upper center: *A*; inscribed in brown ink, over graphite, at right edge of drawing: *schattn*; inscribed in brown ink, lower left corner: *zettul/ +*; inscribed in graphite, bottom left center: *stadt u. Cron (?)*

Inscribed in brown ink on mount, lower left: *F. Sigrist inv. & inc.*

The Metropolitan Museum of Art; Gift of James C. McGuire, 26.216.23

PROVENANCE: James C. McGuire

41b. Drawing for a Book Illustration (Triumph of the Catholic Faith over Heresy ?)

Pen and black ink, gray wash, on paper covered with thin light gray/pink wash

3 11/16 × 5 11/16 (93 × 145)

Inscribed in brown ink, center right: *1*

Inscribed on mount in brown ink, lower left: *F. Sigrist inv. & inc.*

The Metropolitan Museum of Art; Gift of James C. McGuire, 26.216.26

The two previously unpublished drawings exhibited here belong to a group of four sheets (figs. 17 and 18) with similar provenance in the Department of Prints, Metropolitan Museum of Art. Although, according to the museum's records, they were formerly called mural decorations, internal evidence supports the museum's contention that they were designs for prints that may well have served as book illustrations. Along

with the fact that their small size is more suitable to such a task than for transfer to a large scale, they lack any indication of such a procedure of enlargement. On the other hand, two of the drawings, including one exhibited here, have been rubbed with red chalk, indicating that their images were to be transferred to another surface; this technique is common in print production. The notation *zettul* (for *zettel*, Ger., a slip of paper) on one of the sheets shown here suggests that an inscription was to be added.

The framing of the scenes with a rocaille border is also a detail commonly found in Augsburg prints of the eighteenth century (see cat. nos. 30, 65). Although the colorful execution of these drawings might seem an unusual procedure for the preparation of prints, preparatory drawings in various colors of grisaille and also fully colored oil sketches were frequently used for this purpose in the mid-eighteenth

Figure 17. Franz Sigrist, *Design for Book Illustration*, pen and black ink, wash, 94 × 135 mm. The Metropolitan Museum of Art, gift of James C. McGuire, 26.216.71.

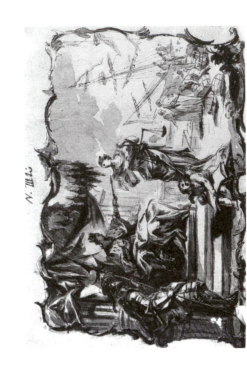

Figure 18. Franz Sigrist, *Design for Book Illustration*, pen and black ink, wash, 100 × 156 mm. The Metropolitan Museum of Art, gift of James C. McGuire, 26.216.70.

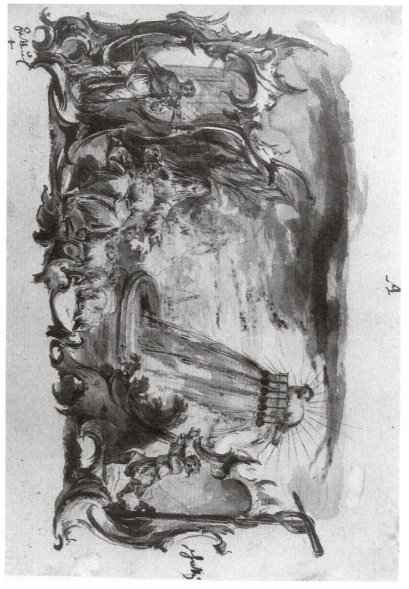

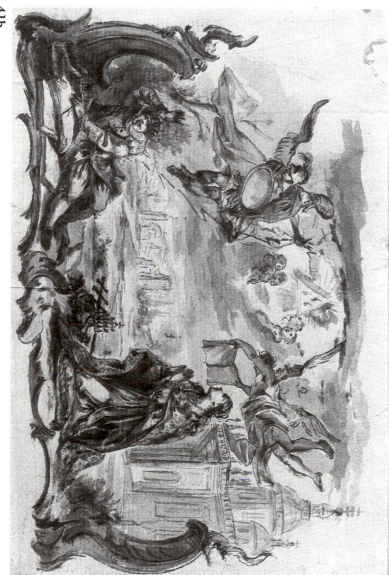

century in Augsburg.[1] The indication *schattn* (Ger., for shadow, or shade, hue) may accordingly be the artist's note to attend to this element in the completion of the copperplate.

The inscriptions *A*, *B*, and *N. III* on these drawings indicate they were part of a larger series. Series of prints were also regularly produced in Augsburg. Prefaced by a title page or some kind of explanatory text, print series were commonly bound together in the form of books there.[2]

Many of these books of prints have a religious or emblematic content similar to that found in the complicated allegories of the Metropolitan Museum drawings, which are related to the Christian, and especially the Catholic, faith. The most easily legible design is that of the drawing reproduced in figure 18, in which angels proclaim the Gospels to the corners of the earth: the Gospels are symbolized by the book being pulled in a triumphal car by two of the symbols of the Evangelists, the lion of Mark and the bull of Luke, with the eagle of John and the angel of Matthew also in attendance. Another of the drawings exhibited here (cat. no. 41a) also clearly alludes to the Christian faith. To the left is a woman adoring a crucifix, a common image of the Christian faith; to the right is depicted a snake on a cross, which is a type of the crucifixion; in the center is the sacrificial lamb, from which flow the waters of life; to the bottom left is a veiled figure of Innocence. In the other drawing exhibited here (cat. no. 41b), an angel holds a book, most likely symbolizing true doctrine, before a female figure kneeling in prayer: she is most likely the Catholic faith, as a cross and triple papal crown lie before her, and a church is depicted behind her. In the sky in the center of the drawing appears a triangular symbol of the trinity (see also cat. no. 16); an angel to the left, most likely St. Michael, casts down lightning bolts against a figure who is studying books in the bottom left corner; this figure is no doubt meant to be a heretic. Since he wears a hat recalling that of scholars of preceding centuries, he may even stand for the Protestants.

The later inscription on the mounts of these drawings, *F. Sigrist inv. & inc.*, points to the hand of Franz Sigrist, who is known to have made such series. During his years of activity in Augsburg, Sigrist painted colorful grisaille oil sketches with rocaille frames, and also made drawings on colored paper for print series of saints and of representations from the Bible.[3]

However, the formal qualities of these designs do not correspond to those found in works executed by Sigrist while in Augsburg. The closest comparisons are rather to be found in oil sketches from Sigrist's later oeuvre. These works display the rather more compact figural ideal with rather dainty, pointed features, and the somewhat stiff draperies seen in the New York drawings.[4] These characteristics correspond to what has been recognized as the onset of classicism in Sigrist's work after his return to Vienna.[5]

Although only one drawing from Sigrist's post-Augsburg period had been previously recognized by the leading specialist on his work, there seems no reason to doubt the ascription of these sheets.[6] Indeed, because the established corpus of drawings by Sigrist is so small, the identification of these designs assumes greater importance. Other drawings by him have been recovered recently, and more may come to light.[7]

1. As for example in the work of Baumgartner, see Deutsche Barockgalerie 1984, pp. 29–32, nos. 78, 81.
2. See Bellot, in Augsburg 1968, p. 405, with further examples given in the catalogue.
3. See Matsche-von Wicht 1977, pp. 38–55, esp. 40, 54, 55.
4. Compare, for example, the oil grisailles of putti, and of Christ on the Mount of Olives, illustrated in Matsche-von Wicht 1977, figs. 83, 84, 71.
5. Matsche-von Wicht 1977, pp. 102f.; Vienna 1977, p. 162.
6. Matsche-von Wicht 1977, p. 214, cat. no. 81, ill. no. 90.
7. See Garas 1980, nos. 21, 22; Salzburg 1981, p. 58, no. 23, ill. p. 59. The recent attribution of a drawing of St. Cecilia in Augsburg to Sigrist, while possible, has less foundation, as its technique is unusual for him and the points of comparison more general: see Augsburg 1987, p. 374, cat. no. 181, ill. p. 375.

Son of the painter Johannes Zick (1702–1762), Januarius Zick was born in Au, near Munich, in 1730. While his father, whom he may have aided in painting frescoes, was working at Schüssenried in 1745–48, he learned the mason's craft from Jacob Emele. His first independent painting was recorded in 1750, after his family had moved to Würzburg; from 1750 he assisted his father in decorating the schloss at Bruchsal. In 1756 he was in Paris, and in 1758 in Basel and probably in Italy.

Zick's independent career as a painter began in 1759 with work in Bruchsal and the castle of the elector in Trier, whose court painter he became during the 1760s; in 1762 he married and settled in Ehrenbreitstein, opposite Koblenz on the Rhine. His major commissions include the interior decoration with frescoes for the Benedictine church in Wiblingen (1778–81), and for the Premonstratensians in Rot an der Rot (1784), as well as much further work in the region of Mainz and Koblenz.

The last of the great German fresco painters of the baroque tradition, Zick died in Ehrenbreitstein on November 14, 1797.

42. The Idolatry of Solomon

Pen and black ink, brush and gray washes, on blue paper
5¼ × 7⅛ (130 × 180)
Signed in black ink on step, lower left corner: *J. Zick f*; inscribed in black ink on step, lower left: *i B.R. c. ü*

PROVENANCE: Galerie Arnoldi-Livie, Munich

Stanford University Museum of Art; Alice Meyer Buck Fund, 82.235

This scene depicts an older bearded man, identified as a king by the crown laid on the step before him, being urged on by a number of women to worship an idol placed on a pedestal at left, before which burns an urn of incense. The hooded men in the background center are probably priests, while the men to the left are probably the king's soldiers.

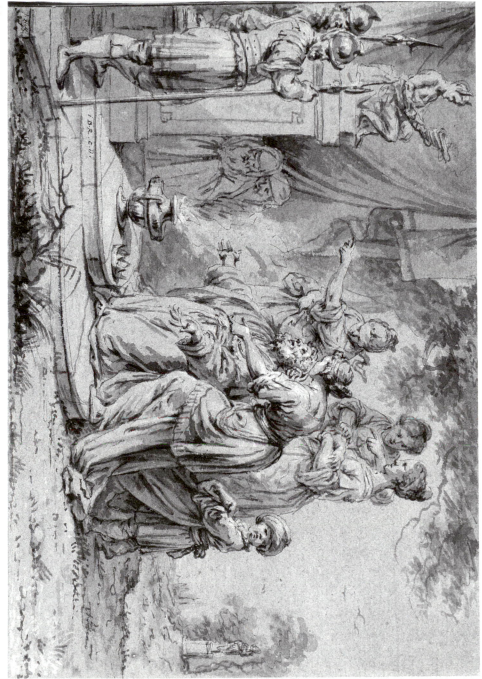

The inscription identifies the scene, as the abbreviated letters probably stand for *1 Buch Regum capitulum 11*. This macaronesque abbreviation alludes to the first book of Kings, chapter eleven, a chapter of the Bible that tells how "when Solomon grew old his wives swayed his heart to other gods . . . Solomon became a follower of Astarte, . . . and of Milcom . . . He did the same for all his foreign wives, who offered incense and sacrifice to their gods" (verse 4).

Januarius Zick, whose authentic signature is found on this work, depicted the story of Solomon on at least one other drawing, a sheet in Koblenz.[1] The Koblenz *Judgment of Solomon*, from 1 Kings 11:4, is somewhat different in dimensions, degree of finish, and perhaps even date, so it is unlikely that the two belong to the same series.

The function of both drawings is also unclear: drawings of similar appearance and date by Zick often serve different purposes. The inscription on the Stanford drawing may suggest a connection with prints or book illustration.

In the absence of many clear points of reference for dating Zick's drawings, it is difficult to situate the Stanford sheet precisely.[2] Nevertheless, it does share certain characteristics, such as its technique, high finish, landscape, and figure forms, with drawings dated 1778.[3] In any event, the work provides a good example of the artist's mature drawing style.

1. Mittel-Rhein Museum, Koblenz, inv. no. G1421, signed, 15.8 × 21 cm.; illustrated in Metzger 1972, p. 107.
2. For the armature of Zick's work, see Metzger 1981, with some attention to drawings.
3. See Schilling 1973, 1, p. 212, nos. 2189–90, 2192–93, ill, 2, pl. 208.

CHRISTIAN BERNHARD RODE
(1725–1797)

Christian Bernhard Rode was born in Berlin on July 25, 1725. He received his first training as a painter from N. Müller, and then studied with the renowned Prussian court painter Antoine Pesne. From 1750 to 1752 he resided in Paris, where he studied the works of Carle van Loo and others; in 1754–55, he journeyed to Italy. At the end of 1755 or early in 1756, he returned to Berlin via Vienna, Prague, and Dresden, marrying there in 1757, and setting up independently as a painter.

In 1756 Rode became a member of the Berlin academy, becoming its director in 1783. Under his direction the academy was reorganized. Many important artists and cultural figures were attracted to it, including Chodowiecki (*q.v.*), who later also became its director. He also wrote a history of Greek painting during his term as director.

Rode was a painter of altarpieces, history paintings, portraits, and allegories. He was also a prolific draftsman and printmaker, producing a wide variety of etchings of different subjects. He supplied designs for the sculptural decoration of many important structures in Potsdam and Berlin, most famous among them probably that for the Brandenburg Gate. All this activity made Rode one of the leading figures in the arts in Berlin in the later eighteenth century, and one of the forerunners of "neoclassicism" there.

Rode died in Berlin on June 24, 1797.

43. Alexander Setting Fire to Persepolis

Pen and brown ink with brown wash, over graphite; circle in graphite
9⅝ × 7⅜ (245 × 187)
Inscribed in dark brown ink, lower right: *An die Könige / I 20*
Watermark: Part of a fleur-de-lys

National Gallery of Art; Ailsa Mellon Bruce Fund, 1988.4.1

PROVENANCE: Unidentified collector (S, not in Lugt, on verso); C. G. Mathes (Lugt 2871, star, verso); Eva Dencker-Winkler

LITERATURE: Dencker-Winkler 1987, p. 26, no. 19, ill.

The inscription in the lower right corner of this drawing indicates the source of this image, and thus helps to identify the subject depicted. The "kings" to which it refers are not those from the book of the Bible, but rather the parallel lives of rulers told by Plutarch. The drawing may therefore have served as a design for a print illustrating a scene from Plutarch.

The story represented is an episode from the biography of Alexander. At a celebration of the defeat of Darius, which took place in the palace at Persepolis, Alexander was instigated by the courtesan Thaïs to set fire to the court of Xerxes, since that predecessor of the Persian king Darius had burned Athens. In Rode's design Alexander is identified as a ruler by the coronet on his head, and as a soldier by the sword in one hand; he is depicted according to Plutarch's account with a torch in his other hand, setting fire to the city, whose ruins lie about him.

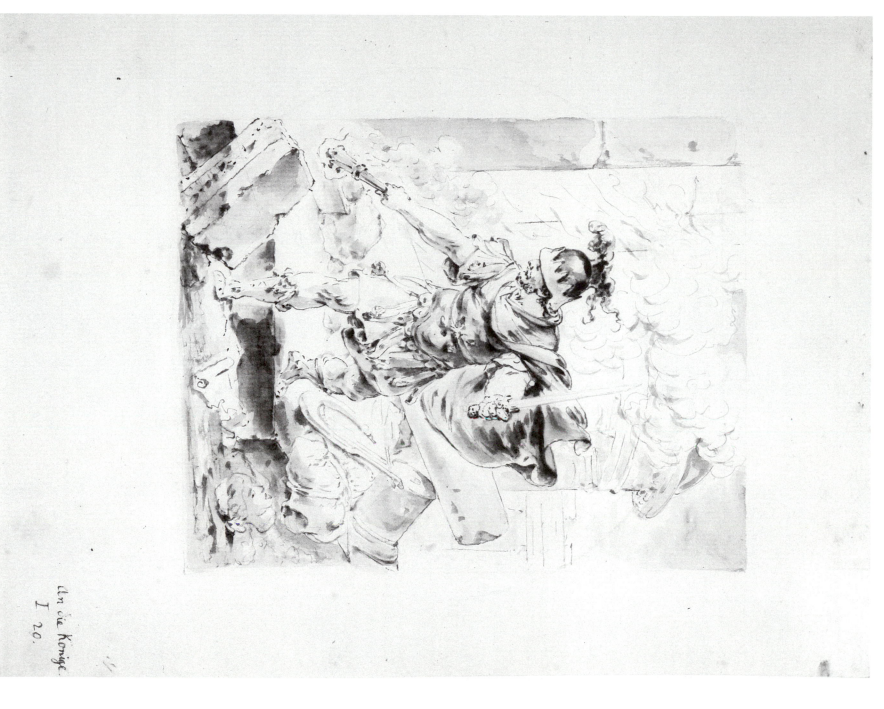

An die Könige
I 2o.

Stories from the life of Alexander were popular subjects for illustration by Rode.[1] They are among the numerous depictions of heroes from antiquity that Rode represented in etchings. Among other authors, Plutarch supplied him with material for works done from the mid-1770s.[2] In comparison with these inventions, the style of this drawing also suggests a dating to this time, but until more research recently initiated on Rode's prints and drawings is completed, neither the exact function nor the date of this drawing can be determined.[3]

In any event, this drawing is characteristic of the choice of themes that Rode depicted in his historical representations, in which, as in contemporary examples from England or France, subjects from ancient history that could stand as moral examples, such as episodes from the life of Alexander, were especially favored.[4] The preparation of such a design for broad dissemination in the print medium could thereby serve what recently has been called the enlightened aims of the artist.[5] In this regard, it shares the didactic aims as well as classical content found in many other representations associated with nascent neoclassicism.

Rode's drawing is very freely done, almost sketchlike in character. This quality ran against the growing tide in contemporary taste and therefore led ultimately to the eclipse of the artist's reputation. In comparison with many other designs found in his vast oeuvre, this sheet nevertheless seems to merit attention for its particular aesthetic features, since it is especially freshly drawn.

1. Other etchings of incidents from Alexander's biography are recorded by Nagler 1835, 13, p. 275, nos. 93, 95.
2. A depiction of Agrippina with the ashes of Germanicus was executed in a drawing, etching, and painting in 1774: see Garas 1980, no. 41. An etching of the death of Socrates dated 1774 was also made by him: see Vienna, Graphische Sammlung Albertina, Hofbibliothek L (10) 1.
3. Kiel 1986 is an example of such work being undertaken; this catalogue was not available at the time of writing, however.
4. See Büttner 1988, p. 40, for this point.
5. Büttner 1988.

MARTIN JOHANN SCHMIDT

(For biography, see cat. no. 26.)

44. The Baptism of Christ (recto and verso)

Pen and brown ink, brown and gray wash, traces of graphite, and of a stylus; verso, pen and brown ink
$9^{7}/_{16} \times 5^{3}/_{8}$ ($9^{1}/_{2} \times 5^{5}/_{16}$, sight); 240×137 (242×136, sight)

Collection of Robert and Bertina Suida Manning

PROVENANCE: Koloman Felner, Lambach (by 1779); Cloister Lambach, in 1818; Stoessel Collection, Vienna(?); William and Eugénie Suida

LITERATURE: Garzarolli-Thurnlackh 1925, pp. 35, 77, fig. 46

This double-sided drawing of the *Baptism of Christ* is a preparatory design for an etching that is signed by the artist and dated 1773.[1] The drawing on the recto is in the same direction as the print. It is therefore likely that the design traced and redrawn on the verso, forming the mirror image of that on the recto, was used directly in the preparation of the print, as Garzarolli-Thurnlackh suggested.

The drawing on the recto is, however, even more freely drawn than the print and more suggestive of light effects. In commenting on the technical handling and sources of its style, Garzarolli-Thurnlackh mentioned the impact of Venetian artists, such as Jacopo Amigoni and Marco Ricci, in addition to the presence of individual Rembrandtesque types. These qualities continue to be evident in Schmidt's drawings (see cat. no. 45), and are also found in Schmidt's paintings from the 1770s.

The inscription on Schmidt's etching indicates that it reproduces a painting "on the Sonntagberg." This is a reference to an altarpiece commissioned in 1765 for the pilgrimage church on the Sonntagberg near Amstetten, in Lower Austria; Schmidt's painting of the *Baptism* there is dated 1773.[2] The church was one of the most popular pilgrimage sites in eighteenth-century Lower Austria, and the commission was part of the substantial rebuilding and redecoration of the building, which included architectural designs by Jacob Prandtauer and Joseph Munggennast, sculpture by Jacob Schletterer, and frescoes by Daniel Gran (*q.v.*).

Although it is obvious that Schmidt would have had an interest in making his work more broadly known, there may have been a more specific incentive for this particular reproductive print. The Manning drawing contains a boundary line with a shield surmounted by a mitre in the center, leaving a space reserved for a coat of arms. These elements, not present in the etching as executed, suggest that the artist may have been contemplating dedicating the print to an ecclesiastical patron.

Along with many other drawings, this design was given by the artist to the Benedictine father Koloman Felner, a pupil and collaborator of Schmidt, who reproduced many of his compositions.[3] Many of the drawings by Schmidt in

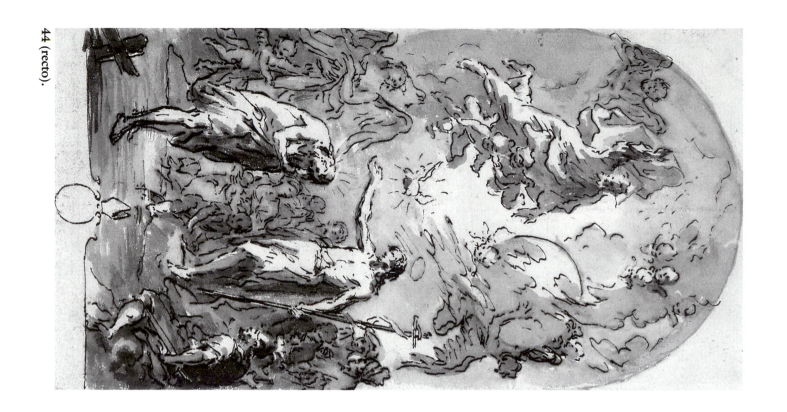

44 (recto).

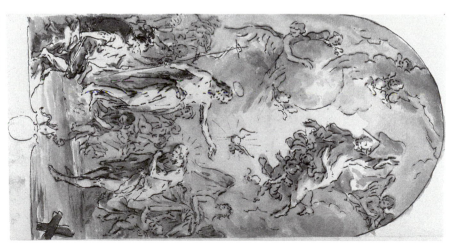

44 (verso).

American collections were derived from Felner's collection, which at his death in 1818 passed into the possession of the abbey at Lambach.[4]

1. The etching is signed *Martin Jo. Schmidt fec. 1773/S. Johannes der Tauffer auf dem Sontagberg hoch 18 sch.* An example of the print is found in the Graphische Sammlung Albertina, Vienna, inv. no. D. III 28, p. 2 upper left. The print is described in Garzarolli-Thurnlackh 1925, p. 107, cat. no. 26, ill. fig. 47.

2. See Riesenhuber 1923, p. 319.

3. It was earlier located in Klebeband B, fol. b21, of the volumes formerly in Lambach. This volume was labeled: *"Original Handzeichnungen Welche ao 1779 dem P. Kolomann Fellner Benediktiner zu Lambach von Herrn Martin Schmidt sind verehret worden, da selber benannten P. Kolomann in der Zeichnungs- und Radierkunst auf einige Monate unterwies."*

4. Besides this drawing and the following catalogue number, these include drawings of *The Virgin Immaculate Triumphant Over Sin and Death* and a grisaille oil sketch of *The Weeping Dauphin* in the Manning collection; a *Holy Family* in the collection of the late E. A. Maser, Chicago; and a series of the Passion in the Cleveland Museum of Art.

45. The Apotheosis of a Painter

Pen and brown and black ink, gray wash, with white heightening, on paper covered by a blue-gray wash
11 15/16 × 7 9/16 (303 × 192)
Dated (by the artist) in gray ink, lower right: *1784*; inscribed in black ink, lower right: *M. Schmidt fecit*

The Spencer Museum of Art, University of Kansas; Museum Purchase, Gift of the Endowment Association, 58.111

PROVENANCE: Koloman Felner; Cloister Lambach, Austria; Schaeffer Gallery, New York; gift of the Endowment Association, 1958

EXHIBITIONS: East Lansing 1959, p. 13, no. 44; Minneapolis 1961, p. 24, no. 47, ill., pl. 2; Allentown 1962, no. 33; Houston 1971, no. 131, ill.

LITERATURE: Garzarolli-Thurnlackh 1925, pp. 31, 87, fig. 84; Dworschak 1955, p. 196, n. 102; *Art News*, November 15, 1955, p. 20 ill.; *The Register of the Museum of Art, University of Kansas*, ii, no. 2, June, 1959, p. 44 ill.; University of Kansas 1962, p. 72, ill.

In the upper left of this composition, putti raise aloft an oval portrait of a bewigged man. A female figure holding a maulstick and paint brushes crowns the portrait with a wreath. To the right, an armored female figure with shield and spear strikes down the group of figures in the bottom of the drawing. The figure with paintbrushes is probably a personification of Painting; the owl behind the woman in armor identifies her as Minerva (Athena), and the ass next to one of the figures in the bottom of the drawing is a common attribute identifying it as Ignorance.

The drawing can thus be related to the theme of Envy and Ignorance as enemies of art.[1] In such allegories Minerva commonly appears, as here, as protectress, or patron, of art.[2] In particular, the painter in the portrait is glorified: the oval medallion suggests his immortality, and the laurel wreath his glory.[3]

In deciphering this allegory Joseph Zykan noted that Pallas Athene (Minerva) was the epitome of academic instruction, and associated it with the academic instruction that Schmidt had himself received.[4] While it is true that Schmidt was trained at the Vienna academy, of which he later became a member, the presence of Minerva may be regarded more generally as an allusion to the intellectual or learned aspects of painting, rather than as a specifically academic allegory.[5]

The original purpose of this drawing is not clear. Garzarolli-Thurnlackh suggested it was a design for an engraving for an end paper (*Vorsatzkupfer*), yet no such print is known, and the specific portrayal of an artist may militate against this hypothesis. On the other hand, representations of this sort of theme were common subjects in *Stammbuchblätter*, contributions in autograph albums,[6] and it is possible that the drawing was intended independently as a gift. In any event, this allegory, revealing another, secular side to Schmidt's art, in comparison with the other drawings in this exhibition, was given to Schmidt's friend, the Benedictine father and printmaker Koloman Felner, to whose collection it can be traced.

1. For representations of this theme, see Pigler 1954, pp. 215-35.

2. For the prevalence of this theme, with a listing including eighteenth-century examples from Central Europe, see Pigler 1974, 2, pp. 497-98.

3. For this connotation of the portrait, see the comprehensive discussion of the ancient portrait type known as the *imago clipeata*, in Winkes 1969.

4. Zykan, in Dworschak 1955, p. 196, n. 102 (Minneapolis 1961, p. 24, cat. no. 47, states incorrectly that this is Garzarolli-Thurnlackh's opinion.)

5. For allegories on the academic ideal, see Kaufmann 1982, pp. 119-48.

6. See Peter-Raupp in Stuttgart 1979, pp. 223-30.

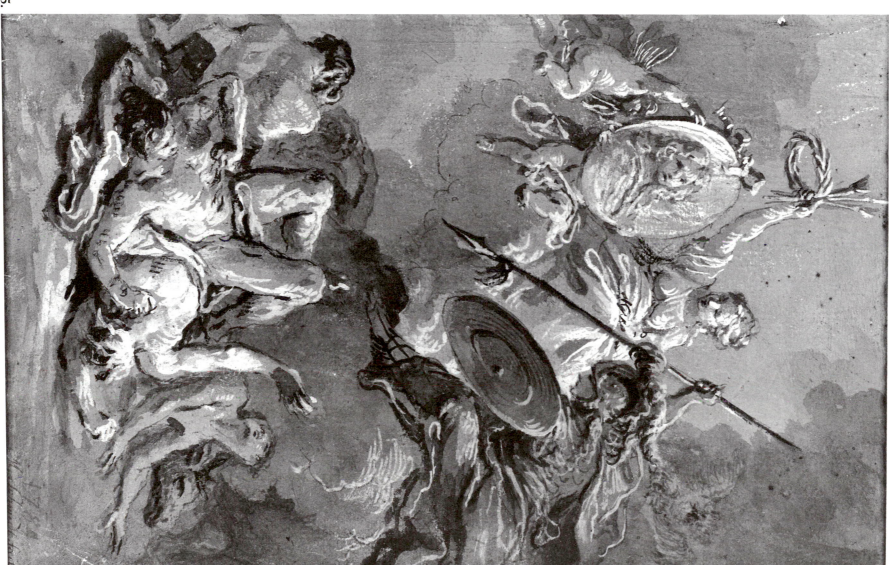

ADAM FRIEDRICH OESER
(1717–1799)

Adam Friedrich Oeser was born the son of a glovemaker on February 17, 1717, in Bratislava (Ger., Pressburg). Although he had been destined for a career as a confectioner, after he had demonstrated ability to paint and draw he was apprenticed to the painter Ernst Friedrich Kammauf (1691–1749). From 1730–33 and again from 1735–39, Oeser managed to study at the academy in Vienna, where he won a prize in 1735; during these years he also came under the influence of G. R. Donner (*q.v.*), who at the time had his workshop in Bratislava.

In 1739 Oeser moved to Dresden, where he stayed until 1756. He excelled at first in painting miniatures, and then gained commissions for portraits, for the Court Church, and for Schloss Hubertusburg. During his years in Dresden, Oeser came into contact with Mengs (*q.v.*) and fell under the spell of Winckelmann. In 1759 Oeser settled in Leipzig. He was named director of the newly founded academy there in 1764, established a collection, and maintained relations with many leading cultural personalities. The most famous of these was Johann Wolfgang von Goethe, to whom Oeser personally taught drawing from 1766 to 1768. He later visited Goethe a number of times in Weimar, and they remained in contact.

Oeser painted a wide variety of easel and wall paintings during this period in Leipzig; he was also active as a sculptor. He is considered one of the leading figures of the neoclassical movement in Germany. He died in Leipzig on March 18, 1799.

with a goddess of a spring, a place of pleasure, whose quiet, or sleep, the onlooker is not supposed to disturb.[5] Hence, the figure in this drawing cautions for quiet.

Although the source of the image is a pseudo-classical inscription, the theme was nevertheless very popular in Renaissance iconography. It is characteristic of Oeser's feeling for the more elegiac aspects of the classical tradition that he has revived the figure of a nymph in this charming drawing.

1. Compare, for example, figures found in drawings in the Graphische Sammlung Albertina, Vienna, D 1696a, D 1699.
2. Compare a signed drawing in Düsseldorf, Kunstmuseum, done in similar medium, inv. no. 20–16.
3. See Dürr 1879.
4. See Herder 1967 (reprint of 1888 edition).
5. For this theme, see Kurz 1953, pp. 171–77.

46. Nymph (Nymph of the Source)

Black chalk (?)
11⅝ × 14⁷⁄₁₆ (295 × 367)
Inscribed on mat: *Die Nymphe des* [sic] *Quelle aus Herders zerstreuten Blätter Schöpfe Schweigend. in blau un Oeser f* 1101 (?)

Crocker Art Museum, 1871.1060

PROVENANCE: A. F. Oeser *Nachlass* (sale, Leipzig, Rost'sche Kunsthandlung, February 3, 1800, no. 1137); R. Weigel (?); Edwin Bryant Crocker

LITERATURE: Dürr 1879, p. 235; Sacramento 1971, p. 158

This drawing presents a female figure type that is exceedingly characteristic of Oeser's oeuvre.[1] She seems to resemble the type of coy nymph that is found in the artist's later work, as does the type of foliage depicted here.[2]

The inscription on the mat allows for a more precise identification and dating of the drawing, for it corresponds almost exactly to the description of a sheet from the estate of Oeser, sold in Leipzig in 1800.[3] The drawing is said to be a representation of the nymph of the source, taken from the *Zerstreute Blätter* of the famed writer Herder (see cat. no. 70), which began appearing in suites of collections starting in 1785.[4] As Oeser possessed the drawing at his death, it cannot only be assumed that he was attached to the sheet, but that it was done late in his life.

The subject represented is a variation on a common theme of the "nymph of the place." This is an image associated

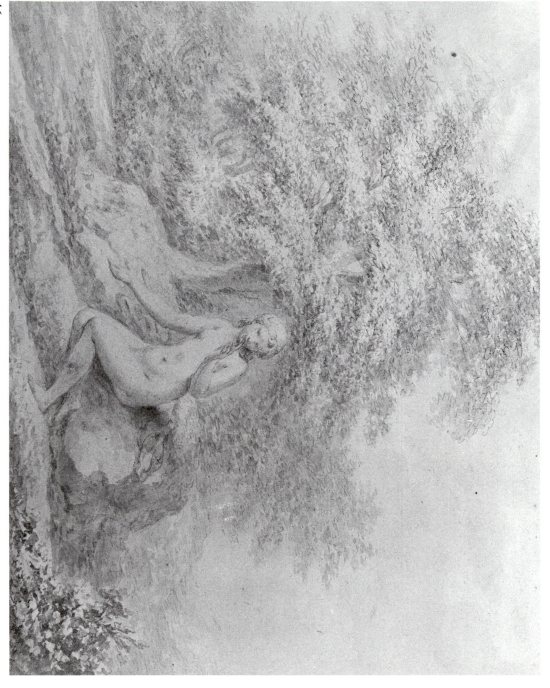

IGNAZ UNTERBERGER

(1748–1797)

Ignaz Unterberger was born in 1748 in Cavalese in the Tyrol. A member of a family of painters, he received his first instruction from his uncle Franz Sebald Unterberger (1706–1776), and then continued with Josef von Alberti. Around 1770 he went to Rome to complete his studies with his brother Christoph (1732–1798). In Rome Ignaz Unterberger collaborated with Mengs (q.v.), Pompeo Batoni, and Anton von Maron; he also executed much admired history paintings and copied old masters, being particularly adept at imitating Correggio.

In 1776 Unterberger settled in Vienna, where he became a member of the academy and imperial court painter in 1795. Besides his work as a painter, mostly of altarpieces, Unterberger was broadly educated and was active as an inventor of engines and other machines. He died in Vienna in 1797.

47. St. Agnes (Allegory of Charity) (recto); St. Agnes (Allegory of Charity) (verso)

Black and red chalk; verso, black chalk
9 × 13½ (232 × 344)
Collection of Robert and Bertina Suida Manning

This is one of two related sheets in the Manning collection.[1] These images on the recto and verso of the sheet exhibited here, as well as that on the second drawing (fig. 19), are all designs for the same composition.

Two other similar sheets by Unterberger are located in the Albertina. On one of them, a study in red chalk, the composition is worked out on the upper and lower parts of the sheet, but the relationship of the figures found in the drawing exhibited here is reversed.[2] The grouping of the figures is still closer than in the other Albertina drawing, where their disposition is different; in the sheet shown here the position of the angel is worked out.

This sequence of studies not only suggests that they were designs for a painting, but also evinces the careful working procedures used by Ignaz Unterberger, as might be expected from his status as member of the Vienna academy. Indeed, a signed red chalk drawing of a statue of Apollo, of a type that might be expected from an academician, also confirms the attribution of these sheets.[3]

Unterberger's artistic orientation, which was shaped by Maron, Mengs, and Batoni, also shows the influence of

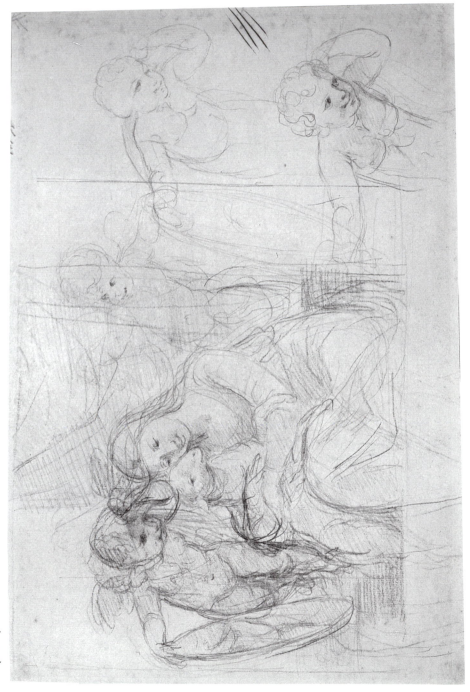

47 (recto).

47 (verso).

Correggio on the use of the chalk medium and in the subject and composition.[4] Unterberger's imitation of Correggio was indeed so close to his source that some of his works long passed for the original; it has even been suggested that one of the Vienna drawings from the same suite as this sheet is related to a composition of *Caritas* or Maternal Love that was engraved as the work of Correggio. However, the subject of all of these sheets, a female figure embracing a lamb, is different, alluding to either St. Agnes or a personification of Chastity.[5] As no finished painting or print related to these drawings has yet been found, the order in which these designs were executed cannot be established with certainty.

1. The second design measures 122 × 202 mm, and is executed in red chalk. It is inscribed in black chalk on the verso: *N 14/16/ Unterberger*.
2. Graphische Sammlung Albertina, Vienna, cat. no. 2241.
3. Innsbruck, Tiroler Landesmuseum Ferdinandeum, inv. no. T 713.
4. For this point, see the remarks by Preiss, in Vienna 1977, p. 185.
5. For this suggestion, see Rome 1972, cat. no. 426, pl. 64.

Figure 19. Ignaz Unterberger, *St. Agnes*, red chalk, 152 × 202 mm. Collection of Robert and Bertina Suida Manning.

Friedrich Heinrich Füger
(1751–1818)

Born in Heilbronn December 8, 1751, Füger displayed an early interest in painting and studied with Nicolas Guibal in Ludwigsburg in 1764. In 1768 he moved to Halle to study law, but his teachers there urged him to dedicate himself to the arts. In 1770 he went to Leipzig to study with Oeser (q.v.), after which he trained at the Dresden academy, having his first great success at its exhibition of 1772.

After a brief sojourn in Heilbronn, Füger moved to Vienna in 1774, soon afterwards securing commissions from the imperial family. In 1776 he journeyed to Rome, staying in Italy until 1783. He then returned to Vienna to become assistant director of the academy, of which he became director in 1795. In 1786 Füger became supervisor of design and painting at the Vienna porcelain factory, and in 1806 director of the imperial painting collection. He died in Vienna on November 5, 1818.

Because of his own works and the positions he occupied, Füger may be regarded as one of the leading proponents of the artistic movements connected with neoclassicism.

rates with this depiction. It is also important that the same style equally served such projects as the religious dramatization of the Gospels. In this way Füger's drawing epitomizes the Austrian deflection of neoclassicism during this period of transition between one empire and another: the old, Holy Roman Empire and the new, more narrowly defined Austrian (later Austro-Hungarian) Empire.

1. This point is also made by Perkins, who refers to drawings for the illustration of this text made in 1798, presumably meaning the sheets in the Graphische Sammlung Albertina, Vienna. It should also be noted that there are drawings for the same project datable after 1800; one design was on the art market in New York, ca. 1985.

48. Socrates and Aspasia

Pen and black ink, gray washes, and white heightening, over black chalk, on light blue paper
18 × 13 1/16 (458 × 332)
Signed and dated, lower left: *H. Füger 1802* (? or 3)

Crocker Art Museum, 1871.82

EXHIBITIONS: Sacramento 1939, no. 69; Detroit 1949, no. 19 (no cat.); Sacramento 1972, p. 39, cat. no. 38, ill. p. 59 (entry by Lois Perkins)

LITERATURE: Scheyer 1949, p. 235, no. 19; Sacramento 1971, p. 152 (called "The Warning")

In her excellent entry on this drawing, Lois Perkins has offered a convincing identification of the subject, which had previously been called "The Warning." She argues that the drawing depicts Socrates, who conforms to a familiar type, with Aspasia, a famous Athenian courtesan and the mistress and adviser of Pericles, who supposedly wrote the Funeral Oration on the fallen Athenian heroes. She was famed for her wisdom and rhetorical gifts, and here she may be seen not warning but debating with Socrates.

The subject as well as the style of the drawing corresponds to the neoclassical taste in Austria ca. 1800 of which Füger was a prime exemplar. In particular, the severe, sculptural treatment of form characterized Füger's style toward 1800; Lois Perkins correctly notes comparable figures in the artist's work after 1800. Both the large format and the technique are also comparable to his drawings for Klopstock's *Messias*.[1]

It is significant that related features found in the heroic and revolutionary tendencies of the manner of David are used here for what is essentially almost a domestic squabble, and one may well contrast Peyron's or David's *Death of Soc-*

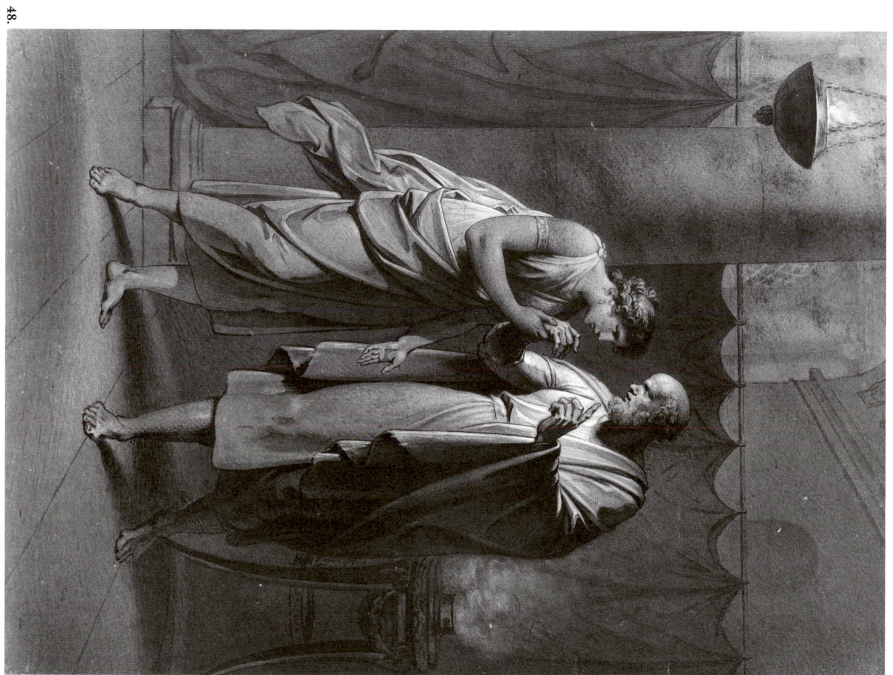

C. Sculptors' Drawings, and
Academies

THOMAS SCHWANTHALER
(1634–1707)

Thomas Schwanthaler belonged to a family of sculptors whose careers spanned three centuries. Born in Ried im Innkreis in 1634, he took over the workshop of his father Hans upon his death in 1656. He is documented as being embroiled in controversies with his rivals Veit Adam Vogl and Ludwig Vogl. Thomas Schwanthaler received his first major commission from the Ried parish church in 1661.

Schwanthaler's wooden sculptures with religious subject matter have given him the reputation of the most important sculptor active in Upper Austria in the second half of the seventeenth century. His most famous work is the double altar of 1676 in the church of St. Wolfgang am Attersee. He died in Ried in February 1707.

49. Pietà

Red chalk, on buff paper
$7^{3}/_{16} \times 11\frac{1}{4}$ (183 × 286)
Watermark: ID (cf. Godefroy 1930, no. 25)

Harvard University Art Museums, Fogg Art Museum; Gift of Belinda Lull Randall from the John Witt Randall Collection, 1898.159

PROVENANCE: Lindner Cabinet (note by Randall on old mat: *From the collection of M. Lindner Professor of Philosophy in the University of Leipsic. No. 103 Frenzel cat. The Painter has also etched this subject.*); John Witt Randall (no. 390; Lugt 2130 on verso); Belinda Lull Randall

EXHIBITIONS: Lawrence, Kansas 1956, p. 15, cat. no. 58; Sarasota 1972, p. 31, no. 70, ill. p. 66

LITERATURE: Mongan 1940, I, p. 217, no. 425

Mongan and Sachs accepted Lindner's attribution of this drawing to Paul Troger, as recorded by Randall, and E. A. Maser and Kent Sobotik also both exhibited it as such. Sobotik also dated it to 1725–30, because of the influence of the Carracci that he saw in it. Mongan and Sachs did note, however, that the use of red chalk is unusual in Troger's drawings; in the main these employ brown inks. Formal qualities of this sheet also differ considerably from Troger's. Comparison to other works by Troger from 1725–30, including a drawing in this exhibition (cat. no. 31) excludes it from that period of the artist's oeuvre.

As the author of the present catalogue first observed, this pietà can be attributed to Thomas Schwanthaler, an artist active fifty years earlier than Troger.[1] The heavy, voluminous draperies that envelop the bodies of the Virgin, St. John, and the Magdalene, the expressive faces, and the compression of the composition recall features in actual sculpture executed by Schwanthaler during the last third of the seventeenth century. Such features are revealed in some of Schwanthaler's most familiar works, such as the altarpieces in the church of St. Wolfgang am Attersee. Individual types in Schwanthaler's sculpture, especially those of his angels, are also recalled by the St. John and Magdalene in the Fogg drawing. The use of red chalk to evoke forms also corresponds to Schwanthaler's sculptural sensibilities.

Comparison to drawings by Schwanthaler secures the attribution. The formal characteristics that have been found in authentic drawings by Schwanthaler, primarily in the so-called Imst sketchbook, and also in the Schwanthaler *Nachlass* in Munich, are also to be seen in the Fogg drawing.[2] These include modelling by means of hatching in red chalk for shadows that do not always observe the boundaries of forms, contour lines forming and reforming so as to suggest resistant material, and movemented draperies that create rhythmical patterns.

The Fogg drawing can thus be associated with a remarkable group of drawings that are related to the workshops of a number of sculptors, including Schwanthaler, Andreas Thamasch, and Georg Kölle. These drawings include both original sheets by Schwanthaler and copies after his drawings. In the group are free studies, works inspired by existing models, designs and apparently copies after sculpture by Schwanthaler and Thamasch. The drawings seem to have been passed from one atelier to another, and thus provide important information on the connections and workshop procedures of late baroque sculptors in Austria.[3]

This group has been enlarged by the recent discovery in the parish church of Erdösmecske, Baranya County, Hungary, of a book of drawings similar to that from Imst.[4] The Hungarian book includes sheets by additional hands, especially Georg Hoffer, as well as several more drawings that can be linked to existing sculpture in Austria.

Despite the variety of hands that can be found in these books, sheets discovered in the Hungarian volume confirm the attribution of the Fogg drawing. In particular, two drawings of St. John the Evangelist from the Erdöcsmecske collection are quite close in conception to the figure in the Fogg sheet. The youthful long-haired saint who reacts emotionally is characterized similarly in all of these sheets.[5] Because of the variety of uses to which such drawings could be put, it is still not possible to determine the exact function of the Fogg sheet: it cannot be identified with any surviving sculpture.

1. Letters to the Fogg Museum of November 6, 1984, and January 16, 1985.
2. For an illuminating description of Schwanthaler's drawing style, followed here, a discussion of the problem of attribution and function of drawings by him as well as a review of the scholarly literature related to these subjects, see Krapf, in Reichersberg am Inn 1974, pp. 126–32, esp. pp. 128–29 (also in Vienna 1974, pp. 105–11, cat. no. pp. 113–20.) Reichersberg am Inn 1974, figs. 84–87, and Vienna 1974, figs. 32–35, also provide illustrations of comparable drawings.
3. For the question of the history of the Imst sketchbook and its relation to the work of Kölle and Thamasch, see the analysis in Gauss 1973, pp. 59–65.
4. For this book, see Boros 1983, pp. 12–33, and Boros 1985, pp. 231–55 (summary pp. 605–7).
5. Illustrated in Boros 1985, figs. 4, 9.

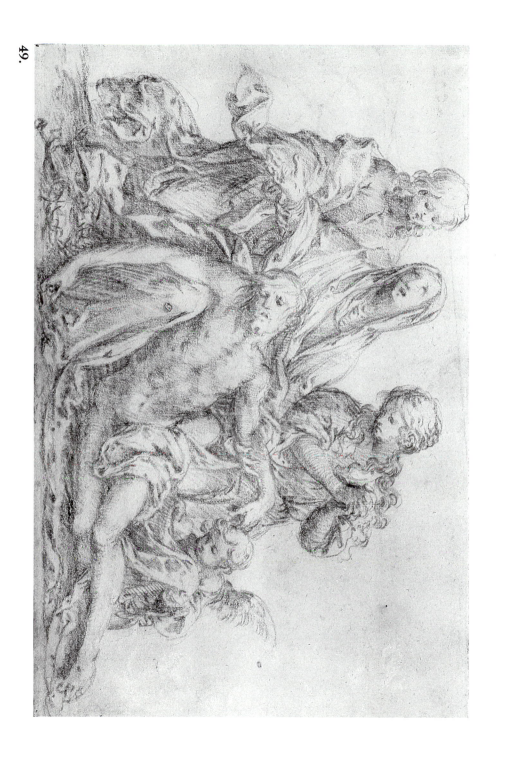

The son of a carpenter and the older brother of Matthäus Donner, Georg Raphael Donner was born in Essling, near Vienna, on May 24, 1693. After receiving his first training from the imperial court jeweller and goldsmith Johann Kaspar Prenner, ca. 1707, he was apprenticed to the sculptor Giovanni Giuliani, who during that period was carrying out major commissions in Vienna and Heiligenkreuz. Around 1715 Georg Raphael and his brother studied with the coincutter Benedikt Richter and probably between 1715 and 1725 studied with Balthasar Permoser in Dresden. During the early 1720s, he is documented as having completed works for Linz and Aschach.

In 1725 he was called to Salzburg by the prince bishop and completed work in Schloss Mirabell there by 1727. However, he did not gain employment either at the Salzburg mint or as Salzburg court sculptor. He thus responded to the invitation of the primate of Hungary to come to Bratislava (Ger., Pressburg), where he maintained a workshop until 1739. During these years he completed many major works, including the former high altar of the St. Martin's church, Bratislava, and the fountain on the *Mehlmarkt* (now the *Neuer Markt*), Vienna. He moved to Vienna and died there on February 17, 1741.

Georg Raphael Donner was the most important Austrian sculptor of the early eighteenth century. Through his impact on his brother Matthäus (*q.v.*) and his pupil Oeser (*q.v.*), his influence on the formation of the classical ideal indeed lasted far longer than his brief career.

50. Kneeling Nude Figure and Two Studies of Angels (recto); Two Rough Studies of Nude Figures (verso)

Recto: graphite, margins ruled in red chalk; verso: black and brown chalks
12½ × 8³⁄₈ (317 × 213)
Signed (?), lower right corner, recto: *Rafael Donner*
Watermark: imperial eagle with a cross and W

The Metropolitan Museum of Art; Harris Brisbane Dick Fund, 47.155.3

PROVENANCE: Gustav Grunewald, New York (Lugt, supplement, no. 1155b on verso); Joseph Stehlin, New York; purchase, 1947

The inscription on the recto of this drawing was possibly written by Donner himself. The signature Raphael Donner is found on medals of the artist's early period and in the years that he worked in Bratislava.[1] Although Donner does not seem to have signed his name elsewhere with an f instead of a ph, orthography was of course not standardized at the time. The signature closely resembles that seen on contemporary documents.[2] If it is not by his hand, it is, in any event, in a contemporary script.

The inscription alone does not necessarily ascertain the authorship of the drawing; but it is significant that this seems to be the unique sheet bearing such a possible signature.[3] There is no reason to doubt the ascription.

The drawing can be compared to both the style and the subject matter of Donner's works. The soft flowing lines found in many Donner sculptures, particularly in lead, are suggested by the use of graphite and chalk in the drawing. The proportions of the figures are also those found in his sculptures. The angels are comparable to those from the former high altar of St. Martin's church, Bratislava (now in the National Gallery, Budapest). They are also comparable to several works executed by his atelier after designs by Donner.[4]

The iconography of the recto cannot be directly connected with any known work by the artist. While the angels resemble those from several sculptures, the kneeling figure, perhaps a martyred saint, or soul, is not found in any piece. On the other hand, the grouping on the left of the verso resembles that of a Lamentation and may be associated with the pietà, executed by the artist for the cathedral in Gurk. The figure on the right is not clearly identifiable.

The very sketchy nature of both sides of the drawing, with many flourishes and pentimenti throughout, indicates that these were preliminary designs, or *pensieri*. It is interesting to note that the artist sketched out his preliminary designs in such a way, before working them up in *modelli*.

While it is uncertain why he may have signed such a study, the Metropolitan Museum of Art drawing is exceedingly important as the unique surviving work in the medium by the artist and is a source of insights into his working procedure.[5]

1. For the signature "Raphael Donner" from 1728, see Pigler 1929, p. 33; for this signature in 1732, see p. 18.

2. See Schlager 1853, p. 151.

3. A drawing of *Jupiter and Selene* in the Graphische Sammlung Albertina, Vienna, inv. no. 14459, Tietze 1933, p. 162, cat. no. 1994, bears the inscriptions *Raphael Donner* on the recto and *Rafael Donner* on the verso; these inscriptions are not in the medium of the drawing and bear no resemblance to either his writing or other handwriting of the time. The drawing in question cannot be connected with Donner's sculpture and seems to be a mid-eighteenth-century Austrian sheet. It seems to have been made after, rather than for, a relief.

4. For example, in the altar designed by the sculptor for the Trinity Church, Bratislava, 1726: see Pigler 1929, fig. 143, pl. 25; Pötzl-Maliková 1973, pl. 25; Sásky 1982, fig. 5, and the high altar in the church in Marianka, near Bratislava, also executed by Donner's workshop in 1736; Pötzl-Maliková 1973, ill. p. 86. I am grateful to Claudia Maué for the references in this and in notes 1 and 2, communicated to me in a letter of February 16, 1987.

5. For Donner's working procedure and his *modelli*, see Maué, in Volk 1986, pp. 157–69. A recently acquired wood statuette in The Art Museum, Princeton University (y198-5), which is the subject of ongoing research by the author, allows these notions to be reconsidered, however.

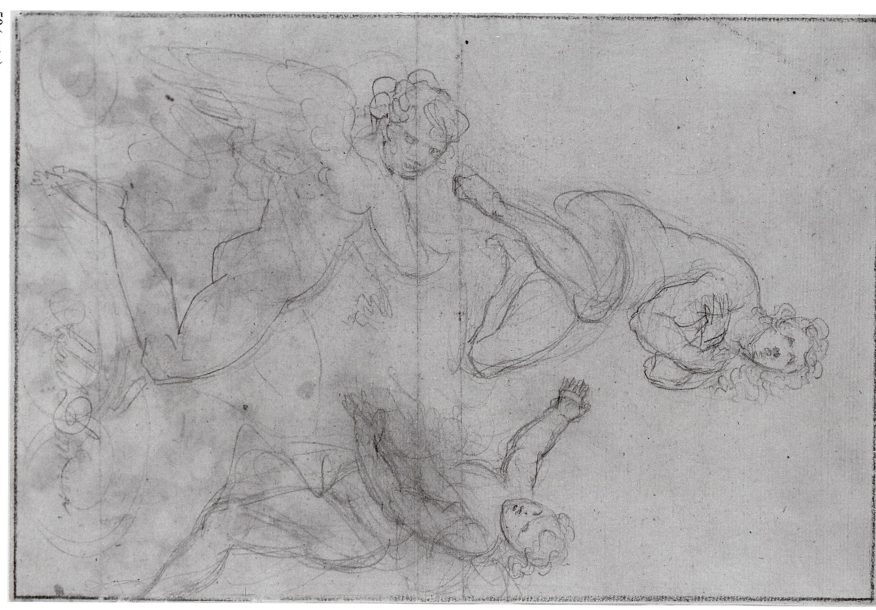

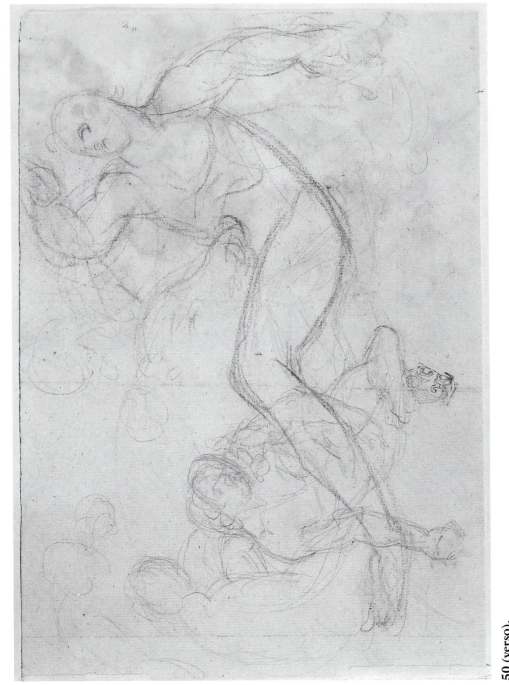

50 (verso).

The younger brother of Georg Raphael Donner (*q.v.*), Matthäus was born in Essling on August 29, 1704. Like their younger brother Sebastian, Matthäus remained a medalist throughout his life, a skill that they had learned from the Swedish coincutter Benedikt Richter in ca. 1715. In 1726 he began studying sculpture at the Vienna academy, winning a gold medal there in 1732.

In the same year, Matthäus Donner was named imperial *Kammermedailleur*, and in 1738 "*wirklicher Münzeisenschneider*." In 1743 he became professor of sculpture at the Vienna academy, and in 1745 director of the *Gravenrschule* there. Besides designing coins and medals, Donner also made portrait busts and metal reliefs. In this latter genre, he helped disseminate his elder brother's style, and by this means as well as through his teaching, he was one of the founders of academic classicism in Vienna. Matthäus Donner died in Vienna on August 26, 1756.

51. Nude Study

Red chalk, traces of black chalk, on white paper, laid down
16½ × 20½ (422 × 522) (sight; irregular)
Monogrammed and dated in red chalk, lower left center: *MD* [ligatured]/*1752*. Inscribed in graphite, lower right: *Matthäus Donner/ Prof. der Malerakademie/ in Wien zwischen 1751 und 1754*; inscribed in graphite, bottom right center: *Matthias Donner feci*; inscribed in graphite, bottom right corner: *A.B.*

Collection of Constance and Stephen Spahn

PROVENANCE: Unknown collector (red chalk inscription, 9 *N.M.*, lower left); Blumka Gallery, New York

BIBLIOGRAPHY: Volk 1985, pp. 51–52, fig. 9

The anonymous author of an old inscription on the drawing interpreted the *MD* monogram as being that of Matthäus Donner, and referred to his role as professor at the academy. Peter Volk also published this drawing with a possible attribution to the sculptor, noting that the lack of comparable material made it impossible to secure the attribution unequivocally: no drawings by either of the Donners had been known previously. Further, as Volk remarks, no other drawings of nudes of this type by south German or Austrian sculptors have hitherto come to light.[1]

Other material presented in this exhibition, however, adds to this picture of sculptors' drawings. Moreover, both the probable function of the sheet, as well as elements of its execution, speak strongly for the attribution to Matthäus Donner. Details of presentation suggest that this drawing of a male nude is an academic study. The composition concentrates on the nude form, largely to the exclusion of setting: the figure in a recognizable space. The model's pose, seeming to lean over a wall, appears to have been assumed over two blocks or crates, probably studio props; the cloth thrown over the larger of the blocks, which seems to constitute this wall, also makes sense as a device to make a rather

awkward pose more comfortable. Similar props such as the box and cloth are found in the academic drawing by Messerschmidt (cat. no. 54), a sculptor who was a pupil of Matthäus Donner. The use of the red chalk medium by sculptors is also long established in Central Europe (see, for example, the drawing by Schwanthaler, cat. no. 49).

From 1743 until his death in 1756, not merely from 1751 to 1754 as the inscription suggests, Matthäus Donner was professor of *Bildhauerei* at the *Kunstakademie* in Vienna; from 1744 he was director of the *Gravenrschule*. An academic study could well have originated as part of Donner's professional activity as an educator. The drawing has been carefully prepared: traces of black chalk visible around the outline of the figure, particularly noticeable by the arms and hands, suggest that it was first outlined in this medium and then worked up in red chalk. The modeling of the figure is achieved through a dense web of red chalk hatching, using the wet end of the chalk for areas of deeper shadows. The presence of the monogram may indicate that the sheet served as a demonstration piece for students: the signature on the drawing by the sculptor Messerschmidt (cat. no. 54) seems to indicate that it served a similar purpose.

Volk remarked on the thoroughly Donner-like qualities of the figure in the sheet. Specifically, he noticed that the model is posed similarly to the statue of the river Traun from Georg Raphael Donner's fountain from the *Mehlmarkt* (called by him the *Neuer Markt*) in Vienna.[2] Although the left leg of the model is not raised as in the sculpture, and his back is not stretched out the same way, it is indeed conceivable that the difficult pose he is made to assume does emulate Georg Raphael Donner's work. Placing models in poses resembling those found in sculpture by Georg Raphael Donner not only corresponds to a process of instruction by emulation but has a particular resonance in regard to this specific figure.

Matthäus inherited Georg Raphael Donner's *Nachlass*, and made use of his brother's workshop material.[3] A model of the Traun figure by Donner or his workshop may indeed have existed among his possessions. It is known that Matthäus had particular interest in the *Mehlmarkt* composition, on which he may have collaborated: he made a medal that employed the motifs of the river gods from the fountain.[4] He may have had pupils in the academy prepare copies of the *modelli* by Georg Raphael Donner.[5] The recollection of the Traun figure in the model's pose may reflect these interests.

This drawing stands as an important link in a chain of recently discovered chalk drawings by major Austrian sculptors from Schwanthaler to Messerschmidt visible in this exhibition.

1. Volk 1985, p. 51: "Eine Deutung des Monogramms auf Matthäus Donner könnte zutreffen, wenngleich sich die Zuordnung mangels Vergleichsma-

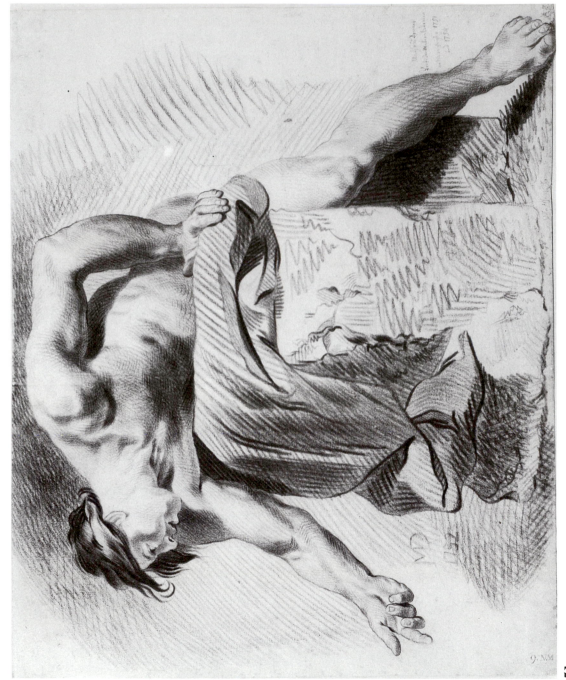

51.

terials nicht eindeutig sichern lässt . . . Weitere derartige Aktzeichnungen süddeutscher oder österreichischer Bildhauer der Rokokozeit sind bisher nicht bekannt geworden."

For the problem of drawings by Georg Raphael Donner, see cat. no. 50, and Maué, in Völk 1986, pp. 158, 165, n. 18.

2. Völk 1985. Though evidently based on a photograph, Völk's general observations can nevertheless be sustained; it should however be noted that the Donner-like qualities are those of the general physical type of the nude, and not of the drawing itself, as comparison with the drawing by Georg Raphael Donner in this exhibition, cat. no. 50, suggests. For an illustration of this Traun river god, the original of which is now in the Österreichische Galerie, Vienna, see for example Baum 1980, 1, pp. 138, 139; Haberditzl 1923, figs. 28–29.

3. See Kádebo 1880, p. 67.

4. Ilg 1893, p. 42, mentions that a foot of a life-size clay model of the figure of the Traun was in the collection of Freiherr Karl von Hasenauer. While Maué, in Völk 1986, pp. 165–66, n. 19, remarks that it is impossible to decide if this and other clay models were workshop productions or later reductions, the size of this model does seem significant.

Ilg 1893, p. 42, also mentions the Matthäus Donner medal to which reference is made here.

5. See Diemer 1979, pp. 170–72, 263–64.

FRANZ IGNAZ GÜNTHER
(1725–1775)

Franz Ignaz Günther was born on November 22, 1725, in Altmannstein, near Ingolstadt. A member of a family of many artists, he received his first instruction from his father, Johann Georg Günther, a sculptor and joiner. From 1743 to 1750 he was an apprentice to the Bavarian court sculptor Johann Baptist Straub, who maintained the largest workshop in southern Germany.

In 1750 Günther traveled to Salzburg and may also have gone on to Venice. He next worked in Mannheim with Paul Egell, the sculptor to the Palatine court, until Egell's death in 1752. Thereupon he may have journeyed down the Main to Würzburg and Bamberg, where his uncle Franz Xaver Anton Günther resided, and on to Moravia, where he may have associated with Richard Georg Prachner, and where a monstrance by him is located. Günther concluded his *Wanderjahre* with a sojourn from May 17 until November 10, 1753, at the academy in Vienna, where he was awarded a gold medal.

Establishing his workshop in Munich in 1754, Günther received many important commissions for sculpture. Among these are works for churches in Rott am Inn (1759ff.), Weyarn (1763), Neustift in Freising (1765f.), Starnberg (1766–68), Mallersdorf (1768), as well as for the *Bürgersaal* in Munich and for Schloss Schleissheim (both 1763). In 1773 he was made court sculptor, and executed models for works in the Nymphenburg castle grounds. He died in Munich in 1775.

Enormously prolific, Günther is regarded along with Straub as the leading south German sculptor of the time.

52. Design for a Funerary Monument

Pen and brown ink, brown and gray wash
11⅝ × 8 (295 × 225)
Inscribed: *D.O.M. / Hic Jacet . . .*

The Metropolitan Museum of Art; Gift of Anne and Carl Stern, 64.530.1

PROVENANCE: August Fries, New York; purchase, 1964

This previously unpublished drawing, once thought to be anonymous and with a mount reading *Nilson*, can be attributed to Franz Ignaz Günther and dated to his most productive period, during his second sojourn in Munich.[1] It represents a freestanding tomb monument, the only such large-scale design for a secular subject known in his oeuvre.[2]

Its inscription not only resembles that of an epitaph, but its lettering "*D.O.M. / Hic Jacet,*" is like that found in epitaphs designed by Günther, and is indeed written in the same handwriting.[3] The skull and hourglass on the upper cornice allude further to mortality. On the other hand the personifications of Charity, to the left, and of Chastity or Humility, to the right, allude to the virtues of the patron, whose noble status is established by the crown surmounting the whole structure, and by the shields with quartering reserved for the depiction of a coat of arms. A similar iconography is found on other tombs of the mid-eighteenth century

in Bavaria.[4] Most likely it is a design for a tomb for a countess, princess, or other noblewoman.

This working drawing resembles many similar designs by Günther. Its graphic language is comparable to that found in other tomb monuments already mentioned, in which a similar balance is preserved between precision and freedom in the use of the media of pen and brush with wash. The elongated and apparently weightless forms placed on a similarly elongated, linear architecture, delineated by a pen, is common to his work.

While the tomb is comparable in structure to other works known from the 1760s, as suggested, the closest comparison for the drawing style is to be found in a drawing dated by G. Woeckel to the mid-1750s. This is a representation of St. Dominic receiving the Rosary, in which in particular the type and modelling of the Virgin can be compared with the figure of Charity on the left of the New York drawing. The sharp angular folds of the garments, comparatively much sharper than in later drawings by the artist, are similar, as is the way in which the figure is shown with covered head. The application of wash is also close.[5] The drawing probably dates therefore to around this time and is an important addition to Günther's oeuvre.

1. According to Museum records, around the time the drawing was purchased, A. Hyatt Mayor also recognized the work was by Günther.
2. Otherwise a design is known for a funerary monument with Mercury as a putto, of ca. 1762, perhaps designed for the artist's uncle, the sculptor Joseph Amand Günther: see Woeckel 1975, p. 366, no. 59, fig. 295.
3. See his design for the executed funerary monument to the dean and parson of St. Peter in Munich, 1759, illustrated in Woeckel 1975, pp. 275–76, no. 39, fig. 214.
4. See Volk 1982, pp. 155–72.
5. Staatliche Graphische Sammlung, Munich, inv. no. 7761, illustrated in Woeckel 1975, p. 228, no. 29, fig. 165.

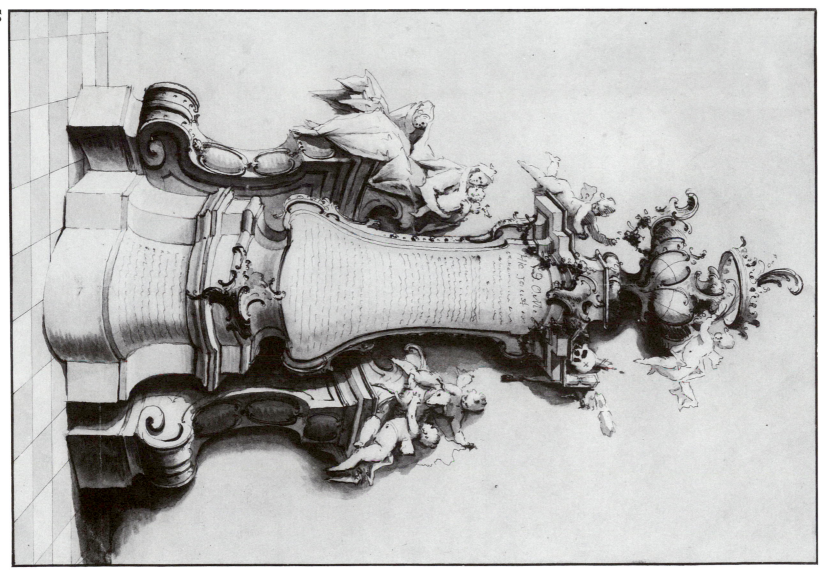

JOSEPH HÄRINGER

(1738–1791)

Son of the sculptor Andreas Häringer, Joseph Häringer was born on December 30, 1738, in Windkreuth (Ger., Unterpeissenberg) near Peissenberg, south of Munich, very near the birthplace of Matthäus Günther (and his brother the sculptor Joachim) on the Hohenpeissenberg. These places are quite near to Wessobrunn, the home of many stuccoists, sculptors, and architects.

Häringer was the pupil of Franz Ignaz Günther and became his collaborator, perhaps as early as Günther's work at Rott am Inn, of 1759. During the 1760s and 1770s, he executed projects after Günther's designs, as in 1772 at the St. Elizabeth Church as well as sometime thereafter at St. Jacob am Anger in Munich.

Upon Günther's death Häringer took over his workshop. On April 23, 1780, he married Maria Anna Günther, the younger daughter of his teacher. Häringer died after a long illness and was buried in Munich on November 27, 1791.

53. Design for an Altarpiece Containing a Painting of the Nativity

Pen and black ink, black and gray wash
15 15/16 × 8 7/8 (405 × 228)
Inscribed in gray ink, lower left: *maßstab von 6 sch.*; in center: *distanz bunt 26 sch weith*; signed and dated, lower right: *Joseph Häringer inv. et fecit 1767*
Watermark: fleur-de-lys above shield, above illegible inscription

The Art Institute of Chicago; Leonora Hall Gurley Memorial Collection, 1922.3525

PROVENANCE: William Gurley (Lugt 1230b, lower right)

EXHIBITION: Sarasota 1972, cat. no. 8, pp. 33–34, ill. p. 69

LITERATURE: Woeckel 1965, pp. 386–401; Woeckel 1975, p. 283, ill. 280, fig. 218

This is the only known signed and dated drawing by Joseph Häringer and is a key work in the determination of the artist's style both as a sculptor and as a draftsman.

The drawing represents an altarpiece that contains a painting of the Adoration of the Shepherds in the middle of a structure supported by a double pair of columns. On the altar proper, on either side of an altar tabernacle surmounted by a personification of Charity, are shown to the left Hope, and to the right Faith. On plinths on the lower level of the altarpiece are seen to the left a robed figure with a tablet, and to the right a figure with a scroll, both probably Prophets. On a level above them are found, to the right, a crowned figure holding a harp who probably represents David, and to the left a turbaned man, perhaps Solomon, to judge from the context. The area above the fictive painting, corresponding to what is called the *Aufsatz* or *Gesprenge* in traditional altarpieces, is occupied by figures of God the Father, who stretches out his hand, and the Holy Ghost, in the midst of a gloriole.

Woeckel has drawn attention to the reliance of the architecture upon Franz Ignaz Günther's designs of ca. 1766 for

the side altars in the church in Freising-Neustift, and has noted the close similarity in the format of four statues and tabernacle figures to the high altar executed by Häringer in ca. 1777 in the church of St. Elizabeth, Munich, after a drawing by Günther. These similarities reveal Häringer's close and continuing dependence on Günther.

This dependence is shown no less in his drawing style, which also resembles that of Günther (see cat. no. 52). Even though somewhat drier in execution, Häringer's drawing evinces a similar wash technique and a preference for long, tapering figural types.

Häringer's design is carefully carried out, however, and this feature, together with the annotated dimensions on the sheet, indicates that it was probably a project for an altarpiece that has not yet been identified. Because of this purpose, it also differs somewhat in appearance from other securely attributed drawings by the artist, copies after designs by Günther for the facade of the Theatine Church, Munich; as copies, these drawings are somewhat flatter, lacking a sense of three dimensionality.[1] Nevertheless, all the drawings concerned are consistent in their use of pen and wash, and for this reason provide a touchstone by which other attributions can be made.[2]

The Chicago drawing may further help to resolve some recent disagreements about attributions to Häringer.[3] On the basis of comparison with the Chicago drawing, and certain Häringer copies after Günther, Häringer's corpus as a draftsman should probably be treated rather cautiously, with ascriptions to his hand restricted to works in similar media, and then in style to the artist. Other drawings by and after Günther are better left to anonymous assistants.

Here Häringer reveals himself as a competent draftsman and worthy follower of his father-in-law Günther.

1. For these drawings in the Halm-Maffei Collection, Staatliche Graphische Sammlung, Munich, see Woeckel 1975, pp. 507–18, cat. nos. 86–89. These drawings are attributed on the basis of their ascription by Felix Halm (1758–1810). See also Munich 1985, pp. 64–65, cat. nos. 51–54, ill.
2. E. g. a drawing in a private collection, Wiesbaden, depicting Christ collapsing under the cross (Munich 1985, pp. 525–26, cat. no. 91), seems convincing.
3. See, for example, Volk 1986, pp. 278–79.

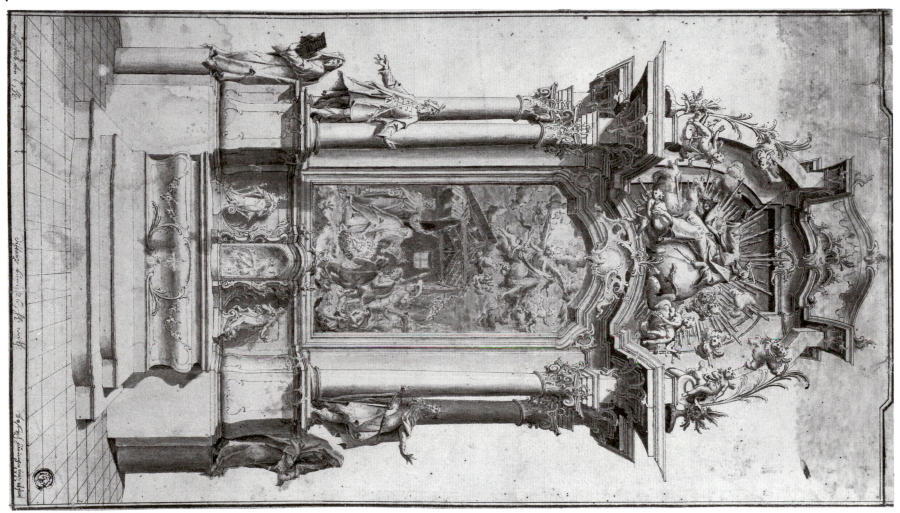

FRANZ XAVER MESSERSCHMIDT
(1736–1783)

Messerschmidt was born in the village of Wiesensteig near Geislingen in the region of Ulm on February 6, 1736. After his father's death in 1746 and his family's move to Munich, he studied with his uncle, the important Bavarian sculptor Johann Baptist Straub (1704–1784), for several years. He then went on his *Wanderjahre*, which included working with another uncle, Philipp Jakob Straub, in Graz. In 1755 he entered the Vienna academy.

Messerschmidt's first independent works, portraits of the Empress Maria Theresia and the Emperor Franz Stephan I, were executed in 1760ff., for the Vienna arsenal (*Zeughaus*) and established his reputation in the genre, in which he worked during the next decade. After a brief study trip to London and Rome in 1765, he returned to Vienna, where on March 11, 1769, he became a member of the academy, and at the same time *stellvertretend* professor for sculpture. From impulses in Rome he introduced a classicizing style that corresponds to Winckelmann's aesthetic. In 1774 he was passed over for a position and given an early pension.

His early retirement was probably the result of his increasing mental illness. This illness cut short his service in 1775 as Bavarian court sculptor, and caused him to become a recluse, living alone in Bratislava (Ger., Pressburg) from 1777. He died in August 1783 in Bratislava.

Messerschmidt is best known for the "character heads" that he executed from ca. 1770, during the period of his illness, under the influence of the psychological and physiognomic theorists Franz Anton Mesmer and Johann Kaspar Lavater.

54. Seated Nude Male Figure Holding a Staff

Black and white chalk, on blue paper
16⅞ × 10½ (422 × 267)
Signed in black chalk, bottom center: *Messerschmidt*
Watermark: double-headed imperial eagle surmounted by a crown above the letters HR

The Metropolitan Museum of Art; Harris Brisbane Dick Fund, 47.155.4

PROVENANCE: Gustav Grunewald, New York (Lugt 1135b in violet on verso); Joseph Stehlin, New York; purchase, 1947

The signature on this drawing is that of Franz Xaver Messerschmidt. A similar, if not identical, signature is found on documents signed by the artist.[1] As no other absolutely certain drawings by the artist have been found, and as this is not a copy after any known sculpture by the artist, there is no reason why the name Messerschmidt would have been placed on this drawing by someone other than the artist.[2]

The absence of other comparable drawings by the artist might seem to call the attribution of this sheet into question: Messerschmidt's working procedures as a sculptor apparently obviated the need for preparatory drawings.[3] Yet it is clear that this sheet served some other purpose. The figure in the drawing is shown seated on a block with his hand holding a staff, which along with his left foot rests on a block. The pose he assumes is quite common for studies from the nude model, just as the staff is a common prop; other similar drawings associated with the Vienna academy are known.[4] The staff terminates in a point, suggesting it is a lance or trident: this might identify the man with Neptune or Adonis, a classical identity that might well have appealed to students in the academy.

Certain formal elements are also comparable to qualities inherent in Messerschmidt's sculpture of the 1760s, the period when Messerschmidt was most closely associated with the Vienna academy. The firm dark outlines, confident handling of foreshortening, and controlled hatching and highlighting not only suggest a sculptor's concerns with tactility but indicate the hand of a competent artist, fully in control of his task, as might be expected of Messerschmidt after his series of successes in the 1760s. Stylistic details, such as the rather hard treatment of the falling folds of material, also specifically characterize his sculpture until ca. 1770.[5]

It is even possible that the presence of the signature on this sheet may be related to its proposed function as a demonstration piece for students in the academy. A similar explanation might account for the unusual full signature on a red chalk drawing by Paul Troger.[6]

The Metropolitan drawing thus assumes a unique place in Messerschmidt's oeuvre, and accordingly an important one in the history of Central European sculpture of the eighteenth century.

1. See Pötzl-Maliková 1982, ill. p. 100. Pötzl-Maliková's first reaction to a reproduction of this sheet, orally to the author, in 1984, was that the handwriting might be his; her subsequent reaction, orally, in 1986, was not so certain.

2. Pötzl-Maliková 1982, p. 39, ill. would like to attribute to Messerschmidt the figural group indicated in the center of a drawing by Joseph Meissl, the Vienna state architect, for the facade of the *Savoysches Damenstift* in Vienna. The basis for this attribution seems to be that Messerschmidt executed the sculpture on the existing facade, for which see Pötzl-Maliková 1982, p. 225, cat. no. 18. The attribution is hard to sustain, in any instance, as it is difficult to imagine why or how Messerschmidt would have added to an architectural drawing, especially after the completion of the project.

3. See Pötzl-Maliková 1982, p. 84. The one drawing attributed to Messerschmidt, as noted above, is executed in wash; for this reason again its authenticity, rather than that of this signed sheet, should be doubted. Following a visit to Messerschmidt's studio, the famed Berlin writer C.F. Nicolai wrote in 1781 that Messerschmidt worked naturally and directly as a sculptor, modelling and carving without drawing beforehand: see Kris 1932, pp. 224ff. (reprinted in Kris 1979, pp. 128–50).

4. For example, a drawing by Caspar Franz Sambach in Budapest, Szépművészeti Múzeum, inv. no. 833 (see fig. 9).

5. This point was also noted by Pötzl-Maliková, orally, in 1984; at this time she also suggested a date of the 1760s for the drawing.

6. Berlin-Dahlem, Kupferstichkabinett, Stiftung Preussischer Kulturbesitz, inv. no. 16556, signed "PAUL TROGER."

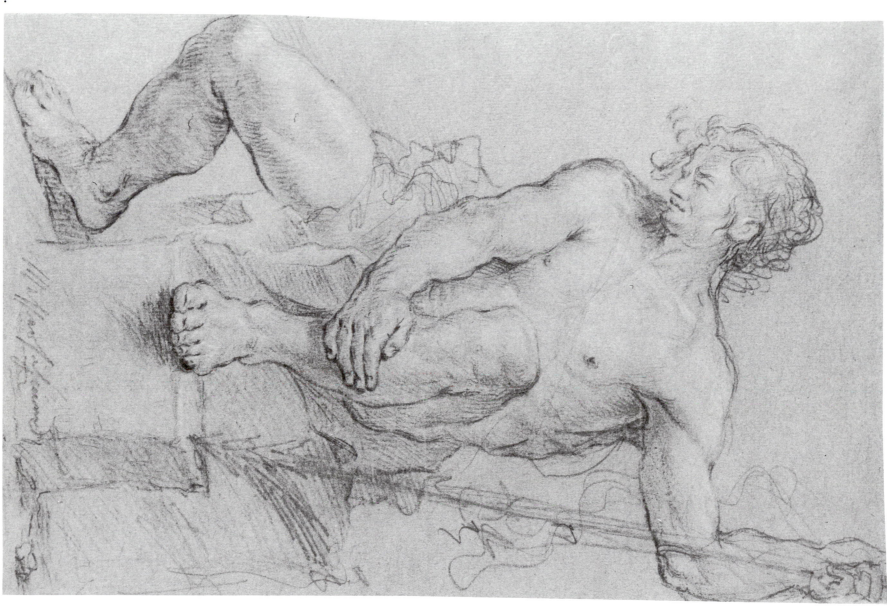

ANTON RAPHAEL MENGS

(For biography see cat. no. 27)

55. Male Nude

Black chalk, on cream-colored paper, covered with gray wash
21 × 14 13/16 (533 × 376)
Signed in gray ink, lower left: *Mengs f.*

National Gallery of Art; Gift of Howard Sturges, 1956.9.13

PROVENANCE: Howard Sturges

This unpublished drawing is similar in its polished use of the chalk medium, size, and style of drawing the human figure to another unpublished drawing dated 1778 of a nude male, also in Washington.[1] Thomas O. Pelzel has authenticated the signature on the sheet exhibited here, and accepted the date of 1778 as plausible.[2]

The Washington drawings correspond to a type of academic nude study found in other collections.[3] The dating of these sorts of drawings to Mengs's last period in Rome, from 1777, is corroborated by the Roman provenance of one of these.[4]

During this period Mengs resided in the Villa Barberini, and established there a large atelier that also functioned as a kind of academy.[5] These drawings of male nudes, with their absence of any subsidiary element and consequent concentration on the human figure, and their indications of studio props—the box on which the figure rests here, the staff by which the nude supports himself in a related drawing in Dublin—may clearly be considered academic studies.

As Mengs customarily made studies of models in poses required for his important compositions, the question remains open as to whether these drawings were preparatory to other works. However, various features of the drawing suggest that it was intended as a teaching tool for his students. Such characters as the equipoise of the figure, the absence of external detail, and the high finish suggest that this was a demonstration piece, as does the large size of the sheet and the presence of Mengs's signature.

As such this drawing may be connected with Mengs's pedagogical and theoretical activities. In this connection, as well as in its polished style, it exemplifies the artist's role as one of the progenitors of neoclassicism.

1. Signed and dated in graphite, lower right: *Antonio Rafael Mengs año 1778.*
2. In a letter of April 17, 1971, in the records of the National Gallery of Art.
3. For example, a sheet comparable in most particulars in the Graphische Sammlung Albertina, Vienna, cat. no. 1906 (Tietze 1933, p. 153).
4. National Gallery of Ireland, inv. no. 3930, illustrated and discussed in Chapel Hill 1983, pp. 56–57.
5. See Pelzel 1968, pp. 241–47.

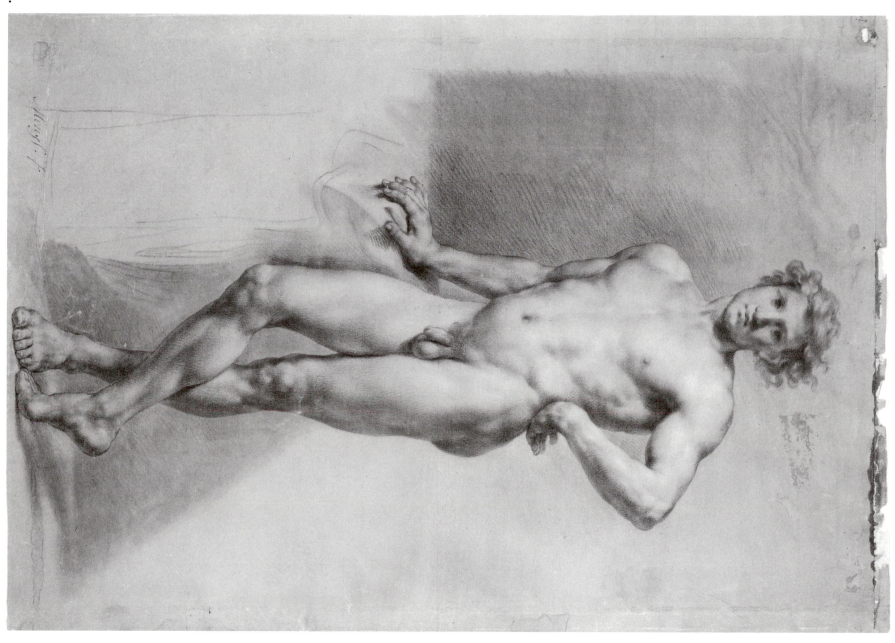

D. Other Designs for Decorative and Architectural Projects

JOHANN AUGUST NAHL THE ELDER

(1710–1785)

Son of the court sculptor Johann Samuel Nahl (1664–1728), from whom he received his earliest training, Johann August Nahl was born in Berlin in 1710. He spent his *Wanderjahre* in Switzerland, from 1728, then in France, ca. 1731–35, Italy, and again in Switzerland, ca. 1737–41. Nahl studied sculpture in Italy and also became acquainted with the newest ornamental inventions in France.

Returning to Prussia in 1741, he entered the service of Frederick II and was appointed *"Directeur des Ornements"* in 1744. Nahl's collaboration with the architect and painter Georg Wenceslaus von Knobelsdorff (1699–1753) and the brothers Johann Christian and Johann Michael Hoppenhaupt (q.v.) created the decorative style known as the Frederician rococo. His most famous work of this period includes the design for the Music Room in the Potsdam *Stadtschloss* (1743–44), the Golden Gallery in the Charlottenburg Palace, and the library of Schloss Sanssouci at Potsdam.

Perhaps because of the pressures of work, Nahl suddenly left the Prussian court in 1746, settling in Bern after a brief sojourn in Strasbourg. At the end of his life Nahl returned to Germany to work on Schloss Wilhelmsthal in Kassel, where he died in 1785.

56. Design for a Wall Panel with a Fireplace

Graphite, pen and black ink, gray and purple washes, with border drawn in black ink

15⅝ × 8⅝ (396 × 219)

Inscribed in graphite on verso: *Cuvilliés*

Cooper-Hewitt Museum; Gift of the Council, 1911-28-36

PROVENANCE: Léon Decloux, Sèvres, purchased after 1906; given by the Council

EXHIBITIONS: Princeton, N.J., Princeton University School of Architecture, January 6–16, 1934; American Federation of Arts, 1953; Baltimore 1959, p. 64, cat. no. 261 (as Cuvilliés); New York 1959, no. 81; Burlington, Vermont, Robert Hull Fleming Museum, University of Vermont, "Rococo Design and Decor," December 3–30, 1961; Cologne 1979, no. 38

LITERATURE: New York 1962, pp. 11, 102, cat. no. 51, ill. p. 63

This design for a wall panel with a fireplace presents within the decorative framework of the chimney wall a graphite image that is most likely meant to indicate a painting, representing a *fête champêtre* set in a landscape. The chimney and frame are built up out of decorative forms known as rocaille. Similar motifs are to be found in the recessed panels to the sides of the central element; rocaille decoration consisting of C- and S-curved foliage extends above the entablature.

Léon Decloux thought that this drawing was by Cuvilliés, and it bore this attribution until ca. 1960. Richard Wunder, however, correctly noted that the sheet could be better attributed to Johann August Nahl, on the basis of the appearance of similar ornament at the palace of Sanssouci, Potsdam, where Nahl worked in 1745–46. Wunder specifically compared the decorative forms especially to the decoration of the library there.

The attribution of drawings like this is difficult, because the decoration of Frederick II's palaces was a collaborative enterprise, involving a team of artists. Johann Michael Hoppenhaupt the Elder (see cat. no. 57), Georg Wenzeslaus von Knobelsdorff, and Nahl all worked together on the same projects, sharing a similar repertoire of ornamental forms and a general style. Documents seldom mention the designer of the completed works.[1]

Nevertheless, stylistic comparison to drawings secured for Nahl strongly suggests that this drawing is by Nahl, or at the least by a close collaborator, an opinion with which the specialist Tilo Eggeling concurs.[2] In particular, Nahl's sketch for the *Musikzimmer* in Sanssouci reveals the same combination of graphite and black pen, with the use of graphite to suggest painted scenes; further, the ornamental motifs are identical, as is the schema of the panel placed above a table or fireplace.[3] The layering of ornament in the Cooper-Hewitt design, in which plant forms develop out of the contours of a mirror, and the relation of the mirror to the table are also found in other drawings by Nahl.[4] The construction of human figures is conceived similarly elsewhere as well, with the fleeting lines used for gathered drapes of clothing in other drawings by the artist.[5] On the other hand the drawing does not have the qualities of sheets by Hoppenhaupt or Knobelsdorff.[6]

Although it is not certain for which project the drawing might have been made, both this author and Tilo Eggeling agree that it has close affinities with designs by Nahl for the *Stadtschloss* in Potsdam, which was destroyed after the Second World War. In particular, the way in which the palm-like leaves go over the borders of mirror and panel, the way central fields and borders seem held in tension, are comparable to Nahl's design for the chimney wall in the *Bronzesaal* of this palace.[7] The design is thus an important example of the Frederician rococo that is possibly connected with a major eighteenth-century project.

1. For the problem of attribution and the effort to unravel it, see Eggeling 1980.
2. Orally, in conversation with the author, 1986.
3. Berlin, Kunstbibliothek, inv. no. Hdz 574.
4. Cf. Berlin, Kunstbibliothek, inv. no. Hdz 573.
5. For example, in Berlin, Kunstbibliothek, inv. no. Hdz 5216.
6. For example, in Berlin, Kunstbibliothek, inv. nos. Hdz 4050, 4528.
7. Illustrated in Bleibaum 1933, pl. 17.

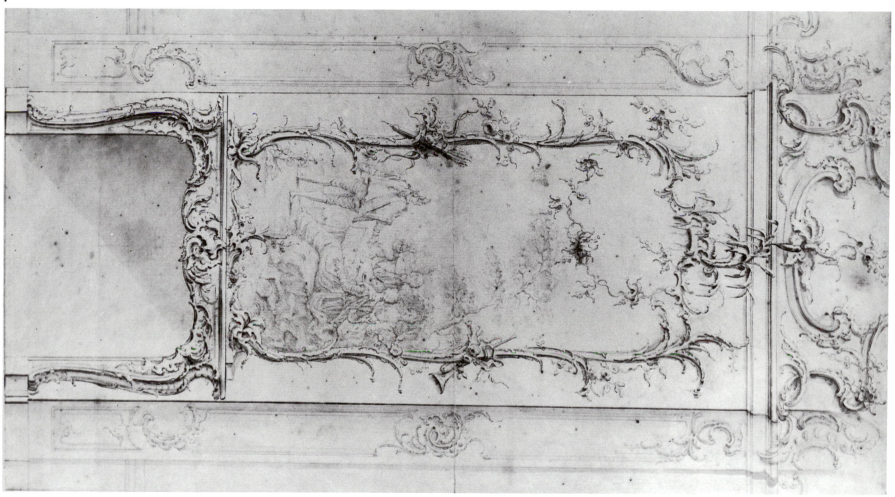

JOHANN MICHAEL HOPPENHAUPT
(1709–ca. 1750)

Johann Michael Hoppenhaupt is sometimes known as Johann Michael Hoppenhaupt the Elder to distinguish him from his younger brother, Johann Christian Hoppenhaupt. He must also be distinguished from another artist of the same name, Johann Michael Hoppenhaupt, who was active in Zittau and Leipzig ca. 1700, and who may have been his father.

Born in Merseburg in 1709, he worked in Dresden, Vienna, and elsewhere before responding to the call to artists that Frederick II ("the Great") of Prussia made upon his accession to the throne in 1740. He worked for Frederick in Potsdam, executing the boiserie in the concert chamber in Potsdam, the decoration in the Palace of the Prince of Prussia, and probably also that of other palaces in Berlin. It is possible that he designed or executed other rooms in Frederick's palaces in Potsdam, although the state of the sources makes it difficult to assign precise roles to the team responsible for what is often termed the Frederician, or Potsdam, rococo.

In 1745 he designed a coach for the tsaress of Russia, and between 1751 and 1755 Johann Wilhelm Meil published engravings after Hoppenhaupt's designs for other coaches and other ornamental projects, which were later reproduced by Johann Georg Hertel. These helped spread knowledge of the important decorative inventions from Potsdam.

Hoppenhaupt returned to Merseburg in 1750, where he died sometime later.

impact on similar designs for carriages made by the Augsburg artist Habermann (see cat. no. 58).[5] In fact, Habermann's designs published by Johann Georg Hertel in Augsburg include one that is exceedingly close to the drawing exhibited here.[6]

This close relationship to Habermann's work, together with uncertainty about the life and works of the Hoppenhaupts, makes the assignment of this drawing to an individual hand difficult. This issue has been a matter of debate in the past, and the confusion about attributions has only recently been somewhat clarified.[7]

Nevertheless, this design can be excluded from Habermann's oeuvre by comparison to his known drawings for prints (see cat. no. 58), and from the oeuvre of Johann Christian Hoppenhaupt on a similar basis. Johann Christian Hoppenhaupt's signed or secure drawings display a much more precise use of outline, and are flatter in their application of wash; in general it may be said that they are less coloristic or painterly than the present drawing.[8] It thus seems best to preserve the traditional attribution to Johann Michael Hoppenhaupt.

If by him, the drawing must have been executed during his period of service at the Prussian court before ca. 1750. Along with the drawing by Nahl in this exhibition, it therefore represents an important example of the Frederician rococo at its height.

57. A Cabriolet (recto)
Wall Decoration and Trellis Arcades (verso)

Pen and black ink, pale lavender and blue washes; verso: pen and ink
13 × 20 (330 × 509)
WATERMARK: IV

Cooper-Hewitt Museum; Friends of the Museum Fund, 1938–88–3188

PROVENANCE: Piancastelli; Edward D. Brandegee; purchased, 1938, Friends of the Museum Fund

EXHIBITIONS: American Federation of Arts, 1953; Baltimore 1959, p. 65, cat. no. 266, ill. p. 75; New York 1959 no. 83; Washington, D.C. 1967, cat. no. 203

LITERATURE: New York 1962, pp. II, 103, no. 56, ill. p. 68

This fanciful drawing for an open carriage typifies a genre of rococo design that seems to have been carried to Germany on one of the waves of taste for things French.[1] The type was introduced to Prussia around 1745 by Frederick II's architects and decorators at Potsdam, J. A. Nahl (see cat. no. 56) and G. W. von Knobelsdorff.[2] Through approximately seventy prints of the subjects made between 1751 and 1755 by Johann Wilhelm Meil after drawings by their collaborator Johann Michael Hoppenhaupt the Elder, and perhaps by Johann Christian Hoppenhaupt, this type of cabriolet became particularly fashionable.[3]

The Hoppenhaupts accordingly gained fame as the designers of decorative cabriolets.[4] It seems clear that they had an

1. For French examples of this sort, see an album of prints after drawings by J. F. Chopard, Cooper-Hewitt Museum, inv. no. 1921–6–272.
2. See Eggeling 1980, pp. 84–87, ills. 85–87.
3. See note 2. An album of these printed designs is also possessed by the Cooper-Hewitt Museum, inv. no. 1921–6–221.
4. See Bleibaum 1933, pp. 32, 70.
5. See Krull 1977, pp. 69–71, ill. 18 b.
6. Inscribed *F.X. Habermann/No. 136/ inv. et del. Io Georg Hertel Excud. Aug: Vind.* An example of this print hangs in the Department of Prints and Drawings, Cooper-Hewitt Museum.
7. See Bleibaum 1933, p. 32, and more thoroughly and convincingly Eggeling 1980.
8. Compare to drawings of ca. 1765–66 in Potsdam, illustrated in Börsch-Supan 1980, p. 126, fig. 85; Potsdam 1986, 2, p. 156, no. XII.26, ill. 157.

FRANZ XAVER HABERMANN

(1721–1796)

Franz Xaver Habermann was born in 1721 in Habelschwerdt, in the region of Glatz (Pol., Kłodzko) in Silesia. Little is known about his early career other than that he began as a sculptor and studied for a time in Italy. Arriving in Augsburg in 1746, he married the widow of the miniaturist Johann Georg Werle and thus became a citizen of the town.

Because opportunities for sculptors in Augsburg were scarce during the middle of the century, Habermann turned to making decorative designs, collaborating with the Augsburg publishers Johann Georg Hertel and Martin Engelbrecht. Through his drawings for ornamentation, bronzes, furniture, and the like, he became an eminent figure in the dissemination of rococo design in Germany. He is also known to have made architectural and perspective drawings. In 1781 Habermann was appointed professor at the newly established drawing school of the academy in Augsburg. He died in Augsburg in 1796.

58. Design for an Interior

Pen and black ink, gray wash, over graphite; red chalk on verso
11⁵/₁₆ × 7⁵/₁₆ (287 × 184+)
Signed and dated in black ink, lower left: *Fra. Xav. habermann inv. et del. 17.*
Inscribed in graphite, lower right: *3*
Watermark: IA

Museum of Art, Rhode Island School of Design; Museum Works of Art Fund, 46.535

PROVENANCE: L. A. Montmorillon, 1849 (according to letter to Museum from Winslow Ames, August 3, 1949); Plaza Art Auction, 1932 (according to letters to Museum from Winslow Ames, July 25, 1949, and August 3, 1949); Winslow Ames (stamp not in Lugt, lower right corner); Durlacher Brothers, New York; purchased, November/December 1946

EXHIBITION: Baltimore 1959, p. 65, no. 265

Habermann's drawing shows a project for the paneling of a room with corresponding furniture. Before an elaborately rococo boiserie is set a secretary surmounted by a clock, which is flanked by two tables holding candelabra. Since the designs of the boiserie, the tables, and the candelabra do not match each other, it is likely that they were intended as alternatives.

As the catalogue *Age of Elegance* correctly noted, the drawing is a design for an engraving belonging to a series published in Augsburg by Johann Georg Hertel, *Bureaux sur fond de lambris*.[1] The traces of red chalk on the verso of the Providence drawing suggest that it was used directly for the preparation of the print. The graphite inscription *3* may also have been added by the engraver.

It was through designs such as this one that knowledge of the latest ideas for interior decoration were disseminated through Augsburg publishers. Habermann's role in the spread of rococo ornament is an important one.[2]

Preparatory drawings by Habermann are apparently rare, and dated designs by him even rarer.[3] Another preparatory drawing by the artist in the United States can be found in the Hylton A. Thomas collection of the University of Minnesota.[4]

1. Baltimore 1959, p. 65. The print is inscribed *F. Xav. habermann inv. et del. No. 3* and *Ioh: Georg Hertel exc. Aug*, and published in the series known as *Bureaux sur fond de lambris*, no. 163. Examples of the engraving can be found in Augsburg, Kunstsammlungen, inv. no. G. 3548, and in the *Ornamentstichsammlung*, Berlin, Kunstbibliothek (see Staatiche Museen zu Berlin 1936, p. 168, no. 1194). For the engraving, see further Guilmard 1880, 1, p. 440, no. 76; Jessen 1922, 3, pls. 154–55.
2. Cf. Krull 1977.
3. Ebba Krull, who is preparing an oeuvre catalogue of Habermann, in a letter to the author of April 20, 1987, remarks that there are very few dated works by Habermann.
4. Cf. Minneapolis 1971, p. 18, no. 17 (with unpaginated addendum), ill. pl. 8.

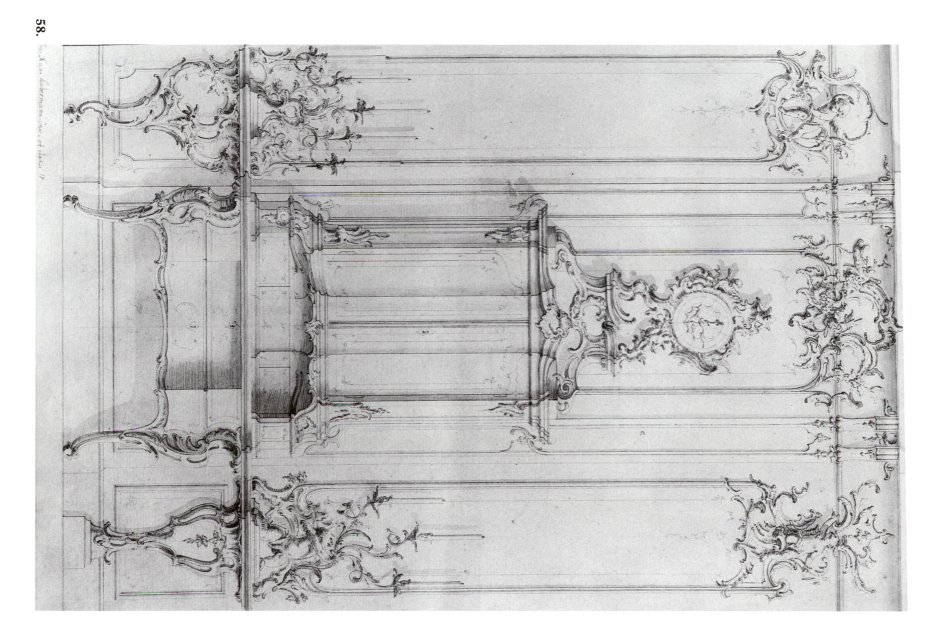

VINZENZ FISCHER

Vinzenz Fischer was born in Schmidham near Griesbach im Rottal, in the parish of Reutern, Lower Bavaria, on April 3, 1729. He received his first instruction as an artist at the Vienna academy in 1749, and made a trip to Italy from 1753 to 1755, during which he probably stayed in Trento, Venice, Bologna, and Rome, and may have become acquainted with Tiepolo and Cignaroli.

In 1760 Fischer is recorded as a "history painter" and a member of the Vienna academy. In 1764 he was made professor for architecture, and later for optics, perspective, and ornamental drawing. In 1780 he became a councillor of the academy.

Fischer was a specialist in painting architecture in the work of colleagues, such as Maulbertsch (q.v.), whose paintings otherwise influenced his own style. As an independent frescoist, Fischer was active in Laxenburg and Vienna, and also supplied altarpieces for Hungary.

He died in Vienna on October 26, 1810.

59. An Easter Sepulchre? (Christ in His Tomb?)

Pen and black ink, gray wash, on light brown paper
19 × 12¼ (484 × 313)
Signed and dated in black ink on socle, bottom right: *Vincenz Fischer/ 22 Novemb: 1757/ in 2 [?] giorni [?]/ Waldkirchen*; illegible inscription in graphite on left side
Watermark: fleur-de-lis in shield, surmounted by a crown, with 4/ WR below

Cooper-Hewitt Museum; Friends of the Museum Fund, 1938–88–3575

PROVENANCE: Piancastelli; Brandegee

LITERATURE: New York 1962, p. 95, ill. no. 15

While Richard Wunder hypothesized that this drawing was connected with a church in the Salzburg region, where Fischer was active in 1758, the inscription in the bottom right of the drawing gives a more accurate indication of its destination. Wunder deciphered it as meaning that the design was intended for a "*Waldkirche,*" or country church. But the inscription in fact reads *Waldkirchen*, and refers to a town in the northwestern part of Lower Austria, near Waidhofen an der Thaya and quite close to the present border between Czechoslovakia and Austria.

The parish church in Waldkirchen was redecorated, and three new altars were consecrated during the eighteenth century. A document of 1765 indicates that the High Altar had been set up and consecrated only a few years earlier.[1] It is possible that Fischer was involved in this project. Waidhofen lies between Vienna, where Fischer was a member of the academy from 1760, and Salzburg, where he worked in 1758.

Attached to the north side of the church choir is a *Heiliges Grab*, a medieval structure connected with Easter, in which tombs of Christ were set up for the rite of reservation of the consecrated Host. The presence of this building at Waldkirchen might support another of Wunder's hypotheses, that the drawing was a design for an Easter sepulchre. These elaborate temporary structures built during Holy Week were common throughout Central Europe and Italy.

The imagery of the drawing might argue in favor of this idea. It represents a tabernacle-like structure that opens up to reveal another construction surmounted by a sunburst. The second, central construction contains a tomb-like object resembling an altar, above which curtains have been drawn back, suggesting that it is covered by a baldachin. The dead body of Christ reposes on this altar-like structure. He is adored by angels on the sides of this tomb and in the sky above, where God the Father is also seen gesturing towards the sepulchre. Angels atop the arched structure in the foreground also carry attributes of the Passion, while two figures placed on pediments below also call attention to the central scene. In the foreground to the left is depicted a pope, perhaps Gregory the Great, who points to Christ with his left hand, and to the right a priest, most likely Aaron.

In support of his hypothesis, Wunder called attention to the fact that Fischer was working as an architect in 1757. It is possible that the design was intended for a structure to replace the Waldkirchen *Heiliges Grab*, since it was common in the eighteenth century to replace earlier constructions with up-to-date ones. If Fischer's drawing was made for the church in Waldkirchen, or for its attached structure, his design was, however, not executed as a permanent edifice, perhaps because his project was overly elaborate for what is essentially a small parish church. Moreover, there are no firm grounds to establish that this structure was actually meant to be built: it should also be remembered that Fischer was an architectural painter.[2]

The elaborate imagery in the middle of the drawing may indicate that it was a fictive design that could more easily have been executed in paint or temporary materials. The November date on the drawing also argues against its connection with a lasting architectural project: the colder months of the year, when fresco painters could not work on the walls, were just those in which they prepared designs for the next season of activity.

Thus there may have been other possible functions for this design. Richard Harprath has hypothesized that it may have served for a Forty Hours devotion.[3] In this practice the Blessed Sacrament is exposed for veneration for forty hours in each of the churches of a diocese.

In any instance, it is most likely that this drawing was a project for the temporary adornment of an existing altar. Considering the possibilities, it is perhaps most likely that it was made for an Easter sepulchre: many similar drawings are known by Austrian artists from the period of this exhibition.[4]

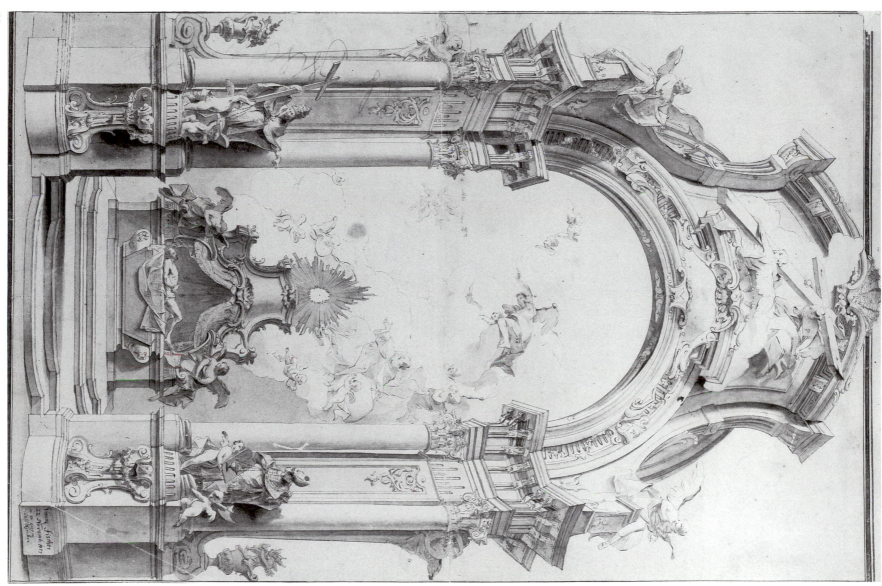

Whatever its function, this sheet is important as a rare surviving drawing by the artist. It is an early document of his activity, showing him at a stage of his career when he may be connected more with the baroque or rococo currents of design in the arts, and not with the neoclassical with which he was later associated.[5]

1. According to a document in the Dekanatsarchiv Raabs, Konsistorialarchiv, St. Pölten, published by Tietze 1911a, p. 42: "Die Kirche sei schön geschmückt und mit drei Altären versehen; der Hochaltar sei vor wenigen Jahren neu hergestellt und konsekriert worden."
2. Peter Volk (orally, 1986) also expressed the opinion that this design was not necessarily for a work with sculpture and architecture.
3. Orally, to the author in 1986.
4. Among many examples may be mentioned the series of designs by Johann Anton Gumpp, treated most recently by Michael Krapf, in Vienna 1980a, pp. 71–76.
5. I know of no other firm drawings by Fischer; the best comparisons to be made to this work are to be found in *Festarchitektur* in Bavaria and Austria (e.g. Munich, Staatliche Graphische Sammlung, inv. no. 35344, fol. 1).

FRANÇOIS JOSEPH LUDWIG CUVILLIÉS THE YOUNGER
(1731–1777)

François Joseph Ludwig Cuvilliés the Younger was the oldest of fourteen children of his like-named father, the famed architect of the Bavarian rococo. Born in Munich on October 24, 1731, he was trained by his father, whom he accompanied on journeys to Kassel in 1749 and in 1754–55; in Paris he attended Blondel's courses on architecture. In 1757 he received a commission in the corps of engineers of the electoral Bavarian army, rising to the rank of captain in 1765.

Upon his father's death in 1768, François the Younger was named second *Oberhofbaumeister* to the Bavarian court. He began work as an independent architect, completing the *Hauptwache* in Munich in 1769, the house of the Bavarian estates (*Landschaftliches Neubau*) in 1774, and churches in Zell an der Pram and in Ansbach.

François the Younger is best known for his work as an engraver, a role in which he was first employed by his father. He played an important part in the dissemination of his father's various ornamental and architectural designs, and continued to make drawings for prints and to publish designs into the 1770s. Chief among his collections is the *Vitruve Bavarois* or *École Bavaroise de l'Architecture*. He died in Munich on January 10, 1777.

60. Design for a Sculptured Bracket Showing a Putto Accompanied by the Attributes of War

Pen and brown ink, gray wash
Inscribed (and signed?) in brown ink, lower left: *Grand Salon troisième / sortie près la porte / d'honneur / Cuvilliés*; inscribed and dated in brown ink, lower right: *grand Trianon/1766*
13½ × 9¼ (342 × 235)
Watermark: MSID

Cooper-Hewitt Museum; Gift of the Council, 1911–28–28

PROVENANCE: Art Market, Lyon (according to Museum notes, purchased by Decloux in Lyon in 1907); Léon Decloux, Sèvres; given by the Council, 1911

The destruction during the Second World War of most of the drawings by the Cuvilliés in Munich makes it difficult to find firm points of comparison for this sheet. Certain works by the elder Cuvilliés are either preparatory studies for prints or else actual designs for architectural details.[1] Drawings with similar motifs, signed and dated by the younger Cuvilliés, are done in a different technique.[2]

The inscription, however, indicates that the drawing is the work of the Cuvilliés and also that it is a copy of a sculpture decorating the Grand Trianon at Versailles. Although no identical figure can be located at the Grand Trianon, similar sculptures of putti with allegorical attributes are still to be found, at least on the grounds there.[3]

While there is no record of a visit to Versailles in 1766 by either François Cuvilliés the Elder or François Cuvilliés the Younger, there is also no reason to doubt the inscription. Other similarly inscribed and dated drawings by the younger Cuvilliés in fact survive.[4]

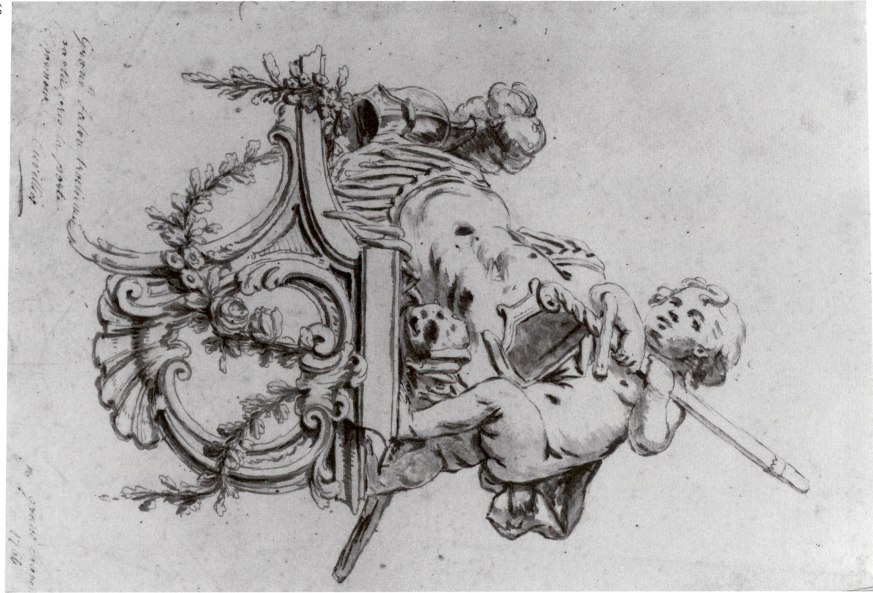

François Joseph Ludwig Cuvilliés the Younger

It is also possible to associate this activity with the biographies of both artists, and especially with that of the younger Cuvilliés. While the father visited France in the mid-1750s, and prepared engravings of French buildings, the son long supplied him with drawings for prints. Since no visit by the elder Cuvilliés to France is known after this time, it being improbable that he would have made such a journey at an advanced age, it is more likely that this drawing is by his son.

François the Younger was in French military service until the death of his father in 1768, when he took over the production of series of engravings of architectural details and designs begun by his father.[5] This drawing can be associated with that interest. He would thus have been in France in 1766, the date of this sheet. Therefore, of a number of drawings in the Cooper-Hewitt Museum attributed to the Cuvilliés, it is presented here, albeit with certain reservations, with the most confidence in its being by the artist.

The interest in the type of allegorical figure represented in this drawing may also be better associated with the work of François Cuvilliés the Younger. The turn away from the rococo, suggested by the recording of a design of the preceding era of Louis XIV, and the depiction of allegorical representations is characteristic of his work. Indeed, in a signed and dated drawing of 1768 for a monument for his father's tomb, the younger Cuvilliés used a similar putto with allegorical motifs.[6] The Cooper-Hewitt drawing is thus a rare example of the artist's work in this medium and a document of an important stylistic change in Bavaria towards 1770.

1. E.g. Augsburg, inv. no. G. 21982, Augsburg 1987, p. 230; cat. no. 109, ill. p. 231.

2. Compare drawings in Düsseldorf, FP 11060, FP 4678, and FP 4676, as well as one illustrated in Braunfels 1986, p. 169, fig. 135, datable 1768.

3. I am grateful to Nicola Courtright for making a careful inspection of the Grand Trianon for me. Good reproductions of features in the Trianon are to be found in Anonymous 1907.

4. E.g. Düsseldorf, Kunstmuseum, inv. no. FP 11060, inscribed in brown ink: *esquissé par Mons. de Cuvilliés fils en 1745. Paris*; inv. no. FP 4676: signed and dated in brown ink, lower right: *Etudes de Mom. De Cuvilliés fils 1761*.

5. Although Schnell 1961, cited in Braunfels 1986, p. 206, records ten examples of series of prints after the Cuvilliés designs, another unrecorded suite of 91 prints for the *Vitruve Bavarois*, otherwise known as the *Ecole Bavaroise de l'Architecture*, can be found in Marquand Library, Princeton University.

6. See Braunfels 1986.

II.

Portraiture

BALTHASAR DENNER
(1685–1749)

Denner was born in 1685 in Hamburg. Having demonstrated artistic abilities at a very young age, he was apprenticed to a Dutch artist in Altona in 1696, and then sent in 1699 to study painting in Danzig (Pol., Gdańsk). In 1701 he was apprenticed to a business career. However, by 1707 he was enrolled at the Berlin academy, and soon thereafter gained a number of portrait commissions across the northern German region. His career took him to Copenhagen in 1717 to paint the king of Denmark, and to Wolfenbüttel in 1720 to paint the duchess of Braunschweig-Wolfenbüttel.

In 1721 Denner moved to London, where he remained until 1728. The latter year began a prolific period of portrait commissions, which took him to Hamburg, Blankenburg, Berlin, Altona, Braunschweig, and Copenhagen. Thereafter Denner settled until 1739 in Amsterdam. From 1740 Denner resided mainly in Hamburg, but commissions at the Mecklenburg court also brought him to Rostock, where he died in 1749. His oeuvre shows him to have been one of the most sought after portrait painters in northern Europe.

61. Portrait of a Man

Black and white chalk, on grayish-blue paper
10¹¹/₁₆ × 13⁷/₁₆ (272 × 341)
Inscribed in graphite on recto, upper left: *Balthazar Denner / 1685–1724 / L. M. Coll. / Peoli Coll.*; inscribed in graphite on verso: *Peoli 205.*

Cooper-Hewitt Museum; Gift of Eleanor and Sarah Hewitt, 1931–66-87

PROVENANCE: L.M. Collection; Peoli Collection (sale, New York, American Art Association, 1894, no. 205); Miss Sarah Cooper Hewitt

This drawing displays the stylistic characteristics of Denner's studies of heads. The concentration on rendering the details of the face, ignoring accessories and even costume, and treating the hair in very fleeting fashion, is found throughout Denner's work. The method of building up of the likeness through parallel strokes of chalk is also typical, as is the combination of different chalks on blue paper.[1]

This drawing seems, however, more highly finished, with the modelling carried out with more carefully modulated steps and the outlines of the figure eschewed, than other sequences of studies that Denner is known to have executed, for example the suite of approximately thirty sheets, predominantly in red chalk, done of his wife in 1713–14.[2] It is possible that this difference might be related to one of function, namely that the Cooper-Hewitt drawing served as a study directly for a finished portrait, rather than an essay in mastery. Even though it is true that his workshop often carried out the clothing and background of his work, it is unlikely that the sitter for a portrait would have posed with his shoulders undraped, as seen here, thereby suggesting that he is probably a model.

In this instance the contrasts between this sheet and the Berlin drawings of Denner's wife probably result from their difference in date. And indeed the more secure hatching in the Cooper-Hewitt drawing, leaving the interstices between the strokes less open, suggests the work of a still more accomplished artist. These qualities may be better compared to study heads by Denner of ca. 1730.[3] In any event, the skillful and exact qualities of execution, more attuned to the Netherlandish or English traditions of portraiture, are fully in evidence here, and suggest why it was that Denner was so popular as a portraitist at the northern European courts.

1. Compare, for example, a drawing in three chalks on blue paper in Copenhagen, Statens Museum for Kunst, Kobberstikkabinett, inv. no. TD 517, no. 7.

2. In the collections in Berlin: for good illustrations of two of these drawings, see Dörries 1943, pp. 42, 43.

3. Compare, for example, a monogrammed and dated drawing of 1730 in Hamburg, Kunsthalle, black chalk with white heightening on brownish paper, 326 × 256 mm, illustrated in London 1975, no. 25, pl. 56.

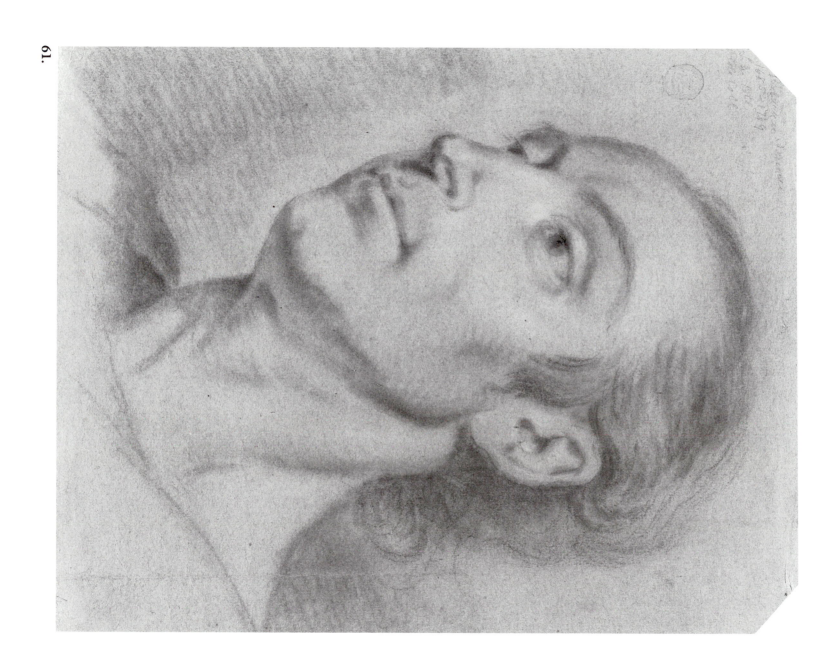

JOHANN PETER MOLITOR (MÜLLER)
(1702–CA. 1756)

Johann Peter Molitor was born in 1702 in Schadeck am Lahn. After studying in Bonn, Berlin, and Dresden, he went to Prague in 1730, settling there definitively in 1734. In Prague he painted landscapes, animal, fruit, and flower studies, and was also known as a painter of genre scenes. Molitor then turned to fresco painting, executing commissions in other places in Bohemia such as Dobříš and Hořín.

In 1756 Molitor traveled to Kraków, where he probably died in the same year or the following year.

62. Portrait of a Girl

Black chalk and stumped white chalk, on blue paper
7⁵⁄₁₆ × 11⁵⁄₈ (186 × 296)
Signed (?) in brown ink, lower left center: *J: Peter Molitor*

Crocker Art Museum, 1871.999

PROVENANCE: Edwin Bryant Crocker

LITERATURE: Sacramento 1971, p. 158

The early nineteenth-century historian Gottfried Johann Dlabacž states that besides his fresco and genre paintings, Molitor was a good portraitist (*ein guter Portraitmaler*).[1] Evidence supporting this assertion can be found in surviving works by the artist, including portraits done in 1746 of Heinrich Paul Mansfeld-Fondi and his wife Josefine, née Czernin, in the schloss at Dobříš in Bohemia; these works have even been attributed to Pompeo Batoni, and have been much praised by twentieth-century historians.[2]

This charming drawing in Sacramento demonstrates Molitor's capabilities as a portrait draftsman. Although it represents a unique example in this genre, and is therefore not comparable to his few other known drawings, there is no reason to doubt the inscription (perhaps a signature) as an indication that this sheet is by his hand.[3] The young girl resting on an album containing portraits—perhaps a Stammbuch (*album amicorum*)—may well be related to some of the artist's aristocratic clients.

The technique used for this drawing, chalks on colored paper, is of course familiar in Venetian drawing. Molitor's painting style has been associated with that of a "Venetian-Viennese" group of artists, and it is possible that he derived this technique from Italian artists he might have met north of the Alps.[4] On the other hand, Wenzel Lorenz Reiner, Molitor's associate and an artist who is said to have affected his style, also used white and black chalks on colored paper for portraits, so that it is more likely that he learned such a technique from Reiner.[5]

The stricter construction of form in Molitor's drawing is also not seen in Reiner's portraits. The treatment of the figure, and general characterization of the head, as well as the pose, are instead similar to the elements seen in some of the angels on a ceiling depicting the apotheosis of St. John Nepomuk painted by Molitor in the *Schlosskapelle* in Hořín, Bohemia (1746). The informality of this drawing and its decorative, even lighthearted aspects are also comparable to qualities that have been associated with Molitor's frescoes.[6]

The recovery of this drawing should therefore cause the critical evaluation of Molitor as a draftsman to be revised. Referring to a drawing by Molitor for a print, Pavel Preiss has emphasized its dry stiffness and dullness, but these qualities do not fairly describe this sheet, which serves another function. Further, comparison with the Hořín ceiling indicates that contrary to Preiss's assertions, fixed contours on Molitor's frescoes and paintings correspond to similar qualities in his drawings.[7] A more positive reevaluation of Molitor as a draftsman and artist seems in order.

1. Dlabacž 1815, 2, p. 328.

2. For this painting and its attribution to Batoni, see Neumann 1970, p. 144; the portrait of the count is visible in fig. 109. This portrait is described and praised by Erich Hubala, in Swoboda 1964, p. 226.

3. Other portraits by Molitor are recorded by Eduard Šafařík in his article on the artist, in Thieme-Becker 1931, 25, p. 38. Although the capital letter M and the concluding r are written somewhat differently, the signature in brown ink seen on a drawing for a ceiling in Berlin-Dahlem, Kupferstichkabinett, inv. no. KdZ 10028, is otherwise comparable. One can imagine no other reason why someone would write *J. Peter Molitor* on this sheet, in any case.

The Berlin drawing and the few other drawings by Molitor are not otherwise comparable to the sheet exhibited here; these include sheets in Augsburg, Städische Kunstsammlungen; Cologne, Wallraf-Richartz Museum Ludwig, inv. no. Z 429; and Prague, Národní Galerie, Grafická Sbirka, inv. no. K 144, illustrated in Preiss 1979, p. 133, fig. 41.

4. Neumann 1970, p. 250, associates Molitor with *venezianisch-wienersch Malerei*.

5. See Reiner's study for a male portrait, Prague, Národní Galerie, inv. no. K 1037, illustrated most recently in Salzburg 1984, no. 23, ill. p. 71.

6. The characterization referred to here is that of Neumann 1970, p. 250; for a good illustration of the Hořín ceiling, see fig. 346.

7. Preiss 1979, p. 132, characterizes his drawing for a print with the following words: "Die trockene Starre und Nüchternheit, mit der diese Zeichnung für den Stecher sorgsam ausgearbeitet ist, sind charakteristische Züge für Molitors gesamte künstlerische Aussage", on p. 21 Preiss says: "Die zeichnerische Fixierung der Konturen auf seinen Fresken und Gemälden hatte jedoch merkwürdigerweise keinen sonderlichen Einfluss auf sein graphisches Schaffen, obwohl er dafür alle Voraussetzungen besass."

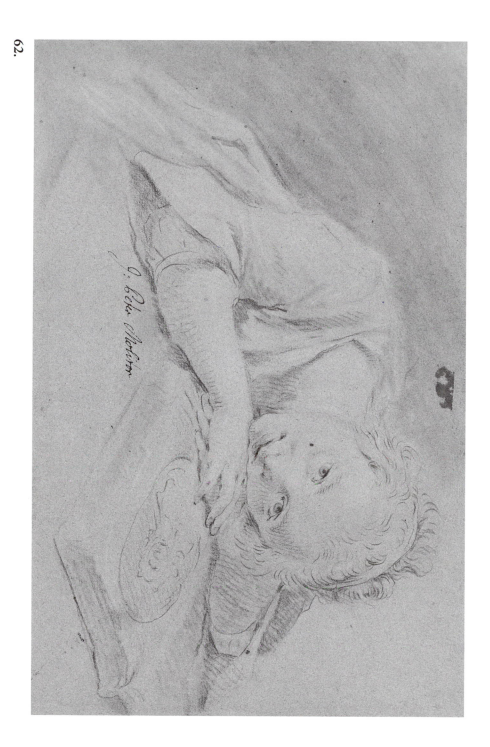

Johann Wolfgang Baumgartner

(For biography, see cat. no. 39.)

63. Empress Maria Amalia

Pen and black ink, gray wash, with white heightening, with composition outlined in gray wash, on blue-green paper
14³/₁₆ × 9⁹/₁₆ (360 × 231)
Watermark: heart with staff, inscribed J H M

Harvard University Art Museums, Busch-Reisinger Museum; Class of 1936 purchase in appreciation of their friend and classmate, Ernst Teves, B.R. 1982.3

An accumulation of details identifies the woman in this drawing as a figure of authority. She holds a sceptre in her right hand, and wears a diadem on her head. Bedecked with jewels and dressed in an elegant gown, she strikes an impressive pose, hand on hip, before a rococo table that is adorned by an eagle, whose claw grasps an orb. On this table is placed a pillow supporting two crowns. To the background right stands a large chair, on whose back is emblazoned a coat of arms.

The crowns and the coat of arms point to her specific identity. The crown to the left, which is rimmed with a fur border, most likely made from ermine, and which has a gold band topped by a cross, is a *Kurfürstenhut*, the crown of a prince elector of the Holy Roman Empire of the German Nation.[1] The crown on which the electress rests her hand is an imperial crown, conforming to the type used especially by the Holy Roman emperors, conspicuous in its combination of mitre-shape, gold band, and lily border (*Lilienzacke*).[2] This type of crown also surmounts the double-headed eagle with an orb (*Weltkugel*) in its right claw, a further symbol of the Holy Roman Empire. The eagle in this instance bears the arms of Bavaria.[3]

Although this drawing has been previously regarded as a portrait of the Austrian Habsburg Empress Maria Theresia, it in fact represents an empress from Bavaria: in the eighteenth century this could only have been Maria Theresia's cousin, Maria Amalia Habsburg (1701–1756). Maria Amalia was the daughter of the Holy Roman Emperor Joseph I Habsburg. She married Charles Albert of Bavaria, who had succeeded to the electoral dignity in 1726, thus giving support to his claims to become emperor. The death in 1740 of the emperor Charles VI, uncle of Maria Amalia and father of Maria Theresia, brought on the conflicts known as the War of Austrian Succession. Although events in this war did not affect Bavaria happily, for it was invaded and occupied, Charles Albert was unanimously elected emperor on January 24, 1742, breaking a two-hundred-fifty-year-old chain of Habsburg possession of the imperial title; Maria Amalia was crowned empress on March 8, 1742. As the Holy Roman Emperor Charles VII, Charles Albert reigned until his death on January 20, 1745: the Harvard portrait of Maria Amalia must therefore date from the period between 1742 and early 1745.

Other portrayals of Maria Amalia confirm the identification. As seen here, Maria Amalia's countenance is much the same as in an engraving by Gabriel Bodenehr of 1742, where she stands by a table on which rests a crown much like the imperial crown seen in the Harvard drawing.[4] This same crown is worn by her in a depiction of her coronation,[5] and the diadem on her head is seen in another portrait engraving.[6]

No doubt this drawing was also intended to assist in the preparation of a portrait engraving of the empress. With all its accoutrements, pose, and composition, the intention was also probably to stress Maria Amalia's majesty, and to spread this image through reproduction. However, no print executed after this drawing can be found. It is possible that the untimely demise of Charles Albert put an end to the project, and that the drawing might be more precisely dated towards the end of 1744 or the beginning of 1745.

Comparison with other works by Baumgartner, including the other drawings presented in this exhibition, leaves no doubt about the attribution to this artist. The technique, medium, type of ornament, and conception of the figure are all his. The Harvard drawing represents an interesting aspect of Baumgartner's work, unique among the several good drawings by his hand in America, and unusual for his oeuvre in general.[7]

1. For the appearance of an electoral crown, see the 1616 allegory by Johann König on the Bavarian claim to the electoral dignity, Munich 1980, 2, pt. 2, cat. no. 559, ill. 13.

2. For an introduction to this type of crown and its iconography, see Fillitz 1959, esp. pp. 23ff, with further bibliography.

3. These arms are seen most clearly in König's miniature. See note 1.

4. Österreichische Nationalbibliothek, Porträtsammlung, 183 173/3, no. 10 inscribed: *"Gabriel Bodenehr sculps. et excud. Augusti. Maria Amalia Dei Gratia Romanorum Imperatrix Secunda Princ. Imp. Iosephi I. Coronata 8 Mart. MDCCXLII."*

5. See Österreichische Nationalbibliothek, Porträtsammlung, 183 173/3, no. 12: *"Eigentliche Abbildung der Crönnug des Grossmächtigen Neu Erwöhlten Römischen Kayserin Frau Frau MARIAE AMALIAE. Joh. And. Steßinger IUnger excud. A.V."*

6. Österreichische Nationalbibliothek, Porträtsammlung, 183 173/3, no. 9, inscribed: *"G. A. Wolfgang sculps."*

7. Other fine drawings by Baumgartner in the United States that can be adduced for comparison of details include *Lazarus and the Rich Man*, Crocker Art Museum, Sacramento, inv. no. 1871.77 (illustrated among other places, in Claremont 1976, p. 48, no. 67, ill. p. 67, as Januarius Zick); *Terra (Allegory of Earth)*, Achenbach Foundation, the Fine Arts Museum of San Francisco, inv. no. 1969.31 (illustrated in Claremont 1976, pp. 8–9, no. 4, ill. p. 63); *St. Bernard of Clairvaux*, signed and dated 1760, Detroit Institute of Arts, F 1980.173 (illustrated in Uhr 1987, no. 9, ills. pp. 33, 51); and *Design for a Detail of an Engraved Doctor's Thesis*, Cooper-Hewitt Museum, 1942–53–1 (illustrated in New York 1959, p. 26, no. 82, ill. p. 27); Huntington Library, San Marino, California, Kitto Bible, 2, fol. 301r, 8, fol. 1282r, 22, fol. 4106v.

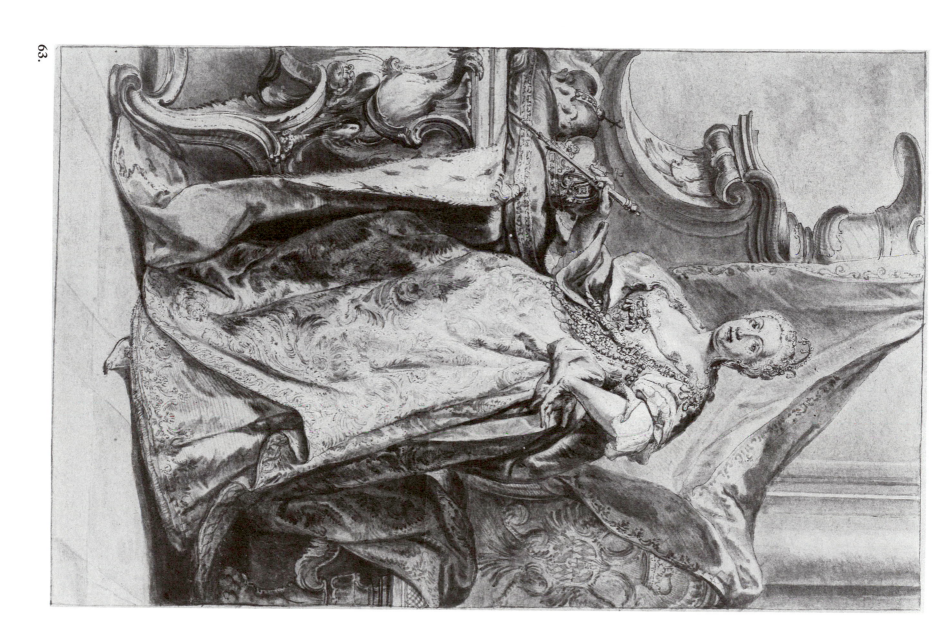

GEORG FRIEDRICH SCHMIDT

(1712–1775)

Georg Friedrich Schmidt was born in 1712 at Schönerlinde near Berlin. He was apprenticed for three years to a portrait engraver, Georg Paul Busch, who was active in that metropolis. In 1737 he journeyed to Paris, meeting en route Johann Georg Wille (*q.v.*), whom he subsequently befriended.

In Paris Schmidt became assistant to Nicolas Larmessin, an engraver. Two engravings commissioned in 1741 by Hyacinthe Rigaud after his portraits helped establish his fame as a portrait engraver. Schmidt was admitted to the French Royal Academy in 1742.

In 1743 King Frederick II called him back to Berlin to become court engraver. Schmidt married in this city in 1746 and remained in Berlin until 1757, when he took up an invitation extended by the Tsarina Elizabeth to come to St. Petersburg.

After a sojourn of five years in Russia, he returned to Berlin in 1762. As during his earlier stay there, his work in the medium established him as one of the prime portrait engravers in Berlin in the eighteenth century. Schmidt died in Berlin in 1775.

64. Portrait of a Man in a Tricorn Hat

Red chalk
$10^1/_{16} \times 7^5/_8$ (256 × 195)
Signed in brown ink, lower left: *Schmidt del.*
Inscribed on verso: *33. Hibb* (?); 1220

National Gallery of Art; Ailsa Mellon Bruce Fund, 1988.17.1

PROVENANCE: Unidentified collector C A (?; mark, not in Lugt, verso); Galerie Arnoldi-Livie, Munich

This portrait is presented and signed in a very similar manner to a drawing of another man wearing a tricorn hat by Schmidt in Berlin. Both sheets are executed in chalk, with the figure set against a background covered with hatching. The head is carefully worked up, while the details of the torso are indicated in more summary fashion. The Berlin drawing has been dated to the period of Schmidt's activity as Prussian court engraver, from 1745 to 1757, and the Washington drawing can most likely be set into this period as well.[1]

Although Schmidt was important as an portrait engraver, the signature and freshness of the design suggest that this drawing is an autonomous portrait, of a type for which other examples are known.[2] It would seem that the medium of red chalk lent itself in his hands to an immediacy and naturalness in the depiction of the sitter.[3] In the Washington drawing this sense is increased by having the figure pressed up very close to the picture plane, while his form assumes most of the space on the sheet.

From his attire the sitter is most likely a *Burger*. The drawing most likely originated as an independent commission, meant to supplement the artist's income. The subject and the presumed circumstances of the commission may explain the apparent differences between this and more traditional court likenesses by Schmidt.

1. The drawing in question is in Berlin-Dahlem, Kupferstichkabinett, Staatliche Museen Preussischer Kulturbesitz, inv. no. KdZ 4606. The dating mentioned here is suggested in London 1985, p. 62, no. 19, ill. p. 63.
2. Vienna, Graphische Sammlung Albertina, inv. no. 4256; cf. Tietze 1933,
4. p. 145, no. 1774, ill., vol. 5, pl. 271.
3. These observations in regard to the Berlin drawing, as well as the description of the style above, are made in Berlin 1987, p. 83, no. 37.

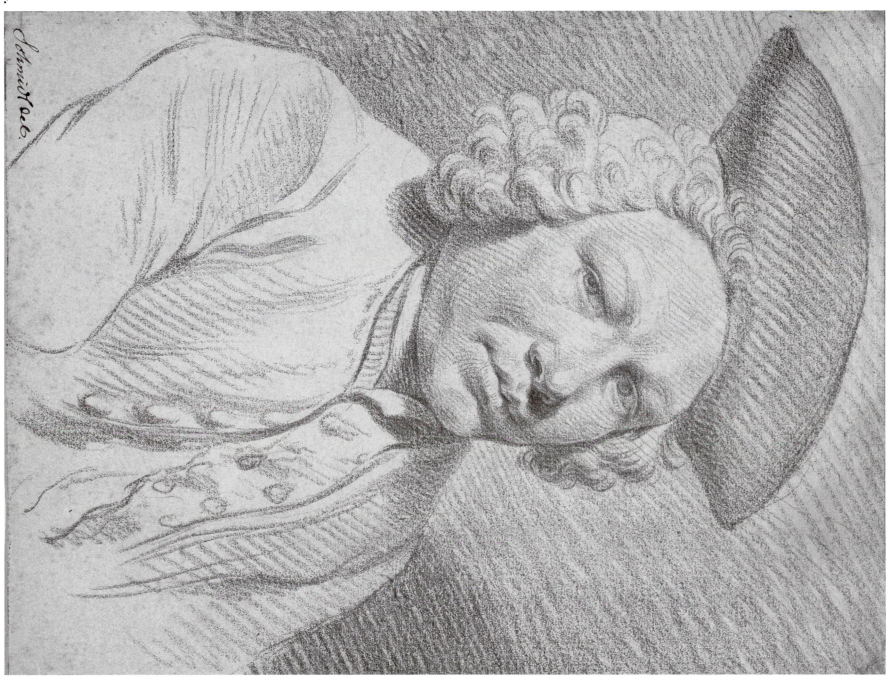

Schmidt.

JOHANNES ESAIAS NILSON

(1721–1788)

Born in Augsburg in 1721, Nilson received his first artistic instruction from his parents, Andreas and Rosina Barbara Nilson, and also from Hieronymus Sperling and Johannes Lorenz Haid. Upon Haid's death in 1751, Nilson took over his expanding publishing house, which produced many engravings, in which Nilson himself specialized.

In 1752 Nilson was called to the Berlin court to execute portraits in miniature of the first Brandenburg electors. This began his extensive activity as a portraitist of sovereigns (see cat. no. 65). Besides these works, Nilson was the most prolific designer and publisher of ornamental prints in Augsburg, making him into one of the most important representatives and disseminators of the rococo in Germany.

In 1761 he was honored by being named painter to the palatine court. In 1769 he became evangelical director of the Augsburg academy, sharing the responsibilities of his position with the Catholic director. In 1778 he was appointed president of the *Kaiserliche Franciscische* academy. Nilson died in Augsburg in 1788.

65a. Design for the Frame of the Portrait of Emperor Francis I

Pen and black ink, gray wash, with graphite
8⅝ × 6⅝16 (220 × 159)
Signed in black ink, lower left: *J. E. Nilson*; dated, lower right: *1759*

Cooper-Hewitt Museum; Gift of the Council, 1921–6–383 (2)

PROVENANCE: Léon Decloux, Sèvres

EXHIBITION: New York 1959, no. 84

65b. Design for the Frame of the Portrait of Erich Christoph Baron Plotho

Graphite, pen and black ink, gray wash
8¼ × 6³⁄16 (210 × 157)
Signed and dated in gray ink: *J:E: Nilson inv: del: 1759 maj:*; inscribed in graphite upper right: *247;* inscribed in gray ink on book: *STATU | TA IMPE | RII | RO*

Cooper-Hewitt Museum; Gift of the Council, 1921–6–383 (13)

PROVENANCE: Léon Decloux, Sèvres

EXHIBITION: New York 1959, no. 84

Suite of Drawings for Frames of Portraits Bound in an Album

Cooper-Hewitt Museum; Gift of the Council, 1921.6.383

65c. King Charles III of Spain (fol. 3)

Pen and black ink, gray wash
8¾ × 6⁵⁄16 (223 × 162)
Inscribed in graphite, upper left: *253*

65d. King Frederick William II of Prussia (fol. 4)

Pen and black ink, gray wash
7⅞ × 6⅛ (200 × 156)
Inscribed in graphite, upper right: *21*

65e. Prince Friedrich Heinrich Ludwig of Prussia (fol. 5)

Pen and black ink, gray wash
8¼ × 6 (207 × 152)
Inscribed in black ink on shield: *Fortitudine*

65f. Johann Alois Sebastian, Duke of Oettingen-Spielberg (fol. 6)

Pen and gray and black ink, gray wash; portrait in graphite
8⅝ × 6³⁄16 (219 × 158)

65g. Friedrich Augustus II, Elector of Saxony (fol. 7)

Pen and black ink, gray wash
6¼ × 8½ (215 × 160)

65h. Friedrich Eugen, Prince of Württemberg (fol. 8)

Pen and black ink, gray wash
7¹³⁄16 × 5¹¹⁄16 (199 × 145)
Inscribed in graphite: *27* (copy after Schuster 312)

65i. Friedrich Augustus Ferdinand, Prince of Prussia (fol. 9)

Pen and black ink, gray wash, portrait in graphite
7⅞ × 6¹⁄16 (200 × 154)
Inscribed in black ink: *Concordia exercitu iuro*; in brown ink, upper right: *26*; in graphite: *12*

65j. Prince Elector Max Joseph of Bavaria (fol. 10)

Pen and black ink, gray wash
8⅞ × 6⁵⁄16 (226 × 161)
Inscribed in black ink on globe: *Traditus* [astrological sign] *per discum* [astrological sign] *16 Jum 1761*; in graphite, upper right: *251* (?)

65k. Karl Friedrich, Margrave of Baden (fol. 11)

Pen and black ink, gray wash, traces of graphite
8¾ × 6⁵⁄16 (222 × 161)
Inscribed in gray ink upper right: *283*

178

65l. Johann Friedrich, Prince of Schwarzberg (fol. 12)

Pen and black ink, gray wash
9⅝ × 6⅛ (230 × 155)
Signed and dated lower right: *J.E. Nilson inv. del. 1767*

The sheets exhibited separately here have been extracted from a series of sixteen designs of varying dates by Nilson assembled into an album by the collector Léon Decloux, which is also placed on display.[1] In all of the drawings a centrally positioned oval, ornamented cartouche leaves a space open for a portrait. In some drawings a figure, drawn lightly in graphite, can be discerned inside the oval.[2]

Nilson's drawings in the Cooper-Hewitt Museum are preparatory designs for portrait engravings of ecclesiastical and secular sovereigns of Europe, who are also identifiable by their coats of arms, initials, and allegorical personifications.[3] Nilson engraved the portraits himself, making various alterations in the iconographic details of the frames and in the inscriptions, and adding titles. In most instances he seems to have adopted existing portraits, concentrating on the decorative frame itself; so many of the drawings leave open spaces within the oval.

Nilson engraved almost one hundred such designs of sovereigns.[4] The collection in the Cooper-Hewitt Museum, hitherto unpublished as a group, represents the largest surviving assemblage of preparatory drawings for the set. It is probably also the most important, as it includes designs for portraits of some of the most outstanding figures in Europe, including the Holy Roman Emperor Francis (Franz I) and King Friedrich Wilhelm II of Prussia.

The inscriptions on some of the prints suggest one of the reasons for their creation. Although Nilson may have anticipated some remuneration from the various courts he celebrated, he undoubtedly intended these prints of prominent personalities for more general sale, both in Germany and in France.[5]

In addition to their primary intention as portraits of rulers with allegorical accoutrements, the ornamental details of these designs are also significant. It was through the replication of such designs that Nilson contributed to Augsburg's role as a major center for the dissemination of eighteenth-century ornamental forms.

65m. Frederick V, King of Denmark (fol. 14)

Pen and black and gray ink
8⅝ × 6³⁄₁₆ (220 × 157)
Inscription from Bible on book

65n. King Stanislas Augustus of Poland (fol. 15)

Pen and black ink, gray wash
9⅜ × 6⁵⁄₁₆ (238 × 160)
Pedestal inscribed in reverse: *STANISLAUS AVGUSTUS/REX POLON*
Inscribed right bottom: *D. 3 Nov. 1771*

65o. Maria Henrietta, Princess of Thurn and Taxis (fol. 16)

Pen and black ink, gray wash
7¾ × 6¼ (198 × 158)
Inscribed upper right: 256 (?)

65p. Johann Friedrich, Count of Ostein, Prince Elector of Mainz (fol. 17)

Pen and black ink, gray wash
8⅞ × 6¼ (225 × 159)
Signed and dated in black ink, lower right: *J.E. Nilson inv. ad. 1767*; inscribed upper right corner: 273

65q. Design for the Frame of the Portrait of Leopold Count Daun

Pen and brown (black?) ink, gray wash, graphite (figure within oval frame); red chalk on verso
8¼ × 6¼ (210 × 158)
Signed and dated in brown ink: *J.E. Nilson: inv: del: 1758.*
Watermark: traces of crown and shield.
Stanford University Museum of Art; Gift of the Committee for Art at Stanford, 83.261

PROVENANCE: Sven Bruntjen

As in the series in the Cooper-Hewitt Museum, the oval cartouche in ink and wash in the center of this drawing, composed of vegetative and rococo ornament, leaves a space open, evidently for a portrait. In fact, a half-length figure wearing a tricorn hat, drawn lightly in graphite, can be discerned inside the oval.

There can be no doubt that this drawing belongs to the same series. It is a drawing for an engraved portrait of Leopold Count Daun, an impression of which is also to be found in the Cooper-Hewitt Museum.[6]

Count Daun was a field marshall of the imperial armies, and the allegorical personifications and accoutrements at the bottom of the sheet accordingly allude to his military identification. To the right, the female figure blowing a trumpet and holding another trumpet can be identified as Fame, who heralds his deeds. The flags, drums, rifles, cannon, cuirasse, and helmet in front of her suggest military trophies. The helmeted female figure in cuirasse with shield

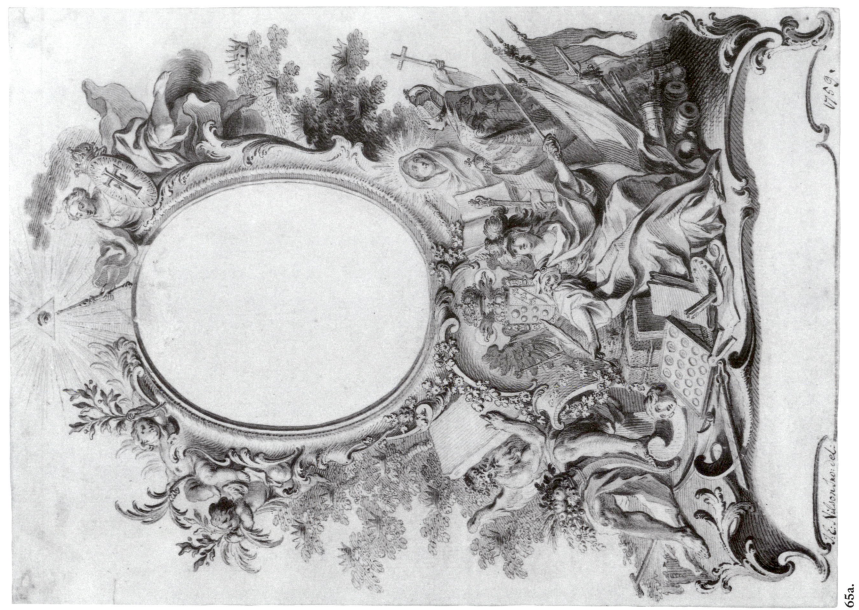

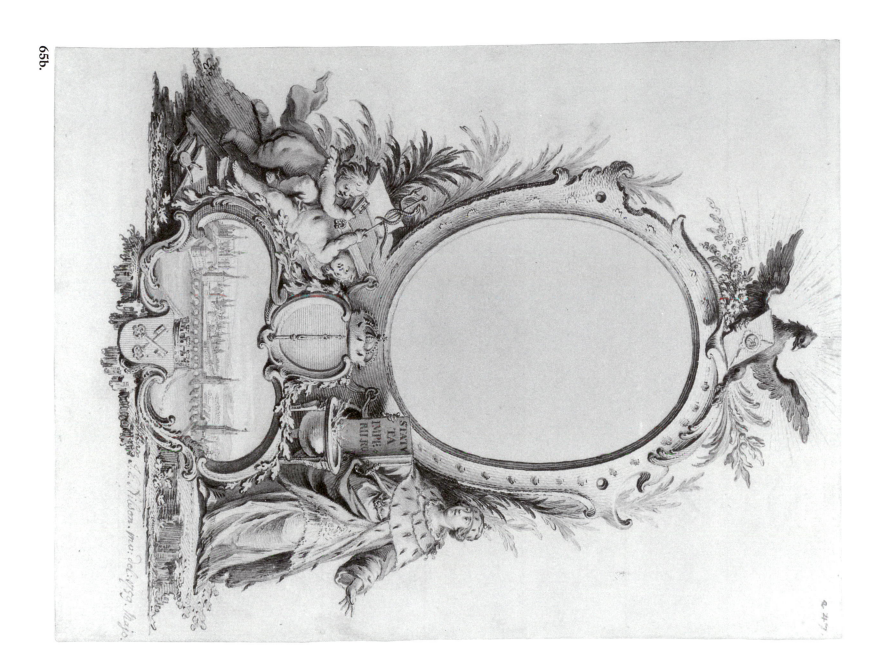

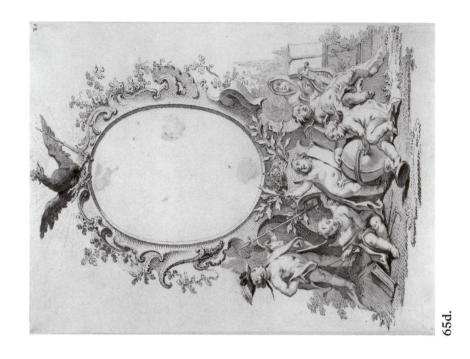

65c.

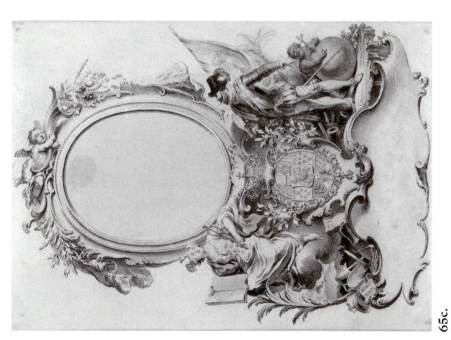

65d.

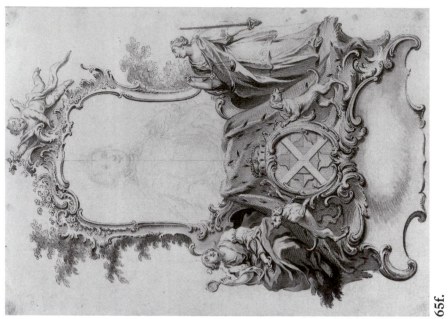

65f.

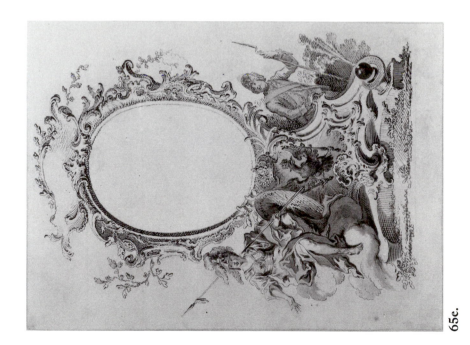

65e.

182

65g.

65i.

65h.

65j.

65k.

65l.

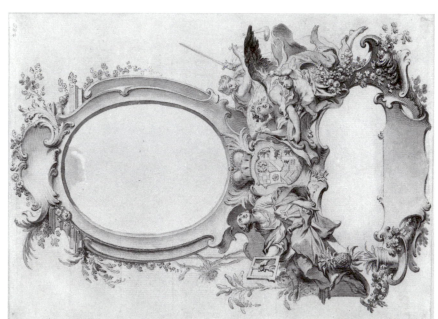

65m.

184

65n.

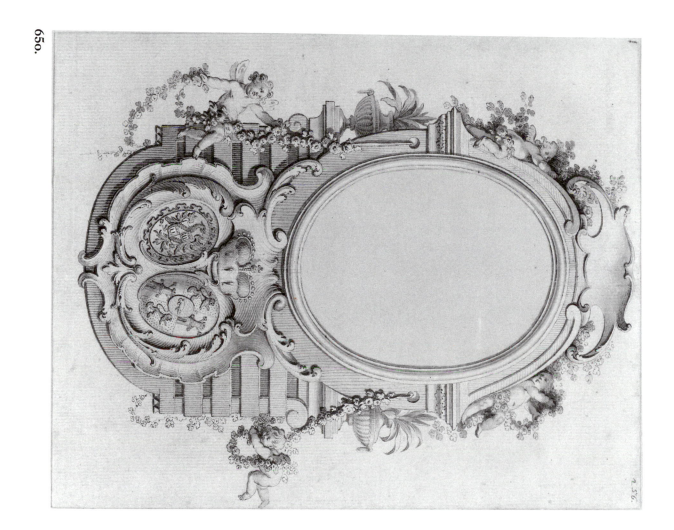

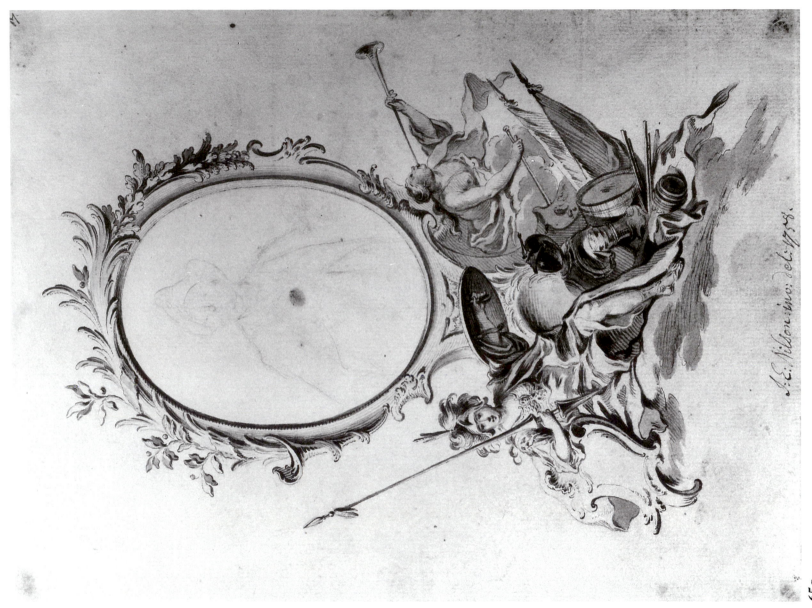

65q.

and lance to the left is in this context most likely to be associated with Bellona, goddess of war; she rests her right arm on a shield that might be reserved for his name or some other inscription. Similar elements, including the two personifications with trophies, appear together in Gottfried Eichler's representation of War in Johann Georg Hertel's edition of Cesare Ripa's *Iconologia*, which was published in Augsburg in 1758, the same year that Nilson, an Augsburg artist, signed and dated this drawing.

The red chalk applied to the verso indicates that the Stanford sheet was used directly in the preparation of the engraving.

1. Decloux's album is entitled on the first folio, *Suite d'encadrements ornés d'attributs divers et de figures allégoriques ou militaires par Jean Nilson.*
2. E.g., for folio 6.
3. The drawings correspond to the following engravings listed in the catalogue raisonné, Schuster 1936 (Schuster's catalogue numbers are listed as cat. nos.):

fol. 2 = p. 116, cat. no. 294
fol. 3 = p. 130, cat. no. 337
fol. 4 = p. 114, cat. no. 288
fol. 5 = pp. 113–14, cat. no. 286
fol. 6 = p. 119, cat. no. 304
fol. 7 = p. 120, cat. no. 308
fol. 8 = p. 123, cat. no. 317
fol. 9 = p. 111, cat. no. 278
fol. 10 = p. 109, cat. no. 271
fol. 11 = p. 108, cat. no. 268
fol. 12 = pp. 121–22, cat. no. 313
fol. 13 = p. 140, cat. no. 368
fol. 14 = p. 120, cat. no. 320
fol. 15 = p. 121, cat. no. 312
fol. 16 = pp. 122–23, cat. no. 315
fol. 17 = pp. 133–34, cat. no. 348

4. See Schuster 1936 for the full listing.
5. See, for example, the inscription of the portrait of Frederick II of Prussia, Schuster 1936, pp. 112–13, no. 282: *Dess: et gravé par J. E. Nilson ce vend à Augsbourg chez l'Auteur, et à Paris chez à Rosselin rue St. Jacques à l'hotel Saumur;* an example of this print is in the Cooper-Hewitt Museum, inv. no. 1944–83–11.
6. Inv. no. 1906–310–101; the engraving is recorded in Schuster 1936, p. 135, as cat. no. 354.

Johann Eleazar Zeisig, called Schenau

(1737–1806)

The son of a damask weaver who learned to draw by copying his father's weaving patterns, Johann Eleazar Zeisig (or Zeissig) was born in 1737 in Gross-Schönau near Zittau, Lusatia. Zeisig's first formal instruction was given him by Johann Christian Bessler, a Dresden portrait painter. In 1756 he accompanied a son of the director of the Dresden academy, Louis de Silvestre, to Paris, where he became associated with Johann Georg Wille (q.v.). While in Paris he worked at the Sèvres porcelain manufacture, studied works in the royal collections, and became well known as a genre painter. It was during this sojourn that he adopted the name Schönau, later Schenau, from his birthplace.

Wille recommended Schenau to Christian Hagedorn, director of the newly founded Dresden academy, to which Schenau applied in 1765 and was called in 1768. He arrived in Dresden in 1770 to take up a position there. In 1772–73 Schenau was appointed professor at the painting and drawing school of the Meissen porcelain manufacture. In 1774 he was named professor at the Dresden academy, becoming in 1776–77 director on an alternating basis with Giovanni Battista Casanova, the brother of the famous writer. When Casanova died in 1795, Schenau became sole director, giving up his position in Meissen in 1796. Schenau died in Dresden in 1806.

academic studies, it is even possible to link these activities together.[3]

1. For example, in Berlin-Dahlem, Kupferstichkabinett, inv. nos. KdZ 5888, KdZ 5847.

2. Berlin-Dahlem, Kupferstichkabinett, inv. no. KdZ 854, illustrated in Bock 1921, 2, p. 182.

3. See, for example, a drawing in black and white chalks on prepared paper, depicting a male nude seated on a block; Vienna, Graphische Sammlung Albertina, inv. no. 14907 (Deutsche Schule, Provisorisch suppl. 7).

66. Self-portrait

Black, white, and red chalks, on brown prepared paper
8 × 6½ (203 × 165)
Signed and dated in black chalk, lower right: *Schenau se ipse del: 1773*

Crocker Art Museum, 1871. 1067

PROVENANCE: Edwin Bryant Crocker

EXHIBITION: Detroit Institute of Arts, 1949, "German Paintings and Drawings from the Time of Goethe in American Collections," no. 121

LITERATURE: Scheyer 1949, p. 247, no. 121; Sacramento 1971, p. 163

Although Schenau is best known for his genre compositions, this fine drawing demonstrates his abilities as a portraitist. It is executed in the same delicate light touch using colored chalks on colored or prepared paper found in other portrait drawings by the artist.[1]

While the drawing has been previously described as the portrait of a gentleman, the inscription makes it obvious that the subject is the artist himself. Indeed, another powerful self-portrait by the artist, done in red, black, and white chalks, on brownish paper, in 1774, is also found in Berlin.[2] The Sacramento drawing is very similar to this sheet, although it lacks the hatching in the background and some of the crosshatching in the face.

The existence of these portraits shows Schenau's interest in this sort of subject just at the time that he became director of the *Zeichenschule* in Meissen and professor at the Dresden academy. Since Schenau used a comparable technique for

JOHANN GOTTLIEB PRESTEL

(1739–1808)

Johann Gottlieb Prestel was born in 1739 in Grönenbach in the Allgäu. He undertook a trip to Italy from 1760–69, visiting Venice, Rome, Naples, Florence, and Bologna. Prestel settled in Nuremberg upon his return, taking up the technique of wood engraving around 1773.

In 1775 he visited Zurich, where he gained the support of Lavater, whose physiognomic theories influenced him. After this year his enterprise for reproductive prints began to flourish. Prestel developed prints in various manners, in particular creating a way of reproducing drawings in facsimile, which is very important for the history of techniques. Because of his fame in this pursuit, he was honored by the elector of Bavaria in 1780, and named an honorary member of the Düsseldorf academy in 1779. After a failed attempt to reproduce the paintings of Adriaen Van der Werff in the Düsseldorf gallery at his own costs, his firm collapsed, and he had to leave Nuremberg in 1782–83.

Prestel then settled in Frankfurt am Main, where he carried on his enterprises with greater or lesser success. Several of his daughters also became artists. One of the foremost reproductive engravers of the late eighteenth century, Prestel died in Frankfurt in 1808.

67. Self-portrait

Black chalk, black and gray ink, traces of white chalk heightening
12³/₁₆ × 8⅝ (312 × 220)
Signed in graphite, bottom right: *J. G. Prestel fec.*

Crocker Art Museum, 1871.581

PROVENANCE: Edwin Bryant Crocker

EXHIBITIONS: Detroit Institute of Arts, 1949, "German Paintings and Drawings from the Time of Goethe in American Collections," no. 102; Crocker Art Museum 1987, "Life or Art"

LITERATURE: Scheyer 1949, p. 244, no. 102; Sacramento 1971, p. 160 (as Johann Amadeus Prestel)

This strong, rapidly sketched drawing presents a convincing likeness of the sitter. The summary execution and relatively informal pose suggest that it was a study used for some further purpose. Prestel, whose authentic signature is found on this sheet, was a specialist in portraiture, and may have used this for such an end.

Comparison of the features of the sitter with a preparatory drawing for an etching in Berlin not only supports this sort of assumption but also indicates his identity. The sitter's hair is tied according to current fashion in a *Zopf*, a queue whose name has supplied the designation for a whole period style, the *Zopfstil*, connected with the second half of the eighteenth century in Central Europe. The man in the Sacramento drawing appears to have the same shaped head, sharp cleft nose, bushy eyebrows, furrowed brow, and deepset eyes as does Prestel in his self-portrait in his atelier.[1] The Sacramento drawing may even be connected with this design.

1. Berlin-Dahlem, Kupferstichkabinett, inv. no. KdZ 10059; see Bock 1921, 2, pl. 174.

ANTON GRAFF
(1736–1813)

Born in Winterthur, Switzerland, in 1736, Anton Graff studied at the drawing and painting school of Ulrich Schellenberg from 1753 until 1756. In 1756 he went to Augsburg to study with the engraver Johann Jacob Haid, and in 1757 to Ansbach to collaborate with the court painter Leonhard Schneider. Returning to Augsburg in 1759, he resided with Haid, while executing commissions on his own. In 1760 he visited Regensburg, Winterthur, and Zurich.

In 1766 he was called to Dresden as court painter and member of the academy. In 1769 he journeyed to Leipzig to work for a book dealer, and in 1771 to Berlin. In the same year, he married the daughter of the theorist Sulzer. In 1783 he became an honorary member of the Berlin academy, and in 1789 professor for portrait painting at the Dresden academy. In 1812 he was made a member of the imperial academies of Vienna and Munich. Graff died in 1813.

Beginning in the 1770s, Graff made numerous trips to make portraits. He was one of the most prolific artists of the century in this genre.

68. Portrait of Johann Georg Sulzer

Graphite
$4\frac{1}{16} \times 6\frac{1}{2}$ (104 × 165)
Dated in brown ink, lower left: *Dresden d* (?) *29 Jan:/1781*; signed in brown ink, lower right: *Anton Graf*; traces of an inscription, cut off, bottom center and bottom right corner

Crocker Art Museum, 1871,523

PROVENANCE: R. Weigel (?); Edwin Bryant Crocker

EXHIBITION: Detroit Institute of Arts, 1949, "German Paintings and Drawings from the Time of Goethe in American Collections," no. 31

LITERATURE: Scheyer 1949, p. 237, no. 31; Berckenhagen 1967, p. 396, cat. no. 1621; Sacramento 1971, p. 152

The man in this signed drawing by the important portraitist Anton Graff, though hitherto anonymous, can be established as Johann Georg Sulzer (1720–1779), the artist's father-in-law. The position of his head, hair style, and costume are all nearly identical with those of a portrait drawing in black chalk and graphite of Sulzer in Leipzig.[1] The Leipzig drawing in turn served as a study for a painted portrait (in Aschaffenburg) of Sulzer with his grandson Carl Anton Graff, datable 1777.[2] Roger Clisby has also recognized the connection of the drawing with a painted portrait by Graff.[3]

Born in Winterthur, Switzerland, like Graff, Sulzer became one of the leading figures of the Enlightenment in Berlin and a major figure in the development of the discussion of aesthetics in Germany. Following appointments as *Hofmeister* in Magdeburg in 1744, teacher of mathematics at the Joachimsthal Gymnasium in Berlin, and member of the Prussian Academy of Sciences in 1750, he was named by Frederick II of Prussia to the Prussian *Ritterakademie* in 1763, whose direction he assumed in 1765. His most famous contribution to the discussion of the fine arts is his *Allgemeine Theorie der Schönen Künste* of 1771–74. (See the discussion in the introduction.)

Besides his personal connection with Sulzer, there were other reasons for Graff, who portrayed many of the outstanding personalities in the contemporary world of arts and letters, to depict Sulzer. Sulzer was portrayed by Graff in numerous drawings and paintings: at least twenty-two versions of portraits by Graff of Sulzer are known. For the Aschaffenburg portrait alone there exist three replicas.[4]

Thus although Sulzer died in 1779, and this drawing is dated 1781, there is no reason to doubt either its inscription or attribution. The chalk strokes and technique of modeling are typical of Graff, comparable, for instance, to those in a self-portrait of ca. 1787 also in Leipzig.[5] Differences in detail between the Sacramento drawing and that in Leipzig, seen in such matters as the treatment of the hair, the furrows in the cheeks, the cravatte, and the shape of the coat, also indicate that it is not simply a copy of the other, perhaps earlier sheet.

It would seem, rather, that this drawing may itself have served as a replica of the artist's earlier composition, or that it was preparatory to another painted replica of the Aschaffenburg picture. Graff may have been preparing such a work at around this time, for on September 30, 1782, W. J. Sulzer thanked him for a portrait of Johann Georg Sulzer.[6]

1. Museum der bildenden Künste [sic], Graphische Sammlung 1. 509, best illustrated in Berlin 1963, no. 85, ill. p. 39. For full references to this drawing, see Leipzig 1986, p. 77, cat. no. 115, ill.
2. Aschaffenburg, Museum der Stadt; see Berckenhagen 1967, p. 354, cat. no. 1355, ill
3. Letter of January 7, 1978, in the Crocker Art Museum. Clisby has associated the drawing with a painting in the National Gallery, Berlin, Stiftung Preussischer Kulturbesitz; see Nationalgalerie, Berlin 1976, p. 151, ill. This is but one of many versions, however, so there is no reason to assume a direct connection, nor to accept Clisby's idea that the painting must be dated 1781; the situation is more complicated.
4. For these works see Berckenhagen 1967, pp. 349–55, cat. nos. 1336–58.
5. Illustrated in Berlin 1963, no. 21; see also Leipzig 1986, p. 62, no. 43, ill.
6. See Berckenhagen 1967, p. 354, cat. no. 1357.

68.

Chodowiecki was born in Danzig (Pol., Gdańsk) in 1726, but moved to Berlin as a young man to assist his uncle as a merchant. Although it was arranged for him to receive some training as an enamel painter, and although he took drawing lessons in the private academy of Bernhard Rode (*q.v.*) in 1743, Chodowiecki was essentially self-taught as an artist.

Having become established as painter of portraits in miniature on enamel, he took up etching around 1758, winning public recognition at this time. In 1764 Chodowiecki was admitted to the Berlin academy; in 1767 he gained renown for painting *Les Adieux de Calas à sa Famille.*

By the 1770s Chodowiecki had become Berlin's most fashionable book illustrator, whose illustrated calendars and almanacs were especially popular. Having been made vice-director of the Berlin academy in 1790, Chodowiecki became director on the death of Rode in 1797. He died four years later in Berlin.

As a printmaker, in particular, Chodowiecki was tremendously productive. His witty depictions of daily life, often with a satirizing or moralizing content, have led him to be compared to William Hogarth.

69. Susanne (The Artist's Daughter at the Age of Twenty-One)

Pen and black ink, brush and watercolor
4³⁄₈ × 7¹⁄₄ (110 × 185)
Signed and dated in black ink, lower right: *D. Chodowiecki del. 1782*

Cleveland Museum of Art; Mr. and Mrs. Lewis B. Williams Collection, 59.84

PROVENANCE: M. Stechow, Berlin (sale, Boerner, Leipzig, cat. no. xxviii, December 10–13, 1919); Heinrich Eisenmann, London; purchased, April 25, 1959

EXHIBITION: Cleveland Museum of Art, "Treasures on Paper. Masterpieces from the Collection of Prints and Drawings," May 10–July 24, 1988

LITERATURE: Lugt 1921, I, p. 443, under no. 2371

This signed and dated drawing is unusual for its size, technique, and subject in Chodowiecki's oeuvre. Executed in watercolor, it gives the likeness of a young lady standing in a landscape. The auction catalogue of the Stechow collection reports what was probably an older tradition, that it represented the artist's daughter, Susanne, at age twenty-one. There seems no reason to doubt that it at least records the traits of a recognizable personage, since such portraits are comparatively rare in the artist's oeuvre.

This charming sheet also offers a record of the *moeurs* of the 1780s, and in this regard it is comparable to the presentation of middle-class society and culture that is a hallmark of Chodowiecki's art. The placement of this elegant and obviously modish young lady in the countryside evokes some of those strivings associated with the yearning to get "back to" nature" that are connected with various "pre-romantic" cultural tendencies such as *Empfindsamkeit.* The tendency toward natural adornment is also suggested by the floral garland in her hair. Altogether the drawing suggests something of the movement of certain bourgeois circles away from stricter sensibilities around the end of the century.

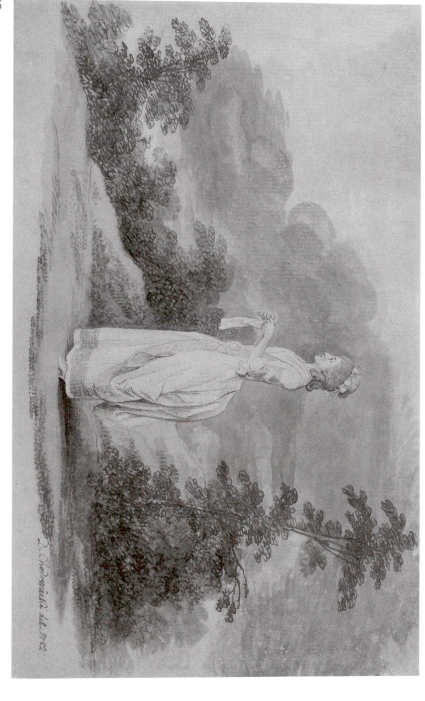

JOHANN FRIEDRICH BIERLEIN
(1768–?)

Not much is known about the life of Johann Friedrich Bierlein, who was born in 1768. He was active in Nuremberg as a painter of portraits in oil and miniature and is also known to have made engravings. Bierlein is still mentioned in 1808, when he is considered one of the better portraitists in Nuremberg.

70a. Portrait of Johann Gottfried von Herder

Graphite on parchment, covered by a white ground
8¹⁵/₁₆ × 5¹⁵/₁₆ (227 × 151)
Inscribed in brown ink on verso: *Schleiermacher*

National Gallery of Art; Rosenwald Collection, 1954.12.218

70b. Portrait of Karoline von Flachsland

Graphite on parchment, covered by a white ground
9 × 5⅞ (228 × 149)
Signed and dated in graphite, center: *Gezeichnet von J.F. Bierlein in Norib. 1786*; inscribed on verso in brown ink: *Flachsland . . . schöfen* (?) *von Herder*

National Gallery of Art; Rosenwald Collection, 1954.12.219

These portraits, identical in medium and support, almost so in dimensions, and similar in format, constitute a pair; the identity of the sitters is established by the inscription in a late eighteenth- or early nineteenth-century hand on the verso of the depiction of the woman. It refers to Karoline von Flachsland, born 1750, who married the famed writer Johann Gottfried von Herder in Darmstadt in 1773. The identification of the couple as Von Flachsland and her spouse is confirmed by comparison to other portraits. The date of 1786 found on her portrait rules out the possibility that the mature man portrayed is Schleiermacher, as the inscription on the verso of the male portrait suggests, since Schleiermacher was only eighteen years old in 1786.

In 1786 the Herders were residing in Weimar. At this time Herder was deeply involved in the reform of education. It is therefore unlikely that these drawings, one of which is indicated as having been executed in Nuremberg (*in Norib.*), were copied from another image, rather than being done from life.

The oval portrait format chosen by Bierlein, in which the sitter is depicted relatively immediately without much adornment, follows a pattern for portraiture "*à la mode*" in Nuremberg.[1] Other works in this format were executed as prints in the 1790s by Bierlein.[2] Drawings in similar format and hatching technique are also to be found by the artist.[3]

The elaborate frames of these drawings, with floral and decorative ornaments, recall the pattern of book illustrations and other portraits of a somewhat earlier era. Their presence here, together with the somewhat unusual choice of a parchment ground, suggests that these drawings were not made for prints, but as presentation pieces. They record a famous figure of the German Enlightenment.

1. See, for example, a portrait drawing of Joseph Baron Neuenstein by Joseph Bergler dated 1794 in Nuremberg, Germanisches Nationalmuseum, inv. no. 7412, illustrated in Nuremberg 1983, p. 24, cat. no. 24, ill.
2. E.g., a portrait of Dr. Johann Schaeffer, Coburg, Kunstsammlungen, inv. no. V. 377.
3. For instance, a signed drawing of 1772 in Copenhagen, Statens Museum for Kunst, inv. no. TV III no. 8, black chalk and graphite, 252 × 209 mm.

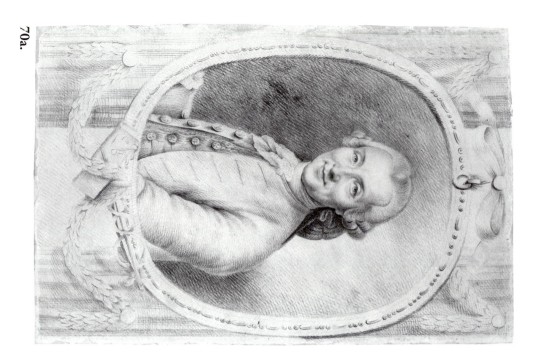

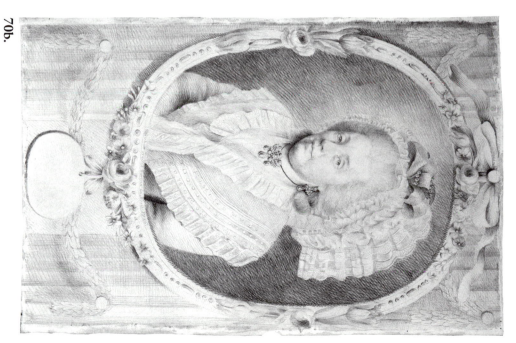

JOHANN HEINRICH WILHELM TISCHBEIN
(1751–1829)

The member of a large Hessian family of artists, Johann Heinrich Wilhelm was born in Haina, in Hesse, on February 15, 1751. He studied first in Kassel with his uncle Johann Heinrich Tischbein the Elder (1722–1789), and then in Hamburg with his uncle Jacob Tischbein and with Johann Dietrich Lilly, his cousin. In 1771–72 he journeyed to Holland and Bremen, and after a sojourn in Kassel, resided from 1777–79 in Berlin. With the support of the Kassel academy, Tischbein traveled to Rome in 1779. He returned to Kassel via Zurich in 1781.

In 1783 Tischbein again went to Rome, staying there until the late 1790s. He met Goethe on the poet's Italian journey of 1786, portraying him in his famed *Goethe in the Campania* in 1787. Because of his friendship with Goethe, Tischbein is often called "Goethe Tischbein," to distinguish him from other members of his family. In 1787 he became director of the Naples academy.

Visiting Kassel and Göttingen in 1799, he resided in Hamburg from 1801 to 1808, when he settled finally in Eutin, Holstein. He died in Holstein June 26, 1829.

burgher types that appealed to many of the prominent personalities, such as his friend and patron Goethe. Tischbein's portrait also foreshadows nineteenth-century German accomplishments in this genre.

1. According to information in the catalogue of the exhibition where this drawing was once shown, Baden-Baden 1968. The companion drawing is inscribed: *Madame de Wieling née 1769.*

2. For Tischbein's portrait drawings, see Mildenberger 1985. A comparable example, treated in a more summary fashion, however, is a female portrait in red and black chalk, Düsseldorf, Kunstmuseum, inv. no. 19/1101.

3. Compare his black chalk portrait of J. C. Lavater dateable ca. 1781, illustrated by Mildenberger in Oldenburg 1987, p. 241, cat. no. 225, ill. 180.

71. Portrait of Guillaume Wieling

Red chalk
12⁷⁄₁₆ × 15¹¹⁄₁₆; 12⁷⁄₁₆ × 7¹⁵⁄₁₆" (316 × 399; 316 × 202) (sheet is folded)
Watermark: IKOOD

Inscribed in graphite on recto, on sheet folded under: *A.G. Guillaume Wieling; BB/ NExSc*; on verso in graphite: *S 2107 pint*; on left inside fold: *Tischbein Joh. I. Aug. Mastricht 1750–1812 Heidelberg*

Harvard University Art Museums, Fogg Art Museum; the Paul J. Sachs Memorial Fund, the Louise Haskell Daly Fund, and Friends of the Harvard University Art Museums Funds, 1985.70

PROVENANCE: Unidentified collector (mark, crossed swords in blue, upper right, recto); collector MM (mark MM in black, lower left, recto); Löwenburg (note in graphite, verso); Kurt Meisner, Zurich; Seiden & de Cuevas, Inc.

EXHIBITION: Baden-Baden 1968, p. 32, no. 25, ill.

The identity of the subject of this portrait is provided by the contemporary inscription on the verso. A portrait of the spouse of the sitter, inscribed with her name, was also in the same collection from which this drawing was acquired.[1]

Although an anonymous note on the verso attributes it to Johann August Tischbein, this drawing is representative rather of the portrait style of the "Goethe Tischbein," Johann Heinrich Wilhelm the Younger. Similar portrait drawings in either red or black chalk, executed in a rather granular manner, are characteristic of the artist.[2]

A firm point of reference for the attribution of this drawing and for a dating in the 1780s is established by comparison to his profile heads of this date.[3] The sitter's costume also corresponds to that period.

The fine portrait exhibited here exemplifies the genre of bourgeois portraiture of the late eighteenth century as it was practiced by Tischbein. It was this kind of idealization of

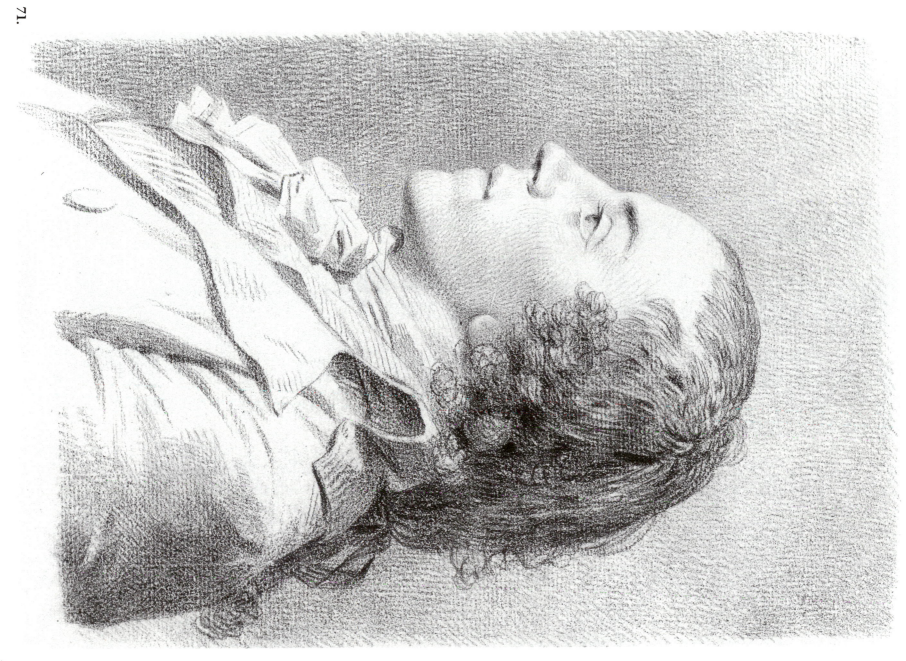

The only daughter of the painter Joseph Johann Kauffmann, from whom she received all her training, Angelika Kauffmann was a child prodigy in both music and painting. Born in 1741 in Chur, she had already aroused attention with a portrait painted in 1752. In 1754 she moved with her parents to Milan, learning more by copying from old masters. After the death of her mother in 1757, she accompanied her father on various commissions. She traveled through Italy in the 1760s, arriving in Rome in 1763. After being elected to a membership in the Florence academy in 1762, she joined the Roman *Accademia di San Luca* in 1765.

In 1766 she settled in London, where during the next fifteen years she attained great artistic and social success. She became a member of the Royal Academy in 1768. After a brief, unfortunate marriage of 1767 had been annulled in 1768, she married the painter Antonio Zucchi in 1781. In 1782 she returned to Rome, where her house became a popular meeting place for artists and writers: among those who frequented it were Goethe, Hackert (*q.v.*), and Tischbein (*q.v.*). She died in Rome in 1807.

72. Portrait of Stanislas Poniatowski

Brush and gray wash, pen and gray ink, traces of gouache
11⅛ × 7¾ (sheet irregular, image 9¹⁵⁄₁₆ × 6¹⁵⁄₁₆) (282 × 196; 252 × 177)
Watermark: fleur-de-lys inside crown in shield

Museum of Art, Rhode Island School of Design; Endowed Membership Fund, 66.273

PROVENANCE: Johann Kauffmann (from the bequest of Angelika Kauffmann); Karl Kauffmann, Bezau (collector's mark, not in Lugt, lower right, and verso); Josef Reith (according to notes on old mat); Karl and Faber, Munich (auction, September 20, 1966, no. 142)

EXHIBITION: Providence 1967, no. 40, pl. 25, ill. p. 27

Angelika Kauffmann's drawing is a study for a full-scale life-sized portrait of Stanislas Poniatowski (1755–1833), nephew of the last king of Poland. The painting is documented as having been finished in Rome in April 1788, and paid for in full by May 12.[1]

The Providence drawing corresponds in most details to the completed painting, as known from an engraving by Pietro Bettellini.[2] Comparison of the drawing with the engraving reveals changes in the stance and gestures of Poniatowski and the statue of liberty, atop the pedestal, as well as alterations in details of Poniatowski's uniform. These differences, and especially the new prominence given to the Polish chivalric orders of the White Eagle and of St. Stanislas, may well indicate the intervention of the patron, and may suggest that the drawing was presented for approval.

Documents reveal a further, intervening stage between the compositional sketch in the Rhode Island School of Design and the completed painting. The artist executed a study of the head of the sitter, which could then be integrated into the completed work. This study is now in the collection of

Andrea Busiri-Vici (Poniatowski), Rome.[3] While the painted study was given to the patron, as the documents imply, the drawing remained with the painter, passing to her heirs.[4]

Prince Poniatowski was an avid patron of Kauffmann and bought several pictures from her in 1788.[5] This portrait evidently capped her work for him.

The prominence given to the figure of liberty in the work undoubtedly refers to the prince's desire for Polish liberty, a cause threatened by Poland's neighbors at the time the work was painted. Poland had already suffered one partition in 1772, and was to undergo two more during the 1790s. The symbolism of this composition is therefore a fitting emblem of this cause.[6]

1. See Manners 1924, p. 154, for details:
"Rome. Finished in April 1788. For his Highness Prince Stanislas Poniatowsky, nephew of the King of Poland,—portrait of the above Prince full length life size figure, wearing officers uniform looking towards a big statue (painted the colour of white marble) representing Liberty placed on a round pedestal with bas reliefs, with figures of a woman symbolical of agriculture and commerce. Painted on canvas of 12 spans by 8 spans—250 Zecchini—received on account on 27th April 400 crowns received 189. On 12th May in full payment of above portrait and the other head on canvas which served as model for the big picture."
See further for this painting Michalkowa 1960, pp. 296–98.

2. Illustrated in Pawłowska 1969, 2, p. 105, fig. 18; the painting is discussed further on pp. 102–9 of this article.

3. Letter to Museum of August 22, 1967.

4. For the provenance of the drawings from Angelika Kauffmann's collection, see Manners 1924, p. 243.

5. Manners 1924, p. 153.

6. For more on Poniatowski, besides the references listed in note 1, see Wielka Encyklopedia 1967, 9, p. 275.

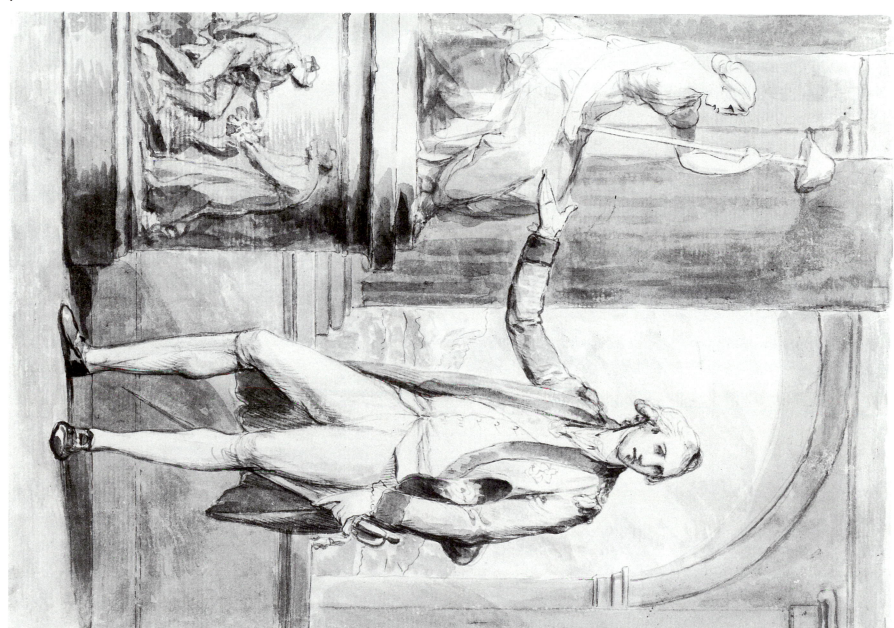

III.

Genre

Born in Augsburg on November 27, 1666, Georg Philipp Rugendas the Elder received instruction in the fundamentals of engraving in the watchmaker's shop of his father, Nikolaus. From 1683 to 1687 he was apprenticed to the painter Isaak Fisches, and he then worked around 1690 in Vienna, probably with Johann M. Hofmann, a medalist and coinmaker.

Rugendas journeyed to Italy in 1692, residing first in Venice, where he worked with the reproductive engraver Molinari. Late in 1693 he traveled to Rome. In Rome he studied alongside Daniel Preissler, and was accepted into the *Schilderbent*, or association, of northern artists with the *Bent* name of "Schild."

Upon his father's death in 1695, Rugendas returned to Augsburg, where in 1697 he married Anna Barbara Haid, a member of a family of printmakers. He worked as a painter of battle, equestrian, and camp scenes, and as an engraver. In 1710 he was made evangelical director of the Augsburg academy. In 1723 he visited Venice again. From 1735, though devoting himself to painting, he also ran a print publishing house in which his sons, who were also artists, assisted.

Highly respected in his lifetime, and celebrated in a later biography published in 1758 by J. C. Füssli, Georg Philipp Rugendas died in Augsburg on May 9 or 10, 1742.

73. Studies of Soldiers in Camp

Graphite
7⅝ × 11½ (186 × 293)
Signed in brown ink, lower right: *G.P. Rug.*; inscribed in black ink, bottom left center: *G* [with flourish] *P*

National Gallery of Art; Ailsa Mellon Bruce Fund, 1985.34.1

PROVENANCE: Th. Agnew & Sons, Ltd., London; purchase, 1985

This drawing is characteristic of a genre of minutely executed studies by Rugendas that depict varying numbers of figures engaged in different activities or caught in differing poses. Similar sheets are found in Nuremberg, and especially in Augsburg; another signed drawing with similar motifs in the United States is in Sacramento.[1]

It has been remarked that the style of these drawings is still rooted in the seventeenth century.[2] Indeed, very similar sheets of studies are signed and dated 1696.[3] The drawings are thus to be located in Augsburg, after Rugendas's return there from Italy in 1695.

Although these studies might seem very modest in appearance, they possess a historical importance, in that they imply the significance of drawings as a form of "*Studie nach der Natur.*" The making of this kind of study was an academic concern, and indeed Rugendas served as director of the Augsburg academy. They embodied an art that was regarded as proceeding "*von dem wahren Sichtbaren der Natur Stuffenweis zur Idee,*" as his biographer J. C. Füssli was to say, and therefore gained him many admirers.[4]

The subjects of these studies, namely activities found in military encampments, supplied material for Rugendas's specialty, the creation of scenes of battle and military life. They were used for finished drawings, for prints, and for paintings.[5] Drawings such as these accordingly formed the basis for pictures that were not only of thematic interest in a time of widespread conflict but, beyond the conception of war as a heroic matter, were regarded as containing a grain of truth.

1. For a similar sheet in Nuremberg, Germanisches Nationalmuseum, inv. no. St. N. 12085, see Heffels 1969, p. 246, cat. no. 293, ill. p. 245, with reference to the drawings in Augsburg; the drawing in Sacramento is inv. no. 1871.58.

2. Heffels 1969.

3. For example, in Dresden, Staatliche Kunstsammlungen, Kupferstichkabinett, inv. no. C 2395, signed and dated: *G. P. Rugendas pinx. et delin. Ao. 1696 d* [?] *15 November Augusta*. A finished battle scene with similar small figures is in Copenhagen, Statens Museum for Kunst, TU 110a, no. 11, signed and dated: *G. P. Rugendas pinx. et delin. Augusta 15 d* [?] *Aprile Ao 1696*.

4. I.e., "stepwise, from the true and visible aspect of Nature toward the idea." See for these points Augsburg 1968, pp. 134–35.

5. Heffels 1969 makes the point about prints, with reference to Von Stillfried, 1879. The studies are obviously also used for more elaborate battle paintings and drawings by the artist: for one such drawing, see the sheet in Copenhagen, cited in note 3, above.

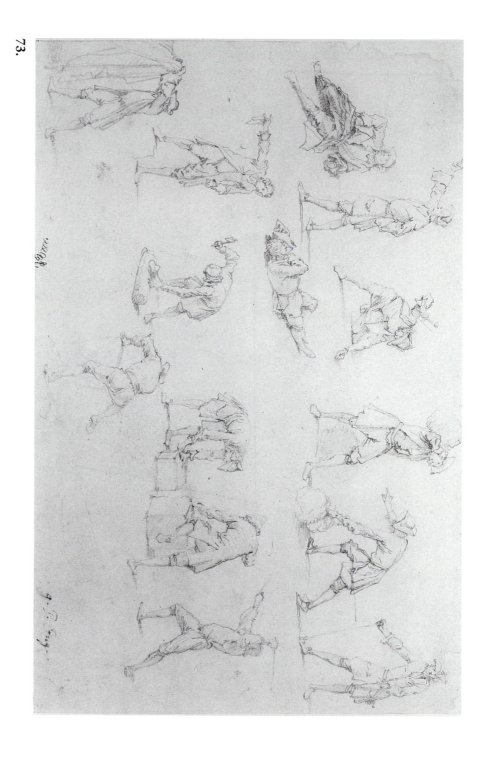

Paul Troger

(For biography, see cat. no. 31.)

74. Two Beggars with their Dog

Pen and brown ink
$13\frac{1}{2} \times 8\frac{15}{16}$ (343×227)
Inscribed in graphite on verso: *Troger*

National Gallery of Art; Ailsa Mellon Bruce Fund, 1981.90.2

Provenance: Blumka Gallery, New York, until 1958; Mr. and Mrs. Winslow Ames, Saunderstown, Rhode Island (blind stamp, lower left); purchased, 1981

Exhibitions: Providence 1965, cat. no. 93, ill.; Sarasota 1972, p. 31, cat. no. 69, ill. p. 65; Hartford 1973, p. 76, cat. no. 31, ill. p. 77

This sheet is characteristic of Troger's calligraphic mode of drawing, in which there seems to be a love of the movement of line for its own sake.[1] The expressive variation in density and length of line and the apparent speed with which the various lines have been drawn are also notable qualities of Troger's work as a draftsman.[2]

Here Troger seems to have sketched in his figures of dishevelled old people with a dog, and then, perhaps noting there was space left on the sheet, to have continued drawing elements unrelated to the composition. There are very fluid sketches of legs in the upper left and lower right corners of the drawing. Their appearance, as well as the absence of a graphite underdrawing of the sort found on Troger's preparatory drawings, makes it highly unlikely that this drawing was intended for a finished composition. Instead, the impression is reinforced that this drawing was done for its own sake.

The motifs found here are common in Troger's oeuvre. The type of blind old man with curving beard and wispy hair occurs in a painting of *Tobias and Anna*, where the old woman can also be seen.[3] The columnar motifs recur frequently, especially in his earlier drawings.

While these motifs might have suggested a dating toward the earlier part of Troger's career, the drawing has been exhibited as a work of the 1730s (in Sarasota) or even toward 1755 (in Hartford). However, the aggravated, jagged strokes are comparable to qualities evinced by sheets related to sketchbooks composed by Troger ca. 1728.[4] It therefore seems reasonable to associate this especially spontaneous drawing with works of that period. Eckhart Knab has also dated the drawing early, before 1730.[5]

1. See Knab, in Altenburg bei Horn 1963, p. 147.
2. See the remarks in Knab 1963, esp. p. 22.
3. Barockmuseum, Österreichische Galerie, Vienna, inv. no. 3159, dated 1728–30, in Baum 1980, 2, pp. 705–6, no. 501.
4. Vienna, Graphische Sammlung Albertina, cat. no. 2069h; also inv. nos. 26981, 27012.
5. Orally, to the author in 1984.

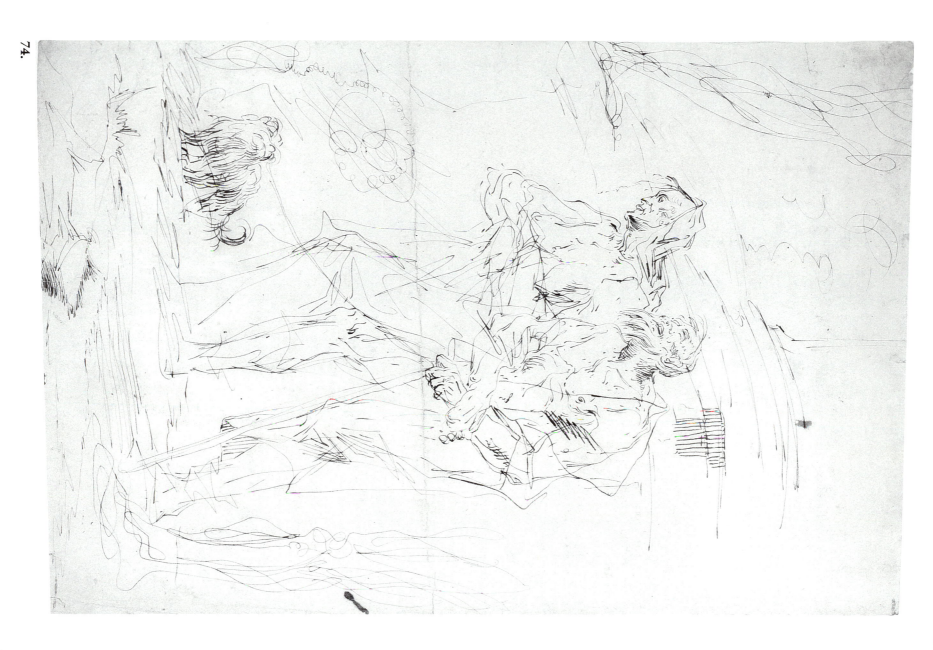

CHRISTIAN WILHELM ERNST DIETRICH
(1712–1774)

The grandson of Johann Ernst Reuscher and son of Johann Georg Dietrich (1684–1752), both court painters in Weimar, Christian Wilhelm Ernst Dietrich was born there in 1712. He received his earliest education as an artist from his father and went to Dresden in 1724 to study with Johann Alexander Thiele (q.v.), who recognized his precocious talents and brought him to Arnstadt to collaborate on the decoration of the schloss in 1728. Returning with his master to Dresden in 1730, Dietrich completed his apprenticeship by 1731, when he was given the title of court painter. After returning home 1731–33, he served Count Brühl in Dresden in 1733–34, whereupon he applied to go on a journey to Holland. While the Netherlands were the source of much of his artistic inspiration, it is uncertain if he was ever able to know Holland at first hand; he is recorded as being in Braunschweig and Salzdahlum in 1737.

Having returned to Dresden in 1741, Dietrich married and was confirmed as court painter. In 1743 he was sent on a trip to Italy, and in 1746 he was made inspector of the newly founded Dresden *Gemäldegalerie*. The Seven Years' War of 1756–63 disrupted Dietrich's career, as it did much of life in Saxony, and caused him to move his home. In 1764 he was named professor for animal and landscape painting at the newly founded Dresden academy, where he was a colleague of Anton Graff (q.v.) and Adrian Zingg (q.v.). Although his productivity declined somewhat during the last decade of his life, he continued to work and teach in Dresden until his death in 1774.

Dietrich's drawings of 1731–32.[6] In particular, the use of pen and ink to create a variety of forms of hatching, and the use of dots, also resembling the etching technique, are very close to that seen in other drawings by Dietrich from the 1730s.[7] For these reasons this hitherto unpublished drawing is presented here under the traditional attribution to Dietrich.

1. For this subject, see most recently the illustrations and discussion in Bremen 1986, pp. 29ff., 75ff.
2. See, in general, Michel 1984, pp. 177–80.
3. For example, a drawing of an Oriental type in black chalk in Budapest, Szépművészeti Múzeum, inv. no. 649; another in black chalk, Munich, Staatliche Graphische Sammlung, inv. no. 358; a drawing of a head study in red chalk, Vienna, Graphische Sammlung Albertina, inv. no. D. 1292; other studies of the type are found there, inv. nos. D. 1345, 1346.
4. Michel 1984, pp. 154–55. For a print after such a painting by Dietrich, see Vienna, Graphische Sammlung Albertina, Deutsche Schule, D. II 8.
5. None can be found in any of the large collections of Dietrich's oeuvre in Central Europe. For this reason Christian Dittrich, curator in the Kupferstichkabinett, Staatliche Kunstsammlungen, Dresden, has doubted the attribution, orally, January 21, 1986.
6. For example, Vienna, Graphische Sammlung Albertina HB 50 (1) 8, no. 190, p. 82.
7. Compare a drawing dated 1732, Veste Coburg, inv. no. Z. 1015.

75. Oriental in a Fantastic Headdress

Pen and brown ink
5 11/16 × 4 3/8 (145 × 112)

National Gallery of Art; Julius S. Held Collection, 1984.1.6

PROVENANCE: W. Mayor, London (Lugt 2799, lower right, recto); Julius S. Held

Depictions of heads of men wearing fantastic headgear resembling turbans were particularly popular in the work of eighteenth-century German artists who imitated or emulated Rembrandt. Often their productions were seen through the interpretation of this type of "character head" as it had been created by Giovanni Benedetto Castiglione in the seventeenth century.[1]

This type of head is often encountered in Dietrich's graphic oeuvre of the 1730s.[2] A number of head studies in black and red chalk of this subject have been found,[3] and paintings of this subject are known to have existed.[4]

This study in pen and ink resembles the kind of Castiglionesque interpretation as it is found elsewhere in Dietrich's oeuvre. The attribution must be advanced with some caution, however, as no other character heads in this medium are known by the artist.[5]

Nevertheless, the drawing does not resemble efforts of this sort by other contemporaries. The technique can be compared to that reproduced in prints of the time after

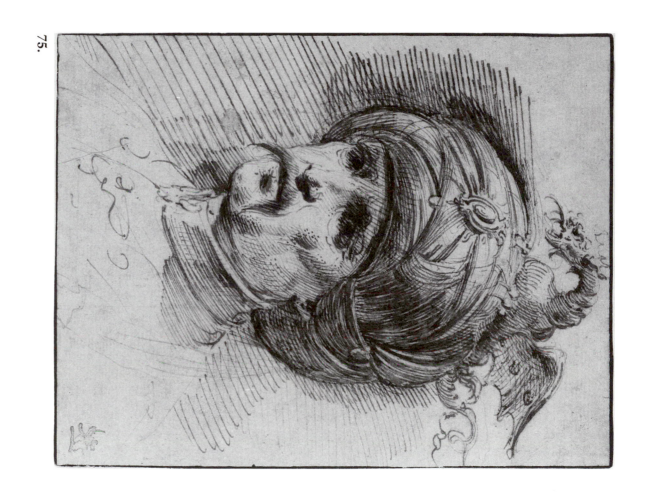

75.

Genre

209

76. A Hermit Saint (?) Reading

Red chalk, on yellowish paper
10¼ × 7⅝ (260 × 194)
Signed and dated in red chalk on bottom center, recto: *Dietricy 1747;* inscribed on verso of mount: *DIETRICY (Chr. W. E. Dietricy) 1712–74*

The Metropolitan Museum of Art; Rogers Fund, 62.134

PROVENANCE: Pierre-Jean Mariette, Paris (Lugt 2097, lower left, recto), entire sheet attached to Mariette mount (Lugt 2859); sale, Paris, November 15, 1775–January 30, 1776, no. 871 of Basan's catalogue of this sale: *Saint François assis dans une espèce de caverne, tenant un gran livre, sujet en hauteur, fait à la sanguine en 1747, dans le style Hollandois*); Jules Dupan, Geneva (Lugt 1440, on mount; sale, Paris, Hôtel des Ventes, rue des Jeûneurs, March 22–28, 1840, no. 998: *Un Ermite lisant au fond de sa cabane et un crucifix, à la sanguine*); Fleurville Antiquities; purchase, 1962

This representation of a hermit reading outdoors before a stone arch is an example of a theme frequently found in Dietrich's oeuvre. There are many drawings and prints after his designs of the same or similar subjects.[1] Although the figure here has been identified both as St. Francis and as a hermit, and bears resemblances to images of St. Jerome, the drawing lacks any specific attributes beyond the hooded monk's or friar's habit that would aid in its identification.

Rather than representing a specific subject, the drawing seems intended to evoke more generally the qualities of Rembrandt's art as seen in numerous works depicting hermits. Dietrich emulated Rembrandt in many media, and in this regard he shared a tendency that is to be found in the work of many German artists of the mid-eighteenth century.[2] In particular, Rembrandt's graphic oeuvre had an immense impact on draftsmen and printmakers.[3]

Like another drawing of a similar subject in Vienna, this sheet was probably made to be sold.[4] It is elaborately executed, signed and dated. While it resembles many other similar compositions by the artist, no print or painting is known to have been made after this drawing.

The drawing was once owned by the famed collector Pierre-Jean Mariette, who is known to have been an admirer of Dietrich's drawings and etchings in a Rembrandt manner, and who tried, through the mediation of Wille, to obtain works by him. The sheet attests not only to Mariette's interest but also to the popularity of Dietrich in France and indeed more generally.[5]

1. For example, a signed and dated drawing of 1732 in pen and brown ink and brown wash, representing St. Jerome praying in a cell, is in the British Museum, London, inv. no. 1856–7–12–955; engravings after drawings by Dietrich of saints or hermits reading can be found in Vienna, Graphische Sammlung Albertina, Deutsche Schule II 9a fol. 41 r; Deutsche Schule 184 (161, 1er and 162, 2ieme). A print by Johann Friedrich Bause, Vienna, Graphische Sammlung Albertina, HB 5096, 2, no. 17, p. 14, also imitates the chalk drawing style found in this sheet.
2. For the general subject of the emulation of Rembrandt in the eighteenth century, see Keller 1981. For Dietrich's emulation of Rembrandt in the general context of the question of imitation in his work, see Michel 1984.
3. For the importance of this subject and the variety of response to Rembrandt, see Bremen 1986.
4. Vienna, Graphische Sammlung Albertina, cat. no. D. 1306, described as a *Verkaufsobjekt*, in Tietze 1933, p. 121.
5. For this subject, see Michel 1984, pp. 206ff.

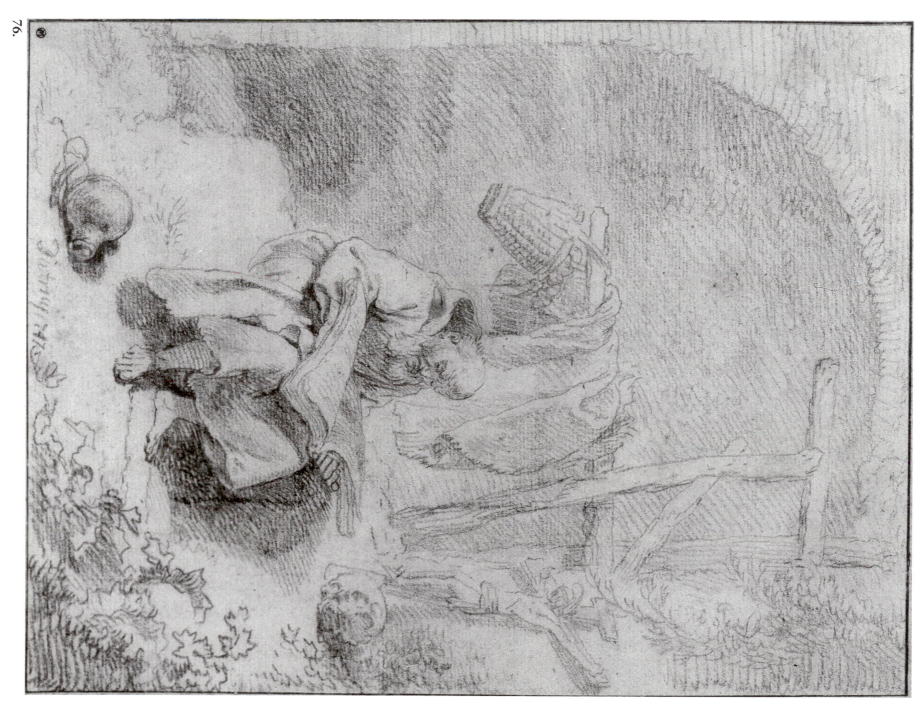

JOHANN KONRAD SEEKATZ

(1719–1768)

Johann Konrad Seekatz was born in Grünstadt on September 4, 1719, the son of the Hessian *Landschaftlicher Maler* and later Worms court painter, Johann Martin Seekatz, and younger brother of the painter Johann Ludwig Seekatz (born 1711), with both of whom he first studied and collaborated. In 1748 he went to the Palatine court in Mannheim, where he was the student of Philipp Hieronymus Brinckmann, the court painter and director of the important picture gallery there. Having learned from his teacher and from the Mannheim collections, Seekatz entered into the service of the Landgrave Ludwig VIII of Hesse-Darmstadt in 1753.

Because his salary as court painter was insufficient to support a family in Darmstadt, Seekatz moved to Frankfurt am Main, where through sales at the fair and the mediation of Councillor Goethe, father of the famous writer, he gained great success with a local middle-class clientele. Subsequently, Seekatz was commissioned by the French *Stadtkommandant* of Frankfurt to decorate his residence in southern France. In 1765 Seekatz also obtained a commission from Ludwig VIII to supply *sopraporti* for his small castle in Braunshart. Seekatz died in Darmstadt on August 25, 1768.

77a. Group of Refugees

Pen and brown ink, brown and gray wash, white heightening
8 1/2 × 14 (210 × 354)

The Pierpont Morgan Library, III, 247a

PROVENANCE: Earl of Warwick, Charles Fairfax Murray

77b. Gypsies Before a Campfire

Pen and brown ink, brown and gray wash, white heightening
8 1/2 × 13 5/16 (210 × 355)

The Pierpont Morgan Library, III, 247b

PROVENANCE: Earl of Warwick, Charles Fairfax Murray

EXHIBITION: Baltimore 1959, p. 65, no. 274

These two drawings were undoubtedly made as a pair. Not only do they share a common provenance, but their compositions, with figures grouped before a tree, and an opening to one side, also complement each other. So, too, do their themes, which represent the quiet activities of peace in contrast with the depredations of war. Similar paired depictions of War and Peace involving scenes of vagabonds or gypsies are repeated in Seekatz's oeuvre.[1]

The Morgan Library drawings can thus be related to a number of paintings by Seekatz datable to the years 1759–64.[2] The group of refugees fleeing with their belongings before marauders who forceably dispossess them of their livestock can be compared to elements in pictures such as one of traveling gypsies, where a similar rag-tag group is found underway,[3] or a representation of war, where soldiers are also shown driving off cattle.[4] On the other hand, the drawing of gypsies before a campfire corresponds to the

theme of robbers, vagabonds, or gypsies enjoying peaceful repose around a campfire, making music, drinking, eating, courting, sleeping, and indulging in other human activities (micturating, wiping a child's bottom) seen in many other paintings by the artist.[5]

Gypsies Before a Campfire is identical in almost all details to a painting of a similar subject in the Schäfer Collection, Schweinfurt.[6] Only slight differences exist between the two works: these include the addition of a sleeping youth to the left of the group formed by the mother with her children in the Morgan drawing, the replacement of two children in the extreme right of the painting by a single youth with a rifle in the drawing, as well as changes in the glances or characterizations of figures. These distinctions nevertheless suggest that the two are variant versions, rather than being two steps in the process of completion of the same work.

The high degree of execution in the Morgan Library sheets suggest that they were made to be finished drawings, rather than preparatory designs. Where preliminary studies are known in Seekatz's oeuvre, they tend to be either freely painted oil sketches or drawings in chalk or graphite.[7]

According to reports that go back to the time of Seekatz, the artist was particularly prized for *Scharmützel, Plünderungen, Bauern-und Zigeunerstücke mit Landschaften . . .*, such as these.[8] It has also long been recognized that these kinds of compositions represent German eighteenth-century adaptations of models found in seventeenth-century Netherlandish art.[9] This observation may be applied both to the style of depiction, in which there is a certain elegance in details of the natural setting, such as the feathery foliage, and to the indications of topography, such as the evidently German schloss seen in the left background of the *Group of Refugees*.

What has not been emphasized is that the thematic of Seekatz's depictions may be related in particular to the artistic tradition of the *Boerenverdriet*, in which the conflicts between soldiers and peasants and their consequences are portrayed.[10] This subject matter may have had a special resonance for Seekatz's audience in Frankfurt and Darmstadt, which are near Spessart, the home of Grimmelshausen's Simplicissimus, whose tale epitomizes such representations of war.

Detlef Hoffmann has demonstrated that the depiction of gypsies also had a special importance for Hesse-Darmstadt. This area was the home of many robbers, who were identified with gypsies; during the mid-eighteenth century, measures were undertaken to control them. Yet the feared gypsy-vagabond-robber could, in his untrammeled freedom, also embody for poets and painters an image of national unity and in some sense "the noble savage." Hence Seekatz could find a ready market among both bourgeois and court circles for depictions of the "natural" life of gypsies such as that seen in the Morgan Library drawings.[11]

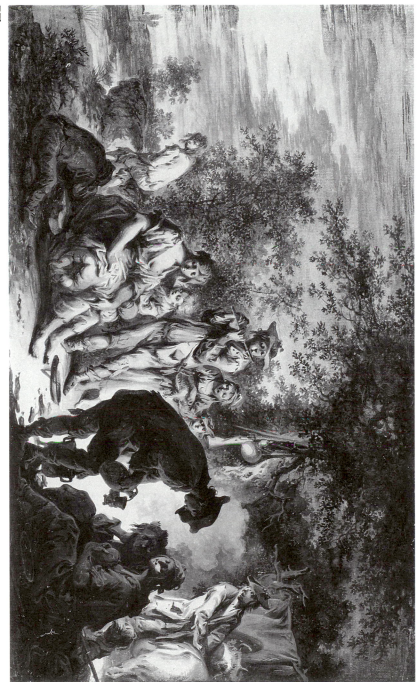

Genre

1. For instance, the *sopraporti* in the Historisches Museum der Pfalz, Speyer, inv. nos. BS 3087 and BS 3086, illustrated in Darmstadt 1980, cat. nos. 287–88, ill. p. 219; Bamberger 1916, p. 240, cites two additional representations of this theme.

2. Bamberger 1916 describes paintings of this sort in his seventh chapter, "*Die Zeit der gemeinschaftlichen Tätigkeit mit dem Frankfurter Malerkreis (1759 bis 1764),*" pp. 119–39. Bamberger lists many such paintings of vagabonds on the move, or gypsies around campfires, on pp. 239–40.

3. Prague, Národní Galerie, inv. no. DO 5384, illustrated in Darmstadt 1980, p. 215, cat. no. 282.

4. Historisches Museum der Pfalz, Speyer, inv. no. BS 3086, illustrated in Darmstadt 1980, cat. no. 288, ill. p. 219.

5. See, for instance, the paintings exhibited in Darmstadt 1980, cat. no. 281, ill. p. 214, cat. no. 283, ill. p. 265; cat. no. 284, ill. p. 227, cat. no. 287, ill. p. 219.

6. Darmstadt 1980, cat. no. 283, ill. p. 265.

7. Compare the illustrations in Darmstadt 1980, pp. 229–35; see also Bamberger 1916, pp. 214–24.

8. See Hoffmann, in Darmstadt 1980, pp. 247–48, n. 32, and Bamberger 1916, p. 132, for Seekatz's reputation in this regard.

9. Besides Bamberger 1916, pp. 76f., *et passim,* see the repeated discussion of this subject by Adolf Feulner, for example, in Feulner 1929, pp. 200–201. Hoffmann, in Darmstadt 1980, pp. 245–65, problematizes this observation.

10. For this theme, see Fishman 1982. Hoffmann, in Darmstadt 1980, p. 258, mentions the representation of peasants' sufferings in images by Seekatz such as those discussed here.

11. Hoffmann, in Darmstadt 1980, pp. 258–65, develops these arguments.

JOHANN GEORG WILLE

(1715–1808)

Wille was born near Giessen in 1715. His father recognized and encouraged his early interest in drawing, sending him to study in Gladenbach with an artist named Kuh when he was only about ten years old. He later worked as an engraver in Marburg and as a painter of musket shafts in Giessen and Usingen.

In 1737 Wille traveled to Paris, befriending Georg Schmidt (*q.v.*) on the way. He settled in Paris and, after a difficult start there, succeeded as a portrait engraver through commissions after the work of Largillière and Hyacinthe Rigaud's recognition of his merits. Marrying in 1747, Wille became a member of the French academy in 1761, being named an officer in 1786. Other honors bestowed on him were membership in the academies of Rouen, Augsburg, Vienna, Copenhagen, and Berlin, and appointment as engraver to the kings of France and Denmark, and to the Holy Roman Emperor. Wille was also active in Paris as a dealer and collector. Furthermore, he maintained contacts with many notable figures of arts and letters throughout Europe. His atelier became a haven for many German and Swiss artists; besides those artists mentioned in this catalogue, his pupils include Ferdinand Kobell (1740–1799) and Christian von Mechel (1737–1817). His diaries, which have been published, are therefore an important source for his period. Wille died in Paris in 1808.

78. Wall and Gate by a Road

Gray wash and watercolor over black chalk
6⅝ × 9⅛ (168 × 232)
Signed and dated in black ink to right: *J.G. Wille / 1766*

Crocker Art Museum, 1871.1062

PROVENANCE: Probably R. Weigel, Leipzig; Edwin Bryant Crocker

EXHIBITION: Detroit Institute of Arts, 1949, "German Paintings and Drawings from the Time of Goethe in American Collections," no. 143

LITERATURE: Scheyer 1949, p. 250, no. 143; Sacramento 1971, p. 166

This signed and dated drawing of 1766 is characteristic of Wille's oeuvre of the 1760s, when he turned increasingly to the creation of genre and landscape compositions, and it indeed combines elements of both. It sets before an inn low-life characters who are involved in an altercation. The incident is located in a rural environment. The subject matter, the naturalistic appeal, and to some degree even the method of execution are comparable to the seventeenth-century Netherlandish tradition.

In this regard Wille may also be seen as belonging to a tradition that had been established by the colony of Flemish artists who had settled in Paris in the seventeenth century, and had fulfilled the demand for such imagery.[1] Unlike his northern predecessors, however, Wille succeeded in operating within the bounds of academic propriety, and in 1761 gained a place for himself in the *Académie Royale.* Works like this

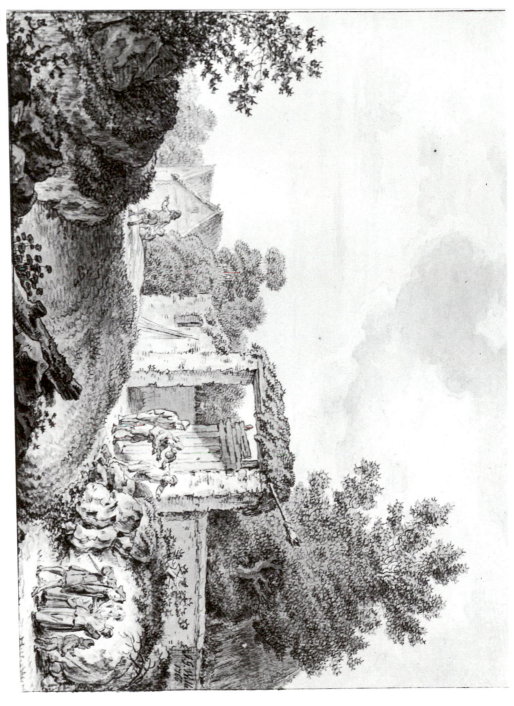

watercolor, which, like other comparable examples of the time, were finished compositions, were successful in their treatment of this kind of subject matter in the spirit of what may be called a lingering taste for the rococo.[2]

Wille was capable of attracting a large number of foreign artists to his atelier. Because of his formative impact on many German and Swiss artists, including several whose work is exhibited here (cat. nos. 64, 66, 91, 92), he deserves a place in this exhibition.

1. For these artists and their work, see most recently the discussion in Crow 1985, pp. 23, 47f., with annotation leading to further sources.
2. See also for this point and for another comparable drawing, Berlin 1987, p. 12, no. 69, ill. p. 23.

JOHANN HEINRICH FÜSSLI (FUSELI)

(1741–1825)

Son of the theorist, portraitist, and art historian Johann Caspar Füssli (1706–1782), Johann Heinrich Füssli was baptized in Zurich in 1741. The painter and writer Salomon Gessner (*q.v.*) stood as godfather. Growing up in this heady atmosphere, Füssli revealed artistic talent at an early age; however, he was sent by his father to study with the theorist Johann Jakob Bodmer at the Zurich collegium. He became ordained as a Zwinglian minister in 1761. Forced to leave Zurich because of a pamphlet he wrote in 1762, Füssli journeyed to Berlin in 1763; there he joined the circle of Johann Georg Sulzer (see cat. no. 68).

In 1764 Füssli was sent to England to act as a liaison between German and English literati; in 1765 he translated Winckelmann into English. Returning to England after a journey to France from 1766 to 1768, he was persuaded to pursue a career as an artist.

In 1770 he traveled to Italy, where he stayed until 1778, becoming the center of a large group of artists associated with the beginnings of neoclassicism. In 1778 Füssli returned to England, where he remained until the end of his life. Working under the name Henry Fuseli, he had a great impact on the English artistic scene of the late eighteenth and early nineteenth centuries. He died at Putney Hill near London in 1825.

happiest. This was the period when he was most closely in contact with the major art theorists in Central Europe as well: in 1765 he published a translation into English of Winckelmann's *Gedanken über die Nachahmung der griechischen Werke in der Malerei und Bildhauerkunst.*

While Füssli was working alongside figures who may be regarded as pillars of the classicizing aesthetic tradition, the theme of the drawing gives some intimation of his own further development. In a candlelit room two men are engaged in a nocturnal conversation. One man sits up startled in his bed, as if he has had a nightmare, or seen an apparition. The dramatic lighting and intimate, even inward psychological turn, presage the development of such themes in later works by the artist such as his *Nightmare.*

Füssli is well represented by drawings in the United States. This drawing has, however, been chosen for exhibition because of its associations with Central European, rather than British, culture, and because it was done at a time when Füssli was firmly anchored therein.

1. See, for example, Schiff 1973, I, 1, p. 436, cat. no. 356, ill. I, 2, fig. 356.

79. Midnight

Pen and brown ink, brown wash
8¼ × 13 (210 × 330)

National Gallery of Art; Ailsa Mellon Bruce Fund, 1971.66.3

PROVENANCE: Anthony D'Offay Fine Art, London; Mr. and Mrs. Lester Francis Avnet; purchase, 1971

EXHIBITION: Palm Beach 1968, no. 23, ill.

The catalogue of the exhibition in which this sheet was first widely displayed reports that Gert Schiff agreed with the attribution to Füssli, and intended to include it in a supplement to his catalogue raisonné of Füssli drawings. Schiff is said to have dated the drawing ca. 1764, and comparison to other known drawings of this time supports his attribution and dating.[1]

Although Schiff suggests this drawing was done around the time when Füssli was sojourning along with Lavater, Felix, Hess, and the theologian Barth in Swedish Pomerania (the region around Stralsund), the exhibition catalogue publishes a date of 1765. Füssli was in Pomerania from April or May 1763 until September of that year; in the beginning of October Johann Georg Sulzer called him back to Berlin to collaborate on the *Allgemeine Theorie der schönen Künste.* In 1764 Füssli was sent to London, more or less as an emissary of Sulzer and the Swiss aesthetic theorists Bodmer and J. J. Breitinger, and began his broader European career.

The dating is of some consequence, for it enables this sheet not only to be set in the earliest stages of Füssli's career, but perhaps during the time that he was reportedly

216

79.
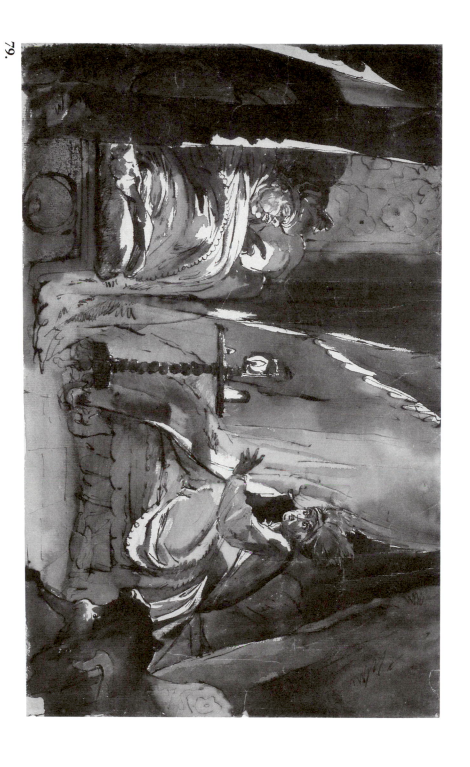

Georg Melchior Kraus

(1733/37–1808)

Georg Melchior Kraus was born in Frankfurt am Main in 1733 (or 1737) and was the son of an innkeeper. Little is known about his origins as an artist: in 1761, when he was already mature, he traveled to Paris, where he may have received instruction from Johann Heinrich Tischbein the Elder (see cat. no. 71). Kraus stayed in Paris until 1766, gaining a certain reputation for his genre scenes.

In 1768 Kraus was admitted to the Vienna academy, and in 1770–71 he traveled, chiefly in Switzerland. In 1775 he is recorded as being in Weimar, where he became director of the Zeichenschule in 1776. In the same year he was admitted to the Zeichenakademie in Hanau as a foreign member.

In Weimar, Kraus was a friend of Goethe, and a key artistic figure for Goethe's circle there. He was also befriended by the physiognomic theorist Johann Kaspar Lavater. From 1786 Kraus edited the Journal des Luxus und der Moden together with Friedrich Bertuch. He died in 1808.

80. Peasant Woman Eating (recto); Figure (verso)

Red chalk with gray-brown wash; verso: traces of red chalk, black chalk outline

15½ × 10¾ (394 × 273)

Inscribed (signed?), lower right corner: *G.M. Kraus*; inscribed in graphite on verso: *Kraus. Weimar*

Crocker Art Museum, 1871.1068

PROVENANCE: R. Weigel, Leipzig (?); Edwin Bryant Crocker

EXHIBITION: Detroit Institute of Arts, 1949, "German Paintings and Drawings from the Time of Goethe," no. 87

LITERATURE: Scheyer 1949, p. 242, no. 87; Sacramento 1971, p. 154

This drawing of a peasant woman eating, with her foot resting on a warmer, corresponds to a large group of studies of single figures and groups from the artist's estate now in his birthplace, Frankfurt am Main. The peasant subject, isolation of the figure from its surroundings, and the shading with broad, light application of washes can be compared to other drawings in this group, both in the medium of this drawing and in watercolor.[1] These drawings have been connected with Kraus's journey to Switzerland in 1770–71, and it is likely that the Sacramento drawing dates from around this time as well.[2]

The use of the red chalk medium provides another reason for associating this sheet with the earlier part of the artist's career. Kraus may have been introduced to its use by his teacher Johann Heinrich Tischbein (see cat. no. 71). Kraus seems, further, to have emulated Greuze and other French artists in his employment of the medium during his stay in Paris in the 1760s; the broad parallel hatching in chalk found in parts of the Sacramento drawing is also evinced in other drawings by Kraus from this period.[3]

The taste for peasant themes may also have been stimulated by artists such as Greuze. The subject matter may also have contributed to his appeal among the court circles in Weimar, where he moved probably soon after the completion of this drawing, and where he was much admired and discussed by Goethe.

1. See Schilling 1973, 1, pp. 155–60, cat. nos. 1563–1639; 3, pls. 270–76. Especially comparable are cat. nos. 1627, 1630 (inv. nos. 6084, 6087).
2. For this dating, see Schenk zu Schweinsberg 1930, p. 12.
3. See further Schenk zu Schweinsberg 1930, pp. 9, 11, and figs. 12, 14, illustrating drawings in the Schlossmuseum, Weimar.

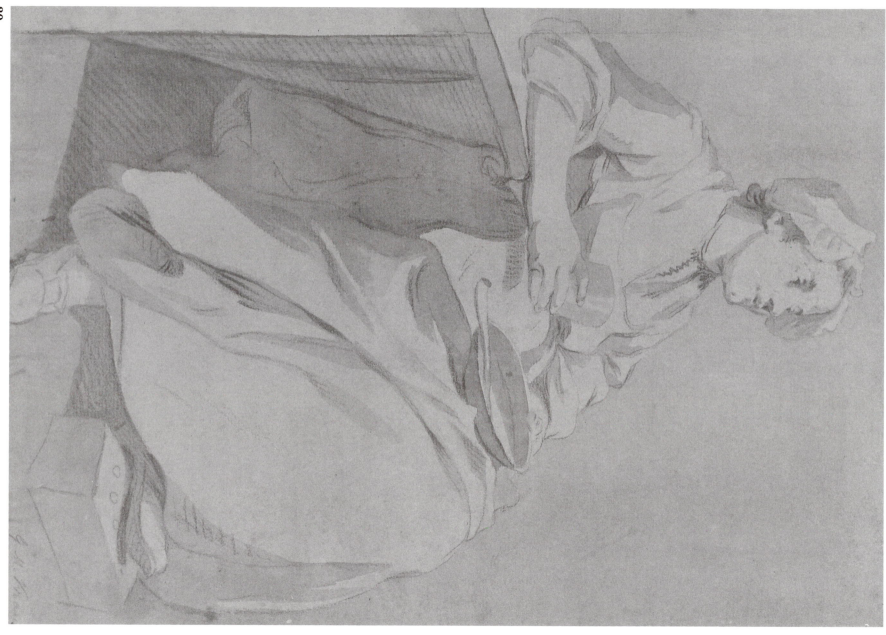

FRIEDRICH ("MALER") MÜLLER

(1749–1825)

Friedrich Müller was born into modest circumstances in 1749 in Kreuznach. After helping his mother with her tavern, he went to Zweibrücken ca. 1766 to study painting with Daniel Hien.

He began to write plays and poetry around 1773 under the name "Maler" Müller, taken from his proclivities as a painter. His writings and personality caught the attention of the court of Pfalz-Zweibrücken, where he was next employed; in 1774 he was drawn to the court of the Elector Carl Theodor of the Palatinate in Mannheim. Although he had acquired a name as a poet, most notably as the author of *Idyllen* (1775) in the genre of Salomon Gessner (*q.v.*), when he was made *fürstlicher Cabinetmaler* in 1777 he decided to dedicate himself to painting, and therefore traveled to Rome.

His first years in Rome were spent writing, however, and he lost his allowance from the Mannheim court. After 1782 he returned to painting, attracting the attention of Prince Ludwig of Bavaria, who gave him the nickname *Teufelsmüller*, from the speciality the artist developed of painting devils. Müller later served Ludwig as an agent in making acquisitions of works of art, and in 1798 was named painter to the Bavarian court. He received a pension from the Bavarian court until his death in Rome in 1825.

It is also true that at this time Müller was particularly interested in low-life subjects for his poetry. He published his first *Idyllen* in 1775. Among them is a work with local color, *Die Schaaf-Schur, eine Pfälzsische Idylle*.

As is evident from this drawing, Müller may be considered as much a writer as a visual artist. But his compositions, however seemingly amateurish, held great charm for many of his contemporaries, by whom he was highly regarded. These included Goethe, who struck up a friendship with Müller around the time of this drawing. Müller also stands for the kind of artist-writer that Goethe tried to become.

1. For an illustration of the etching, see Mathern 1974, p. 48. The auction catalogue correctly points out the connection of the drawing with the print: *Treffliche Zeichnung mit bister in Ostades Geschmack und bekannt durch die Radierung des Meisters bei Nagler* ix p. 558, 10.
2. See Mathern 1974, p. 114, for this dating, and for similar genre depictions, illustrated, e.g., p. 46.
3. This point is also noted by the Du Rosey sale catalogue.
4. See, for example, Munich 1983, no. 68, pl. 73, no. 58, pl. 74.

81. Traveling Players at the Inn Door

Pen and brown ink, brown wash
8⅞ × 6½ (225 × 165)

Crocker Art Museum, 1871.79

PROVENANCE: C. Rolas du Rosey (Lugt 2237, lower right; sale, R. Weigel, Leipzig, June 13, 1864, no. 5435); probably R. Weigel, Leipzig; Edwin Bryant Crocker

EXHIBITIONS: Sacramento 1939, part 2, no. 66; Detroit Institute of Arts, 1949, "German and Austrian Paintings and Drawings from the Time of Goethe in American Collections," no. 93

LITERATURE: Scheyer 1949, p. 242, no. 93

This drawing is a study in reverse for an etching by Müller known as the *Affenkomödie*. The print follows the drawing almost exactly.[1]

A dating of ca. 1776 has been proposed for the etching, and this is most likely the date of the drawing too. At this time Müller made several similar genre compositions.[2] Like this one, they were inspired by the tradition of seventeenth-century genre scenes in the Netherlands, and in particular the work of the van Ostades.[3]

It was also at this time that Müller was active in Mannheim as *Kurpfälzsischer Kabinettmaler*, having gained the favor of the elector, Carl Theodor. Carl Theodor was an important collector of paintings and drawings, who cherished Netherlandish works among those of other schools. He owned many works with genre subjects, among them drawings by the van Ostades and their followers, such as Cornelis Dusart.[4] Müller may have received some inspiration from this source.

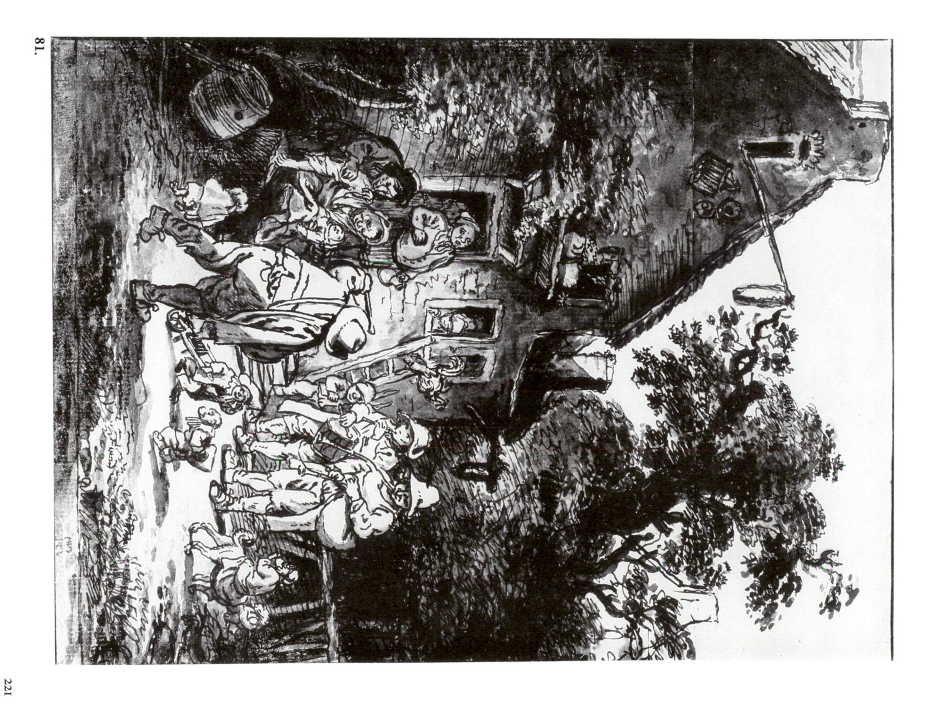

JOHANN JAKOB HOCH
(1750–1829)

Johann Jakob Hoch was baptized in Mainz on July 6, 1750. His father, Johann (Job) Gustav Heinrich (born 1716), his half brother, Johann Peter (born 1741), and his younger brother, Georg Friedrich (born 1751), were all painters. After studying probably first with his father, Johann Jakob attracted the attention of the Prince Elector Bishop Friedrich Karl von Erthal. In 1778 he and his brother were in Vienna; in 1783 he was in Paris, where he probably remained until 1785. He was back in Mainz by 1788. On October 26, 1802, Hoch married. He died on April 2, 1829, leaving behind a private library containing books on art history, French, Italian, and Dutch literature, and a collection of prints.

Hoch painted pictures of landscapes with ruins, monks, and pilgrims, some mythological and allegorical depictions, and religious works, as well as portraits and animal paintings.

82. The Wizard's Spell

Pen and black ink, gray wash
17 × 22⁹⁄₁₆ (432 × 573)

Harvard University Art Museums, Fogg Art Museum; Paul J. Sachs Memorial Fund, Louise Haskell Daly Fund, and Friends of the Harvard University Art Museums Funds, 1985.68

PROVENANCE: Rosenberg & Stiebel, New York; Seiden & de Cuevas, Inc.

This scene takes place in the midst of a dark overgrown forest that is peopled by monkeys, wildcats, owls, and a crocodile. In a clearing an old man who is garbed in vaguely medieval attire has drawn what is evidently a magic circle, on which various quasi-Runic characters have been inscribed, and on which an animal's skull has been placed. He points to it with a cleft stick that is in his right hand, as he raises his left, probably in invocation. The book before him, scroll by his side, and scattered Greek and other characters on the ground inside the circle also suggest that he is casting a spell; the light streaming from above strikes the circle, indicating the effects of his magic powers. A young man dressed in toga and cloak points to a young woman who swoons on a tomb that is again covered with quasi-Runic characters; his gesture suggests that the spell may have to do with reviving her.

The fantastic setting, with its evocation of untamed and even threatening nature, magic, religion, death, and love, as well as its suggestions of a vaguely mythical Germanic past, provides almost a compilation of thematic motifs that can be associated with several "pre-Romantic" cultural movements. While the feelings for nature might be compared to those associated with literary *Empfindsamkeit*, the strong emotional and even mysterious aspects of this work seem best comparable to those linked with *Sturm und Drang* of the later 1770s and 1780s. The depiction of hermits or magicians in the landscape was to flourish in the nineteenth century under the impact of Wilhelm Heinrich Wackenroder.[1]

However, it is perhaps unnecessary to search for a particular literary source for this drawing beyond the artist's own imagination.

Similar themes are known from the work of Johann Jacob Hoch from the 1780s. This artist especially seems to have followed the vogue for scenes of hermits or magicians in a wilderness.[2] The fantastic creatures and landscape recur in a drawing of *The Temptation of St. Anthony*, signed and dated in Mainz July 26, 1781.[3] The trees and robed old men are especially close to those found in a signed and dated drawing of 1787, *Robed Worshippers in a Glade Between an Obelisk and Gothic Ruins*.[4] Further, a gouache dated 1789 depicting a magician preparing a magic potion is known from a nineteenth-century exhibition.[5]

Hoch's paintings were praised for their qualities of finish, effects, and picturesque touch, elements that are also in evidence here.[6]

1. For this vogue, see Ost 1971.
2. For Hoch's place in this vogue, see Ost 1971, esp. pp. 99–107; an example of this sort of theme is a painting by Hoch depicting *Hermits in a Rocky Defile*, illustrated as fig. 20. This picture of 1776 is also illustrated in Bremen 1959, no. 273. See also, in general, Landschulz 1977, pp. 22ff.
3. Illustrated in Fach 1985, no. 57.
4. Illustrated in New York 1981, no. 17, and in New York 1983, no. 1.
5. In the *Ausstellungen des Mainzer Kunstvereins* of May 8, 1829, was recorded: "*Eine Gouache, einen Schwarzkünstler darstellend, der in seinem Arbeitsraum gerade einen Saft zubereitet. Auf einer Flaschenkiste die Bezeichnung J. Hoch F. 1789*"; quoted in Landschulz 1977, pp. 26–27.
6. See the quotation of contemporary praise for Hoch's qualities of *fini, effet, and touche pittoresque*, in Landschulz 1977, pp. 26–27.

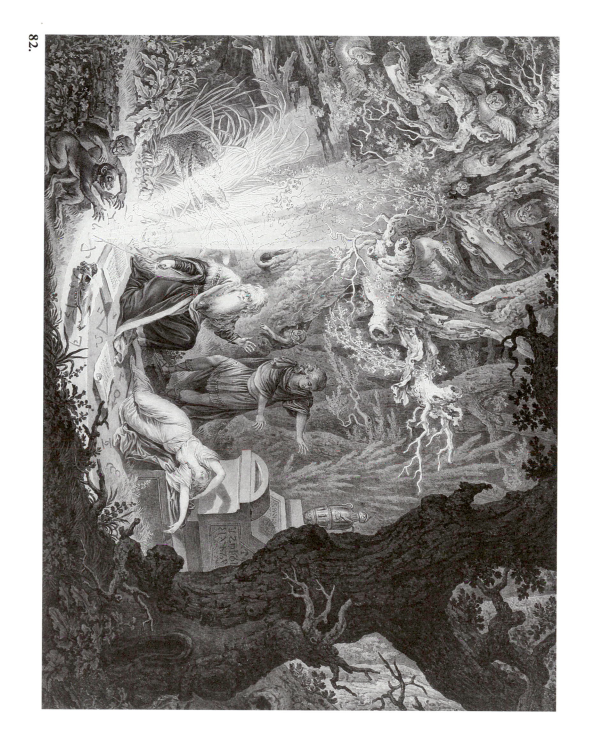

JOHANN CHRISTIAN KLENGEL

(1751–1825)

Klengel was born in Kesseldorf near Dresden in 1751, and already in 1765 became a pupil at the Dresden academy, where he studied with Charles Hutin and Christian Gottlieb Mietzsch. Upon the recommendation of Christian (Ludwig) von Hagedorn, the director of the academy, he began studies with Christian Wilhelm Ernst Dietrich (q.v.), living in his teacher's house until Dietrich's death in 1774. Under Dietrich's influence, Klengel had become a specialist in landscape and animal scenes by the 1770s.

In 1777 Klengel became a member of the Dresden academy, the first alumnus to have been so elected; in 1786 he was also made an honorary member of the Berlin academy. During the years 1790–92, he went on a long-anticipated trip to Italy. After his return, he reached the height of his reputation in the late 1790s, and was made professor for landscape painting at the Dresden academy in 1816. He died in Dresden in 1825.

83. A Family at a Table

Pen and brown ink, brush with brown wash and white heightening, on blue paper
7½ × 6½ (190 × 160)

Crocker Art Museum, 1871.81

PROVENANCE: Edwin Bryant Crocker

EXHIBITION: Sacramento 1939, pt. 2, no. 68; Detroit Institute of Arts, 1949, "German Paintings and Drawings from the Time of Goethe in American Collections," no. 66

LITERATURE: Scheyer 1949, p. 240, no. 66; Sacramento 1971, p. 154

This intimate scene of a family seated at a table very closely resembles a drawing by Klengel of ca. 1785 in the National Gallery in East Berlin.[1] The drawings are almost identical in their compositional elements, technique, and blue paper ground, and differ but slightly in dimensions. There are also only minor differences in detail between the two sheets: the figures in the Sacramento drawing are slightly larger in relation to the room in which they are located, the window has been rounded, its curtain has been drawn with somewhat more flourish, and a crib has been added to the right foreground corner. As the Sacramento drawing is also somewhat more detailed in execution, it is possible it was done slightly after the sheet in Berlin, but both drawings must be quite close in date.

Speaking of the Berlin drawing, Bernhard Dörries has observed that during the 1770s and 1780s Klengel made interior scenes such as this, in which, like Chodowiecki, he used *contrejour* and candlelight effects, with the main figure placed before the light in the center of the composition. Dörries compares this placement of a figure in a social gathering to Caspar David Friedrich's use of the same motif in his landscapes.[2] As Klengel was one of Friedrich's teachers, the point may be well taken. In this bourgeois genre scene,

as in his landscapes, Klengel thereby serves as a transitional figure to the nineteenth century.

1. The East Berlin drawing measures 20.3 × 17.6 cm, and is executed in similar media on blue paper; for it, see Freiberg in Sachsen 1950, p. 25, no. 119; Von Donop n. d., p. 223. The Berlin drawing is illustrated in Dörries 1943, p. 89.
2. Dörries 1943, p. 34.

224

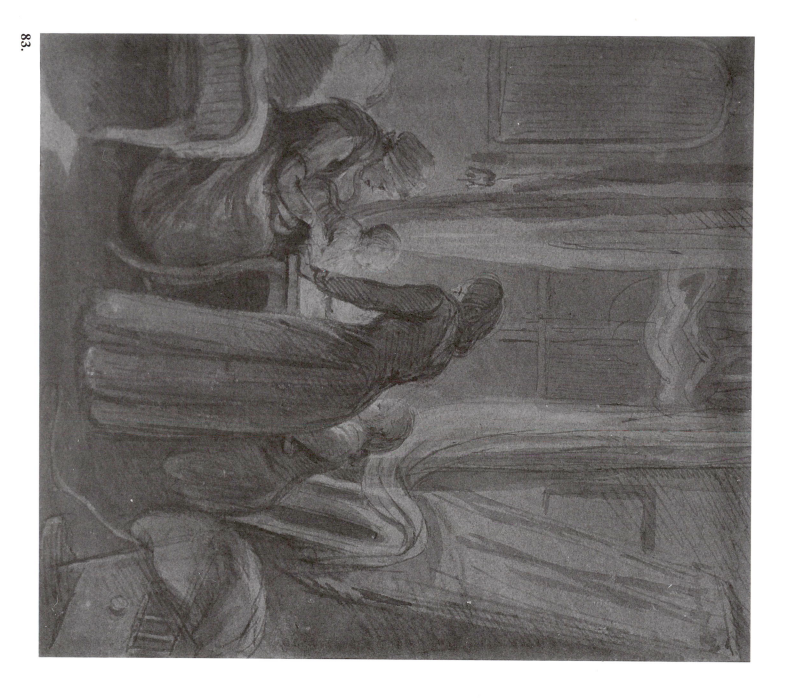

Daniel Nikolaus Chodowiecki

(For biography, see cat. no. 69.)

84. The Improvement of Morals

Pen and red ink over graphite and black ink, red chalk on verso
8 × 13¼ (202 × 336)
Inscribed in black ink over graphite, center, beneath depictions of individual print images: *Weihnacht; Neu Jahr; Ball; Schlitten Fahrt;/Hochzeit; Zwietracht; Eheschliessung; Concert/Komoedie; Diebstahl; Mordbrennen/Pucknick; Krankheit*

Crocker Art Museum, 1871.72

PROVENANCE: Edwin Bryant Crocker

EXHIBITIONS: Sacramento 1939, part 2, no. 58; Detroit Insitute of Arts, 1949, "German Paintings and Drawings from the time of Goethe in American Collections," no. II; Berkeley 1968, p. 32, no. 23, ill. p. 100; Claremont 1976, pp. 14–15, no. 15, ill. p. 96

LITERATURE: Scheyer 1949, p. 234, no. II; Sacramento 1971, p. 34, no. 85, ill. p. 126; Kunzle 1973, I, p. 401

The graphite tracings used for perspective lines underneath the figures and numerous *pentimenti* indicate that this is a preparatory study, and the red chalk on the back that the composition was transferred. The study was, in fact, used for an engraving dated 1787 that was made by Chodowiecki, *Verbesserung der Sitten* (Improvement of Morals).[1] In a letter of March 3, 1787, to Anton Graff, Chodowiecki mentions this engraving in reference to the plans of the printmaker Merino to publish a print each week depicting events of everyday Berlin life.[2]

Chodowiecki's composition piles up satirical comments upon his competitor's scheme, which did not last longer than thirteen weeks, the number of scenes with titles shown on what may be a banner in the center of the drawing. Chodowiecki shows a man in the guise of a mountebank, the traditional title of this drawing: dressed in a fur-trimmed coat, sword at his side, he stands on a stage, pointing at the engravings.[3] His harangue is accompanied by a violinist. This ridicules the trite moralizing, didactic imagery of the engravings, which treated such subjects as "Christmas," a "ball," and a "wedding."[4] This performance seems mainly to attract the interest of two overly emotional women, a few children, and a girl selling pretzels who listens to the speech while a dog steals some of her wares.

The figures in the right background also emphasize the folly of Merino's moralizing effort. A draftsman, who uses the back of another man as a support (no doubt another allusion to Merino), is at work depicting figures who are traditional butts of humor. These images of folly include an ill-matched couple—a spry young gentleman with an old woman at his side—and a woman astride a man. An acrobat and a man on stilts also are seen here.

These figures may be tied in with the figures depicted in the left background, who further satirize Merino and his claim to depict interesting events. A fat draftsman stands

pondering the events before him, real-life follies, as Kunzle has put it, to which the crowd that listens to the mountebank is unattentive. Someone seems to be crying from a window, as a man is seen hanging from a wall, another swallows a dagger as he holds up a drawing, a duel seems to be taking place, and a man falls out of a balloon. Even the frame, with monkeys and a harpy, adds to the satirical tone.

In this drawing Chodowiecki seems not only to be taking a jab at a competitor, but also at the effort to improve behavior by banal and earnest imagery. While he has been compared to Hogarth for his social commentary, in his satire of such efforts at social improvement he may, rather, be seen to be making his own visual critique of some aspects of the Enlightenment.[5]

1. For the engraving, see the listing in Engelmann 1857, p. 302, no. 572, and Engelmann 1859, v, 254; the engraving is reproduced in Claremont 1976, p. 15, fig. 5.

2. Steinbrucker 1921.

3. The fur-trimmed coat seems to be one of the traditional attires of a market salesman or mountebank: see, for instance, a drawing by J. G. Wille in Berlin, illustrated in Berlin 1987, color ill. p. 23. Kunzle regards him as a ballad singer, and adds that a satire on the gruesome folk songs of the period is involved.

4. Kunzle reads the scenes sequentially, as pertaining to a continuous narrative, but this reading does not seem to be consistent with the "current events" part of Merino's plan.

5. For the comparison with Hogarth, see Kunzle 1973, pp. 393ff. For the theme of the critique of the Enlightenment, approached in a different way, see Crow 1986, pp. 9–16.

226

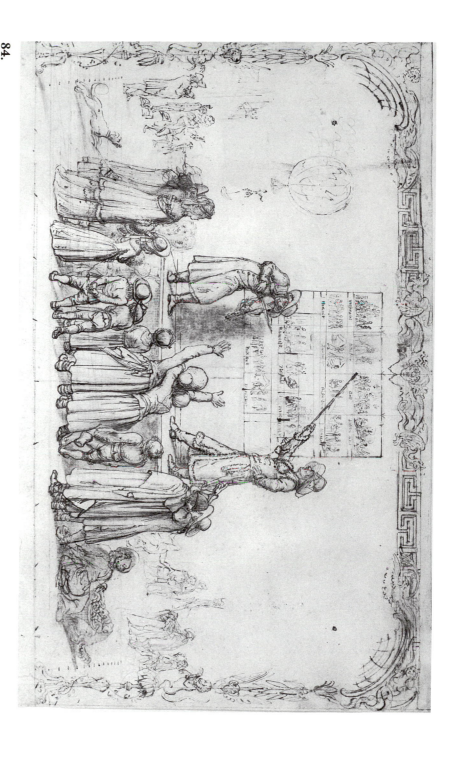

IV.
Landscape
(Including Cityscape and Animal Drawings)

FRANZ JOACHIM BEICH
(1665–1748)

The son of a cartographer, Beich was born in Ravensburg in 1665, and moved to Munich with his family in 1674. By 1702 he had attracted enough attention to receive a major commission from the Bavarian court to paint a series of battles in Hungary in which the Elector Max Emmanuel had participated. He carried out these paintings for the main hall of the palace at Schleissheim, and in 1704, the year in which the work was completed, he was named electoral *Kammerdiener* and court painter.

With Max Emmanuel's defeat and exile in 1704, Beich went to Italy, where he remained until the return of the court in 1715. Beich's circle in Rome included Johann Kupecky (Kupetzky), Franz Werner von Tamm, Gottfried Eichler the Elder, and Christoph Ludwig Agricola, and it was in Italy that he developed his conception of landscape.

Upon his return to Bavaria, Beich painted views of the electoral residences in the galleries of Nymphenburg Palace, from 1718 to 1723, and in 1720ff., scenes of the Turkish wars for Schleissheim. He also worked for other noble and middle-class patrons and was a close friend of Georg Desmarées and Cosmas Damian Asam (*q.v.*). Beich's landscape paintings in particular continued to influence artists into the nineteenth century. He died in Munich in 1748.

85. Landscape

Greasy black chalk ("crayon")
6³⁄₈ × 7³⁄₄ (162 × 197)

Crocker Art Museum, 1871.57

PROVENANCE: Possibly Fürst Carl zu Schwarzenberg (sale Leipzig, Rottes Collegium, November 8, 1826, p. 190, under 3000, nos. 2, 3, or 4; possibly C. Rolas du Rosey (sale, Leipzig, R. Weigel, September 5, 1864); probably R. Weigel, Leipzig; Edwin Bryant Crocker

EXHIBITION: Sacramento 1939, group 2, no. 43

LITERATURE: Sacramento 1971, p. 147

This drawing, which bears an old attribution to Beich, may be associated with twenty-seven sheets by the artist in a similar medium that were sold at the auction of Prince Schwarzenberg in the early nineteenth century. The record of so many black chalk drawings by Beich demonstrates that he did not execute this kind of drawing, although they have not been considered in the art historical literature to date.[1]

Comparable sheets in which the landscape is constructed out of soft black chalk, with hatching applied in soft parallel strokes, and harsh outlines avoided, are to be found in the artist's surviving oeuvre.[2] Compositional and formal motifs, such as the use of a distanced viewpoint and the presence of hanging plants, and other stylistic details, such as the indication of outlines in chalk and of shading by parallels within a rocky prominence, are also characteristic of Beich's work.[3] While no identical compositions by Beich exist, the presentation of mountain themes in his drawings is quite common.[4]

This sort of view, in which a tree and rocks to the left act as a *repoussoir*, opening onto a landscape with a rocky cliff, flowing water, and a town or castle tucked away on a hillside, is also quite familiar in Beich's painting. This genre of wild craggy landscapes reflects the art of Salvator Rosa.[5] Beich was much struck by Rosa's work during his long sojourn in Italy, and continued to create such compositions after his return to Bavaria in 1715.

1. In her relatively cursory account of drawings by Beich, Heidi Bürklin does not discuss any chalk drawings: see Bürklin 1971, pp. 113–16. Although Bürklin did not make any claims to completeness, it should be noted that since her publication many other drawings have been attributed to Beich in major printrooms, e.g. Weimar, Städtische Kunstsammlungen, Schlossmuseum, Kupferstichkabinett, inv. no. KK 323. The subject clearly warrants further study.

2. For instance, in Munich, Staatliche Graphische Sammlung, inv. nos. 14305, 11641.

3. See, for example, a drawing in Braunschweig, Herzog Anton Ulrich-Museum, inv. no. Z 256, 206 × 239 cm.; a note by E. Flechsig indicates that a Dr. Steinacker possesses a signed oil painting by Beich with the same bridge.

4. Compare, for example, Munich, Staatliche Graphische Sammlung, inv. no. 11642.

5. See, for example, the paintings presented in Schleissheim 1976, 2, p. 312, cat. no. 716, pp. 312–13, cat. no. 717, ill. p. 312.

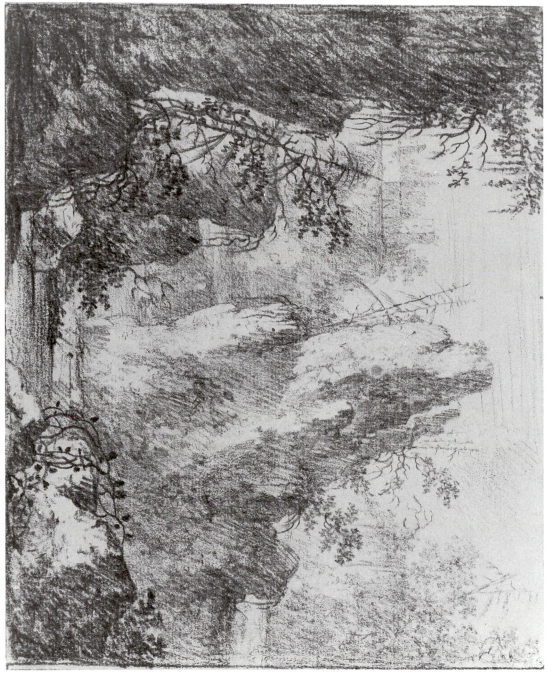

SALOMON KLEINER
(1703–1740)

Salomon Kleiner was born in 1703 in Augsburg, where he received his first instruction from the engraver Johann August Corvinus. By 1721 he was already a specialist at drawing architectural views and *vedute* in Vienna, where he worked for the Augsburg publisher Andreas Pfeffel, who distributed engravings of his scenes of Vienna in 1724 and 1725. In 1722–23 Kleiner made drawings for Imperial Vice-Chancellor Count Friedrich von Schönborn, who subsequently recommended the artist to his uncle Lothar Franz von Schönborn, prince elector of Mainz and prince bishop of Bamberg, who desired to have engravings made of the projects he had built.

After a probable visit to Bamberg, Kleiner went to Mainz in 1724 as electoral court engineer. While in the service of the Schönborn, Kleiner made drawings of various sites in Franconia and the Main region.

In 1727 he returned to Vienna, working there for the rest of his life. He published many views of Viennese buildings, as well as portraits and genre scenes. In his later years, Kleiner became professor at the Theresianum. He died in Vienna in 1740.

the sheet exhibited here, and the other Manning drawings, were intended to serve as designs for a series of views of Viennese churches similar to the group done for Bamberg.

No finished prints are known, however. It is thus also possible that these were intended as finished drawings. In either case, they are important as rare surviving designs by Kleiner, as well as in this instance a record of an important, lost work by Pozzo.

1. See Kerber 1971.
2. See Bösel 1987, nos. 3–4, pp. 40–47.
3. These are found among the unbound engravings in the Graphische Sammlung Albertina, Vienna, inv. no. NF 1451.
4. These views are most easily available, albeit in small reproductions, in Herget 1979.
5. In *Wahrhaffte und genaue Abbildung Aller Kirchen und Clöster, Welche sowohl in der Keyserl: Residenz-Statt Wien als auch in denen innliegenden Vorstätten sich befinden...*, in Herget 1979, fig. 12.

86. The High Altar in the Church "Am Hof," Vienna

Pen and black ink, pink, yellow, and blue washes, with black ink border

16½ × 10⅞ (418 × 202)

Scale inscribed in black ink at bottom: *30 Schuch*

Title inscribed in black ink at bottom of sheet: *Hoch-Altar in der Kirche deren W.W.G.P.P. Jesuiter auf dem Hof in Wienn*. Inscribed in graphite on verso: *21*

Collection of Robert and Bertina Suida Manning

As the inscription indicates, this is a representation in plan and elevation of the (former) high altar of the church "Am Hof," the Jesuit *Professhaus* dedicated to the nine choirs of angels in Vienna. The altar was designed by Andrea Pozzo and erected in 1709, replacing an earlier gothic altar of ca. 1440.[1] Pozzo's altarpiece was part of a redecoration and rededication of the church that began ca. 1657, and included a famed facade design, now attributed to Filiberto Luchese.[2] The earlier gothic altar, into which the altarpiece has been set is visible in the background of the drawing. Pozzo's altar was in turn destroyed and replaced by another project at the end of the eighteenth century.

This drawing is one of four such views of Viennese church interiors in the Manning collection. These are all done in a manner characteristic of the many architectural scenes designed by Kleiner. There exists a similar series of twelve engravings of interiors of churches in Bamberg showing ground plans and elevations engraved after Kleiner.[3]

Kleiner is renowned for his collections of Viennese vistas depicting the many churches, palaces, and gardens of the flourishing imperial residence city.[4] Among the engravings that were executed after his drawings during the years 1724–37 is one of the facade of the church "am Hof."[5] It is possible that

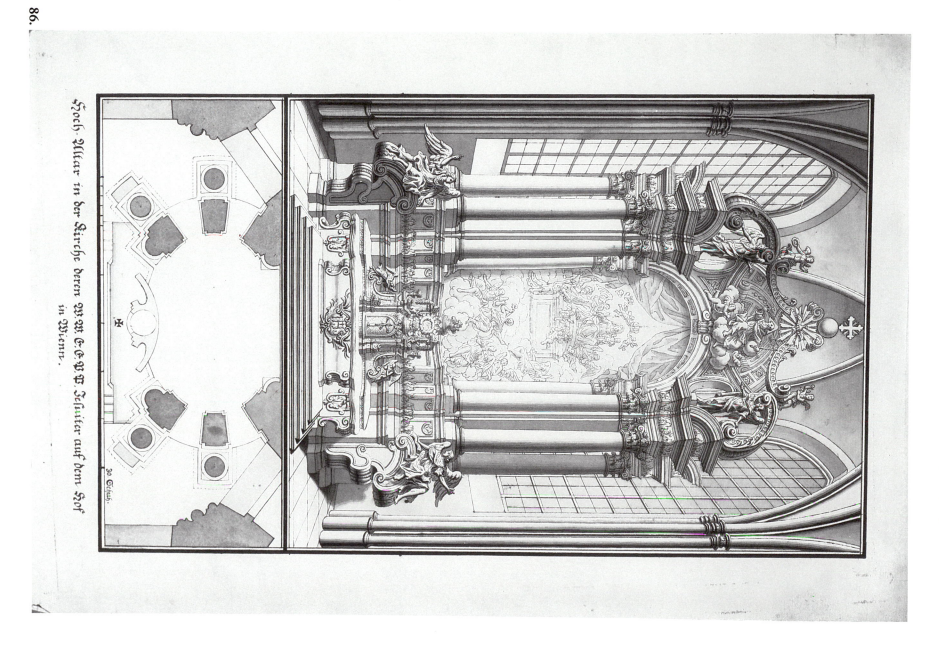

Hoch-Altar in der Kirche deren PP. C.G.P. Jesuiter auf dem Hof in Wienn.

30. Schuh.

Johann Elias Ridinger

(1698–1767)

Johann Elias Ridinger was born in Ulm on February 16, 1698. His father, a scribe, modelled small equestrian and animal figures in his spare time, and may have thereby spurred his son's interest in these subjects. Ridinger was probably apprenticed to the Ulm painter Christoph Resch in 1712, but left the city around 1716, moving to Augsburg, where he studied with the animal and still-life painter Johann Falch. Ridinger was invited by Count Metternich to Regensburg, where he stayed three years. There he could have gained valuable experiences for his future work through observing hunts and the riding school.

Upon his return to Augsburg, he studied with Georg Philipp Rugendas (*q.v.*) in the academy. He married the widow of Johann Seuter in 1723, and founded a publishing house for his prints soon thereafter. In 1759 he became director of the Augsburg city academy. He died in Augsburg on April 10, 1767.

Ridinger's copious graphic production established him as the leading animal artist in Germany. He may also be seen as one of the major draftsmen in Augsburg in the eighteenth century.

87. A Stag

Graphite heightened with white, on paper covered with a gray ground

13³/₁₆ × 10¹¹/₁₆ (333 × 271)

Signed and dated, lower right: *J. E. Ridinger del 1739 m: [mense?] xbris [decembris] in aug [augusta]*

Inscribed at bottom: *Disen Hirsch von ungeraden 24. Enden haben Ihro Hochfürstl. Durchlä [ut] / herr Marckgraff Wilhelm Friderich zu Brendenburg-Onolz-/bach et:c 1719 auf Günzenhäuser Wildfurth Sausenhofer/Letlin in einem Bestaett-Tagen selbst geschossen*

The Pierpont Morgan Library; the E. J. Rousuck Fund, 1973:14

Ridinger was the eighteenth-century German *animalier par excellence*. In over 1200 drawings, mainly for prints, he depicted many representatives of the animal kingdom, as well as animal tales. A specialty was the depiction of the hunt, particularly scenes involving deer. Ridinger was much appreciated in his day, coming to be regarded along with his teacher Rugendas and Nilson (*q.v.*) as one of the leading Augsburg printmakers of the eighteenth century. He has retained admirers to the present.[1]

The Morgan sheet is a fine example of his work and might almost be considered a portrait of a famous stag. The lengthy inscription details the history and significance of the beast.

The sheet was used as a design for a plate in one of Ridinger's series of depictions of animals.[2] Ridinger executed his own engraving after the drawing.[3] Other drawings for the series are also known.[4]

Although Ridinger claims in the title to the series of prints that they were done *nach der Natur*, this is contradicted by the discrepancy of twenty years between the date of the signature and that of the inscription, which tells when

the stag was shot. At most Ridinger may have had knowledge of the preserved head and antlers. It is a testimony to his skill that he has recreated a convincing likeness of the stag in a drawing that also sets it in its habitat.

1. Although in the nineteenth century Ridinger was thoroughly studied and catalogued in Thienemann 1856, he has not received equivalent attention in the twentieth century. An exception is the commemorative exhibition and catalogue, Augsburg 1967, from which some of the information in this entry is gathered.

2. For plate 6 in *Abbildung der jagtbaren Thiere mit derselben angefügten Fährten und Spuhren, Wandel, Gänge, Absprünge, Wendungen, Widergängen, Flugt, und anderen Zeichen mehr mit vielen Fleiss, Zeit und mühe nach der Natur gezeichnet, samt einer Erkläarung.*

3. Several impressions exist, e.g. Vienna, Graphische Sammlung Albertina, Hofbibliothek, LI a (15*) fol. 54, no. 223; also Deutsche Schule III 16, fol. 7.

4. In Munich, Staatliche Graphische Sammlung, inv. no. 267; on the art market, New York, ca. 1985.

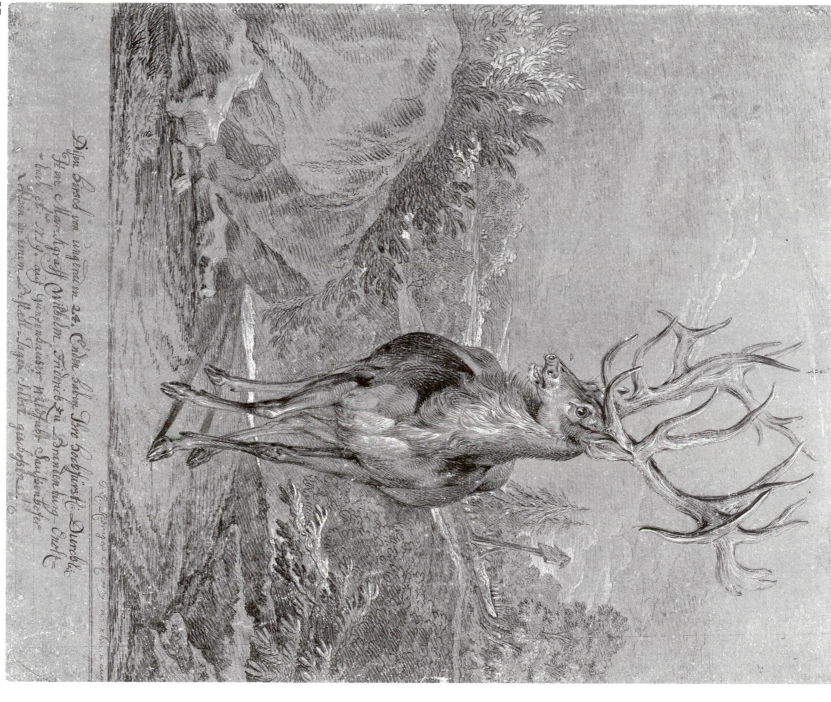

Diser Hirsch ware ungefähre 24. Enden habe Ihr Durchl.
Herr Marckgraff Wilhelm Friderich zu Brandenburg Onol
= bach etc. 1719. auf hiesigen Landes Lustbarkeiten
auf einen Befehl Jagen selbst geschossen.

Johann Elias Ridinger

88. Stags in a Landscape

Pen and brown ink, brown wash
9¾ × 13½ (248 × 337)

The Metropolitan Museum of Art; Harry G. Sperling Fund, 1974.110

PROVENANCE: J. Goll von Franckenstein (note on old mat: *Aus Slg. von Franckenstein 1833 Ns L–16*); purchase, 1974

EXHIBITION: New York 1975, no. 85

LITERATURE: C. G. Boerner 1971

No engraving or drawing of this striking and effective composition of deer is identifiable in the catalogue of works by Ridinger.[1] Nor is any engraving after it found in the extensive collection of his engravings in the Albertina. Yet there is no reason to doubt the authenticity of the drawing.

Very similar drawings by Ridinger exist in which the forms of trees are done in a comparable manner, and the depth of the composition is suggested by the variations in wash and open areas of light.[2] One such signed and dated sheet of 1750 in Copenhagen establishes an approximate date for this design.[3]

Other drawings by Ridinger that were not reproduced in prints are found in the artist's oeuvre.[4] It is possible that the Metropolitan drawing was intended to be made into an engraving that was never executed. In any case, its striking pictorial effects allow it to stand equally well on its own as a finished composition.

1. Thienemann 1856.
2. Compare Vienna, Graphische Sammlung Albertina, inv. no. D. 1128.
3. Statens Museum for Kunst, Kobberstikkabinett, TU 110a, no. 10, signed and dated *JE Ridinger del 1750*.
4. See Heffels 1969, pp. 224–25, no. 251.

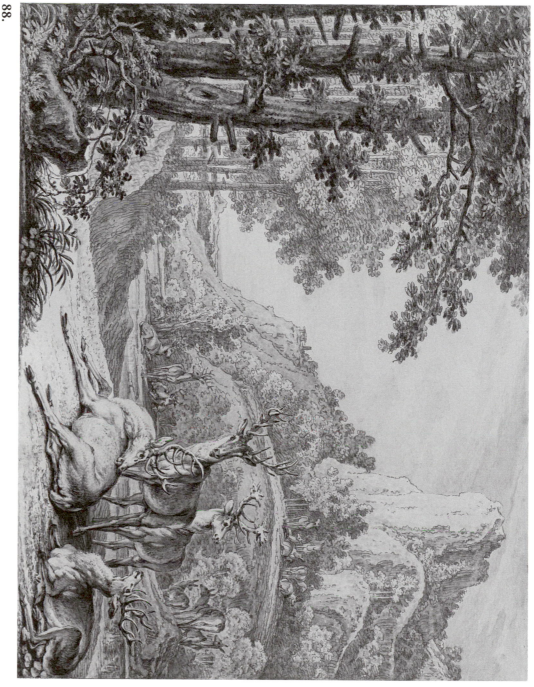

JOHANN ALEXANDER THIELE
(1685–1752)

Johann Alexander Thiele was born in Erfurt in 1685. Originally a soldier, he was interested in drawing, and possibly received his earliest formal instruction as an artist from Christoph Ludwig Agricola, whose landscapes his early works resemble. Sometime around 1716 he settled in Dresden, where he studied painting with Adam von Manyoki (1673–1757) and Franz de Paula Ferg. In 1718 Augustus the Strong employed him at the Dresden court as a *Prospektmaler* (view painter). During the succeeding years he prepared topographic views and landscape etchings.

In 1728 he moved to Arnstadt, where he became court painter and oversaw the art collection of the prince of Schwarzburg-Rudolstadt. At the same time he also worked for the courts of Schwarzburg-Sonderhausen, Braunschweig (Eng., Brunswick), and Kassel.

In 1738 Thiele was called back to Dresden to work for the court of Augustus III. In 1749 he traveled to Schwerin to prepare landscape views of Mecklenburg for the duke there. Thiele died in 1752 in Dresden.

Thiele was the father of the landscape painter and etcher Johann Friedrich Alexander Thiele. Among his students were Christian Wilhelm Ernst Dietrich (*q.v.*).

89. A Marble Crag (Sparsely Wooded Crag) (recto and verso)

Pen and brown ink, brown wash, over black chalk or graphite underdrawing
18 × 13 (458 × 330)
Signed and dated in brown ink on recto, bottom right: *ein weiser Marmorfels/ bey Frauenstein,/ ad viv. del. per JA* [ligatured] *Thiele/ 1746.*; inscribed by the artist in brown ink on verso, bottom right: *Ein ander weiser Mar/ . . felsen bey Frauenst/ . . ad viv del. J.*; inscribed in brown ink on verso, bottom center: *346*

Crocker Art Museum, 1871.603 (#603 inscribed upper left, recto)

PROVENANCE: Muller (inscribed in graphite on recto, upper right: *Geschenck von Hrn. Muller)*; sale, R. Weigel, Leipzig, March 2, 1863, p. 79, cat. no. 1242 (?); probably R. Weigel, Leipzig; Edwin Bryant Crocker

LITERATURE: Sacramento 1971, p. 164

The full inscriptions on both sides of this sheet with indication of location, signature, and date allow it to be situated within the period of Thiele's service for Augustus III, king of Poland and prince-elector of Saxony. In 1738 Augustus III called Thiele to his court in Dresden; although from 1749 Thiele also worked for the court of Mecklenburg-Schwerin, he remained largely in Saxony until his death in 1752. In 1738 it was decreed that Thiele should deliver a painting a year to the Saxon court: he painted mainly "prospects," topographical views of cities and sites in Saxony.[1]

It is most likely that these drawings were made in connection with this activity. The location given on both sides is near Frauenstein, a town in southern Saxony, in the Ore Mountains, which were one of the sources of Saxony's wealth in minerals. Thiele painted ten prospects of the Ore Mountains, chiefly with mining as the focus of interest. Three paintings of the Frauenstein region are known, one of them with the date of 1746.[2]

The presence of drawings on two sides, and the similarity of motif, namely a marble rock, as well as perhaps the number on the verso, suggest that this sheet was taken from a sketchbook. Such a book may well have been assembled while Thiele was at work preparing his views of Saxony. Sheets with a similar kind of execution, and immediate observation of nature, are known elsewhere in Thiele's oeuvre. One example is a view of a forest stream, executed in pen and brown ink and brown and gray wash.[3] The lengthy inscription with signature may however indicate that it was removed to be presented as a gift, or for sale.

Whereas the landscapes that Thiele painted for the court were intended to provide recognizable backgrounds for the presentation of courtly events or Saxon possessions, the naturalistic impetus of these drawings has a further significance.[4] The motifs chosen are without specific reference to Saxon possessions, and instead seem to be chosen because of their natural interest. The drawings are quickly sketched in graphite and then worked up with quickly applied washes: they are executed with a freshness that suggests direct observation of nature. Thiele himself emphasizes this point, when he signs the drawings: *ad. viv., ad vivum*, meaning after or according to life.

While the manner of presentation suggests direct observation from nature, this type of drawing is not without a tradition. Important antecedents are Roelandt Savery's studies of mountainous regions, even of the same Ore Mountains, done while in the service of Rudolf II, who sent the artist out to sketch "rare wonders of nature."[5] For the style of drawing landscape in brush and wash, and even the mountainous motifs, there are also prototypes to be found in the work of Gaspard Dughet.[6]

As a direct record of nature without other, human references, as well as a study of the Saxon environment, this drawing is an important document for Thiele's "realistic" conception of landscape. It was on this basis, as well as from his painted *redute* with topographic indications, that a Saxon school of landscape was to develop in the work of Dietrich and other Thiele pupils, culminating with artists such as Friedrich and Ludwig Richter in the nineteenth century.

1. For these paintings, see Stübel 1914, and esp. p. 30, for mention of the effect of the decree.
2. See Stübel 1914, p. 30, and for the paintings of the Frauenstein region, p. 53, no. 15 (1749); p. 55, no. 39 (1746); and p. 57, no. 67.
3. Vienna, Graphische Sammlung Albertina, inv. no. 23818; see Tietze 1933, 4, no. 1282, ill. vol. 5.
4. For Thiele's role as a landscape draftsman, see the remarks in Stuttgart 1988, p. 132.

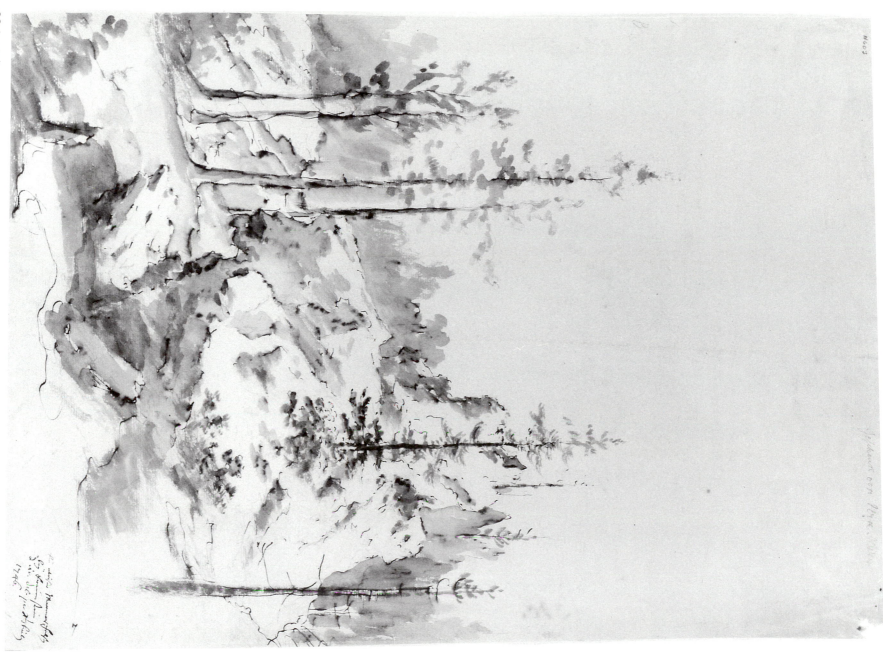

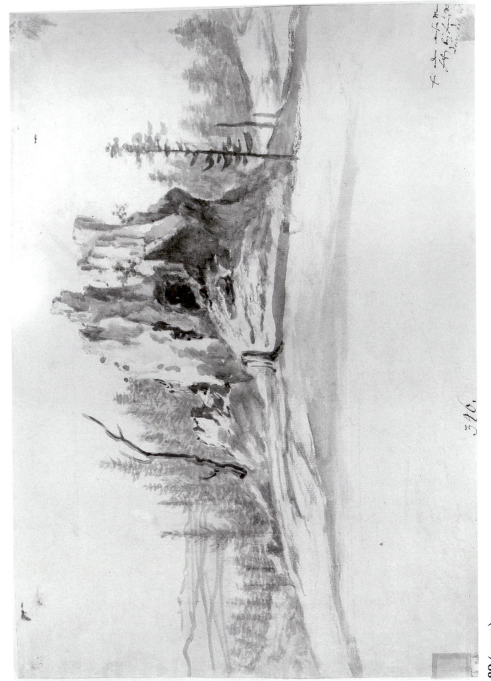

Johann Alexander Thiele

5. For Savery's drawings from nature, see most completely Spicer 1979; book forthcoming.

6. For the technique, see Düsseldorf, Kunstmuseum, inv. no. FP 4713 recto, illustrated in London 1973, no. 46, ill. Dughet's interest in rocky, mountainous motifs is evinced by inv. no. FP 8049, no. 42, illustrated in London 1973, no. 42.

Völker Manuth, in an entry on a drawing by Thiele in Berlin, inv. no. KdZ 9495, in Berlin 1987, p. 137, no. 98, points to connections with Dughet.

Johann Christoph Dietzsch

(1710–1769)

Johann Christoph Dietzsch is the best known and most productive of the seven children of the artist Johann Israel Dietzsch (1681–1754), all of whom became artists. Born in Nuremberg on March 9, 1710, he was trained by his father and worked as a painter, chiefly of watercolors, landscapes, fruit and flower pieces, and kitchen pieces. He also made many drawings and produced several series of landscape etchings. Johann Christian Dietzsch died in Nuremberg on December 11, 1769. His daughter, Susanna Maria Dietzsch, whose death in 1800 brought the family to an end, was a bird painter.

90. Two Men Resting Near a Lake

Black chalk, black ink, with gray washes

9⁹⁄₁₆ × 13¹⁄₁₆ (244 × 333)

Monogrammed, lower right on rock: *J.C.D.*; inscribed (signed?) in brown ink on mount: *J.C. Dietsch*; in blue ink on mount, lower right: *#61*

National Gallery of Art; Julius S. Held Collection, 1984.1.7

PROVENANCE: Unidentified French (?) eighteenth-century collector (inscription in eighteenth-century hand on verso, at top: *Portefeuille #9. Dessein #.7*); Ehrenzweig Estate, 1965; Julius S. Held (collector's stamp on verso)

This drawing is executed in similar media and bears an identical monogram to that found on other sheets by Dietzsch.[1] The overall composition, treatment of details, and various elements of the design are typical of his hand as well.[2] The application of the wash is exceedingly delicate here, with ink being used merely to accentuate the chalk drawing, and the view of the mountain setting quite dramatic.

These figures suggest that this drawing was made as a finished composition. Drawings by the artist that are regarded as compositional studies for small paintings employ a different combination of media and are more loosely handled than is this sheet.[3] If the inscription on the mount, identical in handwriting and orthography to one found on other sheets, was put there by the artist, this would also indicate that the drawing was mounted in his shop and intended for display.[4]

In Dietzsch's oeuvre, motifs are often repeated, suggesting that he drew upon a stock for production of his rather copious oeuvre.[5] Drawings for sale were often presented in pairs, but a mate for this one has not yet been identified nor has a print of the composition been found.

1. E.g., in Brussels, Musée Royale des Beaux-Arts, inv. no. 1031, but these details are found quite commonly in other drawings as well.
2. Comparison can be made for the hatching to a landscape drawing in Vienna, Graphische Sammlung Albertina, inv. no. D 1244, and for the tree and figure forms to a drawing also there, inv. no. D. 1255.
3. Compare, for example, a drawing in the Albertina, inv. no. 3932.
4. A drawing in Darmstadt, Hessisches Landesmuseum, inv. no. AE 1146, bears an identical inscription within the drawing itself.
5. An example of the use of almost identical traveling figures in a landscape can be found in a drawing in the Gurley Collection (the Art Institute, Chicago) and a sheet in Nuremberg, Germanisches Nationalmuseum, inv. no. Hz 7007, illustrated in Nuremberg 1983, p. 33, cat. no. 20.

F. C. Dietsch.

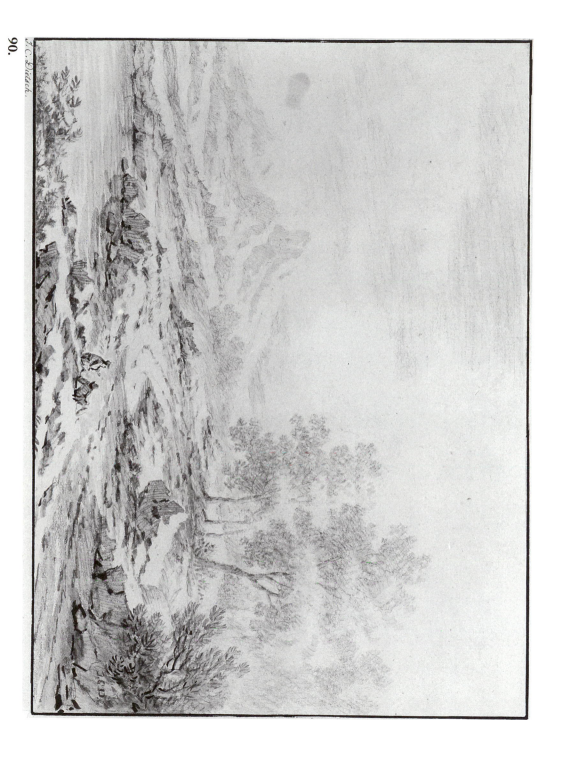

JOSEPH ROOS THE ELDER
(1726–1805)

A member of a dynasty of landscape artists, Joseph Roos was the great grandson of Johann Heinrich Roos, grandson of Philipp P. Roos ("Rosa da Tivoli"), and son of Cajetan Roos. Born in Vienna on October 9, 1726, he studied at the Vienna academy, and then at the academy in Dresden, where he also assisted Bibiena and Servandoni on the decoration of the opera. In 1757 he was recorded as being in Berlin, but by 1758 he was back in Dresden.

In 1760 Roos became royal Polish painter, and in 1764 electoral Saxon court painter; he was also a member of the Dresden academy. The king of Poland and elector of Saxony allowed him to return to Vienna, where he painted the wall paintings in the so-called "Rosa-rooms" in Schönbrunn. In 1772 he journeyed to London and in the same year left Dresden for Vienna, where he was called to become director of the imperial picture gallery. He oversaw the transference of the collections into the Belvedere and also catalogued the collection there in 1796 and 1804.

Roos was named a member of the Accademia di San Luca in Rome in 1773, and of the academies of Parma, Florence, Bologna, and Madrid in 1800. He died in 1805.

91. Landscape

Brush with gray and blue washes over graphite
10³/₁₆ × 8 (259 × 203)
Inscribed in black ink over graphite, upper center: *Das gewölk war grau und ungewiss / Das geburg blau und der Nebel über die bruge war auf blau luft* [?] *grau, No. 54*; signed and dated in black pen over graphite, at bottom: *Joseph Rosa f. 1763 bey Steyr, in Österreich*

University of Michigan Museum of Art, 1970.2.90

PROVENANCE: Private collection, Austria (Austrian Bundesdenkmalamt stamp on old mat); Edward Sonnenschein, Chicago; purchase from his estate

LITERATURE: Taylor 1974, pp. 24–25, no. 67, ill. p. 71

in wash, suggest that this drawing and others like it were also intended as finished designs, unrelated to paintings.

The pastoral subject matter in this and in many of Joseph Roos's other drawings resembles that found in works of the dynasty of animal and landscape painters founded by the artist's great-grandfather, Johann Heinrich Roos.[5] In this particular treatment by the eighteenth-century scion of the family, the effect created by the attention to actual details of the visible is different. Veracity in the treatment of nature becomes paramount.

In this regard, Roos may not simply be dismissed as an epigone of his more important forebears.[6] This landscape also differs from the decorative tendencies with which Roos may be associated, as at Schönbrunn, and points instead to the observed landscape of the later eighteenth and nineteenth century (cf. cat. nos. 93, 94, 95, 102, 103, 105).

1. "The clouds gray and uncertain / the mountains blue and the mist above the bridge was on blue air gray. . . "
2. ". . . *bey Steyr*"; this reading corrects Taylor's "*Rögen*," a nonexistent place. Other elements of her transcription and translation have also been slightly corrected.
3. See Vienna, Graphische Sammlung Albertina, inv. nos. D 2267, 2268.
4. See Vienna, Graphische Sammlung Albertina, inv. nos. D 22624, 30861; Weimar, Städtische Kunstsammlungen, Schlossmuseum, Kupferstichkabinett, inv. no. K 2912.
5. For this point, see also Steinebrei, in Kaiserslautern 1985, p. 70.
6. This is the characterization offered in Baum 1980, 2, p. 580.

In this drawing Roos has replicated the meteorological conditions he has described in his lengthy inscription by means of the gray and blue washes.[1] The graphite underdrawing suggests that the artist has done the drawing on the spot, as Mary Cazort Taylor also noted.

The site on which this drawing was made is however correctly read as near Steyr, a city lying in the midst of mountains in the eastern part of Upper Austria (Austria above the Enns).[2] The bridge seen here may be across one of the local rivers of the region, the Enns or Steyr.

Drawings in similar technique and bearing similar inscriptions are common in Roos's work.[3] Other sheets dated 1764 indicate that at this time the artist may have traveled around Austria making such studies.[4] This represents an important facet of his activity, for during the years 1763–65, the artist was also involved in painting the mural decorations of the so-called "Rosa-Rooms" in Schloss Schönbrunn in Vienna. The complete signature, as well as the final execution

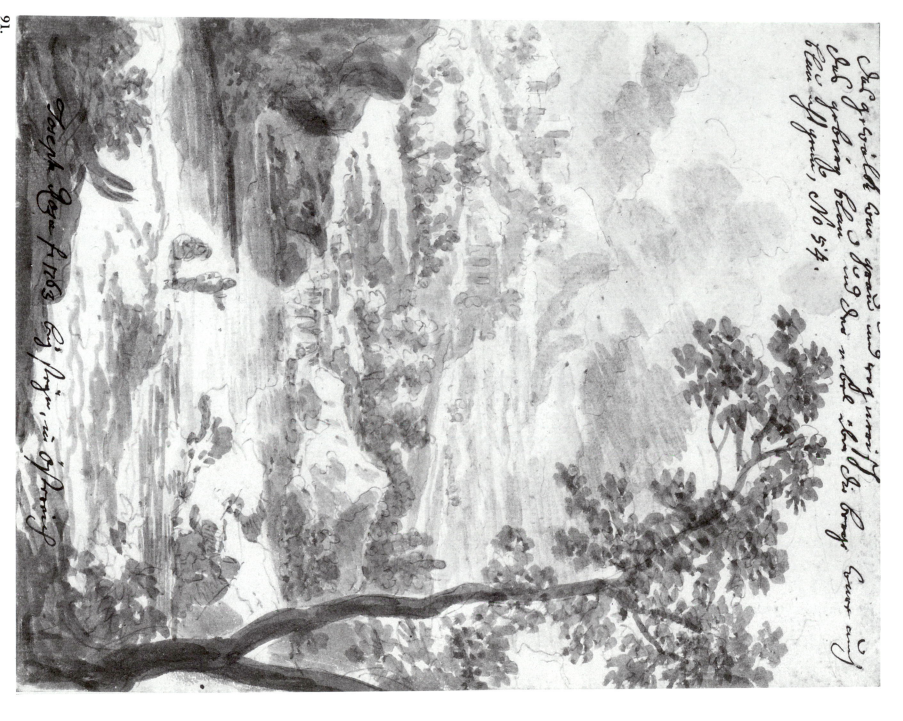

Franz Edmund Weirotter
(1733–1771)

Franz Edmund Weirotter was baptized in Innsbruck on May 29, 1733. After being orphaned at an early age, he studied painting there either with Josef Rumer or Franz Michael Huber, and later with the history painter Josef Schmutzer (see fig. 10 in introduction). From 1751 to 1755 he was a student at the academy in Vienna; according to his own autobiographical comments, he was inspired by Christian Hilfgott Brand's pictures to become a landscape artist. After journeys through Germany as an art dealer, he worked for a year and a half as landscape painter to the electors of Mainz and Trier.

Events in the Seven Years' War caused Weirotter to move to Paris, where he arrived in 1759. There he fell under the influence of Johann Georg Wille (q.v.), whose journal records Weirotter's presence on many trips made to draw in the French countryside. Wille provided an introduction to Winckelmann when Weirotter visited Rome in 1763–64, and also arranged for him to receive an appointment in 1766 as professor of landscape drawing at the *Kupferstecherakademie* that had been founded in Vienna in 1765.

Having previously turned down an offer from the Dresden academy, Weirotter took up his professorship in Vienna in 1767. Weirotter died in Vienna on May 11, 1771, leaving behind a large graphic oeuvre.

92. Boulders

Red chalk
12⁵/16 × 11¹¹/16 (315 × 295)
Watermark: posthorn in shield

Collection of Andrew Robison

The owner of this drawing has attributed it to Weirotter on the basis of comparison to a black and white chalk drawing of a waterfall in the British Museum, which he regarded as very similar.[1] This attribution can be confirmed by further comparison to the many studies of trees in the Vienna Akademie der Bildenden Künste that are executed in the same medium as the Robison drawing, namely red chalk, and display comparable rocks and vegetation.[2]

The procedure of sketching in the countryside and drawing humble elements of nature is one that Weirotter learned from his teacher Johann Georg Wille in Paris. The use of the chalk medium for nature studies also bespeaks the influence of François Boucher, as does perhaps even the use of red chalk, also commonly employed in landscapes by Fragonard.[3] Posthorn in shield watermarks are also found in paper used by Fragonard.[4]

The choice of rocks as a subject for close study may be compared to another theoretical interest of the time. The re-edition in Paris in 1760 and publication of a German translation (Leipzig 1766) of Roger de Piles's *Cours de Peinture par principes* indicates the contemporary interest in his text. And De Piles says of rock formations that "…whatever their form be, they are usually set out with clefts, breaks, hollows,

bushes, moss, and the stains of time; and these particulars, well managed, create a certain idea of truth."[5]

The strong connection with the drawing in London, which is inscribed as having been done in 1769 in the Styrian mountains, as well as with the mass of similar material in Vienna, suggest that this sheet was drawn during Weirotter's period as professor at the newly founded Viennese *Kupferstecherakademie*, from 1767 until his death in 1771. The careful observation and articulation of forms, the isolation of the drawn object without any indication of setting, and even the use of chalk are comparable to the treatment of the nude in the academy at this time (see cat. no. 54). Moreover, pure nature studies are not found in Weirotter's work in Paris, where traces of human presence, as represented by farm buildings or cottages, are usually in evidence.

As the inscription on the London sheet indicates, Weirotter often went into the Austrian countryside to make sketches. He followed the example of his teacher Wille in bringing his students with him, urging them to draw from nature. Because of their assiduity in this endeavor, Weirotter and his students were even once arrested as spies.[6]

Drawings such as this attest to Weirotter's contribution to the development of a naturalistic landscape art, in which a concentration on humble details may be related to academic concerns and even issues of theoretical importance.

1. British Museum, inv. no. o.o. 4 no. 1, black and white chalk, on blue-gray paper, inscribed: *Wasserfall in den Steyermärkischen Gebürgen nach der Natur gezeichnet von Weirotter. 1769.*
2. E.g. Vienna, Akademie der Bildenden Künste, inv. nos. 4769, 9929, 9931, 1571.
3. For Boucher's use of black chalk for a study of a tree, see Jacoby 1986, cat. no. I.D.1, ill. For Fragonard's red chalk landscapes, see, for example, Paris 1987, cat. nos. 24, 25, 27, 29.
4. See Washington 1978, p. 177.
5. De Piles 1708, pp. 218–19. The English translation presented here is that made "by a painter," London 1743, p. 134
6. For this incident and Weirotter's activity as a teacher of landscape, see Pötschner 1978, p. 21.

246

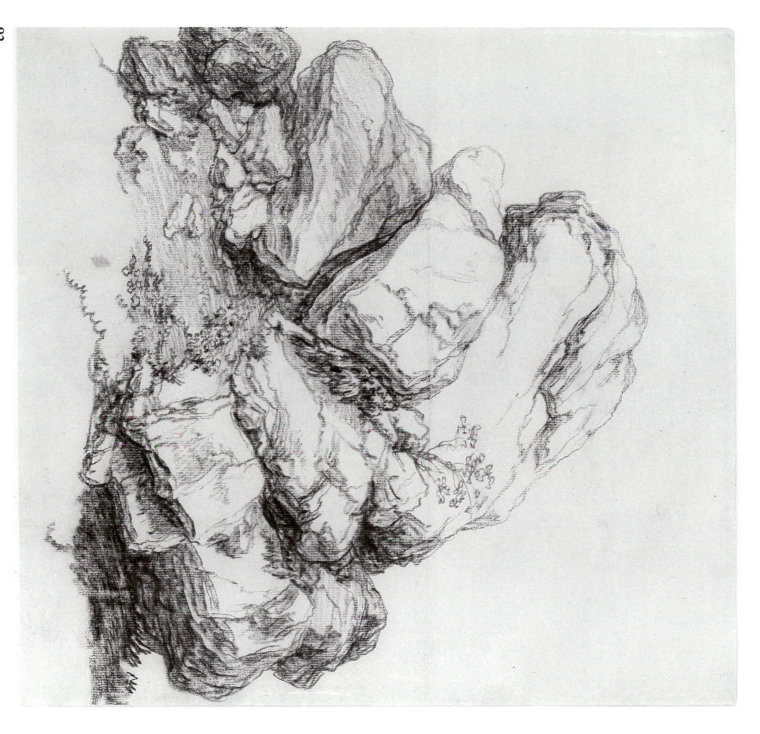

The scion of a long line of painters, Jakob Philipp Hackert was the elder son of a Berlin portraitist from whom he received his name; his younger brother was Johann Gottlieb Hackert (1744–1773). Jakob Philipp Hackert was born in Prenzlau in 1737, and from 1753 trained as an artist in Berlin, first with his uncle, and then in the academy under Blaise Nicholas Lesueur. In 1762 Hackert journeyed to Swedish Pomerania and Rügen, in 1764 to Stockholm, and in 1765 to Paris. After a brief return to Berlin, Hackert moved to Rome, where he remained for eighteen years.

Having received commissions from King Ferdinand IV of Naples starting in 1782, Hackert became his court painter in 1786 and moved to Naples. In 1787 he met Johann Wolfgang von Goethe there and developed a long relationship with him. Goethe helped contribute to the artist's great fame as a landscape painter and draftsman.

Because of the upheavals that occurred in Naples in response to the French Revolution, Hackert had to flee the city. He settled on an estate at San Piero di Careggio near Florence, where he worked until his death in 1806.

93. Sketchbook

Various media on paper, 59 folios, 58 with drawings, bound in green parchment
9½ × 6¾ (240 × 174)
Various sheets inscribed and dated 1765 and 1766

Museum of Fine Arts, Boston; Gift of Joseph H. Clark, 12.374

PROVENANCE: Freiherr C.F.L.F. von Rumohr (inscribed in graphite, inside front cover: *Die Kunstsammlung des Freiherrn C.F.L.F. Von Rumohr beschr von L. G. A. Frenzel 1846 no. 4300. Ein Buch in grünen Pergamentband mit 58 Blatt schönen Landschaft-und Prospektstudien deutscher, französischer und italienischer Landschaften, davon die erste mit 1766 bezeichnet. In verschiedenen Manieren ausgeführt von Jac. Phil. Hackert. 9 Zoll breit 6 Zoll 8 Linien hoch. Höchst interessantes Buch von grossem Werth, einzelne Blätter in Aquarell, andere in Sepia und einige ganz ausgeführt.*); Joseph Clark

LITERATURE: Thieme-Becker 1922, 15, p. 412

This important volume is a long-lost sketchbook, one of two compiled by Hackert on his trip in France in 1766. Both volumes belonged to the collection of the art historian Rumohr, but it seems that the whereabouts of the Boston volume were unknown after the sale of his collection in 1846. Indeed, it has remained unpublished since its existence was recorded, with the remarks "*zur Zeit nicht nachweisbar*" (current whereabouts unknown) in 1922.[1]

Fifty-seven of the folios in the Boston volume contain landscape scenes, or related details such as huts or farmhouses on the verso; the last folio has a graphite sketch of human figures on the verso, the only such representation of human beings in the book. Many of the sheets are inscribed with locations in France, largely around Paris and along the Seine, and dated 1766.[2] According to the inscription on the first sheet of the companion volume, they were made on a journey to Normandy.[3]

The drawings display a variety of techniques. These include: graphite exclusively (folio 18); graphite with gray wash (folio 15); graphite with ink and wash and red chalk (folio 9); washes (folios 13 and 14); red chalk exclusively (folios 27 and 28); graphite and watercolor (folio 33); and pure watercolor (folio 35).

Although many of the drawings give the appearance of having been made on the spot, no conclusions can be inferred about Hackert's working process. Many of them are quite finished in appearance. Although Hackert's trip has been described as a *Studienreise*, this description does not account for the quality of many of the drawings, which often contrast in appearance with the more sketchy character of studies by the artist that were indeed probably merely preliminary studies for other drawings (or paintings); e.g. in the Fogg Museum of Art). Moreover, since the book contains designs in techniques not typical of sketches, it is probably not correct to refer to it simply as a "sketchbook."

The drawings in the Boston volume also display a wide variety of styles. Some of them, studies of huts, recall the drawings of Abraham Bloemaert or other seventeenth-century Dutch draftsmen. Others, studies of a hut (folio 27) or wall (folio 28), executed in red chalk, suggest the impact of drawings by French artists such as Boucher that Hackert may have seen in Paris. They thus indicate that Hackert was experimenting not only with techniques but with landscape styles. The Boston volume is an exceedingly important compendium of drawings from the early part of his career, and it is worthy of further study.

1. The other volume is in the collection of the Goethe-Nationalmuseum, Weimar. This information relies on the account in Thieme-Becker.
2. Folio 1 is inscribed: *près de la Seine 1766*; folio 2: *Vue de la Seine 1766*; folio 3: *au Vaugirard 1766*; folio 4: *à Ville Parisij 1766*; folio 7: *à Vaugirard 1766*; folio 8: *à Vaugirard*; folio 17: *Vue de la Seine à St. Ouen*; folio 18: *à St. Ouen 1766*; folio 19: *rue de la Seine 1766 à Paris*; folio 24: *à Massy 1766 le 16eme* [?]; folio 25: *à Massy 1766*.
3. "*Voyage de Normandie. An 1766.*" its inscription.

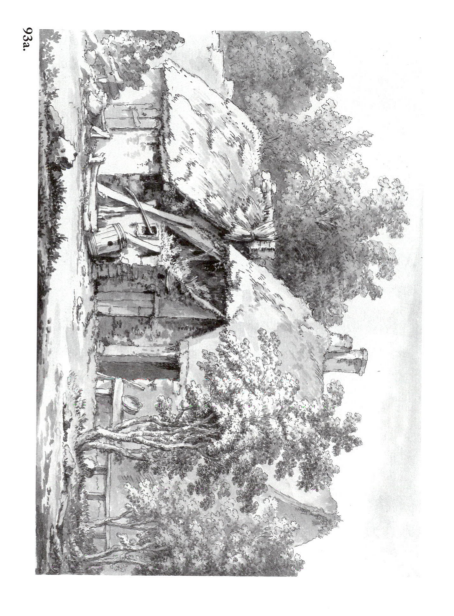

93a.

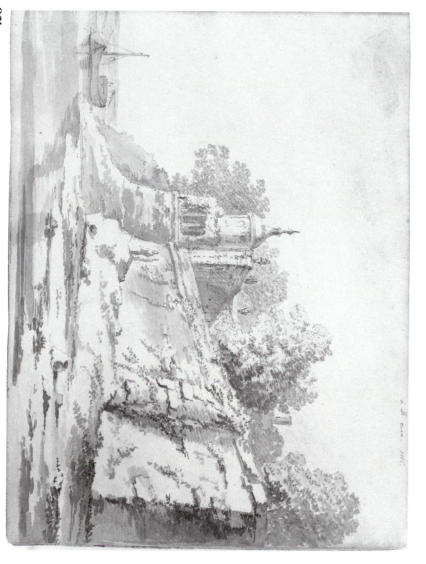

93b.

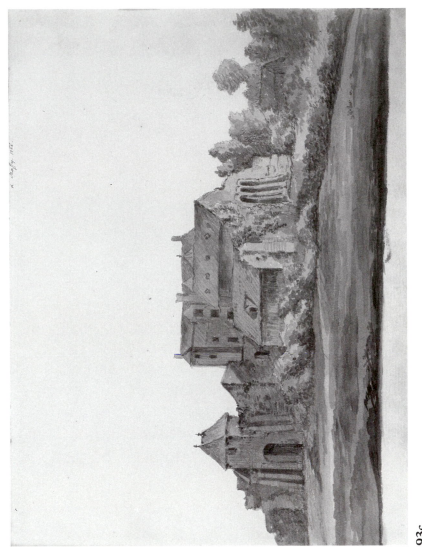

93c.

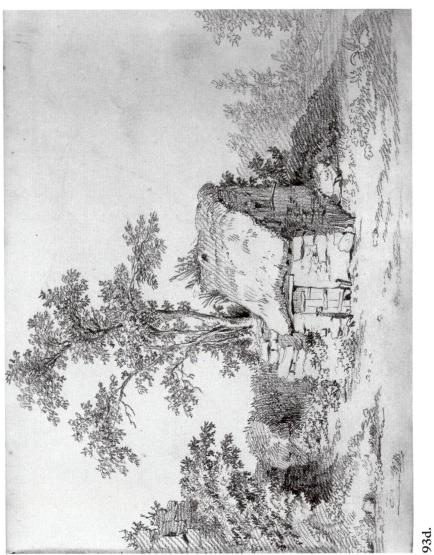

93d.

Jakob Philipp Hackert

94. A Large Tree at Albano

Pen and brown ink, brown wash
$25^3/8 \times 22^7/16$ (644 × 507)
Inscribed (signed?): *A Albano Ph Hackert*

The Metropolitan Museum of Art; Purchase, Mr. and Mrs. David
T. Schiff Gift, 1977.418

PROVENANCE: Blumka, New York; purchase, 1977

LITERATURE: Goldfarb 1982, p. 285, ill. p. 284, fig. 1

This large detailed work typifies the tree studies that Hackert drew throughout his career from the 1760s on.[1] A tree with massive trunk and full foliage dominates a rise in the foreground, beyond which there extends to the horizon a landscape with recognizably Italian features, such as the tower in the middle ground. This compositional format is also found in Hackert's painting.[2]

The depiction of a motif taken from nature, in which the effort seems to reproduce an actual site rather than an ideal landscape, exemplifies Hackert's means of drawing landscape *nach der Natur*. This approach to what in painting was called *Aussichtsmalerei* or *Prospectmalerei* is found in both his finished pictures and his wash drawings. It is especially prevalent in his views around Naples and in the Campania, where this view, identified as having been done near Albano, was made. This study can be compared stylistically to sheets from the 1780s, including the artist's other drawings in this exhibition (cat. nos. 93, 95).[3]

Hillard Goldfarb has related this drawing to the proscriptions of the theorist Johann Georg Sulzer (see cat. no. 68), according to which the artist must depict the beauties of nature by finding the dominant unifying element in his subject, here the tree. Goldfarb adduces this work as an example of Hackert's own confirmation of Sulzer's thesis in his drawing, as well as in his writing, of the emphasis on working outdoors and studying nature in detail. Accordingly a single tree such as that represented in this drawing could be the subject of studies made over a long period of time.

It was this type of design that appealed to critics in Germany, foremost among them Goethe, who brought the artist renown.

1. For an early example of the type, see a study dated 1769 in the Graphische Sammlung Albertina, Vienna, inv. no. D 1921.
2. For a closely comparable picture, note the work illustrated in Krönig 1964, p. 15, fig. 8.
3. For the points made in this paragraph, see Krönig 1971, p. 175; for other comparable drawings of the 1780s, see p. 184, fig. 133, and p. 189, fig. 137.

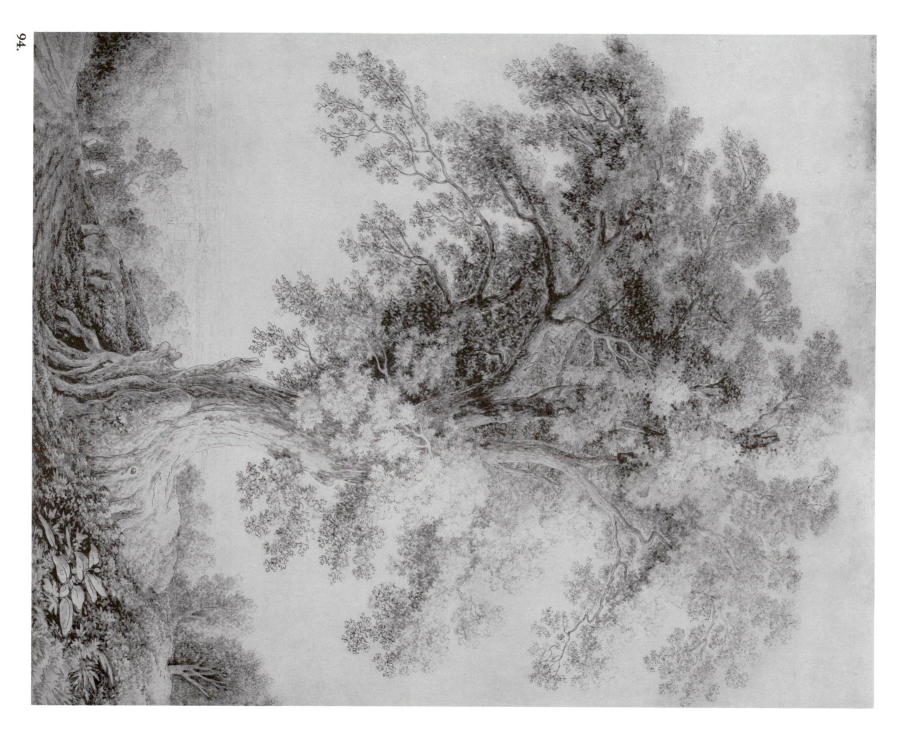

95. View of Castel Gandolfo

Pen and brown ink, brown wash, over black chalk
20⅞ × 29½, sight (530 × 750)
Inscribed, upper left, recto: *a Castel Gandolfo Duome* [?] *il Prato vers Marine 1782. Se joint à No. 1. No. 2.*

The Metropolitan Museum of Art; Rogers Fund, 64.194

PROVENANCE: Jean-Baptiste-Florentin Gabriel de Meryan, Marquis de Lagoy, Aix-en-Provence (Lugt 1710, lower right corner, recto)

LITERATURE: Goldfarb 1982, pp. 285–86, ill. p. 284, fig. 2

Castel Gandolfo, a town situated between Marino and Albano on the traditional route from Rome to Naples, can be seen here in the middle distance. The inscription indicates that the view is over a meadow, looking toward Marino. Visible in the drawing are, from the right, or the north of the town, the Piazza del Plebiscito, the papal summer palace built for Urban VIII in 1629 by Carlo Maderno, the Villa Cibo, and the centralized church of San Tommaso da Villanova built by Bernini in 1661. At the south end of the town, to the left, lies the Villa Barberini.[1]

As exemplified by this drawing and the other sheet exhibited here, which was drawn nearby at Albano (cat. no. 94), Hackert assimilated certain aspects of the idealized vision of the same geographical region that had been transfigured in the work of such seventeenth-century artists as Claude Lorrain and Nicolas Poussin, while concentrating on rendering the elements of nature and topography in precise detail. Hillard Goldfarb notes that the drawing also corresponds to the working method proposed by Hackert in his theoretical remarks on landscape, according to which an artist should work on a large scale, and choose an ideal depth of forty to sixty miles for a broad vista; the drawing thus typifies Hackert's contribution to the tradition of the *veduta*.

The result is a characteristic *Erinnerungsblatt*, or *ricordo*, of the sort that would have been popular with travelers to Italy.[2] The inscription may indicate that this was partly the intention of this drawing, while the numbering may suggest that it was part of a series.

1. Because of these features, the title of the drawing in the files of the Metropolitan Museum of Art, *View of Marino in the Alban Hills*, should be corrected.
2. For Hackert's "sepia" drawings as *Erinnerungsblätter*, see Krönig 1971, p. 175.

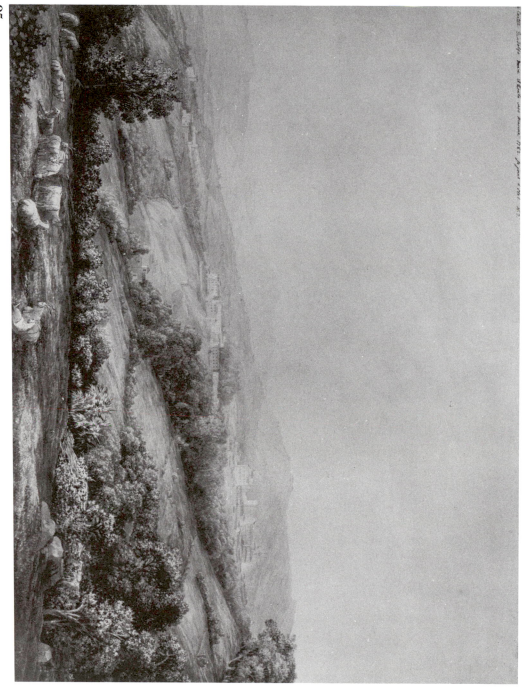

Salomon Gessner
(1730–1788)

Salomon Gessner was born in Zurich in 1730, the son of a respected bookseller whose printing and publishing business he entered at the end of his formal education in 1748. In 1749 he was apprenticed to a bookseller in Berlin, but decided to devote himself to landscape painting and drawing; during this period he also wrote his first poems.

Returning to Zurich in 1750, Gessner took over his father's business but devoted himself to poetry. Early in the 1750s Gessner also began executing independent etchings and engraved illustrations for books. In 1756 he published the first collection of his idylls.

His artistic output increased from the 1760s, when he not only produced prints, but also supplied designs for the porcelain factory established in 1763 outside Zurich. His earliest works in watercolor and gouache date from the 1770s, and he turned increasingly to these media in the 1780s. Temples, grottoes, and waterfalls became the central motifs of his work at this time. Gessner died in Zurich in 1788.

Gessner is not only known for his landscapes, which are often of an idyllic character, but also for his poetry and his letters on art theory.

the period when this drawing was executed, however, Gessner was turning increasingly to the use of gouache and watercolor for works in this genre. Here he still uses the media familiar from his earlier essays in this particular idyllic mode.

1. See Bircher 1982, p. 40.
2. See Bircher 1982, pp. 37–38.

96. The Ford

Graphite and wash
10½ × 16½ (267 × 417)
Signed and dated in pen, lower left: *S. Gessner/1777*

Crocker Art Museum, 1871.76

EXHIBITIONS: Sacramento 1939, part 2, no. 63; Detroit Institute of Arts, "German Paintings and Drawings from the Time of Goethe in American Collections," no. 24; Lawrence, Kansas 1956, p. 10, cat. no. 15

LITERATURE: Scheyer 1949, p. 236, no. 24

This sheet displays many typical elements found in Gessner's drawings. Under a prominent leafy tree, a pair of shepherds rest with their flocks by a stream from which a goat drinks. The stream issues from a waterfall in the middle ground to the right. At right is found a rock formation covered with moss. At left travelers are coming and going in the direction of some huts that stand on a hillock.

These elements are combined to suggest the characteristic idyll created by Gessner in his poetry and painting alike, in which Gessner evokes what has been described as a landscape inspired by Pan.[1] This sheet also employs Gessner's favored pictorial format, enabling him to prepare a work of reasonable size that could also be easily transported and used to decorate a smallish room. The preparation of this sort of idealized pictorial world was aimed at an audience similar to that which bought his poems.[2]

An analysis of the style of the wash drawing demonstrates Gessner's characteristic combination of Claudean sources with traces of Anthonie Waterloo and other seventeenth- and eighteenth-century draftsmen to create his vision. During

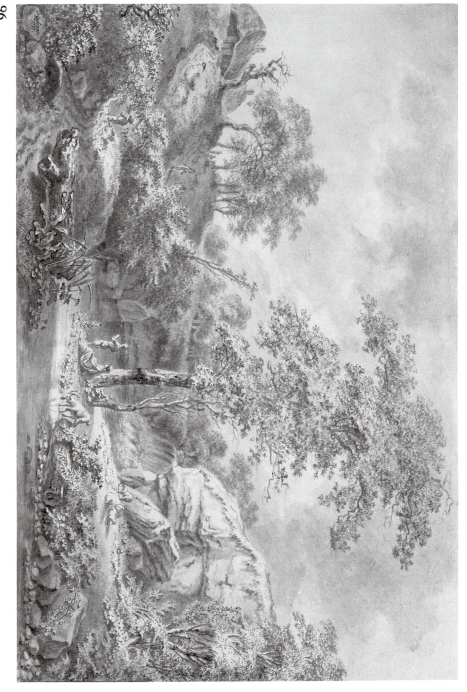

Landscape (Including Cityscape and Animal Drawings)

Johann Christian Klengel

(For biography, see cat. no. 83.)

97. Daphnis and Chloe (after Gessner's Idyll)

Pen and brown and black ink, brown wash, on cream paper
18⅝ × 26½ (472 × 672)
Watermark: Shield surmounted by a crown with a fleur-de-lys, and a name beneath

Signed (?) in brown inks, lower right: *Klengel inv.*
Inscribed in red ink on verso: *No. 486 N. H.*; in graphite: *Klengel del.*; *Daphnis und Chloe aus Gessners Idillen*

Harvard University Art Museums, Fogg Art Museum; Gift of Belinda Lull Randall from the John Witt Randall Collection, 1898.576

PROVENANCE: Lindner Collection, Leipzig (inscription by John Randall on verso: *This fine original drawing is by Professor Klengel, prof. design, Dresden, and comes from the Lindner collection at Leipsic.* 253); John Witt Randall; Belinda Lull Randall

An inscription on the verso of this drawing correctly identifies the subject as a depiction of Daphnis and Chloe from Salomon Gessner's idyll, first published in his *Neue Idyllen* of 1772. In Gessner's idyll two shepherds, the brother and sister Daphnis and Chloe, go to pray for their father's health at a herm (called by Gessner a *Säule*, or column) of Pan, situated beneath spruce trees on a hill. Chloe has woven garlands for Pan and draped them around his statue, and she brings along her basket of fruit and a dove. The drawing depicts the climactic moment when Chloe offers to sacrifice her dove to Pan: a voice is heard saying that the gods hear the prayers of the innocent, and that their father is healthy,

In drawing style, as well as in mood and subject, this drawing depends on Gessner. The dainty figures placed amidst looming trees and other natural forms, the careful execution, and the somewhat repetitious handling of foliage, are all comparable to Gessner (see cat. no. 96).

Although Klengel made Arcadian landscapes later in his career, the impact of Gessner is particularly evident in his art during the later 1770s and early 1780s.[1] Other elements, such as the drawing's meticulous execution and recollections of Netherlandish landscapes, also point to a date of ca. 1780, and the Harvard drawing seems comparable in other aspects with other Klengel designs from this period.[2]

The very large format of this drawing is found elsewhere in Klengel's oeuvre, in drawings with similar subject matter.[3] These drawings were all probably made as finished compositions for collectors, who would have responded to a subject taken from the best-known work of German literature of the time.

1. For a landscape dated ca. 1780, which evinces the impact of Gessner, see Nuremberg, Germanisches Nationalmuseum, inv. no. Hz 840, discussed and illustrated in Heffels 1969, p. 167, no. 183.
A later Arcadian landscape is in Weimar, Städtische Kunstsammlungen, inv. no. K 1218, 615 × 474 mm. See Freiberg in Sachsen 1910, p. 29, no. 155. illustrated in Hamann 1925, p. 78.

2. See, for example, a drawing in the Staatsgalerie Stuttgart, inv. no. 6019, illustrated and discussed most recently in Stuttgart 1985, pp. 50–51, no. 20, ill.

3. Besides the drawings in Weimar and Stuttgart mentioned in the previous note, there is a similar sheet in Düsseldorf, Kunstmuseum, measuring 472 × 620 mm, depicting an Italian landscape, and therefore from the 1790s.

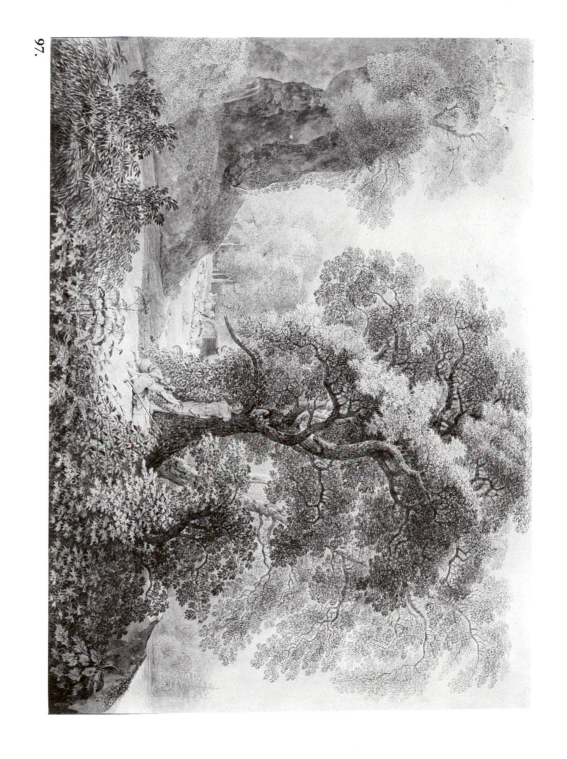

Franz Innocenz Kobell was born in Mannheim on November 23, 1749, and trained as an accountant in Mainz. He tired of this profession and returned to Mannheim, where he was supported by his older brother, the landscape artist Ferdinand Kobell (1740–1799). In 1771 Kobell attended the *Zeichnungsakademie* in Mannheim from 1771 to 1778. At this time he also befriended Friedrich Müller (*q.v.*). In 1778 he obtained a fellowship from the prince elector Carl Theodor to travel to Italy. He resided chiefly in Rome from 1779 to 1784, studying the works of seventeenth-century masters of landscape, to which genre he also devoted himself.

In 1780 Franz Innocenz Kobell was named court painter by Carl Theodor, who had moved his court to Munich. After returning to Germany he settled in Munich in 1793, where he lived together with his brother Ferdinand and his nephew Wilhelm, an important artist in his own right. Kobell was a prolific draftsman whose graphic oeuvre encompasses more than 10,000 sheets. He died in Munich on January 14, 1822.

98. A Romantic Landscape

Pen and brown ink, brown and gray wash
14 1/8 × 20 3/4 (359 × 528)
Watermark: D & C Blauw (cf. Guiffrey 1907, no. 55)
Inscribed on the mount: *Franz Kobell del* (and by Randall: *On the Mediterranean Coast Jos. Vernet has painted—a similar scene and often engraved.*)

Harvard University Art Museums, Fogg Art Museum; Gift of Belinda Lull Randall from the John Witt Randall Collection, 1898.107

PROVENANCE: John Witt Randall; Belinda Lull Randall

EXHIBITIONS: Cambridge, Mass., Germanic Museum, 1935; Detroit Institute of Arts, 1949, "German and Austrian Paintings and Drawings from the Time of Goethe," no. 80; Cleveland 1964, no. 71

LITERATURE: Mongan 1940, 1, pp. 214–15, no. 420, ill. vol. 3, fig, 211; Scheyer 1949, p. 241, no. 80

This drawing evinces many of the qualities that Siegfried Wichmann has found most characteristic of the work of Franz Innocenz Kobell. It employs as its central motif a geological structure, namely a grotto that also serves as a stage drop, with a steep stone wall to one side functioning as a coulisse. These are combined with suggestions of ruins and antique reminiscences such as a sphinx and an urn.[1] All open up to a Mediterranean vista, which the former owner, Randall, thought similar to Vernet, but may also be compared to works by one of Kobell's sources of inspiration, namely Claude Lorrain. This observation pertains also to the idyllic dalliance of the couple seen in the right corner of the drawing.

The manner in which the antique elements are stressed throughout this work recalls the way in which some of Goethe's comments on the use of ruins as elements for theater decoration are also applicable to Kobell's landscape drawings. They almost seem like theatrical props; this is an effect that the grotto reinforces.[2]

The variability of Kobell's style makes it difficult to date his drawings precisely. Nevertheless, the increased attention to detail and meticulous execution seem most comparable to qualities notable in his drawings after 1788.[3] The refinement of technique, together with the composition and the use of classical figures in the foreground, correspond to his stylistic phase of the early 1790s, which may coincide with his taking up residence with the artists Ferdinand and Wilhelm Kobell in Munich.[4]

1. See Wichmann 1974, p. 2: "Im Zentrum der Darstellung steht die geologische Struktur. Daher bevorzugt er die Felskulisse mit Schluchten, Grotten, Steilufern, klammartige Einschnitte in Bergformationen, Felsplateaus . . . in Verbindung mit Ruinen und antikisierenden Bauten."
2. See Goethe's remarks quoted in Wichmann 1974, p. 6, n. 15, on Kobell's drawings: ". . . wo Ruinen und Trümmer aller Art ausgesäet oder wenn man will zusammengestellt sind, möchten geschmackreichen Künstlern zum Stoff und zugleich zum Anlass dienen die hier geforderten Dekorationen für ihre Theater glücklich auszubilden."
3. Compare Wichmann 1974, cat. nos. 3, 8.
4. Compare in this regard elements seen in a drawing in Stuttgart, inv. no. 890, illustrated in Stuttgart 1985, pp. 72–73, no. 31, ill.

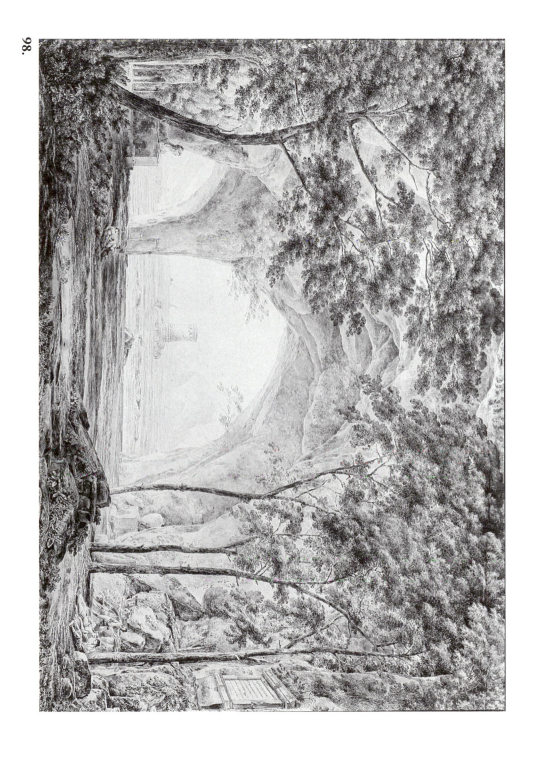

CHRISTOPH NATHE

(1753–1806)

Christoph Nathe was born in 1753 in Nieder-Bielau in the district of Görlitz, Lusatia. He perhaps received his earliest instruction as an artist from the mathematician Schulz in the Görlitz Gymnasium, as Nathe is reputed to have been an "intellectual" artist. In 1774 Nathe traveled to Leipzig to study with Adam Friedrich Oeser (q.v.), with whom he also learned engraving. Sometime in the late 1770s he returned to Upper Lusatia to work, resuming contact with the Oeser's circle, which was to include J. C. Reinhart (q.v.); early in the next decade, he made the first of several trips into the Riesengebirge. After a sojourn in Switzerland in 1783–84, he was back in Leipzig.

From 1787 to 1798 Nathe was active in Görlitz as city drawing master. He left this position in 1799, and moved to Lauban in 1803. Nathe died in 1806 on a visit to Schädewald near Macklissa in the district of Lauban.

99. View above a River

Brush and brown ink wash over underdrawing in graphite
14⅞ × 20⅛ (378 × 512) (376 × 511 according to J. Ruda)
Signed and dated in brown ink on rock, upper right: *Nathe 1786*

Crocker Art Museum, 1871.85

PROVENANCE: Sale, Rudolf Weigel, November 23, 1863, p. 34, cat. no. 707 (?); Edwin Bryant Crocker

EXHIBITION: Sacramento 1939, part 2, no. 71

LITERATURE: Scheyer 1949, p. 243, no. 95; Scheyer 1965, pp. 236, 267, n. 3, 268, n. 36; Sacramento 1971, p. 158

Ernst Scheyer states that this signed and dated sheet of 1786 exemplifies the fixed compositional schema that Nathe developed during the 1780s for drawings that were intended for quick sale. The foregrounds of such drawings typically display a coulisse, formed out of different kinds of rocks and trees and extending diagonally upward to the top of the sheet; the dark tonality of this compositional element contrasts with the other half of the sheet, which opens up to a view on to a river, boats, houses, and mountains. In the foreground, before the coulisse, there often rests a figure like the shepherd or wanderer seen here.[1]

In these drawings Nathe also employs a manner of executing foliage in repeated brushstrokes of wash. This style was probably learned from Nathe's teacher Oeser.[2] It resembles a similar handling of foliage found in the oeuvre of other contemporary draftsmen, such as Franz and Ferdinand Kobell and Johann Klengel (see cat. nos. 97, 98).

Scheyer corrects the identification of the locale from its previous title *Above the Rhine*, indicating that it depicts the area around Görlitz in Lusatia, in the region of the rivers Neisse, Pleisse, or Elbe. Certainly much of the landscape in the area of Lusatia, now in the southeastern corner of the German Democratic Republic, and in neighboring Silesia, now in southwestern Poland, still resembles that shown in

this drawing. As Scheyer notes, however, this drawing may also represent a fantastic landscape, rather than an exact topographic view.

In any instance, this sort of evocation of the surroundings of Görlitz is characteristic of the products made by Nathe to supplement his income as city drawing master. While it is somewhat more conventional than the other sheets by the artist in this exhibition, representing what Scheyer calls an average example of the artist's work, it nevertheless serves as an important example of the artist's work. The qualities seen in this work were developed in later drawings by Nathe and received much attention from later artists, thereby having an impact on the representation of nineteenth-century landscapes.

1. See Scheyer 1965, p. 255, for this description.
2. Scheyer 1965, p. 246. Scheyer gives as an example of Oeser's qualities as a landscape draftsman another drawing in Sacramento, inv. no. 1871.68, best illustrated in Sacramento 1971, fig. 96. While this sheet is currently attributed to Oeser's son, Johann Friedrich Ludwig (1751–1792), the point can also be made by reference to undisputed landscapes, e.g. a Swiss landscape in Leipzig, Museum der Bildenden Künste; illustrated in Stendal 1976, p. 70, cat. no. 138, ill. pl. 21.

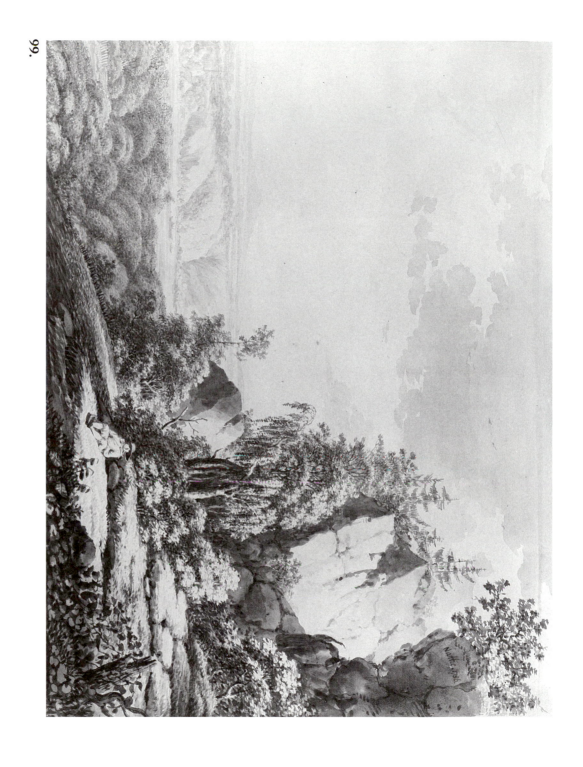

100. Village Overlooking a River

Brush with brown and gray-brown ink wash, over graphite underdrawing

13½ × 21 (334 × 529)

Crocker Art Museum, 1871.84

PROVENANCE: Sale, R. Weigel, Leipzig, November 23, 1863, p. 34, no. 707 (?); Edwin Bryant Crocker

EXHIBITIONS: Sacramento 1939, part 2, no. 71; Detroit Institute of Arts, 1949, "German Paintings and Drawings from the Time of Goethe in American Collections," no. 96; Sacramento, Crocker Art Museum, 1987, "Life or Art"

LITERATURE: Scheyer 1949, p. 243, no. 96; Scheyer 1965, p. 256, ill. p. 253, fig. 85, p. 267, n. 3; Sacramento 1971, p. 158

This large, beautiful sheet presents in the background a view of a village that can again be localized in Lusatia. Scheyer notes that the half-timbered houses with steep roofs are of the Lusatian or lower Silesian type that add to the charm of Nathe's later village landscapes. In fact, landscapes such as this, with cottages strewn along a hillside by a quiet stream, can still be seen in southern Lusatia, relatively near the border of the German Democratic Republic with Czechoslovakia, for example in the neighborhood of Hainewalde.

To a certain extent, Scheyer's description of this sheet as using a compositional scheme similar to that in the *View Above a River* (cat. no. 99) is pertinent, in that Nathe again places a figure in a patch of light, before a dark clump of foliage that contrasts with the luminous vista of the village. The general resemblance may serve to date this drawing in the 1780s. However, the topographic elements in the two drawings are not at all similar, in that the rocky coulisse found in the other sheet is not present here, nor is the river with steep banks. Even if both drawings are freely recomposed landscapes, as Scheyer suggests, rather than specific localities, it is not at all clear that they are inspired by the same sort of natural setting.

In comparison with the other Nathe drawing from Sacramento exhibited here, this sheet also displays a more light-filled space, and avoids a certain fussiness of detail. The woman with the dog in the foreground also recalls, as Scheyer notes, the denizens of Oeser's landscapes, and similar figures with abstracted, slightly idealized features can be found in Kobell's landscapes as well (cat. no. 98). The handling of light and the movement of the foliage on the trees mirror some of Nathe's best work. All these qualities produce what Scheyer has recognized as a more imaginary atmospheric composition, which is not without a certain poetic charm.[1]

1. See notes to the previous entry for information pertaining to this drawing as well.

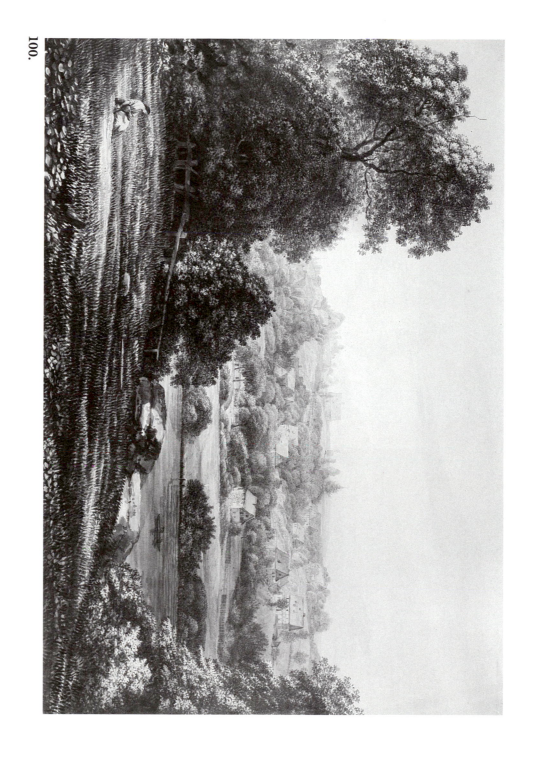

101. The Woodchopper's Rest

Brush and brown wash, white body color, traces of red wash and gray wash, on brown paper
18 × 21⁵⁄8 (471 × 558)
Signed and dated in brown wash on log, bottom right center: *Nathe 1795*

Santa Barbara Museum of Art, 65.54

PROVENANCE: Lucien Goldschmidt, New York; Museum Purchase, 1965

LITERATURE: Moir 1976, p. 104, ill. p. 105

The towering rock formations and trees, which reach to the top of this striking drawing, close off the background and dwarf and isolate the seated figure in the foreground, resulting in a much different compositional format than that found in the two other drawings by Nathe in this exhibition. The rich application of brown wash, and touches of washes in other hues, create a much richer coloristic effect. The mood has thus been changed considerably from that frequently found in Nathe's designs of the 1780s.

It would seem that the location of the scene is also different, indeed some 100 miles away from Görlitz. Ernst Scheyer has identified the setting as that of the Fichtelgebirge in Silesia, "which abound in such picturesque locations." There may have been a special reason for the attraction of this setting, because in the same year that Nathe did this drawing, he designed a monument for his patron, the art collector Herr von Schuhmann, to be erected on the *Fürstenstein* in this region.[1]

The contrast of the frail individual against the ruggedness of nature, and the suggestion of the dignity of labor of common people, as exemplified by this scene, are elements that Alfred Moir has compared to the thought of Rousseau, and noted as thematically anticipating Caspar David Friedrich (*q.v.*). The point may further apply to a specifically aesthetic issue. The evocative, poetic handling of an inherently picturesque topography is an important component of the Saxon landscape tradition and was developed by Friedrich, the leading heir to that tradition, into the full-fledged Romantic landscape.

1. See the letter from Ernst Scheyer to Herb Andree of May 11, 1974, in the Museum's files.

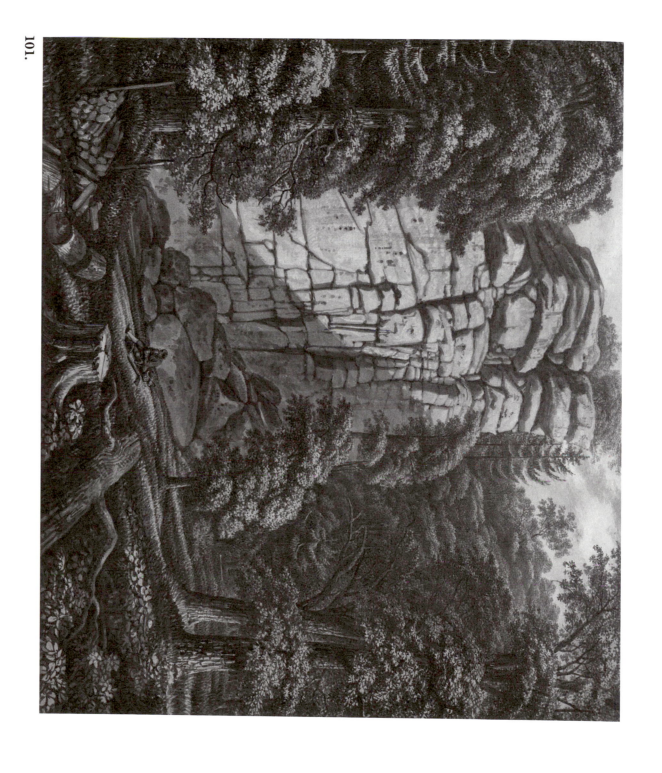

Landscape (Including Cityscape and Animal Drawings)

Born in St. Gallen, Switzerland, on April 16, 1734, Adrian Zingg studied with the engraver Rudolf Holzhalb in Zurich from 1753 to 1757. After working with Johann Ludwig Aberli in Bern, he accompanied Aberli and Johann Melchior Mörikofer in 1759 to Paris, where he resided until 1766. In Paris Zingg worked with Johann Georg Wille (q.v.) and also associated with Jakob Philipp Hackert (q.v.). His engravings after Dutch, French, and contemporary German masters earned him a great reputation.

Consequently he was invited to teach at the Dresden academy, which was reorganized in 1764, finally accepting an offer in 1766. In Dresden he set up a workshop for making engravings that employed among others his pupil Carl August Richter. He also befriended both Christian Wilhelm Ernst Dietrich (q.v.) and Anton Graff (q.v.), the latter of whom, from 1766, accompanied him on frequent walking tours in Saxony and adjacent regions.

Zingg became a member of the Vienna academy in 1767, and of that in Berlin in 1787. In 1803 he became professor of landscape at the Dresden academy. He died in Dresden on May 26, 1816.

Zingg's large oeuvre had a marked impact on the development of landscape drawing in Saxony in the late eighteenth and early nineteenth century, notably in the work of C.D. Friedrich (q.v.).

102. A View of Dresden

Pen and black ink, gray wash
18⅞ × 25¼ (478 × 642)
Watermark: C & I Honig (cf. Guiffrey 1907, no. 77)
Inscribed in graphite on verso, lower left: *Zingg*; in brown ink, center: *Dresden*; in graphite, bottom right: *Zingg* and *9 gr*; in graphite, bottom right corner: *sale of Richter sale H* [?] *n. 326*

Harvard University Art Museums, Fogg Art Museum; Gift of Belinda Lull Randall from the John Witt Randall Collection, 1898.115

PROVENANCE: Carl August Richter, Dresden; Adrian Ludwig Richter, Dresden (inscription of Randall on old mat: *Executed by Adrian Zingg for the elder Richter (father of Louis Richter of Dresden) and purchased at the sale of his effects at Dresden*); John Witt Randall (no. 476; Lugt 2130, on verso); Belinda Lull Randall

EXHIBITIONS: Detroit Institute of Arts 1949, "German Paintings and Drawings from the Time of Goethe in American Collections," no. 145; Lawrence, Kansas 1956, p. 16, cat. no. 66

LITERATURE: Mongan 1940, 1, p. 219, no. 430, 3, fig. 213; Scheyer 1949, p. 250, no. 145

This vista of Dresden is seen from a spot on the south bank of the Elbe to the west of the center of the old city, where such famed buildings as the *Zwinger* are situated. The spectator's viewpoint is approximately that of the draftsman shown working in the middle ground. To the left appears the river bank of Dresden-Neustadt (the part of the city on the north bank of the Elbe), and in the center of the drawing, the Augustus bridge joining the Neustadt to the old city. On the right side of the drawing the most prominent monuments that can be discerned are, in order, the large dome of the *Frauenkirche*, the spire and main body of the *Hofkirche*, and the tower of the schloss.

The location of the draftsman in the drawing provides a surrogate for Zingg himself. This detail can be related to a long tradition of representation that dates back to the sixteenth century: draftsmen placed within drawings of landscape or city views attest to the actuality of the scene.[1] The inclusion of conventional genre elements, such as details of people watching the draftsman, also reinforces the effect of reality of the scene.

In these regards the Fogg view exemplifies Zingg's role within the history of the *veduta* in Saxony, and of vistas of Dresden in particular. In the later eighteenth century, Zingg made numerous views of the Saxon towns and countryside. He may be regarded as part of a tradition that leads from Thiele (see cat. no. 89) through Bernardo Bellotto to C. D. Friedrich (see cat. no. 105).

Zingg's particular contribution to this development is also suggested by other elements of this composition, where topographic exactness is combined with elements that anticipate Romantic conceptions of landscape. These include the emphasis on naturalistic details in the foreground, such as the large, boldly drawn plants and weeds, the contrasting areas of light, and the animated clouds. These seemingly secondary features gain in importance, as the buildings of Dresden are found only in the background of the drawing. The technique Zingg developed for his landscape and city views, in which the pen strokes become increasingly delicate as they approach the background, adds to the overall effect of transposing compositional emphases from particular aspects of topography to more universally discoverable elements of nature.

The costumes of the figures in this drawing point to a date around 1790.[2] The scaffolding discernible on the spire of the *Kreuzkirche* in the right background, partially covered by clouds, allows a more precise dating of 1788, for it was in this year that the rebuilt church tower designed by Hölzer was completed.[3] This sheet antedates the arrival of Friedrich in Dresden in 1798, and the appointment of Zingg, already professor at the Dresden *Kupferstecherakademie*, as professor of landscape drawing at the Academy of Fine Arts in 1803. In this regard, as in its new thematic emphasis, the drawing may also be recognized as providing a link with Friedrich's art.

According to Randall's inscription, this sheet belonged to Carl August Richter, a pupil and employee of Zingg, and later passed into the hands of Ludwig Richter. This finely executed and evidently finished *veduta* would have made an appropriate gift for a landscape artist. Since it also belonged to Ludwig Richter, who himself gained renown as a draftsman and painter of landscapes and topographic views later in the nineteenth century, it can be thought of as pointing to broader associations in the history of landscape drawing.[4]

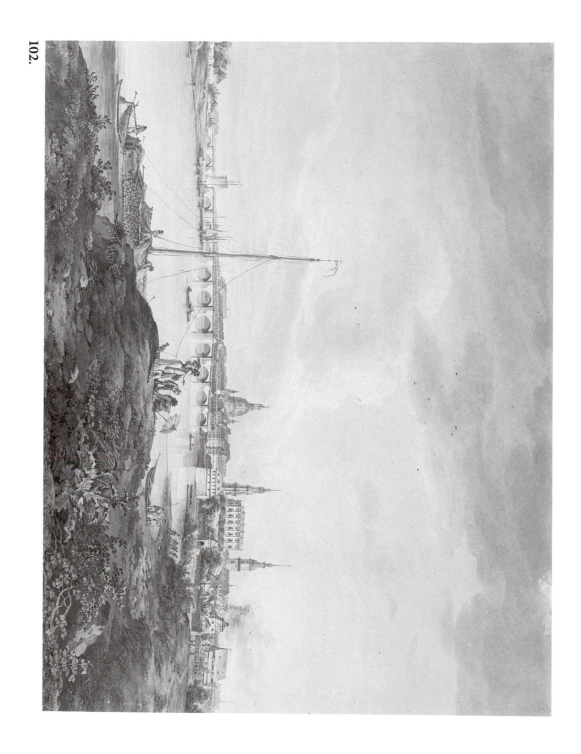

1. For example, in landscapes by Bruegel, Georg Hoefnagel, and other artists, as discussed in Winner 1985, pp. 85–96.

2. Compare the attire of the fashionable female figures with dress worn about this date, as presented in Arnold 1973, p. 20.

3. See Löffler 1955.

4. Another Zingg drawing from the Randall collection is also to be found in the Fogg Museum, inv. no. 1898.475; its earlier provenance is unclear, however.

Landscape (Including Cityscape and Animal Drawings)

JOHANN CHRISTIAN REINHART
(1761–1847)

Born in Hof in northern Bavaria on January 24, 1761, Johann Christian Reinhart first studied theology. He then turned to art, studying from 1779 to 1782 at the Leipzig academy, where his instructor was Adam Friedrich Oeser (q.v.); he continued his training in 1783 at the Dresden academy under Johann Christian Klengel (q.v.). In 1784 he embarked on a *Wanderjahr* in Saxony and Bohemia.

Having met Friedrich Schiller in 1785, he was admitted to Schiller's circle, and turned to writing poetry for the next two years. In 1786 he moved to Meiningen, however, and lived until 1789 at the court of Duke Georg of Saxe-Meiningen, who became his friend.

In 1789 Reinhart settled in Rome, where along with Asmus Jakob Carstens and Joseph Anton Koch formed the core of a German artists' colony. The realistic approach to the depiction of nature of his earlier days gradually gave way during his Roman sojourn to what is regarded as the "heroic" composed landscape, of which he is considered the prime exponent. Though admitted to the Berlin academy in 1810 and to the Munich academy in 1830, and named painter to the court of King Ludwig I of Bavaria in 1839, Reinhart remained in Rome until his death on June 9, 1847.

103. Artist Sketching Beneath Spreading Trees

Pen and black ink and graphite, on cream paper
19 9/16 × 26 3/8 (497 × 665)
Inscribed in graphite, lower right: 5; inscribed on verso: *J.C. Reinhart um 1800 Feuchtmayr Z 317/ Abb. 268/ nachlass Ruckert*

Harvard University Art Museums, Fogg Art Museum; Purchase, Paul J. Sachs Memorial Fund, Louise Haskell Daly Fund, and Friends of the Harvard University Art Museum Funds, 1985.74

PROVENANCE: Possibly Carl Ludwig Fernow (1763–1808); possibly Friedrich Bertuch (1747–1822; according to letter of September 16, 1809, from Heinrich Meyer to Johann Wolfgang von Goethe)[1]; Hugo Rücker; Rüdiger Rücker, Frankfurt am Main; Ralph Grosse, Frankfurt am Main; Seiden & de Cuevas, Inc.; purchase, 1985.74

LITERATURE: Feuchtmayr 1975, pp. 76, 371, cat. no. Z 317, ill. 268

one of the presence of man in the midst of the grandeur of nature. Feuchtmayr also remarks on the resemblance between preliminary drawings, of which she considers this one, and studies of architecture executed by the artist in Italy in the 1790s, in that they use simple means to communicate both the monumentality of their subject—here trees, or nature itself—and a picturesque (*malerisch*) atmosphere.[3] These qualities were evidently appreciated by previous owners of the sheet, including the critic Fernow who praised Reinhart's achievements.

A second drawing in the Fogg Museum with an attribution to Reinhart is in fact a copy or second version of a sheet by Johann Christian Klengel.[4] Nevertheless, the misattribution points to the close relationship of these artists' work, and the associations that may be drawn between this generation of landscapists of around 1800 and tendencies that are often called Romantic.

Inge Feuchtmayr has dated this drawing ca. 1800, comparing it with a preparatory study for an etching of Pan playing the flute that is dated 1795.[2] The basis of her comparison is the similarity between the two drawings in the transparent manner of execution, in which forms are only partially marked out with the pen. Feuchtmayr suggests that this kind of design, lacking indications of shading, was used as a preliminary study for an etching.

Here Reinhart depicts a draftsman sketching underneath a large chestnut tree and oak, at left and right. The close-up view of a scene in the woods is also characteristic of Reinhart's vision of landscape from the 1790s, as described by Feuchtmayr.

While the appearance of the draftsman lends a pretense of reality to the scene, in its suggestion that an artist, conceivably Reinhart, was present (see cat. no. 102), the effect is not one of topographic exactness. Rather, the feeling evoked is

1. For the provenance of drawings from the Rückert collection, see Feuchtmayr 1975, p. 374, under Z 375; Feuchtmayr quotes Meyer saying that Bertuch has *"aus dem Fernowschen Nachlass die Landschaften von Reinhart an sich genommen."*

2. See Feuchtmayr 1975, p. 374, cat. no. 375, fig. 401.

3. Feuchtmayr 1975, p. 76.

4. Fogg Art Museum, 1985.73, black chalk on yellowish paper, 522 × 391 mm. Weimar, Städtische Kunstsammlungen, Kupferstichkabinett, inv. no. KK 1191, black chalk on yellow paper, 520 × 383 mm., was exhibited as the work of Klengel in Freiberg in Sachsen 1950, p. 31, no. 167 (not illustrated).

The provenance of the Fogg drawing from Grosse's collection, if it could be traced back to Fernow, is unconvincing in itself. Fernow was interested in many more artists than Reinhart, whose works he could have owned, and he did not make the attribution himself: for Fernow as a writer on art, see the references in Schlosser [Magnino] 1964. The provenance of the Weimar drawing is more telling, as it comes from Klengel's own *Nachlass*. (For drawings by other artists from Klengel's collection in Weimar, see, for example, counterproofs of Nicolaes Berchem, inv. nos. KK 4771 and 4772, cited in Weimar 1981, p. 8, nos. 47, 48 [not illustrated]).

Feuchtmayr's argument that the ductus of the numbers in the date of 1802 on the Fogg sheet correspond to those of Reinhart is also unconvincing: they are done in pen, while the drawing itself is in black chalk, so there is no evidence that they are by the same hand, even if we were to accept her argument that the date was written by Reinhart.

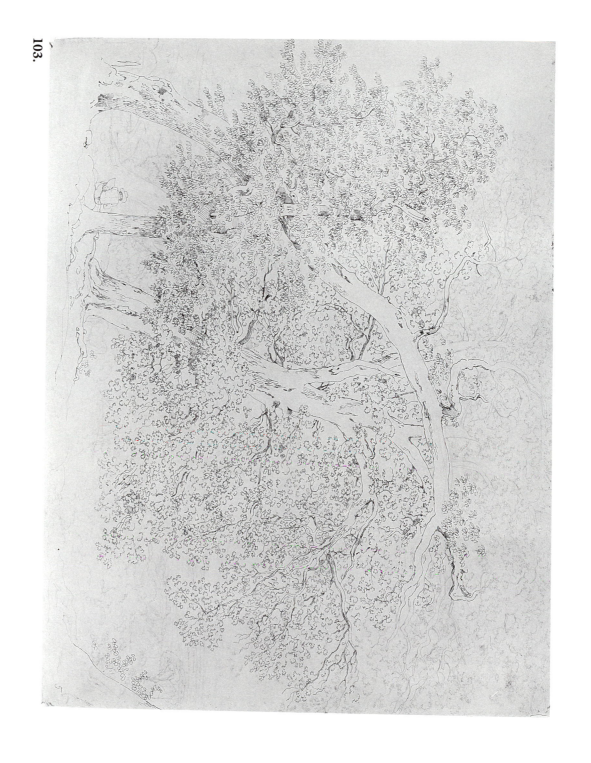

Martin von Molitor

(1759–1812)

Born 1759 in Vienna, Martin von Molitor began studies at age twelve with the landscape artist Johann Christian Brand at the reunited academy in Vienna. In 1784 he was a member of this academy. Although he never officially became a professor there, he exerted a great influence on its students. He later became curator of the imperial *Hofbibliothek*.

Von Molitor produced landscape views in gouache that were particularly well received, and from 1802 he made numerous views of the Tyrol. Having established himself as a leading landscape artist of the turn of the century, he died in Vienna in 1812.

104. Mountain Landscape

Pen and brown and black ink, brown wash, on paper covered with light brown wash, with a frame in black ink
$7\frac{5}{16} \times 9\frac{13}{16}$ (202 × 249)
Signed and dated in brown ink, bottom left corner: *Molitor/1796*

The Pierpont Morgan Library; Purchased on the Director's Fund in honor of Mr. and Mrs. Eugene Victor Thaw, 1986.119

This highly finished drawing is very finely executed. The careful execution, together with the presence of the black frame and the signature and date, all suggest that, despite its relatively small format, the drawing was intended for presentation.

The lighting effects are quite delicate and atmospheric, lending it an evocative effect, which, along with the dominance of a central motif, recalls the landscapes of Claude Lorrain. In this regard, this small landscape is not so far removed from so-called "ideal landscapes" that begin to appear in Von Molitor's work around 1798.[1]

On the other hand, the unidealized workers, gathering branches in the foreground, have been given compositional emphasis. They, and the hut in the center, are larger in relation to the composition than are similar motifs seen in later drawings. These features correspond more to the approach of earlier eighteenth-century landscapes, which have been related to the tradition of "Dutch" landscapes as far as their naturalistic attitude is concerned.[2]

In his study of Viennese landscapes, Peter Pötschner has commented on the transformation of landscape style in Von Molitor's work from the late 1790s as paradigmatic of the development of the "ideal" landscape after 1800.[3] Yet it might be argued that the drawing reveals this tendency and what Pötschner describes as a "real" approach to landscape. In the way that this "realistic" approach transforms the Claudean ideal into something more modest, or *bieder*, it might equally be said that Von Molitor's landscape anticipates the *Biedermeier*.

1. See for comparison a landscape with ruins in Stuttgart, inv. no. 3905, illustrated in Stuttgart 1985, p. 88, no. 40, ill. p. 89, with a discussion of its relation to this trend and to other drawings on p. 88. Pötschner 1978, pp. 60–62, stresses Von Molitor's role in the development of the "ideal" landscape.
2. Stuttgart 1985, p. 88, describes the historical transition.
3. Pötschner 1978.

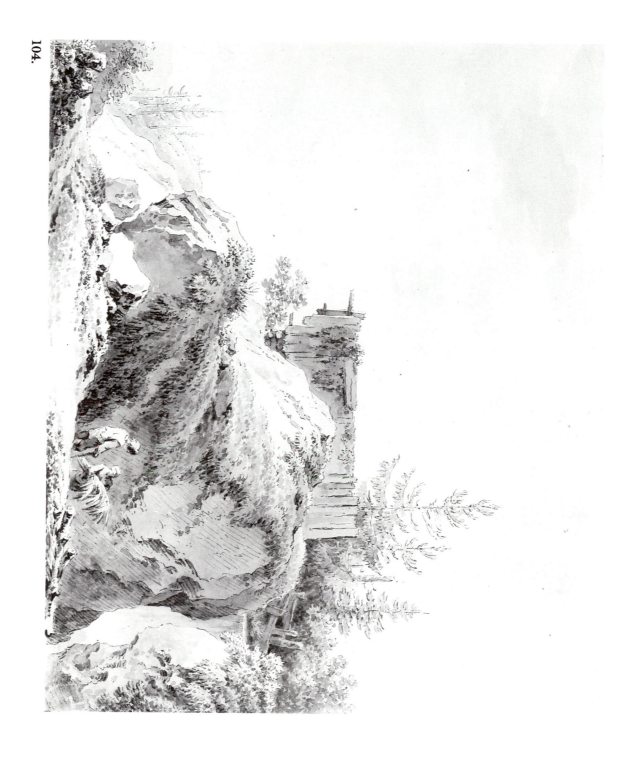

104.

CASPAR DAVID FRIEDRICH
(1774–1840)

Caspar David Friedrich is the most famous artist associated with German Romanticism.

Born in Greifswald in Pomerania on September 5, 1774, he studied from around 1790 with Johann Gottfried Quistorp, an architect and drawing instructor at the university there. In 1794 Friedrich moved to Copenhagen to study at the academy, where his teachers were Christian August Lorentzen, Jens Juel, and Nicolai Abildgaard. After a brief sojourn in Berlin, Friedrich settled in Dresden in 1798. He was to reside there the rest of his life, except for numerous visits to Greifswald, such as one in 1801 when he met Philipp Otto Runge. In the following year, he began to make trips to the island of Rügen and to Bohemia.

In Dresden Friedrich became the center of a circle of Romantic writers and artists including Tieck, Novalis, and others; in 1808 he joined the literary group *Phöbus*, which included Kleist, Müller, and Körner. Awarded a prize by Goethe in 1805, he was visited by him in 1810, and returned the visit in 1811. In 1810 Friedrich was also elected member of the Berlin academy. In 1816 he was admitted to the Dresden academy and was nominated for professor there in 1824. In 1825 he became seriously ill, and in 1835 was crippled by a stroke; he died in Dresden in 1840.

the harbinger of a new movement, but as the culmination of a tradition of draftsmanship that goes back to Thiele (cat. no. 89) in Saxony.[2] As such he provides an appropriate conclusion to this exhibition.

1. Helmut Börsch-Supan's comment is recorded in the curatorial files of the Morgan Library. For comparable drawings from the Mannheim sketchbook, see Hamburg 1974, p. 130, cat. nos. 31–34.
2. For more background to Friedrich and the Saxon tradition, and other examples of this sort by Friedrich, see recently New York 1988, esp. cat. nos. 39–40.

105. Rider Conversing with a Standing Figure under a Blasted Tree

Graphite
7⅞ × 8³/₁₆ (199 × 208)
Inscribed by the artist in brown ink, lower center: *den 1 April 1801*
Watermark: D & C Blau

The Pierpont Morgan Library; Purchased as the Gift of Mr. Charles C. Cunningham, Jr., Mr. and Mrs. Geoffrey Platt, Mr. Axel Rosin, and Mrs. Michael Tucker, 1983.85

PROVENANCE: Galerie Arnoldi-Livie, Munich

This graphite drawing is comparable to several other sheets by Friedrich done at the same time. In format and inscription it may be compared to several drawings that have been connected with the artist's so-called "Mannheim sketchbook," a group of nature studies that may have belonged to one book, as Helmut Börsch-Supan has also noted.[1]

These studies were executed during the artist's first return to Pomerania, from January 1801 to July 1802. At this time he wandered around the Pomeranian countryside and on the island of Rügen, making sketches like that shown here, both of natural phenomena and of the people he encountered.

Although Friedrich is generally associated in the history of art with the development of Romanticism, this nature study demonstrates his links to earlier traditions as well. While it is true that studies of blasted trees such the one in this drawing recur in his paintings, this sheet reveals that this sort of element is always grounded in observed nature. In this sheet, and indeed in many other drawings in the Dresden collections, he may thus be regarded not only as

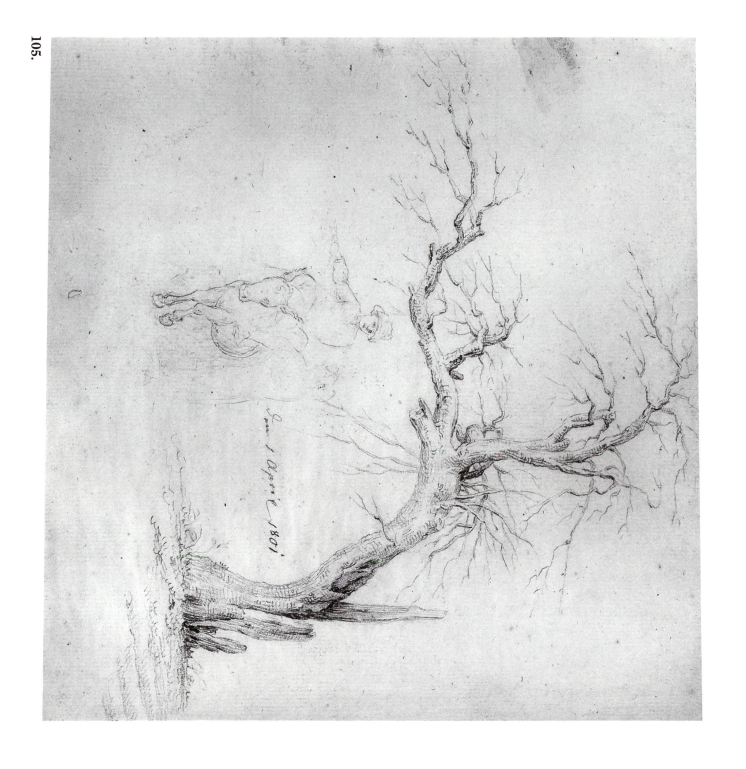

Bibliography of Sources Cited

Adriani 1935 Adriani, Gert. *Die Klosterbibliotheken des Spätbarock in Österreich und Süddeutschland.* Graz, 1935.

Allentown 1962 Allentown, Allentown Art Museum, and elsewhere. *Old Master Drawings.* Exh. cat. Allentown, 1962–63.

Altenburg bei Horn 1963 Altenburg bei Horn. *Ausstellung Paul Troger und die österreichische Barockkunst.* Exh. cat. Altenburg bei Horn, 1963.

American Federation of Arts 1953 American Federation of Arts. *Decorative Design of the Rococo Period.* 1953–54.

Anonymous 1907 Anonymous. Guérinet, A., ed. *Le Palais du Grand Trianon: Extérieurs, Intérieurs, Sculptures Décoratives, Meubles et Bronzes.* Paris, n.d. [1907]

Anonymous 1948 Anonymous. *Die Kunstdenkmäler Hohenzollerns 2. Kreis Sigmaringen,* Stuttgart, 1948.

Anonymous 1984 Anonymous. *Pfarr- und Wallfahrtskirche Heiligkreuz zu Donauwörth.* Donauwörth, 1984.

Arnold 1975 Arnold, Janet. *Patterns of Fashion I.* New York, 1975.

Aschenbrenner 1965 Aschenbrenner, Wanda and Gregor Schweighofer. *Paul Troger: Leben und Werk.* Salzburg, 1965.

Atlanta 1985 Atlanta, High Museum of Art, and elsewhere. *Master Drawings from Titian to Picasso: The Curtis O. Baer Collection.* Exh. cat. (catalogue by Eric M. Zafran). Atlanta, 1985–87.

Augsburg 1967 Augsburg. *Johann Elias Ridinger, 1698–1767.* Exh. cat. (catalogue by Rolf Biedermann). Augsburg, 1967.

Augsburg 1968 Augsburg, Rathaus and Holbeinhaus. *Augsburger Barock.* Exh. cat. (ed. Christina Thon). Augsburg, 1968.

Augsburg 1987 Augsburg, Städtische Kunstsammlungen. *Meisterzeichnungen des deutschen Barock aus dem Besitz der Städtischen Kunstsammlungen Augsburg.* Exh. cat. (catalogue by Rolf Biedermann). Augsburg, 1987.

Augsburg 1988 ———. *Matthäus Günther 1705–1788: Festliches Rokoko für Kirchen, Klöster, Residenzen.* Munich, 1988.

Aurenhammer 1955 Aurenhammer, Gertrude. "Das Melker Skizzenbuch des Martino Altomonte," *Jahrbuch für Landeskunde von Niederösterreich* 32 (1955–56), pp. 242ff.

Aurenhammer 1958 ———. *Die Handzeichnung des 17. Jahrhunderts in Österreich.* Vienna, 1958.

Aurenhammer 1965 Aurenhammer, Hans. *Martino Altomonte.* (mit einem Beitrag "Martino Altomonte als Zeichner und Graphiker" von Gertrude Aurenhammer). Vienna, 1965.

Aurenhammer 1973 ———. *J.B. Fischer von Erlach.* Cambridge, Massachusetts, 1973.

Baden-Baden 1968 Baden-Baden, Staatliche Kunsthalle. *Handzeichnungen alter Meister aus schweizer Privatbesitz.* Exh. cat. Baden-Baden, 1968.

Bäuml 1950 Bäuml, Elisabeth. *Geschichte der alten reichsstädtischen Kunstakademie von Augsburg.* Dissertation. Munich, 1950.

Baldinucci 1681 Baldinucci, Filippo. *Vocabolario toscano dell'Arte del Disegno.* Florence, 1681.

Baltimore 1959 Baltimore, the Baltimore Museum of Art. *Age of Elegance: The Rococo and its Effect.* Exh. cat. Baltimore, 1959.

Bamberger 1916 Bamberger, Ludwig. *Joh. Conrad Seekatz: Ein deutscher Maler des achtzehnten Jahrhunderts; sein Leben und seine Werke.* Heidelberg, 1916.

Bammes 1962 Bammes, Gottfried. *Das zeichnerische Aktstudium. Seine Entwicklung in Werkstatt, Schule, Praxis und Theorie.* Leipzig, 1962.

Basel 1973 Basel, Kunstmuseum, Kupferstichkabinett. *Zeichnungen des 17. Jahrhunderts aus dem Basler Kupferstichkabinett.* Exh. cat. (catalogue by Tilman Falk). Basel, 1973.

Bauer 1962 Bauer, Hermann. *Rocaille. Zur Herkunft und zum Wesen eines Ornament-Motivs.* Berlin, 1962.

Bauer 1980 ———. *Rokokomalerei. Sechs Studien.* Mittenwald, 1980.

Bauer 1978 Bauer, Linda Freeman. "'Quanto si disegna, si dipinge ancora': Some Observations on the Development of the Oil Sketch." *Storia dell'arte* 32 (1978), pp. 45–57.

Baum 1980 Baum, Elfriede. *Katalog des Österreichischen Barockmuseums in Unteren Belvedere in Wien.* 2 vols. Vienna and Munich, 1980.

Becker 1971 Becker, Wolfgang. *Paris und die deutsche Malerei, 1750–1840. Studien zur Kunst des 19. Jahrhunderts 10.* Munich, 1971.

Benesch 1947 Benesch, Otto. "A Group of Unknown Drawings by Matthäus Günther for Some of his Main Works." *The Art Bulletin* 29 (March 1947), pp. 49–52.

Berckenhagen 1967 Berckenhagen, Ekhart. *Anton Graff: Leben und Werk.* Berlin, 1967.

Bibliography of Sources Cited

Bergmüller 1723 — Bergmüller, Johann Georg. *Anthropometria, sive statura hominis a nativitate ad consummatum aetatis incrementum ad dimensionum et proportionum regulas discriminata. . . .* Augsburg, 1723.

Berkeley 1968 — Berkeley, California, University Art Museum. *Master Drawings from California Collections.* Exh. cat. (catalogue by Juergen Schulz). Berkeley, 1968.

Berlin 1963 — Berlin, Staatliche Museen zu Berlin Nationalgalerie. *Anton Graff, 1736–1813.* Exh. cat. Berlin, 1963.

Berlin 1979 — Berlin, Schloss Charlottenburg. *Berlin und die Antike.* Exh. cat. 2 vols. Berlin, 1979.

Berlin 1979a — Berlin, Staatliche Museen Preussischer Kulturbesitz. *Architektenzeichnungen 1479–1979.* Exh. cat. (catalogue by Ekhart Berckenhagen). Berlin, 1979.

Berlin 1982 — ———. *Ex Bibliotheca Regia Berolinensi. Zeichnungen aus dem ältesten Sammlungsbestand des Berliner Kupferstichkabinetts.* Exh. cat. (catalogue by Peter Dreyer). Berlin, 1982.

Berlin 1987 — Berlin. *Deutsche Zeichnungen des 18. Jahrhunderts: Zwischen Tradition und Aufklärung.* Exh. cat. (catalogue by Thomas W. Gaehtgens et al.). Berlin, 1987.

Biedermann 1985 — Biedermann, Rolf. "A Drawing by Gottfried Eichler the Younger." *The Register of the Spencer Museum of Art* 6, no. 2 (1985), pp. 22–29.

Biedermann 1987 — See Augsburg 1987

Binghamton 1970 — Binghamton, University Art Gallery, State University of New York at Binghamton, and elsewhere. *Selections from the Drawing Collection of Mr. and Mrs. Julius S. Held.* Exh. cat. Binghamton, 1970.

Bircher 1982 — Bircher, Martin et al. *Salomon Gessner.* Zurich, 1982.

Blažíček 1954 — Blažíček, O.J. "Umění a umělci 17. a 18. věku IV." *Umění* 2, no. 4 (1954), pp. 335–37.

Bleibaum 1933 — Bleibaum, Friedrich. *Johann August Nahl, der Kunstler Friedrichs des Grossen und der Landgrafen von Hesse-Kassel.* Baden bei Wien and Leipzig, 1933.

Bock 1921 — Bock, Elfried. *Staatliche Museen zu Berlin. Die Zeichnungen alter Meister im Kupferstichkabinett. Die deutschen Meister: Beschreibendes Verzeichnis sämtlicher Zeichnungen.* 2 vols. Berlin, 1921.

Bode 1891 — Bode, Wilhelm von. *Die grossherzogliche Gemälde-galerie zu Schwerin.* Vienna, 1891.

Boerner 1966 — Boerner, C.G. *Ausgewählte Druckgraphik und Handzeichnungen aus vier Jahrhunderten. Lagerliste no. 42.* Düsseldorf, 1966.

Boerner 1966a — ———. *Handzeichnungen vor 1900. Lagerliste no. 44.* Munich and Düsseldorf, 1966.

Boerner 1971 — ———. *Alte Graphik, Neuere Graphik, Zeichnungen, Neue Lagerliste no. 56.* Düsseldorf, 1971.

Boerner 1981 — ———. *Lagerliste Nr. 74.* Düsseldorf 1981.

Boerner 1982 — ———. *Neue Lagerliste Nr. 77.* Düsseldorf, 1982.

Börsch-Supan 1980 — Börsch-Supan, Helmut. *Die Kunst in Brandenburg-Preussen: Ihre Geschichte von der Renaissance bis zum Biedermeier dargestellt am Kunstbesitz der Berliner Schlösser.* Berlin, 1980.

Bösel 1987 — Bösel, Richard. "Die Fassade der Kirche am Hof und ein unbekanntes Bauprojekt für St. Michael in Wien." *Kunsthistoriker* 4, no. 3–4 (1987), pp. 40–47.

Boros 1983 — Boros, László. "A pécsi vázlatkönyv Cszobraszrajzok a 17. századból." *Művészettörténeti Ertesitö* 31 (1983), pp. 12–33.

Boros 1985 — ———. "17. századi ostrák szobrászvázlatok baranyában." *Baranyai Levéltári Füzeltek* 65 (1985), pp. 231–55, 605.

Braunfels 1968 — Braunfels, Wolfgang, ed. *Lexikon der christlichen Ikonographie.* 8 vols. Rome, Freiburg, Basel, Vienna, 1968–76.

Braunfels 1986 — ———. *François Cuvilliés: Der Baumeister der Galanten Architektur des Rokoko.* Munich, 1986.

Braunschweig 1983 — Braunschweig, Herzog Anton Ulrich-Museum. *Herzog Anton Ulrich von Braunschweig: Leben und Regieren mit der Kunst.* Exh. cat. (ed. Rüdiger Klessmann). Braunschweig, 1983.

Bremen 1959 — Bremen, Kunsthalle. *Um 1800: Deutsche Kunst von Schadow bis Schwind.* Exh. cat. Bremen, 1959.

Bremen 1971 — ———. *Bildkunst im Zeitalter Johann Sebastian Bachs: Meisterwerke des Barock aus dem Besitz der Kunsthalle Bremen.* Exh. cat. Bremen, 1971.

Bremen 1986 — ———. *In Rembrandts Manier: Kopie, Nachahmung und Aneignung in den graphischen Künsten des 18. Jahrhunderts.* Exh. cat. Bremen and Lübeck, 1986–87.

Briquet — Briquet, C. M. *Les Filigranes: Dictionnaire historique des marques du papier.* 4 vols. Paris and elsewhere, 1907.

278

Brno 1985 Brno, Moravská Galerie. *Rakouská a moravská kresba 18. století.* Exh. cat. (catalogue by Jiří Kroupa). Brno, 1985.

Bruchsal 1981 Bruchsal, Schloss Bruchsal. *Barock in Baden-Württemberg: Vom Ende des Dreissigjährigen Krieges bis zur Französischen Revolution.* Exh. cat. Bruchsal and Karlsruhe, 1981.

Bruford 1935 Bruford, W.H. *Germany in the Eighteenth Century: The Social Background of the Literary Revival.* Cambridge, England, 1935.

Bryson 1981 Bryson, Norman. *Word and Image: French Painting of the Ancien Régime.* Cambridge, New York, and Melbourne, 1981.

Bürklin 1971 Bürklin, Heidi. *Franz Joachim Beich (1665–1748): Ein Landschafts- und Schlachtenmaler am Hofe Max Emanuels.* Dissertation. Munich, 1971.

Bushart 1964 Bushart, Bruno. "Die deutsche Ölskizze des 18. Jahrhunderts als autonomes Kunstwerk." *Münchner Jahrbuch der bildenden Kunst* 3. F., 15 (1964), pp. 145–76.

Büttner 1988 Büttner, Frank. "Bernhard Rodes Geschichtsdarstellungen." *Zeitschrift des Deutschen Vereins für Kunstwissenschaft* 42, no. 1 (1988), pp. 33–47.

Cambridge 1958 Cambridge, Massachusetts, the Fogg Art Museum. *Drawings from the Collection of Curtis O. Baer.* Exh. cat. Cambridge, 1958.

Chapel Hill 1983 Chapel Hill, and elsewhere. *Master European Drawings from the Collection of the National Gallery of Ireland.* Exh. cat. Smithsonian Institution Traveling Exhibition Service, 1983.

Chicago 1978 Chicago, the David and Alfred Smart Gallery, the University of Chicago. *German and Austrian Painting of the Eighteenth Century.* Exh. cat. (catalogue by Edward A. Maser). Chicago, 1978.

Christoffel 1923 Christoffel, Ulrich. *Deutsche Kunst, 1650–1800.* Munich, 1923.

Claremont 1976 Claremont, California, Montgomery Art Gallery, Pomona College, and elsewhere. *18th Century Drawings from California Collections.* Exh. cat. (catalogue by David W. Steadman and Carol M. Osborne). Claremont, 1976.

Cleveland 1964 Cleveland, the Cleveland Museum of Art. *Neo-Classicism: Style and Motif.* Exh. cat. (catalogue by Henry Hawley). Cleveland, 1964.

Cologne 1979 Cologne, Wallraf-Richartz Museum, Museum Ludwig. *Idee und Anspruch der Architektur:*

Crocker Art Museum 1979 Crocker Art Museum. *Handbook of Paintings.* Sacramento, 1979.

Crow 1985 Crow, Thomas E. *Painters and Public Life in Eighteenth-Century Paris.* New Haven and London, 1985.

Crow 1986 ———. "La critique des Lumières dans l'art du dix-huitième siècle." *Revue de l'Art* (1986), pp. 9–16. Reprinted as "The Critique of the Enlightenment in Eighteenth-Century Art." *Art Criticism* 3, no. 3 (1987), pp. 17–31.

Darmstadt 1914 Darmstadt, Residenzschloss. *Deutsches Barock und Rokoko: Herausgegeben im Anschluss an die Jahrhundert-Ausstellung deutscher Kunst 1650–1800.* 2 vols. Exh. cat. (catalogue by Georg Biermann et al.). Leipzig, 1914.

Darmstadt 1980 Darmstadt, Hessisches Landesmuseum. *Darmstadt in der Zeit des Barock und Rokoko.* Exh. cat. Darmstadt, 1980.

Das Achtzehnte Jahrhundert 1985 *Das Achtzehnte Jahrhundert und Österreich. Jahrbuch der Österreichischen Gesellschaft zur Erforschung des achtzehnten Jahrhunderts 2.* Vienna, Cologne, Graz, 1985.

Dasser 1970 Dasser, Karl Ludwig. *Johann Baptist Enderle (1725–1798): Ein schwäbischer Maler des Rokoko.* Wessenhorn, 1970.

Dehio 1919 Dehio, Georg. *Geschichte der deutschen Kunst.* 6 vols. Berlin, 1919–26.

Dencker-Winkler 1987 Dencker-Winkler, Eva. *Meisterzeichnungen: Master Drawings.* Zurich, 1987.

Detroit 1983 Detroit, Detroit Institute of Arts. *From a Mighty Fortress: Prints, Drawings, and Books in the Age of Luther, 1483–1546.* Exh. cat. (catalogue by Christiane Andersson and Charles Talbot). Detroit and Ottawa, 1983.

Deutsche Barockgalerie 1984 Augsburg, Deutsche Barockgalerie. *Deutsche Barockgalerie, Katalog der Gemälde.* Augsburg, 1984.

Dickel 1987 Dickel, Hans. *Deutsche Zeichenlehrbücher des Barock: Eine Studie zur Geschichte der Künstlerausbildung.* Hildesheim, Zurich, and New York, 1987.

Diener 1979 Diener, Claudia. *Georg Raphael Donner: Die Reliefs.* Dissertation. Heidelberg, 1977; Nuremberg, 1979.

Dilly 1988 Dilly, Heinrich. *Deutsche Kunsthistoriker 1933–1945.* Munich, 1988.

Dlabačz 1815 Dlabačz, Gottfried Johann. *Allgemeines historisches Künstler-Lexicon für Böhmen und zum Theil auch für Mähren und Schlesien.* Prague, 1815.

Dobrzycka 1958 Dobrzycka, Anna. *J. W. Neunhertz. Malarz Śląski.* Prace Komisji Historii Sztuki 6, pt. 1. Poznań, 1958.

Donop n.d. Donop, Lionel von. *Handzeichnungen, Aquarelle und Olstudien in der K. Nationalgalerie Berlin,* n.d.

Dörries 1943 Dörries, Bernhard. *Deutsche Zeichnungen des 18. Jahrhunderts.* Munich, 1943.

Dresden 1972 Dresden, Staatliche Kunstsammlungen, Kupferstichkabinett. *Zeichnungen alter Meister aus der Ermitage zu Leningrad: Die Sammlung Brühl.* Exh. cat. Dresden, 1972.

Dubowy 1925 Dubowy, Ernst. "Felix Anton Scheffler: ein Beitrag zur Kunstgeschichte des 18. Jahrhunderts." *Jahrbuch des Vereins für christliche Kunst in München* 6 (1925/26), pp. 89–281.

Dürr 1879 Dürr, Alphons. *Adam Friedrich Oeser: Ein Beitrag zur Kunstgeschichte des 18. Jahrhunderts.* Leipzig, 1879.

Düsseldorf 1968 Düsseldorf, Kunstmuseum. *Niederländische Handzeichnungen 1500–1800 aus dem Kunstmuseum Düsseldorf.* Exh. cat. (catalogue by Eckhard Schaar). Düsseldorf, 1968.

Düsseldorf 1969 ———. *Meisterzeichnungen der Sammlung Lambert Krahe.* Exh. cat. (catalogue by Eckhard Schaar and Dieter Graf). Düsseldorf, 1969–70.

Düsseldorf 1988 ———. *Von Mantegna bis Watteau: Zeichnungen aus der Sammlung des Kurfürsten Carl Theodor.* Exh. cat. Düsseldorf, 1988.

Dworschak 1955 Dworschak, Fritz et al. *Der Maler Martin Johann Schmidt, genannt "Der Kremser Schmidt," 1718–1801.* Vienna, 1955.

East Lansing 1959 East Lansing, Michigan, Kresge Art Center, Michigan State University. *College Collections: An Exhibition on the Occasion of the Dedication of the Kresge Art Center, Michigan State.* Exh. cat. East Lansing, 1959.

Eckardt 1929 Eckardt, Anton. *Die Kunstdenkmäler von Niederbayern 21, Bezirksamt Griesbach.* Munich, 1929.

Eggeling 1980 Eggeling, Tilo. *Studien zum Friderizianischen Rokoko: Georg Wenceslaus von Knobelsdorff als Entwerfer von Innendekoration.* Berlin, 1980.

Ehrenstrahl 1918 Ehrenstrahl, David Klöcker. *Kurtzer Unterricht, Observationes und Regulen von der Mahlereij.* G.M. Silfverstolpe, ed., Arkiv för svensk konst- och kulturhistoria. Stockholm, 1918.

Ellenius 1960 Ellenius, Allan. *De Arte Pingendi: Latin Art Literature in Seventeenth-Century Sweden and Its International Background.* Uppsala and Stockholm, 1960.

Engelmann 1857 Engelmann, Wilhelm. *Daniel Chodowieckis sämmtliche Kupferstiche...* Berlin, 1857.

Engelmann 1859 Engelmann, Wilhelm. *Archiv für die Zeichnenden Künste,* Robert Naumann, ed., 5, 1859, pp. 254ff.

Essen 1986 Essen, Villa Hügel. *Barock in Dresden: Kunst und Kunstsammlungen unter der Regierung des Kurfürsten Friedrich August I von Sachsen und Königs August II. von Polen genannt August der Starke 1694–1733 und des Kurfürsten Friedrich August II. von Sachsen und Königs August III. von Polen 1733–1763.* Exh. cat. Leipzig, 1986.

Ettlingen 1982 Ettlingen, Schloss Ettlingen. *Asam in Schloss Ettlingen, 1732–1982.* Exh. cat. (catalogue by Hanna Hafner et al.). Ettlingen, 1982.

Ewald 1965 Ewald, Gerhard. *Johann Carl Loth, 1632–1698.* Amsterdam, 1965.

Fach 1985 Joseph Fach. *Aquarelle und Zeichnungen.* Frankfurt am Main, 1985.

Fauchier-Magnan 1958 Fauchier-Magnan, Adrien. *The Small German Courts in the 18th Century.* Trans. Mervyn Savill, London, 1958.

Feuchtmayr 1975 Feuchtmayr, Inge. *Johann Christian Reinhart 1761–1847: Monographie und Werkverzeichnis.* Munich, 1975.

Feulner 1929 Feulner, Adolf. *Skulptur und Malerei des 18. Jahrhunderts in Deutschland.* Wildpark-Potsdam, 1929.

Feulner 1942 ———. *Kunst und Geschichte: Eine Anleitung zum kunstgeschichtlichen Denken.* Leipzig, 1942.

Fillitz 1959 Fillitz, Hermann. *Die österreichische Kaiserkrone und die Insignien des Kaisertums Österreich.* Vienna and Munich, 1959.

Fishman 1982 Fishman, Jane Susannah. *Boerenverdriet: Violence between Peasants and Soldiers in Early Modern Netherlands Art.* Ann Arbor, 1982.

Fleischhauer 1958 Fleischhauer, Werner. *Barock in Herzogtum Württemberg.* Stuttgart, 1958.

Florence 1982 Florence, Gabinetto Disegni e Stampe degli Uffizi. *Disegni dell'Europa occidentale dall'Ermitage di Leningrado. Disegni.* Exh. cat. (catalogue by I. Grigorieva, et al.). Florence, 1982.

Freiberg in Sachsen 1950 Freiberg, Stadt- und Bergmuseum. *Johann Christian Klengel 1751–1824: Gemälde und Zeichnungen.* Exh. cat. Freiberg in Sachsen, 1950.

Freude 1909 Freude, Felix. *Die Kaiserlich Französische Akademie der Freien Künste und Wissenschaften in Augsburg.* Augsburg, 1909.

Füssli 1770 Füssli, Johann Caspar. *Geschichte der besten Künstler in der Schweiz nebst ihren Bildnissen.* Zurich, 1770.

Füssli 1795 ———. *Leben der berühmten Maler: G. Ph. Rugendas und J. Kupetzki.* N.p., 1795.

Gaehtgens 1987 See Berlin 1987

Gage 1980 *Goethe on Art.* Selected, edited, and translated by John Gage. Berkeley and Los Angeles, 1980.

Garas 1959 Garas, Klara. "Joseph Winterhalter, 1743–1807." *Bulletin du Musée National Hongrois des Beaux-Arts* 14 (1959), pp. 75–90.

Garas 1960 ———. *Franz Anton Maulbertsch, 1724–1796.* Vienna, 1960.

Garas 1961 ———. "Zu Einigen Problemen der Malerei des 18. Jahrhunderts: Die Malerfamilie Palko." *Acta Historiae Artium* 7 (1961), pp. 229–50.

Garas 1974 ———. *Franz Anton Maulbertsch: Leben und Werk, Mit Oeuvrekatalog geordnet nach Standorten.* Salzburg, 1974.

Garas 1980 ———. *Deutsche und österreichische Zeichnungen des 18. Jahrhunderts: Ausgewählte Meisterwerke des Graphischen Sammlung des Museums der bildenden Künste.* Budapest, 1980.

Garzarolli-Thurnlackh 1925 Garzarolli-Thurnlackh, Karl von. *Das Graphische Werk Martin Johann Schmidts (Kremser Schmidt), 1718–1801.* Zurich, Vienna, and Leipzig, 1925.

Garzarolli-Thurnlackh 1928 ———. *Die barocke Handzeichnung in Österreich.* Zurich, Vienna, and Leipzig, 1928.

Gauss 1973 Gauss, Ulrike. *Andreas Thamasch, 1639–1697: Stiftsbildhauer in Stams und Meister von Kaisheim.* Weissenhorn, 1973.

Gay 1966 Gay, Peter. *The Enlightenment: An Interpretation.* Vol. 1, *The Rise of Modern Paganism.* New York, 1966. Vol. 2, *The Science of Freedom.* New York, 1969.

Gerich 1908 Gerich, Alfred. "Die Kuppel- und Deckengemälde in der Jesuitenkirche zu Mannheim." *Freiburger Diözesan-Archiv* 10 (1909), pp. 149ff.

Gerich 1909 ———. "Die künstlerische Ausstattung der Jesuitenkirche zu Mannheim." *Mannheimer Geschichtsblätter* 9 (1908), pp. 208–14.

Glaser 1983 Glaser, Hubert et al. *Vita Corbiniani. Bischof Arbeo von Freising und die Lebensgeschichte des hl. Korbinian.* 30. Sammelblatt des Historischen Vereins Freising. Munich, 1983.

Godefroy 1930 Godefroy, Louis. *L'oeuvre gravé de Adriaen van Ostade.* Paris, 1930.

Goldfarb 1982 Goldfarb, Hilliard. "Defining 'Naïve and Sentimental' Landscape: Schiller, Hackert, Koch, and the Romantic Experience." *The Bulletin of the Cleveland Museum of Art* 69, no. 9 (1982), pp. 282–96.

Gradmann 1943 Gradmann, Erwin. *Bildhauer-Zeichnungen.* Basel, 1943.

Grosswald 1912 Grosswald, Olgerd. *Der Kupferstich des XVIII. Jahrhunderts in Augsburg und Nürnberg.* Dissertation. Munich, 1912.

Grotkamp-Schepers 1980 Grotkamp-Schepers, Barbara. *Die Mannheimer Zeichnungsakademie (1756/69–1803) und die Werke der ihr angeschlossen Maler und Stecher.* Frankfurt am Main, 1980.

Grundmann 1967 Grundmann, Günther. *Barockfresken in Breslau.* Frankfurt am Main, 1967.

Guiffrey 1907 Guiffrey, Jean, and Pierre Marcel. *Inventaire général des dessins du Musée du Louvre et du Musée de Versailles: École Française.* 12 vols. Paris, 1907–75.

Guilmard 1880 Guilmard, Désiré. *Les Maîtres Ornemanistes: Dessinateurs, Peintres, Architectes, Sculpteurs et Graveurs: Écoles Française, Italienne, Allemande et des Pays-Bas.* 2 vols. Paris, 1880.

Gundersheimer 1930 Gundersheimer, Hermann. *Matthäus Günther: Die Freskomalerei im süddeutschen Kirchenbau des 18. Jahrhunderts.* Augsburg, 1930.

Gutkas 1985 Gutkas, Karl, ed. *Prinz Eugen und das barocke Österreich.* Vienna, 1985.

Hagedorn 1762 Hagedorn, Christian Ludwig von. *Betrachtungen über die Mahlerey.* Leipzig, 1762.

Hálová-Jahodová 1947 — Hálová-Jahodová, C. *Brno. Stavební a umělecký vývoj města.* Prague, 1947.

Hamacher 1987 — Hamacher, Bärbel. *Arbeitssituation und Werkprozess in der Freskomalerei von Matthäus Günther (1705–1788).* Munich, 1987.

Hamacher 1987a — ———. *Entwurf und Ausführung in der süddeutschen Freskomalerei des 18. Jahrhunderts.* Munich, 1987.

Hamann 1925 — Hamann, Richard. *Die deutsche Malerei vom Rokoko bis zum Expressionismus.* Leipzig and Berlin, 1925.

Hamburg 1974 — Hamburg, Hamburger Kunsthalle. *Caspar David Friedrich 1774–1840.* Exh. cat. (catalogue by Werner Hofmann). Hamburg, 1974.

Hämmerle 1928 — Hämmerle, Albert. "Johann Evangelist Holzer als Radierer." *Das Schwäbische Museum,* 1928.

Harries 1983 — Harries, Karsten. *The Bavarian Rococo Church: Between Faith and Aestheticism.* New Haven and London, 1983.

Hartford 1973 — Hartford, Wadsworth Athenaeum. *One Hundred Master Drawings from New England Private Collections.* Exh. cat. (catalogue by Franklin W. Robinson). Hartford, 1973–74.

Haskell 1980 — Haskell, Francis. *Patrons and Painters: A Study in the Relations between Italian Art and Society in Baroque Italy.* 2d ed. New Haven, 1980.

Hatfield 1943 — Hatfield, Henry Caraway. *Winckelmann and his German Critics 1755–1781: A Prelude to the Classical Age.* New York, 1943.

Heckmann 1954 — Heckmann, Hermann. *M.D. Pöppelmann als Zeichner.* Dresden, 1954.

Heffels 1969 — Heffels, Monika. *Die deutschen Handzeichnungen, Band IV: Die Handzeichnungen des 18. Jahrhunderts. Katalog des Germanischen Nationalmuseums Nürnberg.* Nuremberg, 1969.

Hegemann 1958 — Hegemann, Hans Werner. *Deutsches Rokoko.* Königstein im Taunus, 1958.

Heinecken 1768 — Heinecken, Karl Heinrich von. *Nachrichten um Künstlern und Kunstsachen.* Leipzig, 1768.

Hempel 1965 — Hempel, Eberhard. *Baroque Art and Architecture in Central Europe.* Harmondsworth, 1965.

Hentschel 1969 — Hentschel, Walter. "Die Zentralbauprojekte Augusts des Starken," *Abhandlungen der sächsischen Akademie der Wissenschaften zu Leipzig, Philosophisch-historische Klasse* 60, 1. Berlin, 1969.

Herder 1773 — Herder, Johann Gottfried von. *Von deutscher Art und Kunst.* Hamburg, 1773.

Herder 1967 — ———. *Sämtliche Werke.* 33 vols. Bernhard Suphon, ed. Hildesheim and New York, 1967–68.

Herget 1979 — Herget, Elisabeth. *Das florierende Wien: Vedutenwerk in vier Teilen aus dem Jahren 1724–1737.* Dortmund, 1979.

Holborn 1964 — Holborn, Hajo. *A History of Modern Germany, 1648–1840,* vol. 2. Princeton, 1969.

Horn 1951 — Horn, Adam. *Die Kunstdenkmäler von Schwaben II: Landkreis Donauwörth.* Munich, 1951.

Houston 1971 — Houston, The Museum of Fine Arts. *From the Collection of the University of Kansas Museum of Art.* Exh. cat. (catalogue by Randolph A. Youle et al.). Houston, 1971.

Hubala 1981 — Hubala, Erich. *Johann Michael Rottmayr.* Vienna and Munich, 1981.

Huber [1801] — Huber, Michel. *Catalogue raisonné du Cabinet d'Estampes de feu Monsieur Winckler, Banquier et Membre du Senat à Leipzig. Contenant une Collection des Pièces Anciennes et Modernes de toutes les Ecoles, dans une Suite d'Artistes Depuis l'Origine de l'Art de Graver jusqu'à nos Jours.* 3 vols. Leipzig, 1801–05.

Huggler 1976 — Huggler, Max. *Sigmund Freudenberger, der Berner Kleinmeister 1745–1801.* Bern, 1976.

Ilg 1893 — Ilg, Albert. *Georg Raphael Donner: Gedenkschrift zum 100. Jahrestage der Geburt des grossen österreichischen Bildhauer.* Vienna, 1893.

Isphording 1982 — Isphording, Eduard. *Gottfried Bernhard Göz, 1708–1774: Ölgemälde und Zeichnungen.* 2 vols. Weissenhorn, 1982–84.

Jacoby 1986 — Jacoby, Beverly Schreiber. *François Boucher's Early Development as a Draftsman, 1720–1734.* Dissertation. New York and London, 1986.

Jávor 1984 — Jávor, Anna. "Kracker Becsben 1719–1744/46." *Művészettörténeti Értesítő.* (1984), pp. 197ff.

Jessen 1922 — Jessen, Peter. *Meister des Ornamentstichs: eine Auswahl aus vier Jahrhunderten.* 4 vols. Berlin, 1922–23.

Josephson 1959 — Josephson, Ragnar. *Ehrenstrahls målareära.* Svenska humanistiska förbundets skrifter 68. Stockholm, 1959.

Justi 1956 Justi, Carl. *Winckelmann und seine Zeitgenossen*. 5th ed. Cologne, 1956.

Kadebö 1880 Kadebö, Heinrich. *Matthäus Donner und die Geschichte der Wiener Graveur-Akademie in der ersten Periode ihres Bestandes*. Vienna, 1880.

Kaiserslautern 1985 Kaiserslautern, Theodor-Zink-Museum. *Der Tiermaler Johann Heinrich Roos, 1631–1685: Gemälde, Zeichnungen, Druckgraphik: zum 300. Todestag*. Exh. cat. Kaiserslautern, 1985.

Kaufmann 1982 Kaufmann, Thomas DaCosta. "The Eloquent Artist: Towards an Understanding of the Stylistics of Painting at the Court of Rudolf II." *Leids Kunsthistorisch Jaarboek* 1 (1982–83), pp. 119–48.

Kaufmann 1988 ———. *Art and Architecture in Central Europe, 1550–1620: An Annotated Bibliography*. Boston, 1988.

Kaufmann 1988a ———. *The School of Prague: Painting at the Court of Rudolf II*. Chicago and London, 1988.

Keller 1981 Keller, Ina Maria. *Studien zu den deutschen Rembrandtnachahmungen des 18. Jahrhunderts*. Dissertation, Munich, 1971. Berlin, 1981.

Kemp 1979 Kemp, Wolfgang. ". . . einen wahrhaft bildenden Zeichenunterricht überall einzuführen." *Zeichnen und Zeichenunterricht der Laien 1500–1870. Ein Handbuch*. Frankfurt am Main, 1979.

Kerber 1971 Kerber, Bernard. *Andrea Pozzo*. Berlin and New York, 1971.

Kiel 1986 Kiel. *Kunst im Dienste der Aufklärung: Radierungen von Bernhard Rode 1725–1797. Mit einem Gesamtverzeichnis aller Radierungen des Künstlers im Besitz der Graphischen Sammlung der Kunsthalle zu Kiel*. Frank Büttner, ed. Kiel, 1986.

Klepper 1959 Klepper, J. *In tormentis pinxit*. 2d ed. Stuttgart, 1959.

Klessman 1984 Klessman, Rüdiger, and Reinhold Wex, eds. *Beiträge zur Geschichte der Ölskizze vom 16. bis zum 18. Jahrhundert: Ein Symposium aus Anlass der Ausstellung "Malerei aus erster Hand: Ölskizzen von Tintoretto bis Goya" im Herzog Anton Ulrich-Museum Braunschweig*. Braunschweig, 1984.

Kloster Aldersbach 1986 Kloster Aldersbach. *Cosmas Damian Asam, 1686–1739: Leben und Werk*. Exh. cat. (catalogue by Bruno Bushart and Bernard Rupprecht). Kloster Aldersbach, 1986.

Knab 1954 Knab, Eckhart. "Daniel Gran als Zeichner." *Wiener Jahrbuch für Kunstgeschichte* 15 (1954), pp. 145–72.

Knab 1963 ———. "Über den Zeichenstil und einige Zeichnungen Paul Trogers." *Albertina Studien* 1, no. 1 (1963), pp. 21–36.

Knab 1977 ———. *Daniel Gran*. Vienna and Munich, 1977.

Knackfuss 1908 Knackfuss, Hermann. *Geschichte der Königlichen Kunstakademie zu Kassel*. Kassel, 1908.

Knott 1978 Knott, Nagia. *Georg Anton Urlaub (1713–1759): Ein fränkischer Maler*. Würzburg, 1978.

Koch 1873 Koch, John. *Die Siebenschläferlegende: ihr Ursprung und ihre Verbreitung*. Leipzig, 1873.

Koller 1970 Koller, Manfred. "Die Akademie Peter Strudels in Wien (1688 bis 1714)." *Mitteilungen der österreichischen Galerie* 14, no. 58 (1970), pp. 5–74.

Koschatzky 1986 Koschatzky, Walter. *Die Kunst der Zeichnung: Technik, Geschichte, Meisterwerke*. 5th ed. Munich, 1986.

Kosel 1976 Kosel, Karl. "Neuentdeckungen zum Lebenswerk von Johann Rieger." *Jahrbuch des Vereins für Augsburger Bistumsgeschichte e. V.* 10 (1976), pp. 245–64.

Krapf 1979 Krapf, Michael. *Die Baumeister Gumpp*. Vienna and Munich, 1979.

Kris 1932 Kris, Ernst. "Die Charakterköpfe des Franz Xaver Messerschmidt: Versuch einer historischen und psychologischen Deutung." *Jahrbuch der Kunsthistorischen Sammlungen in Wien*, n.F. 6 (1932), pp. 169–228.

Kris 1979 ———. "A Psychotic Sculptor of the Eighteenth Century." Pp. 128–50. *Psychoanalytic Explorations in Art*. 4th ed. New York, 1979.

Kroměříž 1982 Kroměříž, Muzeum Kroměřížska. *František Antonín Grimm: Architekt XVIII. století*. Exh. cat. (catalogue by Jiří Kroupa). Kroměříž, 1982.

Krönig 1971 Krönig, Wolfgang. *Eine Italien-Landschaft des 18. Jahrhunderts in Deutschen Archäologischen Institut zu Berlin: Philipp Hackerts Ansicht der Solfatara bei Neapel*. Berlin, 1971.

Krönig 1964 ———. "Sepia-Zeichnungen aus der Umgebung Neapels von Philipp Hackert." *Wallraf-Richartz-Jahrbuch* 33 (1971), pp. 175–204.

Kroupa 1985 Kroupa, Jiří. "Poznámky Sonnenfelsově koncepci umění." *Uměleckohistorický Sborník* (1985), pp. 195–209.

Kroupa 1986 ———. *Alchymie Štěstí. Pozdní Osvícenství a Moravská Společnost.* Kroměříž and Brno, 1986.

Krull 1977 Krull, Ebba. *Franz Xaver Habermann (1721–1796): ein Augsburger Ornamentist des Rokoko.* Augsburg, 1977.

Kuba-Hauk 1978 Kuba-Hauk, Waltraut. "Caspar Franz Sambach, 1715–1795." Unpublished dissertation. Vienna, 1978.

Kubler 1962 Kubler, George. *The Shape of Time: Remarks on the History of Things.* New Haven and London, 1962.

Künstle 1926 Künstle, Karl. *Ikonographie der Christlichen Kunst: II, Ikonographie der Heiligen.* Freiburg im Breisgau, 1926.

Kunzle 1973 Kunzle, David. *History of the Comic Strip. Volume I: The Early Comic Strip: Narrative Strips and Picture Stories in the European Broadsheet from c. 1450 to 1825.* Berkeley, 1973.

Kurz 1953 Kurz, Otto. "Huius nympha loci: A pseudo-classical inscription and a Drawing by Dürer." *Journal of the Warburg and Courtauld Institutes* 16 (1953), pp. 171–77.

Lanckorońska/Oehler 1932 Lanckorońska, Maria, and Richard Oehler. *Die Buchillustration des XVII. Jahrhunderts in Deutschland, Österreich und der Schweiz.* Leipzig, 1932–34.

Landschulz 1977 Landschulz, Marlene. *Mainzer Maler aus der ersten Hälfte des 19. Jahrhunderts: Die Meister und ihre Werke.* Dissertation. Mainz, 1977.

Lankheit 1954 Lankheit, Klaus. *Die Zeichnungen des Kurpfälzischen Hofbildhauers Paul Egell (1691–1752).* Karlsruhe, 1954.

Lankheit 1975 ———. "Egid Quirin Asams Entwurf zum Kuppelgemälde der Mannheimer Jesuitenkirche." *Pantheon* 23 (1975), pp. 34–40.

Larsson 1985 Larsson, Lars Olof. "Nationalstil und Nationalismus in der Kunstgeschichte der zwanziger und dreissiger Jahre." *Kategorien und Methoden der deutschen Kunstgeschichte, 1900–1930.* Lorenz Dittmann, ed. Stuttgart, 1985, pp. 169–84.

Lawrence, Kansas 1956 The University of Kansas Museum of Art. *German and Austrian Prints and Drawings of the Eighteenth Century.* Exh. cat. Lawrence, Kansas, 1956.

LeClaire 1987 LeClaire, Thomas. *Peter Brandl (1668 Prag-Kuttenberg 1735).* Hamburg, 1987.

LeClaire 1987a Thomas LeClaire, *Kunsthandel IV. Handzeichnungen und Aquarelle 1500–1900.* Hamburg, 1987.

Leipzig 1985 Leipzig, Museum der bildenden Künste. *Kunst der Buchzeit. Malerei und Zeichnungen aus Sammlungen der DDR.* Exh. cat. Leipzig, 1985.

Leipzig 1986 *Anton Graff: Selbstbildnis vor der Staffelei. Meisterwerke aus dem Museum der bildenden Künste, Leipzig. Dokumentation und Interpretation.* Exh. cat. Leipzig, 1986.

Lhotsky 1941 Lhotsky, Alphons. *Die Geschichte der Sammlungen. Festschrift des Kunsthistorischen Museums in Wien, 1891–1941,* vol. I. Vienna, 1941–45.

Löffler 1955 Löffler, Fritz. *Das alte Dresden: Geschichte seiner Bauten.* Dresden, 1955.

London 1972 London, the Royal Academy, and the Victoria and Albert Museum. *The Age of Neo-Classicism.* Exh. cat. Council of Europe. London, 1972.

London 1973 London, the Victoria and Albert Museum, and Edinburgh, the Talbot Rice Arts Centre. *Master Drawings of the Roman Baroque from the Kunstmuseum Düsseldorf: A Selection from the Lambert Krahe Collection.* Exh. cat. (introduction and catalogue by Dieter Graf). London, 1973.

London 1975 London, Heim Gallery, and elsewhere. *German Baroque Drawings.* Exh. cat. (catalogue by Dieter Graf). London, 1975–76.

London 1985 London, Goethe Institute. *The Art of German Drawing IV: German Drawings of the 18th Century from the Collection of the Berlin Kupferstichkabinett Staatliche Museen Preussischer Kulturbesitz.* Exh. cat. (introduction by Thomas W. Gaehtgens). London, 1985.

Lorenz 1986 Lorenz, Hellmut. "Zur Internationalität der Wiener Barockarchitektur." *Wien und der europäische Barock. Akten des XXV. Internationalen Kongresses für Kunstgeschichte* 7. Vienna, 1986, pp. 21–30.

Los Angeles 1968 Los Angeles, Los Angeles County Museum of Art, and elsewhere. *Image and Imagination. Oil Sketches of the Baroque. Collection Kurt Rossacher.* Salzburg, 1968–69.

Lugt 1921 Lugt, Frits. *Les Marques de Collections de Dessins et d'Estampes.* 2 vols. Amsterdam, 1921; The Hague, 1956.

Luther 1988 Luther, Edith. *Johann Heinrich Frauenholz.* Münster, 1988.

Lützow 1877 Lützow, Carl Friedrich Arnold von. *Geschichte der Kaiserlich Königlichen Akademie*

Madrid 1980 der bildenden Künste. Festschrift zur Eröffnung des neuen Akademiegebäudes. Vienna, 1877.

Madrid, Prado. *Antonio Rafael Mengs 1728–1779*. Exh. cat. Madrid, 1980.

Manners 1924 Manners, Victoria, and G.C. Williamson. *Angelica Kauffmann, R.A.: Her Life and Her Works.* New York, 1924.

Marx 1979 Marx, Harald. "Pierre Jean Mariette und Dresden." *Dresdener Kunstblätter* 23 (1979), no. 3, pp. 77–87.

Maser 1960 Maser, Edward A. "German and Austrian Rococo in American Collections." *Connoisseur*, no. 145 (1960), pp. 130–35.

Maser 1971 Ripa, Cesare. *Baroque and Rococo Pictorial Imagery: the 1758–60 Hertel Edition of Ripa's "Iconologia".* Introduction, translations, and 200 commentaries by Edward A. Maser. New York, 1971.

Mathern 1974 Mathern, Willy. *Maler Müller der Bad Kreuznacher Maler und Dichter: Friedrich Müllers Bildkunst und Dichtung.* Bad Kreuznach, 1974.

Matsche-von Wicht 1977 Matsche-von Wicht, Betka. *Franz Sigrist 1727–1803: Ein Maler des 18. Jahrhunderts.* Weissenhorn, 1977.

Mattenklott 1984 Mattenklott, Gert. "Die neue Kunst und ihr Publikum. Rezeptionsweisen einer erweiterten Öffentlichkeit." *Ideal und Wirklichkeit der bildenden Kunst im späten 18. Jahrhundert.* Herbert Beck et al., ed. Frankfurter Forschungen zur Kunst 11. Berlin, 1984, pp. 13–43.

Mayr 1903 Mayr, Anton. "Beziehungen des Augsburger Malers und Kupferstechers Gottfried Bernhard Göz zum Stifte Admont: Ein Beitrag zur Kunstgeschichte." *Zwanzigster Jahresbericht des K. K. Carl Ludwig-Gymnasiums im XII. Bezirke von Wien.* Vienna, 1903.

Meinecke-Berg 1971 Meinecke-Berg, Viktoria. *Die Fresken des Melchior Steidl.* Dissertation. Munich, 1971.

Melk 1980 Melk, Benediktinerstift. *Österreich zur Zeit Kaiser Josephs II., Mitregent Kaiserin Maria Theresias, Kaiser und Landesfürst.* Exh. cat. Vienna, 1980.

Mengs 1762 Mengs, Anton Raphael. *Gedanken über die Schönheit und über den Geschmak in der Malerey.* Zurich, 1762.

Mengs 1780 "Lezioni pratiche di Pittura." *Opere di Antonio Raffaello Mengs* . . . Giuseppe Niccola d'Azara, ed. 2, 1st ed. Parma, 1780, pp. 217–91.

Metropolitan Museum of Art Drawings 1895 New York, the Metropolitan Museum of Art. *Drawings, watercolor paintings, photographs and etchings, tapestry, etc.* Handbook no. 8. New York, 1895.

Metzger 1972 ———. *Januarius Zick: Datierte und datierbare Gemälde.* Koblenz, 1972.

Metzger 1981 Metzger, Othmar. *Kataloghefte des Mittelrhein-Museums Koblenz II: Januarius Zick, Gemälde und Zeichnungen.* Koblenz, 1981.

Michalkowa 1960 Michalkowa, Janina. "Rzymski Portret Stanisława Poniatowskiego." *Biuletyn Historii Sztuki* 22, no. 3 (1960), pp. 296–98.

Michel 1984 Michel, Petra. *Christian Wilhelm Ernst Dietrich (1712–1774) und die Problematik des Eklektizismus.* Dissertation, Munich, 1983; Munich, 1984.

Mick 1984 Mick, Ernst Wolfgang, *Johann Evangelist Holzer (1709–1740): Ein frühvollendetes Malergenie des 18. Jahrhunderts.* Munich and Zurich, 1984.

Milan 1966 Milan, Palazzo Reale. *L'arte del Barocco in Boemia.* Exh. cat. Milan, 1966.

Milde 1981 Milde, Kurt. *Neorenaissance in der deutschen Architektur des 19. Jahrhunderts: Grundlagen, Wesen und Gültigkeit.* Dresden, 1981.

Mildenberger 1985 Mildenberger, Hermann. "Ein Kunstler zwischen den Stilen: Bildniszeichnungen Johann Wilhelm Tischbeins." *Kunst und Antiquitäten* 1 (1985).

Minneapolis 1961 Minneapolis, University Gallery, University of Minnesota. *The Eighteenth Century: One Hundred Drawings by One Hundred Artists.* Exh. cat. Minneapolis, 1961.

Minneapolis 1971 ———. *The Hylton A. Thomas Collection: Paintings, Drawings, Prints, Furniture, and Decorative Arts.* Exh. cat. Minneapolis, 1971.

Moir 1976 Moir, Alfred. *European Drawings in the Collection of the Santa Barbara Museum of Art.* Santa Barbara, 1976.

Möhle 1947 Möhle, Hans. *Deutsche Zeichnungen des 17. und 18. Jahrhunderts.* Berlin, 1947.

Mongan 1940 Mongan, Agnes, and Paul J. Sachs. *Drawings in the Fogg Museum of Art.* 3 vols. Cambridge, Massachusetts, 1940.

Monnier 1977 Monnier, Geneviève. "Le corps et son image. Anatomies et Académies." *La Revue du Louvre et des Musées de France* 27, no. 3 (1977), pp. 182–84.

Müller 1896 Müller, Hans. *Die Königliche Akademie der Künste zu Berlin 1696–1896.* Berlin, 1896.

Munich 1958 Munich, Residenzmuseum. *Europäisches Rokoko. Kunst und Kultur des 18. Jahrhunderts.* Exh. cat., Council of Europe. Munich, 1958.

Munich 1980 Munich, Residenzmuseum. *Wittelsbach und Bayern: Um Glauben und Reich, Kurfürst Maximilian I.* Exh. cat. (catalogue by Hubert Glaser). Munich, 1980.

Munich 1983 Munich, Staatliche Graphische Sammlungen, Neue Pinakothek. *Zeichnungen aus der Sammlung des Kurfürsten Carl Theodor.* Exh. cat. (catalogue by Dieter Kuhrmann et al.). Munich, 1983–84.

Munich 1985 Munich, Bayerisches Nationalmuseum. *Bayerische Rokokoplastik. Vom Entwurf zur Ausführung.* Exh. cat. (catalogue by Peter Volk et al.). Munich, 1985.

Nagler 1835 Nagler, G.K. *Neues Allgemeines Künstler-Lexikon.* 22 vols. Munich, 1835–52.

Nagler 1857 ———. *Die Monogrammisten und diejenigen bekannten und unbekannten Künstler aller Schulen. . . .* 5 vols. Munich and Leipzig, 1857–79.

Nationalgalerie Berlin 1976 Nationalgalerie Berlin. *Nationalgalerie Berlin. Verzeichnis der Gemälde und Skulpturen des 19. Jahrhunderts.* Berlin, 1976.

Nerdinger and Zimmermann 1986 Nerdinger, Winfried, and Florian Zimmermann. *Die Architekturzeichnung. Vom barocken Idealplan zur Axonometrie.* Munich, 1986.

Netopil 1983 Netopil, Leopold, and Franz Wagner, eds. *Imagination und Imago: Festschrift Kurt Rossacher.* Salzburg, 1983.

Neumann 1970 Neumann, Jaromír. *Das böhmische Barock.* Vienna, 1970.

Neustätter 1933 Neustätter, Ernst. *Johann Evangelist Holzer (1709–1740).* Dissertation. Munich, 1933.

New York 1959 New York, Columbia University. *Great Master Drawings of Seven Centuries: A Benefit Exhibition of Columbia University for the Scholarship Fund of the Department of Fine Arts and Archaeology.* Exh. cat. New York, 1959.

New York 1959 New York, the Cooper Union Museum and elsewhere. *Five Centuries of Drawing: The Cooper Union Centennial Exhibition.* New York, 1959–61.

New York 1962 ———. *Extravagant Drawings of the Eighteenth Century.* Exh. cat. (catalogue by Richard P. Wunder). New York, 1962.

New York 1967 New York, Columbia University, Department of Art History and Archaeology. *Masters of the Loaded Brush. Oil Sketches from Rubens to Tiepolo.* Exh. cat. (introduction by Rudolf Wittkower). New York, 1967.

New York 1973 New York, Herbert E. Feist Gallery. *Master Drawings.* Exh. cat. New York, 1973–74.

New York 1975 New York, the Metropolitan Museum of Art. *European Drawings Recently Acquired, 1972–1975.* Exh. cat. New York, 1975–76.

New York 1981 New York, Shepherd Gallery. *German Drawings and Watercolors 1780–1880: A Survey of Works on Paper by German-Speaking Artists.* Exh. cat. New York, 1981.

New York 1983 ———. *Fifty German Nineteenth-Century Drawings and Watercolors.* Exh. cat. New York, 1983.

New York 1988 New York, The Pierpont Morgan Library. *The Romantic Spirit. German Drawings, 1780–1850, from the Nationalgalerie (Staatliche Museen Berlin) and the Kupferstichkabinett (Staatliche Kunstsammlungen Dresden), German Democratic Republic.* Exh. cat. New York, 1988.

Nuremberg 1962 Nuremberg, Germanisches Nationalmuseum. *Barock in Nürnberg, 1600–1750. Aus Anlass der Dreihundertjahrfeier der Akademie der bildenden Künste.* Exh. cat. (introduction by Ludwig Grote). Nuremberg, 1962.

Nuremberg 1983 ———. *Zeichnungen der Goethezeit aus einer neuerworbenen Sammlung.* Exh. cat. (catalogue by Rainer Schoch). Nuremberg, 1983–84.

Oettingen 1900 Oettingen, Wolfgang von. *Die Königliche Akademie der Künste zu Berlin 1696–1900.* Berlin, 1900.

Oldenburg 1987 Oldenburg, Landesmuseum. *Johann Heinrich Wilhelm Tischbein: Goethes Maler und Freund.* Exh. cat. (catalogue by Hermann Mildenberger et al.). Oldenburg, 1987–88.

Ost 1971 Ost, Hans. *Einsiedler und Mönche in der deutschen Malerei des 19. Jahrhunderts.* Bonner Beiträge zur Kunstwissenschaft. Düsseldorf, 1971.

Otto 1979 Otto, Christian F. *Space into Light. The Churches of Balthasar Neumann.* New York, Cambridge, Mass., and London, 1979.

Palm Beach 1968 Norton Gallery of Art, Palm Beach, Florida, and elsewhere. *Old Master Drawings from the Collection of Mr. and Mrs. Lester Francis Avnet.* Palm Beach, 1968.

Paris 1987: Paris, Grand Palais, and New York, the Metropolitan Museum of Art. *Fragonard.* Exh. cat. (catalogue by Pierre Rosenberg). Paris and New York, 1987–88.

Pavel 1978: Pavel, Jakub, and Eva Šamánková. *České Budějovice.* Prague, 2d ed., 1978.

Pawlowska 1969: Pawlowska, Magdalena. "O portrétách polskich Angeliki Kauffmann," *Rocznik Muzeum Narodowego w Warszawie* 13, no. 2, 1969, pp. 73–144.

Pelzel 1968: Pelzel, Thomas O. *Anton Raphael Mengs and Neoclassicism: His Art, His Influence, and His Reputation.* Unpublished dissertation. Princeton University, 1968.

Peters 1973: Peters, Heinz. "Wilhelm Lambert Krahe und die Gründung der Kunstakademie in Düsseldorf." *Zweihundertjahre Kunstakademie Düsseldorf:* E. Trier, ed. Düsseldorf, 1973, pp. 1–30.

Pevsner 1973: Pevsner, Nikolaus. *Academies of Art, Past and Present.* 2d ed. New York, 1973.

Pigler 1954: ——. "Neid und Unwissenheit als Widersacher der Kunst." *Acta Historiae Artium* 1 (1954), pp. 215–35.

Pigler 1929: Pigler, Andreas. *Georg Raphael Donner.* Leipzig and Vienna, 1929.

Pigler 1974: ——. *Barockthemen: Eine Auswahl von Verzeichnissen zur Ikonographie des 17. und 18. Jahrhunderts.* 2 vols., 2d ed. Budapest, 1974.

Piles 1708: Piles, Roger de. *Cours de peinture par principes.* Paris, 1708.

Piles 1743: ——. *The Principles of Painting . . . To Which is Added the Balance of Painters. . . .* Trans. by a painter. London, 1743.

Pinder 1965: Pinder, Wilhelm. *Deutscher Barock.* 3d ed. Königstein im Taunus, 1965.

Popp 1904: Popp, Joseph. "Martin Knollers Malrezepte." *Zeitschrift des Ferdinandeums* 48 (1904), pp. 120–28.

Pötschner 1978: Pötschner, Peter. *Wien und die Wiener Landschaft: spätbarocke und biedermeierliche Landschaftskunst in Wien.* Salzburg, 1978.

Pötzl-Maliková 1973: Pötzl-Maliková, Maria. "Die Schule G. R. Donners in der Slowakei." *Mitteilungen der österreichischen Galerie* 17, no. 61 (1973), pp. 77–180.

Pötzl-Maliková 1982: ——. *Franz Xaver Messerschmidt.* Vienna and Munich, 1982.

Potsdam 1986: Potsdam, Neues Palais in Sanssouci. *Friedrich II. und die Kunst: Ausstellung zum 200. Todestag.* Potsdam, 1986.

Prague 1968: Prague, Národní Galerie. *Petr Brandl, 1668–1735.* Exh. cat. (catalogue by Jaromír Neumann). Prague, 1968.

Preiss 1962: Preiss, Pavel. "Nové příspěvky k dílu Jiřího Viléma Neunherze." *Umění* 10, no. 1 (1962), pp. 90–93.

Preiss 1975: ——. "Franz Karl Palko als Zeichner." *Bulletin du Musée Hongrois des Beaux-Arts,* no. 45 (1975), pp. 63–108.

Preiss 1979: ——. *Barockzeichnungen: Meisterwerke des böhmischen Barocks.* Hanau, 1979.

Preissler 1740: Preissler, Johann Daniel. *Die durch Theorie erfundene Practic, oder Gründlich-verfasste Reguln deren man sich als einer Anleitung zu berühmter Künstlere Zeichen-Wercken bestens bedienen kan.* 4 vols. 4th ed. Nuremberg, 1740.

Preissler 1759: ——. *Gründliche Anleitung, welcher man sich im Nachzeichnen schöner Landschafften oder Prospecten bedienen kan, den Liebhabern der Zeichen-Kunst mitgetheilet und eigenhändig in Kupffer gebracht.* 5th ed. Nuremberg 1759; 1st ed. Nuremberg 1734.

Princeton 1977: Princeton, The Art Museum, Princeton University. *Eighteenth-Century French Life-Drawing: Selections from the Collection of Mathias Polakovits.* Exh. cat. (catalogue by James Henry Rubin). Princeton, 1977.

Princeton 1982: Princeton, The Art Museum, Princeton University. *Drawings from the Holy Roman Empire 1540–1680: A Selection from North American Collections.* Exh. cat. (catalogue by Thomas DaCosta Kaufmann). Princeton, 1982.

Providence 1957: Providence, Rhode Island School of Design. *The Age of Canova: An Exhibition of the Neo-Classic.* Providence, 1957.

Providence 1965: ——. *Drawings from the Collection of Mr. and Mrs. Winslow Ames.* Exh. cat. Providence, 1965.

Providence 1967: ——. *Recent Acquisitions 1966–67.* Providence, 1967.

Reichersberg 1974: Reichersberg am Inn, Augustinerchorherrenstift. *Die Bildhauerfamilie Schwanthaler, 1633–1848: Vom Barock zum Klassizismus.* Exh. cat. Linz, 1974.

Reisberger, n.d.: Reisberger, Ludwig, ed. *Eine Lanze für die Freskomalerei mit eine Anleitung zur Fresko-*

——. *malerei nach dem Manuskripte Martin Knollers 1786.* Technische Flugblätter der Deutschen Malerzeitung die Mappe, no. 1, n.d.

Reno 1978 Reno, Nevada, Church Fine Arts Gallery, University of Nevada. *Master Drawings from the E.B. Crocker Art Gallery.* Exh. cat. Reno, 1978.

Riesenhuber 1923 Riesenhuber, Martin. *Die kirchlichen Kunstdenkmäler des Bistums St. Pölten.* St. Pölten, 1923.

Robson-Scott 1965 Robson-Scott, W. D. *The Literary Background to the Gothic Revival in Germany.* Oxford, 1965.

Rome 1972 Rome, Museo di Roma, Palazzo Braschi. *Artisti Austriaci a Roma dal Barocco alla Secessione.* Instituto Austriaco di Cultura in Roma. Rome, 1972.

Rothstein 1976 Rothstein, Eric. "'Ideal presence' and the 'non finito' in eighteenth-century aesthetics," *Eighteenth-Century Studies* 9, no. 3 (Spring 1976), pp. 307–32.

Rott 1917 Rott, Hans. *Kunst und Künstler am Baden-Durlacher Hof.* Karlsruhe, 1917.

Rotterdam and Braunschweig 1983 Rotterdam, Museum Boymans-van Beuningen, and Braunschweig, Herzog Anton Ulrich-Museum. *Malerei aus erster Hand: Ölskizzen von Tintoretto bis Goya.* Exh. cat. Rotterdam, 1983–84.

Rowlands 1970 Rowlands, John. "Germanisches Nationalmuseum, Nuremberg. Die deutschen Handzeichnungen." *Master Drawings* 8 (1970), pp. 290–95.

Ruemann 1931 Ruemann, Arthur. *Das deutsche illustrierte Buch des XVIII. Jahrhunderts.* Studien zur deutschen Kunstgeschichte, Heft 282. Strassburg, 1931.

Rupprecht 1959 Rupprecht, Bernhard. *Die bayerische Rokoko-Kirche.* Münchner Historische Studien, Abteilung Bayerische Geschichte, 5. Kallmünz, 1959.

Rupprecht 1980 ——. *Die Bruder Asam: Sinn und Sinnlichkeit im bayerischen Barock.* Regensburg, 1980.

Sacramento 1939 Sacramento, E.B. Crocker Art Gallery. *Old Master Drawings from the E.B. Crocker Collection. The German Masters 15th to 19th Centuries.* Exh. cat. (catalogue by Alfred Neumeyer). Sacramento, 1939.

Sacramento 1971 ——. *Master Drawings from Sacramento.* Sacramento, 1971.

Sacramento 1972 ——. *Classical Narratives in Master Drawings Selected from the Collection of the E.B. Crocker Art Gallery.* Seymour Howard, ed. Sacramento, 1972.

Sacramento 1983 ——. *Saints and Sinners in Master Drawings: Selected from the Collection of the Crocker Art Museum.* Seymour Howard, ed. Sacramento, 1983.

Salzburg 1954 Salzburg, Residenzgalerie. *Johann Michael Rottmayr: Werk und Leben.* Exh. cat. Salzburg, 1954.

Salzburg 1981 Salzburger Barockmuseum. *Österreichische Barockzeichnungen aus dem Museum der Schonen Künste in Budapest.* Exh. cat. (catalogue by Klara Garas). Salzburg, 1981.

Salzburg 1984 ——. *Wenzel Lorenz Reiner (1689–1743): Ölskizzen, Zeichnungen und Druckgraphik.* Exh. cat. (catalogue by Pavel Preiss). Salzburg, 1984.

Sandrart 1675 Sandrart, Joachim von. *L'Academia todesca della architectura, scultura e pittura: oder, Teutsche Academie der edlen Bau- Bild- und Mahlerey-Künste.* 2 vols. Nuremberg, 1675–79.

Sarasota 1972 Sarasota, Florida, the John and Mable Ringling Museum of Art. *Central Europe 1600–1800.* Exh. cat. (catalogue by Kent Sobotik). Sarasota, 1972.

Sartorius 1700 Sartorius, Augustinus. *Cistercium Bis-Tercium seu Historia Elogialis in qua Sacerrima Ordinis cisterciensis Anno Domini 1698 a Sui Origine Sexies, seu Bis-ter Saecularis.* 1700. German ed. Prague, 1708.

Sásky 1982 Sásky, Ladislav. *Bratislavské Rokoko.* Bratislava, 1982.

Schenk zu Schweinsberg 1930 Schenk zu Schweinsberg, Eberhard. *Georg Melchior Kraus.* Weimar, 1930.

Scheyer 1949 Scheyer, Ernst. "German Paintings and Drawings from the Time of Goethe in American Collections." *Art Quarterly* 12, no. 3 (1949), pp. 231–56.

Scheyer 1961 ——. *Die Kunstakademie Breslau und Oskar Moll.* Würzburg, 1961.

Scheyer 1965 ——. "Christoph Nathe und die Landschaftskunst des ausgehenden 18. Jahrhunderts," in *Schlesische Malerei der Biedermeierzeit. Bau- und Kunstdenkmäler des deutschen Ostens,* Reihe C, Schlesien, Bd. 2. Frankfurt am Main, 1965, pp. 241–68.

Schiff 1973 Schiff, Gert. *Johann Heinrich Füssli, 1741–1825.* Zurich and Munich, 1973.

Schiller 1966 — Schiller, Gertrud. *Ikonographie der christlichen Kunst.* 4 vols. Gütersloh, 1966–80.

Schilling 1973 — Schilling, Edmund. *Städelsches Kunstinstitut Frankfurt am Main, Katalog der deutschen Zeichnungen: Alte Meister.* 4 vols. Munich, 1973.

Schlager 1853 — Schlager, J.E. *Georg Raphael Donner.* Vienna, 1853.

Schleissheim 1976 — *Altes und Neues Schloss Schleissheim. Kurfürst Max Emanuel: Bayern und Europa um 1700.* Exh. cat. (catalogue by Hubert Glaser). Munich, 1976.

Schlosser[-Magnino] 1964 — Schlosser[-Magnino], Julius von. *La letteratura artistica. Manuale delle fonti della storia dell'arte moderna.* Trans. Filippo Rossi, 3d ed. Florence and Vienna, 1964.

Schmidt 1941 — Schmidt, J. Heinrich. "Zur Geschichte der Düsseldorfer Akademie." *Jahresbericht der Staatlichen Kunstakademie Düsseldorf 1941–44,* pp. 53–87.

Schnell 1961 — Schnell, Johannes. *François de Cuvilliés' Schule Bayerische Architektur. Ein Beitrag zum Stichwerk und zur Architekturtheorie beider Cuvilliés.* Dissertation. Munich, 1961.

Schoener 1966 — Schoener, Susanne. *Handzeichnungen von Cosmas Damian Asam.* Unpublished thesis. Munich, 1966.

Schrötter 1908 — Schrötter, Georg. *Die Nürnberger Malerakademie. . . .* Würzburg, 1908.

Schulze 1940 — Schulze, Friedrich. *Adam Friedrich Oeser und die Gründung der Leipziger Akademie.* Leipzig, 1940.

Schuster 1936 — Schuster, Marianne. *Johann Esaias Nilson: Ein Kupferstecher des süddeutschen Rokoko, 1721–1788.* Munich, 1936.

Schwarz 1959 — Schwarz, Heinrich. "Franz Anton Maulbertsch in American Museums." *The Baltimore Museum of Arts News* 23, no. 1 (1959), pp. 9–15.

Sedlmayr 1925 — Sedlmayr, Hans. *Fischer von Erlach der Ältere.* Munich, 1925.

Sedlmayr 1930 — ———. *Österreichische Barockarchitektur, 1690–1740.* Vienna, 1930.

Sedlmayr 1932 — ———. "Zum Oeuvre Fischers von Erlach." *Belvedere,* no. 9/10 (1932), pp. 89–115.

Sedlmayr 1938 — ———. "Die politische Bedeutung des deutschen Barocks." Festgabe für Heinrich Ritter von Srbik. *Gesamtdeutsche Vergangen heit. Festgabe für Heinrich Ritter von Srbik.* Wilhelm Bauer, et al. Munich, 1938, pp. 126–40.

Sedlmayr 1938a — ———. "Vermutungen und Fragen zur Bestimmung der altfranzösischen Kunst." *Festschrift Wilhelm Pinder, zum sechzigsten Geburtstage.* Leipzig, 1938, pp. 9–27.

Sedlmayr 1959 — ———. *Epochen und Werke. Gesammelte Schriften zur Kunstgeschichte.* 2 vols. Munich, 1959–60.

Sieveking 1976 — Sieveking, Hinrich. "Georg Anton Urlaub." *Die Kunst und das schöne Heim* 12 (1976), pp. 741–56.

Simon 1984 — Simon, Adelheid, and Franz X. Schlagberger. *Matthäus Günther 1705–1788: der Höhepunkt der Freskomalerei im Rokoko.* Prüm, 1984.

Spicer 1970 — Spicer, Joaneath Ann. "The 'Naer het leven' Drawings: By Pieter Brueghel or Roelandt Savery?" *Master Drawings* 8 (1970), pp. 3–30.

Spicer 1970a — ———. "Roelandt Savery's Studies in Bohemia." *Umění* 18 (1970), pp. 270–75.

Spicer 1979 — ———. *The Drawings of Roelandt Savery.* Unpublished dissertation. Yale University, 1979.

Spielman 1977 — Spielman, John P. *Leopold I of Austria.* London, 1977.

Staatliche Museen zu Berlin 1936 — Staatliche Museen zu Berlin. *Katalog der Ornamentstichsammlung der Staatlichen Kunstbibliothek Berlin.* 2 vols. Berlin, 1936–39.

Steinbrucker 1921 — Steinbrucker, Charlotte, ed. *Briefe Daniel Chodowieckis an Anton Graff.* Berlin and Leipzig, 1921.

Steinmetz 1985 — Steinmetz, Horst, ed. *Friedrich II. König von Preussen und die deutsche Literatur des 18. Jahrhunderts.* Stuttgart, 1985.

Stendal 1976 — Stendal, Winckelmann-Museum. *Adam Friedrich Oeser: Freund und Lehrer Winckelmanns und Goethes.* Exh. cat. (ed. Max Kunze). Stendal, 1976–77.

Stillfried 1879 — Stillfried, Heinrich Graf. *Leben und Kunstleistungen des Malers Georg Philipp Rugendas und seiner Nachkommer.* Berlin, 1879.

Storrs 1973 — Storrs, the William Benton Museum of Art, the University of Connecticut. *The Academy of Europe: Rome in the 18th Century.* Exh. cat. (catalogue by Frederick Den Broeder). Storrs, 1973.

Stübel 1914 — Stübel, Moritz. *Der Landschaftsmaler Johann Alexander Thiele und seine sächsischen Prospekte.* Leipzig and Berlin, 1914.

Stuttgart 1959 — Stuttgart, Museum der Bildenden Künste. *Die Hohe Carlsschule.* Exh. cat. Stuttgart, 1959–60.

Stuttgart 1964 Stuttgart, Staatsgalerie, Graphische Sammlung. *Der barocke Himmel. Handzeichnungen deutscher und ausländischer Künstler in Deutschland.* Exh. cat. Stuttgart, 1964.

Stuttgart 1979 ———. *Zeichnung in Deutschland: Deutsche Zeichner 1540–1640.* Exh. cat. (catalogue by Heinrich Geissler). Stuttgart, 1979–80.

Stuttgart 1984 ———. *Meisterwerke aus der Graphischen Sammlung, Zeichnungen des 15. bis 18. Jahrhunderts.* Exh. cat. Stuttgart, 1984.

Stuttgart 1985 ———, and Pfalzgalerie, Kaiserslautern. *Deutsche Landschaftszeichnungen des 18. Jahrhunderts aus der Graphischen Sammlung.* Exh. cat. (catalogue by Otto Pannewitz). Stuttgart, 1985.

Sulzer 1794 Sulzer, Johann Georg. *Allgemeine Theorie der bildenden Künsten.* 2d ed. Leipzig, 1794.

Swoboda 1964 Swoboda, Karl Maria, ed. *Barock in Böhmen.* Munich, 1964.

Taylor 1974 Taylor, Mary Cazort. *European Drawings from the Sonnenschein Collection and Related Drawings in the Collection of the University of Michigan Museum of Art.* Ann Arbor, 1974.

Tenner 1966 Tenner, Helmut. *Mannheimer Kunstsammler und Kunsthändler bis zur Mitte des neunzehnten Jahrhunderts.* Heidelberg, 1966.

Thaler 1978 Thaler, Herfried. *Josef Ferdinand Fromiller (1693–1760): Ein Beitrag zur Barockmalerei in Kärnten.* Unpublished dissertation. Vienna, 1978.

Thieme-Becker 1907 Thieme, Ulrich, and Felix Becker. *Allgemeines Lexikon der Bildenden Künstler von der Antike bis zum Gegenwart.* 37 vols. 1907–50.

Thienemann 1856 Thienemann, Georg August Wilhelm. *Leben und Wirken des Unvergleichlichen Thiermalers und Kupferstechers Johann Elias Ridinger. . . .* Leipzig, 1856.

Thomasius 1970 Thomasius, Christian. *Deutsche Schriften.* Peter von Düffel, ed. Stuttgart, 1970.

Tietze 1907 Tietze, Hans, ed. *Die Denkmäle des politischen Bezirkes Krems, mit einem Beiheft: Die Sammlungen des Schlosses Grafenegg.* Österreichische Kunsttopographie 1. Vienna, 1907–08.

Tietze 1909 ———. "Wiener Gotik im 18. Jahrhundert." *Kunstgeschichtliches Jahrbuch der K.K. Zentralkommission für Kunst und historische Denkmäle* 3 (1909), pp. 162–8s.

Tietze 1911 ———. "Programme und Entwürfe zu den grossen österreichischen Barockfresken." *Jahrbuch der Kunsthistorischen Sammlungen des Allerhöchsten Kaiserhauses* 30 (1911), pp. 1–28.

Tietze 1911a ———. *Die Denkmäle des politischen Bezirkes Waidhofen a.d. Thaya.* Österreichische Kunsttopographie 6. Vienna, 1911.

Tietze 1914 ———, and Franz Martin. *Die profanen Denkmäle der Stadt Salzburg.* Österreichische Kunsttopographie 13. Vienna, 1914.

Tietze 1933 ——— et al. *Die Zeichnungen der deutschen Schulen bis zum Beginn des Klassizismus. Beschreibender Katalog der Handzeichnungen in der Graphischen Sammlung Albertina* 4–1s. Vienna, 1933.

Tintelnot 1943 Tintelnot, Hans, ed. *Kunstgeschichtliche Studien. Dagobert Frey zum 23. April 1943.* Breslau (Wrocław), 1943.

Tintelnot 1951 ———. *Die barocke Freskomalerei in Deutschland. Ihre Entwicklung und europäische Wirkung.* Munich, 1951.

Trottmann 1986 Trottmann, Helene. *Cosmas Damian Asam, 1686–1739: Tradition und Invention im malerischen Werk.* Nuremberg, 1986.

Uhr 1987 Uhr, Horst. *The Collections of The Detroit Institute of Art: German Drawings and Watercolors, Including Austrian and Swiss Works.* New York, 1987.

University of Kansas 1962 University of Kansas. *Handbook: The Museum of Art.* Lawrence, Kansas, 1962.

Venice 1959 Venice. *Disegni Veneti del Settecento nello Collezione Paul Wallraf.* Exh. cat. (catalogue by Antonio Morassi). Venice, 1959.

Vienna 1934 Vienna, Österreichische Galerie. *Das Barockmuseum im Unteren Belvedere.* Vienna, 1934.

Vienna 1937 ———. *Entwürfe von Malern, Bildhauern und Architekten der Barockzeit in Österreich.* Exh. cat. Vienna, 1937.

Vienna 1974 Vienna, Oberes Belvedere. *Thomas Schwanthaler, 1634–1707.* Exh. cat. Vienna, 1974–75.

Vienna 1977 ———. *Österreichische Barockmalerei aus der Nationalgalerie in Prag.* Exh. cat. (catalogue by Pavel Preiss). Vienna, 1977–78.

Vienna 1980 Vienna, Schloss Schönbrunn. *Maria Theresia und ihre Zeit.* Exh. cat. Vienna, 1980.

Vienna 1980a Vienna, Österreichische Galerie. *Die Baumeister Gumpp: Eine Künstlerdynastie des Barock in Tirol.* Exh. cat. (catalogue by Michael Krapf). Vienna, 1980.

Vienna 1981
Vienna. *Der Verlag Artaria. Veduten und Wiener Alltagsszenen.* Exh. cat. Vienna, 1981.

Vienna 1986
See Lorenz 1986

Volk 1982
Volk, Peter. "Johann Baptist Straubs Törring-Epitaph in Au am Inn." *Münchner Jahrbuch der bildenden Kunst* 33 (1982), pp. 155–72.

Volk 1985
———. "Bildhauer als Zeichner: Zu einigen Entwürfen süddeutscher Rokokobildhauer." *Kunst und Antiquitäten* 2 (1985), pp. 46–55.

Volk 1986
———. *Entwurf und Ausführung in der europäischen Barockplastik: Beiträge zum internationalen Kolloquium des Bayrischen Nationalmuseums und des Zentralinstituts für Kunstgeschichte.* Munich, 1986.

Wagenman 1919
Wagenman, Eugen. *Die Bauten der Jesuiten in Mannheim und ihre innere Ausstattung.* Dissertation. Karlsruhe, 1919.

Wagner 1967
Wagner, Walter. *Die Geschichte der Akademie der bildenden Künste in Wien.* Veröffentlichungen der Akademie der bildenden Künste in Wien, 1. Vienna, 1967.

Wagner von Wagenfels 1692
Wagner von Wagenfels, Hans Jakob. *Ehren-Ruff Teutsch-Lands; das ist, Ein gründlicher Bericht von Ulrsprung, Tugenden und löblichen Eigenschafften der Teutschen. . . .* Vienna, 1692.

Walter 1928
Walter, Friedrich. *Bauwerke der Kurfürstenzeit in Mainz.* Augsburg, 1928.

Wangerman 1973
Wangerman, Ernst. *The Austrian Achievement 1700–1800.* London, 1973.

Washington, D.C. 1966
Washington, D.C., the National Gallery of Art, and elsewhere. *17th and 18th Century European Drawings.* Exh. cat. (catalogue by Richard P. Wunder). Washington, 1966–67.

Washington, D.C. 1967
Washington, D.C., Smithsonian Institution, National Collection of the Fine Arts. *Treasures from the Cooper Union Museum.* Exh. cat. Washington, D.C., 1967.

Washington, D.C. 1974
Washington, D.C., the National Gallery of Art. *Recent Acquisitions and Promised Gifts: Sculpture, Drawings, Prints.* Exh. cat. Washington, D.C., 1974.

Washington, D.C. 1978
———. and Cambridge, Massachusetts, Fogg Art Museum. *Drawings by Fragonard in North American Collections.* Exh. cat. (catalogue by Eunice Williams). Washington, D.C., 1978–79.

Washington, D.C. 1984
———. and New York, the Pierpont Morgan Library: *Old Master Drawings from the Alber-*
tina. Exh. cat. Washington, D.C., and New York, 1984–85.

Weimar 1981
Weimar, Kunsthalle am Theaterplatz. *Rembrandt und seine Zeitgenossen: Handzeichnungen niederländischer und flämischer Meister des 17. Jahrhunderts aus dem Besitz der Kunstsammlungen zu Weimar.* Exh. cat. Weimar, 1981.

Weinberger 1923
Weinberger, Martin. *Deutsche Rokokozeichnungen. Die Zeichnung.* 1st series, Die Deutschen 5. Munich, 1923.

Wellek 1967
Wellek, René. *Concepts of Criticism.* New Haven, 1967.

Wichmann 1974
Wichmann, Siegfried. *Franz Kobell 1749–1822. Erste Ansätze zu einer chronologischen Ordnung des graphischen Werkes.* Munich, 1974.

Wichner 1888
Wichner, Jakob. *Kloster Admont in Steiermark und seine Beziehungen zur Kunst, aus archival Quellen.* Vienna, 1888.

Wielka Encyklopedia 1967
Wielka Encyklopedia Powszechna 9, Warsaw, 1967, p. 275, s.v. Stanisław Poniatowski.

Wiesinger 1979
Wiesinger, Liselotte. "Berliner Maler um 1700 und die Grundung der Akademie der Künste und die mechanischen Wissenschaften," in *Berlin und die Antike.* Exh. cat. Schloss Charlottenburg, Berlin, 1979, pp. 80–93.

Wiesner 1864
Wiesner. *Die Akademie der bildenden Künste zu Dresden.* Dresden, 1864.

Will 1762
Will, Georg Andre. *Die Geschichte der Nürnbergischen Maler-Akademie.* Nuremberg, 1762.

Winckelmann 1769
Winckelmann, Johann Joachim. *Gedanken über die Nachahmung der griechischen Werke in der Malerei und Bildhauerkunst.* Dresden, 1755; Ludwig Uhlig, ed., Stuttgart, 1969.

Winkes 1969
Winkes, Rudolph. *Clipeata Imago: Studien zu einer römischen Bildnisform.* Dissertation. Bonn, 1969.

Winner 1985
Winner, Matthias. "Vedute in Flemish landscape drawings of the 16th Century." *Netherlandish Mannerism.* Papers given at a symposium in the Nationalmuseum Stockholm, 1984, Görel Cavalli-Björkman, ed. Stockholm, 1985, pp. 85–96.

Woeckel 1965
Woeckel, Gerhard. "Ignaz Günthers Vorarbeiten für den Hochaltar von Rott am Inn." *Pantheon* 23, no. 6 (1965) pp. 386–401.

Woeckel 1975 ———. *Ignaz Günther. Die Handzeichnungen des kurfürstlich bayerischen Hofbildhauers Franz Ignaz Günther (1725–1775)*. Weissenhorn, 1975.

Wolfenbüttel 1979 Wolfenbüttel, Herzog August Bibliothek. *Sammler Fürst Gelehrter. Herzog August zu Braunschweig und Lüneburg, 1579–1666*. Wolfenbüttel, 1979.

Woltmann and Woltmann, Alfred, and Karl Woermann. Woermann 1888 *Geschichte der Malerei* 3, pt. 2. Leipzig, 1888.

Würzburg 1982 Würzburg, Martin-von-Wagner-Museum. *Deutsche Zeichnungen 1500–1800 aus dem Martin-von-Wagner-Museum der Universität Würzburg*. Exh. cat. (catalogue by Erich Hubala and Ulrich Söding). Würzburg, 1982.

Wüthrich 1956 Wüthrich, Lukas Heinrich. *Christian von Mechel. Leben und Werk eines Basler Kupferstechers und Kunsthändlers (1737–1817)*. Basel, 1956.

Photographs

Courtesy of The Art Institute of Chicago, nos. 1, 29, 53, figs. 7, 11, 12, 13; Bayerische Staatsbibliothek, Munich, fig. 14; The Cleveland Museum of Art, nos. 39, 69; The Cooper-Hewitt Museum, the Smithsonian Institution's National Museum of Design, New York, nos. 35, 56, 57, 60, 61; Crocker Art Museum, Sacramento, California, nos. 8, 34, 40, 48, 67, 68, 78, 80, 84, 89, 96; Clem Fiori, Blawenburg, New Jersey, no. 30, fig. 2; Harvard University Art Museums, Cambridge, Massachusetts, nos. 4, 9, 23, 38, 49, 63, 71, 82, 97, 98, 102, 103, fig. 4; Scott Hyde, New York, no. 59; Robert Lorenzson, New York, no. 51; A. F. Madeira, nos. 33, 37, 46, 62, 66, 81, 83, 85, 99, 100; The Metropolitan Museum of Art, nos. 2, 15, 17, 28, 41, 50, 52, 54, 76, 88, 94, 95, figs. 17, 18; Minneapolis Institute of Arts, fig. 3; Museum of Art, Rhode Island School of Design, Providence, nos. 31, 58, 72; courtesy of Museum of Fine Arts, Boston, nos. 27, 93; National Gallery of Art, Washington, D.C., nos. 10, 13, 16, 18, 43, 55, 64, 70, 73, 74, 75, 79, 90; Karl Obert, Santa Barbara, California, no. 101; John Parnell, nos. 65a–o; Philadelphia Museum of Art, nos. 20, 21, fig. 8; The Pierpont Morgan Library, New York, nos. 19, 26, 77, 87, 104, 105; The Spencer Museum of Art, The University of Kansas, Lawrence, nos. 36, 45; Staatliche Graphische Sammlung, Munich, fig. 16; Städtische Kunstsammlungen, Augsburg, fig. 15; Stanford University Museum of Art, nos. 42, 65q; Sterling and Francine Clark Art Institute, no. 3; Szépmüvészeti Múzeum, Budapest, fig. 9; Taylor & Dull, New York, fig. 1; University Art Museum, University of Minnesota, Minneapolis, no. 5, fig. 6; The University of Michigan Museum of Art, Ann Arbor, nos. 11, 91.